The Art of
Ford Madox Brown

Kenneth Bendiner

The Art of
Ford Madox Brown

The Pennsylvania State University Press
University Park, Pennsylvania

Library of Congress Cataloging-in-Publication Data

Bendiner, Kenneth, 1947–
 The art of Ford Madox Brown / Kenneth Bendiner.

 p. cm.
 Includes bibliographical references and index.
 ISBN 0-271-01656-6 (alk. paper)
 1. Brown, Ford Madox, 1821–1893—Criticism and interpretation. I. Title.
 ND497.B73B46 1998
 959.2—dc20 96-31023
 CIP

It is the policy of The Pennsylvania State University Press to use acid-free paper for the first
printing of all clothbound books. Publications on uncoated stock satisfy the minimum require-
ments of American National Standards for Information Sciences—Permanence of Paper for
Printed Library Materials, ANSI Z39.48-1992.

For
Claire, Zachary, Ezra, and Nancy

Contents

Acknowledgments

I am very grateful for a travel grant provided by the American Philosophical
Society, and for the financial support given by the Department of Art History of the
University of Wisconsin–Milwaukee. I would like to thank Mary Bennett, Sanford
Berger, Martin Biesly, Judith Bronkhurst, Jane Cunningham, Charles Nugent,
Robert Rosenblum, Lewis Schultz, Allen Staley, Julian Treuherz, Raymond
Watkinson, and Stephen Wildman for their generous assistance. Philip Winsor's
unwavering interest in publishing this book is also deeply appreciated.

List of Illustrations

COLOR PLATES

FIGURES

Introduction

This book examines the paintings and designs of Ford Madox Brown (1821–93). Each chapter treats a fundamental component of his art. Archaism, humor, realism, Aestheticism, and Brown's social concerns are the topics. The interrelation of these themes surfaces as the book progresses, the most persistent connector being Brown's negative sensibility. And Brown's negativism most forcefully displays itself through humor. To a considerable degree, this book charts the course and meaning of comedy through Brown's career.

Many features of Brown's art reflect Pre-Raphaelitism. He was a key figure in this art movement from its inception in 1848 through its later stages. Yet Brown's art diverges from and plays against the ideals of Pre-Raphaelitism at several points in his career. His works are distinctive, even eccentric; while other major Pre-Raphaelites eventually achieved critical acclaim, Brown never quite did so. Perhaps in consequence, his art as a whole has not been seriously studied to any large extent.

This is not to say that Brown is an unknown master. In recent decades, the articles and catalogue entries of Mary Bennett (who is at work on a catalogue of the artist's oeuvre) have greatly increased our knowledge. Her 1964 exhibition at the Walker Art Gallery, Liverpool was groundbreaking.[1]

In addition, Allen Staley has studied Brown's landscapes in detail.[2] Lucy Rabin has written on Brown's history paintings.[3] Virginia Surtees has published Brown's diary.[4] A. C. Sewter has catalogued Brown's stained-glass designs.[5] Several authors have published on Brown's most famous painting, *Work,* and Julian Treuherz has discussed the many Browns in Manchester.[6]

Most recently Teresa Newman and Ray Watkinson have provided a new biography of Brown.[7] The previous one, by Brown's grandson, Ford Madox Hueffer, had been published in 1896.[8] There have also been articles devoted to Brown by several other scholars of Pre-Raphaelitism, the Arts and Crafts Movement, and Victorian art in general.[9]

Yet for all this, there is much in Brown's art that has not been investigated. His humor, for example, has remained virtually unexamined, except by Hueffer very briefly and by Brown's son-in-law, William Michael Rossetti, in a magazine article of 1886.[10] The relation of Brown's art to the Aesthetic Movement has hardly been touched, and Brown's expression of political and social views has been tackled with regard to only a few paintings. Even some of the fundamental questions of realism and revivalism, at the heart of both Pre-Raphaelitism and Brown's art, call for revision. This book sets out to give Brown's works the attention they demand.

Chronologies of Brown's life and work are included to offer the reader a general outline of the artist's career. Appendixes contain some of Brown's most important

publications, which are not to be found in most libraries. I have used the word "realist" as an adjective throughout the text in order to avoid some of the naive associations of the word "realistic." "Archaism" has been employed instead of the more common term "primitivism" to describe the attempt by artists to achieve qualities of rude freshness. "Primitivism" is too broad. "Archaism" suggests an attraction to something not just crude and unsophisticated, but also old and antiquated. Outside of these two words, the reader will find, I believe, neither highly specialized terms nor obscure language.

1

Archaism

Ford Madox Brown's paintings are inextricably tied to Pre-Raphaelitism, the major new art movement of mid-nineteenth-century England. And Pre-Raphaelitism encompasses two seemingly contradictory interests: archaism and realism. Archaism attempts to revive the qualities of crude, early art. Realism aims to represent the world without bias or past conventions of art. How are these two goals related? This chapter tries to answer that question.

The young art students who founded the Pre-Raphaelite Brotherhood in the autumn of 1848, William Holman Hunt, John Everett Millais, Dante Gabriel Rossetti, and four friends, were inspired by art from before the time of Raphael.[1] This dependence on art from before the sixteenth century and the High Renaissance can be called archaism. The Pre-Raphaelites admired such artists as Fra Angelico, Benozzo Gozzoli, and Hans Memling. And these painters were generally perceived in the mid-nineteenth century as "primitives," "Gothic" painters of stilted, garish, and flat images. At best, such archaic masters, it was widely argued, held the seeds of greatness that would blossom in the art of Raphael, Michelangelo, Titian, and the later Old Masters. A number of publications in England around midcentury by Lord Lindsay, Mrs. Jameson, and Franz Kugler, among others, gave new attention and praise to

these primitives, especially for their Christian spirituality.[2] But Giorgio Vasari's evolutionary view of the history of art still held sway, and the Pre-Raphaelites embraced the supposedly crude infancy, rather than the graceful maturity of great art.

The Pre-Raphaelites, however, also proclaimed themselves realists, who replicated what their eyes perceived around them. They sometimes painted out-of-doors, directly before their subjects, to increase their attention to reality. They depicted forms in minute detail without generalization, and allowed visual conflicts, flattening effects, unbeautified models, harsh lighting, and entangled compositions to remain in their final canvases. Realism is a problematic concept, open to endless philosophical argument, and will be discussed at greater length later. At present we merely note that, however impossible the aim, the copying of nature, "rejecting nothing, selecting nothing," to use John Ruskin's phrase of 1843, was a Pre-Raphaelite tenet. Ruskin's published diatribes against art-school idealizations and mannerisms, and his call to young artists to find truth in the humble copying of nature undoubtedly encouraged at least some of the Pre-Raphaelites in their realist goal.[3] And Ruskin also admired the primitives of the fourteenth and fifteenth centuries.[4]

The mingling of archaism and realism lies at the heart of Pre-Raphaelitism and is also fundamental to the art of Ford Madox Brown. Brown has always been considered a Pre-Raphaelite, yet he was never an official member of the Pre-Raphaelite Brotherhood. Whether Brown was offered membership and rejected it, or whether he was rejected by the founders is unclear, because of contradictory reminiscences of the parties involved.[5] Nevertheless, Brown tellingly told his friend Lowes Dickinson in 1851 that the critics "smell a rat, and begin to know that if not an actual Pre-Raphaelite Brother, I am an aider and abettor of Pre-Raphaelitism."[6] And in that same year, Brown wrote to Holman Hunt, giving the clearest statement of his relation to the Brotherhood:

> Your picture [*Valentine Rescuing Sylvia;* Birmingham Museums and Art Gallery] seems to me without fault and beautiful to its minutest detail, and I do not think that there is a man in England that could do a finer work; it is fine all over. I have been to see Millais. His pictures are wonders in colour and truth; in fine, admirable for all they intend, but I like yours better for my own use. . . . If Rossetti will only work, you will form a trio which will play a great part in English art, in spite of [Augustus] Egg's predictions. I mean to be much more careful in future, and try next time to *satisfy myself.* I wish I had seen you tonight, for I am full of your picture, and should like to shake you by the hand. I have had serious thoughts of joining P.R.B. on my pictures this year, but in the first place I am rather old to play the fool, or at least what would be thought to be doing so; in the next place I do not feel confident enough how the picture will look, and unless very much liked I would not do it; but the best reason against it is that we may be of more service to each other as we are than openly bound together.[7]

The letter to Hunt proclaims Brown's indebtedness and closeness to the Brotherhood. His aims, styles, subjects, and entire development remained interlocked with those of the official members of the Brotherhood. But Brown's relationship to the younger painters was not simple. He can be perceived as both forerunner and follower of Pre-Raphaelitism. As a painter in an archaistic style, dependent upon fifteenth-century art, he was a teacher of the Pre-Raphaelites, and even gave lessons for a short while to Rossetti in 1848. But as a realist who described the world in microscopic detail and brilliant light, Brown was a follower of the Pre-Raphaelites.

Brown's linear and "Gothicized" image of John Wycliffe (1847–48; Color Plate I, Fig. 17), for example, looks forward to the quaint, awkward, and colorful vision of the young Virgin Mary (1848–49) by Brown's pupil, Rossetti (Fig. 94). The minute natural detail and sunlight of Brown's *Chaucer* (1845–51) (Color Plate II, Fig. 14), however, reflect the innovations of Hunt and Millais (Figs. 95 and 96). What complicates any consideration of Brown's relation to the Pre-Raphaelite Brotherhood and clouds any discussion of his development is Brown's persistent penchant for retouching and revising his works over decades. Both the *Wycliffe* and the *Chaucer,* for example, underwent various touch-ups and transformations by Brown. Brown's roles of predecessor and adherent cannot be absolutely proven by visual evidence. Even the original appearance of Brown's earliest productions and slightest creations are open to question. He reworked his youthful efforts, repainted small potboilers, and added inscriptions to his drawings at various points in his career. Many of his works remained in his hands for decades; in addition, we know that on several occasions he bought back and borrowed works that had been sold in order to retouch them.[8] Nevertheless, archaism and realism stand as the crucial characteristics of Brown's art and Pre-Raphaelitism at least through the mid-1850s. But what does archaism have to do with realism?

One possible answer is that these two concerns of Brown and the Pre-Raphaelites do not logically cohere, and that there is no essential connection. The founders of the Brotherhood in 1848, ranging in age from nineteen to twenty-three, were mostly boisterous students, rebelling against the stagnant art of their day. They were not philosophers of aesthetics, rationally concerned with ideas, and their friend Brown, a few years older, was also not greatly attracted to theoretical speculation. Nevertheless, there are possible links between archaism and realism that at least were voiced on occasion. Ruskin made the connection in 1851, when, with qualifications, he defended the Brotherhood against vitriolic criticism in the press. The Pre-Raphaelites, Ruskin declared in the *Times* of 13 May:

> intend to return to early days in this point only —that, as far as in them lies, they will draw either what they see, or what they suppose might have been the actual facts of the scene they desire to represent, irrespective of any conventional rules of picture-making; and they have chosen that unfortunate though not inaccurate name because all artists did this before Raphael's time, and after

Raphael's time did *not* this, but sought to paint fair pictures, rather than represent stern facts.[9]

Ruskin denied that the Pre-Raphaelites' works actually looked like fifteenth-century images; only the young artists' devotion to visual facts tied them to the "primitives" of an earlier age. Well, yes. One would not mistake a Pre-Raphaelite painting of 1849 or 1850 (Figs. 94–96) for a genuine fifteenth-century image, but the Pre-Raphaelites' general pictorial sources were obvious to every other reviewer of the day, and there is ample documentation of the Pre-Raphaelites' enthusiasm for such art.[10]

Ruskin's explanation was not based upon conversations with the Pre-Raphaelites. He did not even meet them until after his second letter to the *Times* of 30 May 1851 (which largely elaborated the points of the first).[11] Ruskin's defense may be more of a celebration of his own concepts than an accurate account of the Pre-Raphaelites'. He had sung the praises of such fourteenth- and fifteenth-century painters as Giotto, Fra Angelico, Ghirlandaio, and Perugino in the second volume of *Modern Painters* (1846), seeing them as innocent masters of truthfulness.[12]

Ruskin's pamphlet titled *Pre-Raphaelitism,* published in August 1851, while making some of the same points as his letters, paid greatest attention, strangely enough, to Ruskin's favorite artist, J. M. W. Turner.[13] Turner was not much admired by the Pre-Raphaelites, and his art looks nothing like theirs, but for Ruskin, "Turnerism" and Pre-Raphaelitism were the same: the truthful depiction of nature. Somehow, Ruskin's explanations seem more Ruskinian than Pre-Raphaelite. On the other hand, the conception of the "primitives" as realists had been present in Pre-Raphaelite circles before Ruskin's letter of 1851.

In the short-lived Pre-Raphaelite magazine, the *Germ,* which consisted of but four issues in 1850, there appeared an article in February titled "The Purpose and Tendency of Early Italian Art." This brief essay by Frederic George Stephens, a member of the Brotherhood, aimed "to encourage and enforce an entire adherence to the simplicity of nature."[14] The modern school of English art (that is, the Pre-Raphaelites), wrote Stephens, produces "pure transcripts and faithful studies of nature, instead of conventionalities and feeble reminiscences of the Old Masters; an entire seeking after originality and a more humble manner than has been practical since the decline of Italian Art in the Middle Ages." He continued: "This patient devotedness appears to be a conviction peculiar to, or at least more purely followed by, the early Italian Painters; a feeling which, exaggerated, and its object mistaken by them, though still held holy and pure, was the cause of the retirement of many of the greatest men from the world to the monastery. The modern artist does not retire to monasteries, or practice discipline; but he may show his participation in the same high feeling by a firm attachment to truth in every point of representation."

Stephens then noted "that this [modern] movement is an advance, and that it is of nature herself, is shown by its going nearer to truth in every object produced, and by its being guided by the very principles the ancient painters followed, as soon as they attained the mere power of representing an object faithfully. These principles are now

revived, not from them, though through their example, but from nature itself." Stephens discussed briefly the works of Giotto, Gozzoli, Ghiberti, Ghirlandaio, Fra Angelico, Orcagna, and other early Italians. He considered the Carracci and other seventeenth-century masters as the hateful antitheses of the primitives. Most of Stephens's points, no matter how tortuously expressed, are close to those of Ruskin, including the religious tone of the realist message. It would seem that the Pre-Raphaelites had come into contact with Ruskin's ideas by 1850, and that Ruskin's letters of 1851 thus accurately defined the Brotherhood's ideals. Holman Hunt certainly attributed the Brotherhood's aims to the influence of Ruskin's *Modern Painters,* which he read in 1847.[15] But Hunt was recounting such matters in the late nineteenth and early twentieth centuries, when he had grudges against various other historians of Pre-Raphaelitism, and had particular biases to defend. Hunt sought to downplay archaism in the development of Pre-Raphaelitism, and downgrade the importance of both Rossetti and Brown. Ruskin and realism were his hobbyhorses. In any event, ideas very similar to those of Ruskin were presented in the *Germ* in 1850.

Brown too apparently developed an interpretation of archaism as realism in the early days of Pre-Raphaelitism. In 1848, shortly after the foundation of the Brotherhood, and long before the *Germ* appeared, Brown published two articles in the *Builder.* Both of these articles praised the early Italian painters, and attributed their virtues to the study of nature.[16] His first essay, published 4 November 1848, largely concerned patronage in England, and defended several earlier articles on the subject in the *Builder* by Brown's friend and fellow archaistic painter, William Cave Thomas.[17] Brown was responding to an anonymous letter to the editor that criticized Thomas's views. The anonymous writer, who called himself "Amateur," had particularly praised Tintoretto, and Brown took him to task:

> It is not customary at this period to praise at one breath masters such as Fra Angelico, Perugino, and the Bellini; and then again, Tintoret, Guido, and the Caracci; it is not at present customary to express equal pleasure at the guileless inexperience of the one school and the pedantic incapacity of the other; neither is it common at this moment to hear historical painters mention Domenichino and the eclectic school as if their efforts were either to be admired or imitated; it is not prudent to make such a display about Tintoret merely because a graduate of Oxford has lately made a great fuss about him, while the men of most note throughout Europe show nothing but indifference towards him.[18]

Brown thus proclaimed a contrast between the Italian primitives, whom he also called "imperfect but truthful masters," and various sixteenth- and seventeenth-century painters, who had created "the insipid trash that has been imported into this country." Brown's withering comment about "a graduate of Oxford" alludes to Ruskin. Ruskin had published the first volume of *Modern Painters* (1843) as "A Graduate of Oxford," and his second volume included a long and passionate tribute to Tintoretto's symbolism and artistic power.[19] We can be certain, therefore, that Brown had some

familiarity with Ruskin's writings by the autumn of 1848, but that wholehearted admiration for Ruskin was not necessarily present. Indeed, Teresa Newman and Raymond Watkinson view Brown's derogatory allusion to Ruskin in this article as the beginning of the lifelong antagonism between the two men.[20]

In his *Builder* article of 4 November, Brown was not so willing as Ruskin to see great natural truth in art after the fifteenth century. He admired the naturalism of William Hogarth, and could see great merit in the works of such moderns as Ary Scheffer, J. A. D. Ingres, Peter Cornelius, and Daniel Maclise: all of these living painters had found inspiration in the art of the primitives. But Brown, even more than Ruskin, saw the sixteenth century as a decline, and would not grant great truthfulness to Tintoretto or Titian or Veronese as Ruskin did.[21] Brown saw the contrast between art before Raphael and after Raphael as more absolute. His incidental remark about the "Graduate of Oxford" should not be overblown, but it tells us that in trying to understand the relationship between archaism and realism, we should not necessarily conceive of Brown and his Pre-Raphaelite friends as unquestioning Ruskinians.

Brown's second *Builder* article (2 December 1848) was titled "On the Influence of Antiquity on Italian Art," and elaborated the views set forth in his first article, giving greater specificity and a broader historical perspective. Early Italian art, claimed Brown, had been progressing toward greater truth through the study of nature, when it became polluted by reverence for antiquity. Giotto had "first impressed on the childhood of art the character of true pathos and dignity," and advances were made by Masaccio and Filippino Lippi. But then the fashion for classical statuary arose, and

> it is not to be supposed that men like Raffaelle and Michelangelo, would be loathe to avail themselves of the impetus thus given, or the advantages it held out to them; none are so easily led as the inexperienced, and till then art had been in its childhood. What in fact, did they want? they who, early inured to the severe study of nature, had imbibed the vital qualities of individuality and expression, which can be obtained from that source alone; they who had inherited a simple and pure taste from their predecessors; they who had surpassed them; what more could they require, if not greater perfection in drawing, and a bolder outline? This was ready prepared for them in the works of antiquity daily brought to light, and is it to be supposed that . . . they should refuse the proffered boon, the ready chance of improvement, and devote themselves laboriously to extort from nature that which apparently lay beneath their grasp? The shortest route sufficed *their* purpose; they took it.

Raphael and Michelangelo, continued Brown, "had strained the band that held them to nature to the utmost tension, —and then successors broke it; and through all the phases of the decline of art, the less nature was resorted to, the lower the degradation, till general disgust brought about a reaction which is now beginning to bear fruit." By late 1848, therefore, the art of the primitives represented realism. In

Brown's historical view, Michelangelo, Raphael, and most later painters represented a decline into falsity and mannerism.

In 1865, Brown attempted to sum up the links between his early archaistic style and the Pre-Raphaelite devotion to realism. At his self-organized one-man show of that year at 191 Piccadilly, he presented a catalogue of the exhibited works with extensive commentary. Regarding one of his earliest archaistic works, an untraced portrait of James Bamford, painted in 1846, Brown wrote,

> Compared with the head of Mr. Madox and the other five works of the same period in this collection, it looks as if painted by another hand, and that of a beginner; those on the contrary, appear to realize their aim as well as the style permits. Chiefly on account of this peculiarity, I have thought it interesting to include it in this collection. To those who value facile completeness and handling, above painstaking research into nature, the change must appear inexplicable and provoking. Even to myself at this distance of time, *this instinctive turning back to get round by another road,* seems remarkable. But in reality it was only the inevitable result of the want of principle, or rather confliction of many jarring principles under which the student had to begin in those days. Wishing to substitute simple imitation for *scenic effectiveness,* and purity of natural colour for scholastic depth of tone, I found no better way of doing so than to paint what I called a *Holbein of the 19th century.* I might, perhaps, have done so more effectively, but stepping backwards is *stumbling work* at best.[22]

Holbein evidently stands here as an example of early, unflinching realism, a master who did not idealize.[23] Brown's statement of 1865 suggests astonishment at his own development. The turn backward to late medieval art or other primitive images appears not to be the result of rational deliberation or some coherent understanding of early art as more truthful. The whole process in Brown's words appears "instinctive," a "*stumbling*" effort.

Perhaps most important in this journey from primitivism to realism was a distaste for "*scenic effectiveness,*" for ideally beautiful art, for the principles Brown had learned in art school. What was initially significant, it seems, was the utter crudity of this early exercise in archaism—the work of "a beginner." The "*turning back to get round by another road*" was a pathway not immediately recognizable as a road to realism. Archaism, rather, was a way to steer toward childlike purity, and away from all that he had been taught. Archaism was a means to begin over again. In fact, before volume 2 of Ruskin's *Modern Painters* (1846), the art of the fourteenth and fifteenth centuries was rarely associated with notions of truth to natural appearances. And prior to the first productions of the Pre-Raphaelites in 1849, archaistic painters, inspired by the very same early artists, displayed virtually none of the realism evident in the minutely studied paintings of Hunt and Millais.

In mid-nineteenth-century descriptions of the Italian primitives, such as those by Ruskin, Stephens, and Brown given above, notions of realism are mingled with ideas

of innocence. Attributed to Fra Angelico, Benozzo Gozzoli, and the like are sweet simplicity, unpretentiousness, and childlike sincerity. Brown, in his article in the *Builder* of 4 November 1848, thus referred to the early Italians' "guileless inexperience." The very ignorance of these unskilled painters was a sign of purity and moral worth. These were the long-standing associations of primitivism in art as it arose in the late eighteenth century. English neoclassicists such as John Flaxman and William Blake had turned for inspiration on occasion not only to ancient classical art and the High Renaissance, but to fifteenth-century Italian painting and medieval manuscript illumination.[24] Whether antique or Gothic, all these sources possessed the cleansing power of innocence, a means to reject the complexities and gimmickry of later, more sophisticated forms of art.[25]

In the first decades of the nineteenth century, this lust for primitivism became also tied to religious values. The Brotherhood of Saint Luke, or the Nazarenes, as this group of German artists was also called, was among the most dedicated of archaists. The Nazarenes attempted to return to the art of the fourteenth- and fifteenth-century Italians and to the art of Dürer. The early masters were seen not as sincere copyists of nature, but as sincere Christians.[26] Most of the Nazarenes were Roman Catholic and saw their revival of early art as a spiritual movement. The supposed innocence of the primitives was a sign of faithfulness. This pure art belonged to a time before the rationalism of the Renaissance and before the heresies of the Reformation.

Although the Nazarenes began as but a small band of art students in Vienna in 1809, the residence in Rome of these German painters from 1810 onward made their works and ideas familiar to an international public, and the Nazarenes' influence spread wide. In the decades after 1810 the Nazarenes and their German followers often softened their archaistic style, adding illusionistic features, monumentality, and gracefulness in many instances. But in England in the 1840s, when Nazarene art became highly familiar, archaism and Nazarenism were synonymous.

Catholic revivalist writers at the close of the eighteenth century, such as Wilhelm Heinrich Wackenroder, had first presented the Italian and Northern primitives as Christian heroes, stimulating the Nazarenes. Later Catholic art propagandists, such as Alexis François Rio and Charles René Montalembert, continued this theme, glorifying the productions of the Nazarene Brotherhood as the resuscitation of moral, innocent, and spiritual art.[27] These Continental authors did not discern any realist impulses in the early Italians or their modern German imitators. Rio, in *De la poésie Chrétienne* (1836), even saw the spirituality of the primitives of the Middle Ages as antithetical to the naturalistic forces in later Italian art.[28] One can understand how the supposedly innocent spirit of the early artists could be elaborated to signify the innocent perception and representation of nature. But this linkage only becomes notable in the 1840s in England.

In 1841, the Catholic, Gothic Revival architect A. W. N. Pugin, England's most rabid defender of all things medieval, could write that the Nazarenes had "raised up a school of mystical and religious artists who are fast putting to utter shame the natural and sensual school of art, in which the modern followers of paganism have so largely

degraded the representation of sacred personages and events."[29] Naturalism or real-ism evidently had nothing to do with archaism here, and Pugin quoted Montalembert and Rio at length in this same work.[30] But in an article in the *Builder* in August 1845, Pugin dropped his antirealist view of early art and Nazarenism. He now wrote that "the finest productions of Christian Art are the closest approximations to nature, and when they failed in proportion and anatomy, it was not a defect of principle but of execution."[31] Here is evidence of the crucial change in the meaning of archaism: from spiritually antirealist to spiritually realist. And Brown's and the Pre-Raphaelites' development in this direction occurred not too long thereafter. Pugin's new under-standing of the primitives in 1845 was probably not inspired by Ruskin's views; the primitives are not mentioned in volume 1 of *Modern Painters* (1843), and volume 2 had not yet been published. But perhaps Ruskin's realist gusto, certainly present in volume 1, had some effect, and Pugin defended his favorite artists in the light of this new taste.

Pugin's comments of 1845 mark a momentous change in the perception of the primitives. But his new view did not produce immediate, widespread reverberations. Ruskin would move toward Pugin's view in 1846, and Brown and the Pre-Raphaelites would do so in 1848. But far into the 1840s, art magazines such as the *Athenaeum* and popular journals such as *Punch* would continue to denounce the primitives and archa-istic painters as exemplars of unrealism in art. Brown's first embrace of an archaistic style can be dated to the same time as Pugin's article—1845. But his transformation was almost certainly not a direct result of Pugin's ideas. His statement of 1865 indi-cates that Brown initially had no conception of archaism as a means to achieve real-ism in art. Brown was led to take up archaism by the need to succeed in his profession.

Brown had come to London from Paris in 1844 with the express purpose of entering the competition for the decoration of the Houses of Parliament. In one of its rare efforts at state art patronage, the British government, with Prince Albert at the head of the Fine Arts Commission, had decided to ornament the new Palace of Westminster with frescoes.[32] The first contest to select artists for the project had been held in 1843. Brown entered the second competition the following year, submitting work in a style indebted to Eugène Delacroix and other nonarchaistic masters (Fig. 11). His previous history paintings, such as *The Execution of Mary Queen of Scots* (1840–41; Fig. 2) and *The Prisoner of Chillon* (1843; Fig. 6) had similarly mixed French Romanticism with the extravagant style of Henry Fuseli (Fig. 123). Brown's *Ascension* of 1844 (Fig. 9) was also Fuseliesque.[33] Indeed, before 1845, Brown dabbled fitfully in a wide range of styles. Stern neoclassicism in the mode of J.-L. David appears in one of his earliest works, *Blind Begger with Child* (1837; Fig. 1). Charming Biedermeier detail and polish in the manner of Ferdinand von Waldmüller, however, crop up in a family portrait of 1844 (Fig. 10). Other of Brown's paintings of the early 1840s are more forcefully Delacroix-like (for example, *Manfred on the Jungfrau;* Fig. 3), or Rem-brandtesque (*Manfred in the Chamois Hunter's Hut;* Fig. 4), or comically Hogarthian (*Dr. Primrose and His Daughters;* Fig. 5).

Brown had obviously followed no single line of development before 1845, and his

remark in the 1865 catalogue about the "confliction of many jarring principles under which the student had to begin in those days" is perfectly expressed in his early work. His training under Davidian masters in Ghent and Bruges, and a Rubensian history painter in Antwerp (Baron Wappers), and his experience of the Parisian artworld from 1840 to 1844 had produced an eclectic and confused young artist.

Brown failed to gain any prize or any commission in the Parliament competition of 1844. His entry cartoons of *Adam and Eve* (lost) and *The Body of Harold Brought Before William the Conqueror* (Fig. 11) had been conceived in France, and were at odds with what was brewing in England.[34] In Britain, the archaistic art of the Nazarenes was the new and vibrant force. Brown could certainly have been informed in France of this development. He would have been familiar with the style through the works of such Nazarene-inspired French painters as Hippolyte Flandrin, and through the reproductions of Nazarene works displayed in Parisian print shops, even if he had not seen the original productions of the Germans.[35] In any event, however, Brown failed to respond to Nazarenism immediately.

The Parliament fresco competitions were largely responsible for English interest in the Germans. The Nazarenes had gained notoriety for reviving fresco painting both in Rome and Germany, and now England was planning just such a course of decoration. The advice of Peter Cornelius, a major Nazarene painter, was sought.[36] It was also widely believed that the German Prince Albert favored Nazarene art, and for a time it seemed possible that German artists would be commissioned.[37] Furthermore, the secretary of the Fine Arts Commission was Charles Eastlake, who had many contacts with Nazarene painters.[38] Equally important in encouraging Nazarene archaism in England was the character of the newly built Parliament. It was the first secular public building in the Gothic Revival style, and therefore archaistic, medieval-style murals were appropriate. The chief architect, Charles Barry, may have conceived the general form of this seat of government in a basically classical manner, but he was commissioned to create a neomedieval building, and his associate A. W. N. Pugin carried through the Gothic dressing with a dominating vigor.

Pugin was responsible not only for the architectural detail: in 1844, Barry put him in charge of the design of all furniture, metalwork, and tiling in Parliament.[39] Although neo-Gothic architecture had been toyed with by English architects since the middle of the eighteenth century, the Houses of Parliament represented the mammoth triumph of this style. And it was astonishing to Pugin's contemporaries. As late as 1848, *Punch* could find the revived "primitivism" of the Palace of Westminster worthy of mockery. *Punch* provided an updated, but crudely childlike version of the Bayeux Tapestry, and offered it to Barry. The pretend tapestry (Fig. 97), which depicts an expected new French invasion, "will be strictly in character with the building, 'brand new and intensely old.' . . . As you have raised a middle-age building for modern senators, with middle-age decorations for modern debates, and middle-age characters for modern inscriptions, I beg to offer my middle-age representation of a modern event. . . . I trust my design and my verses will be found in strict harmony with your

noble modern-antique Houses of Parliament."[40] This sally was part of a long series of jabs at the Parliament building, its decorations, and Pugin's Gothic taste.

In 1845, *Punch* had presented a suitably medieval cartoon of Justice (with Pugin's monogram) for the new Parliament (Fig. 98).[41] *Punch* explained that Justice is of "Medieval cut," because "cheek by jowl as she will be with CHIVALRY, and other Gothic company, [she] will otherwise resemble a denizen of waters out of its element." And "the Justice of Parliament . . . should be delineated in a style approaching caricature or burlesque which is precisely that of the Art of the middle ages." *Punch*'s mock-decoration is described as "tardigrade," "quaintly clumsy," and "deformed," "so that she may be devoid of the Paganism of symmetry and beauty." No hint of realism is attached to *Punch*'s view of this archaistic art, only anticlassicism. And needless to say, during this entire period in the mid-nineteenth century, the art of the fourteenth and fifteenth centuries was considered not "early Renaissance," but wholly "Medieval," or "Gothic."

Again turning to *Punch* in 1845, we find "Advice to Aspiring Artists," which claims that the painter seeking employment at Parliament

> can do nothing without models, and the best models that he can choose are the Germans. . . . As to copying Raphael and Michael Angelo, he need take pattern from them in no respect except in his personal costume. It is now admitted that those individuals were very poor daubers, their style being a great deal too free and easy, and not at all cramped, stiff and wooden enough for high art. They had, in particular, a certain bad knack for foreshortening, a process very allowable in a caricature, but which in all grand or serious subjects ought to be avoided. . . . He ought to consider Nature as opposed to Art. Indeed he should not go to Nature at all. . . . English sense is very common sense, and greatly inferior to German nonsense—at least in the opinion of certain patrons of the Fine Arts.[42]

Accompanying this jibe, which again linked archaism with antirealism, are a childlike doodle and pseudomedieval scenes (Figs. 99 and 100).

The characteristics of the German neo-Gothic style were further detailed in later *Punch* issues. In 1848, *Punch* saw two opposing camps of high art at the Royal Academy: "Medieval-Angelico-Pugin-Gothic, or Flat Style" versus "Fuseli-Michael-Angelesque School."[43] Two illustrations elaborated the point (Fig. 101). Archaism here was above all seen as a slap in the face of High Renaissance traditions and Henry Fuseli's Romantic interpretations of them. One could argue with *Punch*'s interpretation of art history, but the idea of archaism's contrast to accepted values of the past is clearly expressed. If one had to place Brown's 1844 *Harold* cartoon (Fig. 11) in one of these categories mockingly invented by *Punch* in 1848, it would belong to the "Fuseli-Michel-Angelesque-School." The muscularity, extravagant gestures, radically foreshortened foreground figure, and general dynamism place it in this nonarchaistic camp.

Punch's barbed commentaries in the 1840s reveal the general perception of archaistic painting as crude, unnatural, antagonistic toward previously revered Old Masters, a German movement at odds with traditional English taste, and linked to the Gothic Revival architect and Catholic apologist A. W. N. Pugin. *Punch*'s view was not isolated from the opinion of more serious journals. The *Athenaeum,* for example, reviewed two archaistic paintings at the Royal Academy in 1845 by John Rogers Herbert (a Catholic artist who would eventually receive mural commissions at the Houses of Parliament):

> It is needless, assuredly, to say that we do not enter into the fopperies and extremes of that school of art to which this composition must be referred. We cannot understand Modern Times masquerading in Middle Ages garb—nor conceive that flatnesses and formalities of old, inevitable and natural, are now embraced and cultivated as beauties *because* they are old. This for the hundredth time: —because the evil is growing with Mr. Herbert. . . . How far he can go by way of freak, is to be seen in his portrait of Mr. A. W. Pugin (423), an attempt at the old German stiffness, very curiously pedantic. The face of the critical and ultra-Catholic architect, most canonically dressed in black velvet robes, and inlaid into a background of what country people would call "savage green" damask is flat as the Sun's visage on a tea-board. The artist, we fear, has not learned his lesson. However deficient they might be in science, the antique painters, after whom he strains, were perfect as regards mechanism. The purity, and richness, and solidity of their painting has presented their works with the unimpeded lustre of diamonds and rubies to the present hour. No make-shift work is there! no snuff-shadows under the nose—no escaping from the tedious process of working up a surface by hatchings, and stipplings, and streaks, —of which devices (inventions of modern flimsiness) Mr. Herbert is not clear. Perhaps the patience, the concentrated thought, the very material, even, of these antique painters may be unattainable; but in these lay their strength: —and not in aping the short-comings of a less-instructed century.[44]

Punch, the *Athenaeum* and other magazines inform us also that archaism was new, fashionable, and growing in the English artworld. It was probably the controversial success of archaism that led Brown to take up the novel style.

In the first Parliament competition of 1843, a number of archaistic cartoons received prizes and praise, but non-Nazarenesque entries by G. F. Watts and the French-trained friend of Brown, Edward Armitage, also gained awards.[45] In the contest of 1844, where Brown exhibited *Adam and Eve* and *The Body of Harold,* however, the domination of Nazarene-inspired art became apparent. The prizewinners were William Dyce, Daniel Maclise, C. W. Cope, Richard Redgrave, and William Cave Thomas, all of whom dabbled to some extent in stiff, Gothicized, spatially limited, and harshly linear images redolent of German influence. In July 1844, the commissioners chose six artists to prepare designs for six arched compartments in the House of Lords; this constituted a tentative commission, and the six painters selected were Dyce, Cope,

Thomas, Maclise (Fig. 102), Redgrave, and J. C. Horsely. Other competitors in the next contest, in 1845, were instructed to take up any of the same six subjects assigned to the commissioned artists. The commissions handed out in July were not guaranteed, but the archaistic direction of success was obvious. Cave Thomas, who had studied in Munich under a Nazarene follower, Wilhelm Kaulbach, was a close friend of Brown. Thomas's commission was later revoked by the Fine Arts Commission, but his archaistic bent and initial success would have further encouraged Brown.[46]

Brown's submission of 1845, *The Spirit of Justice,* illustrates his opportunism, his newfound archaism. His entry, as best as can be judged from the surviving watercolor sketch (Fig. 12) possessed Nazarenesque symmetry, flatness, severity of drawing, Gothic features, and medieval subject.[47] So pervasive did Nazarene influence on the fresco competitions appear, that many years later, Brown recollected that Peter Cornelius had essentially told the commissioners to hire the Nazarenesque William Dyce for the mural work.[48] While it is true that Dyce had been invited by the commissioners to enter the contests, Brown's story is unsubstantiated.[49] It tells us nevertheless of Brown's perception of German authority at the time.[50]

The requirements of the Parliament competitions would haunt Brown's art for years. For example, his lost portrait of James Bamford (1846), that "Holbein of the 19th century," was probably partly inspired by the Parliament project. In 1843, the Fine Arts commissioners proposed that the decorations might include a series of "Tudor portraits"—and no doubt they had in mind something like Holbein's portraits for the court of Henry VIII.[51] Brown's image of Chaucer (Color Plate II, Fig. 14), begun in 1845, even in its Pre-Raphaelite state of 1851, bears a resemblance to Maclise's great success at Parliament, *The Spirit of Chivalry* (Fig. 102). And the reviewer in the *Athenaeum* of 1848 rightly noted that Brown's *Wycliffe* (Color Plate I, Fig. 17) looked as if it were "obviously designed with a view to its execution in fresco," the proposed medium of the Parliament murals.[52] The critic in the *Art Journal* similarly remarked, "This is a beautiful and valuable production, brought forward in the manner of fresco."[53]

The attraction to Nazarene archaism was so strong in 1845 that after submitting *The Spirit of Justice,* Brown set off for the headquarters of the Nazarenes, Rome. This trip to a southern climate, which began in August 1845 and ended in June 1846, was ostensibly to help cure his first wife, who was dying of tuberculosis. But the choice of Rome was undoubtedly also determined by Brown's artistic concerns, and after arriving in September 1845, he duly visited the studios of Peter Cornelius and Friedrich Overbeck. He remembered these meetings with fondness and reverence:

> Overbeck I visited first. No introductions were necessary in Rome at that time. I was very young—not, I believe, above two or three-and-twenty. Overbeck was in a small studio with some four or five visitors. He was habited in a black velvet dressing-gown down to the ground, corded round the waist; on his head a velvet cap, furred, which allowed his grey curling locks to stray on his shoulders. He bore exactly the appearance of some figure of the fifteenth century.

When he spoke to me it was with the humility of a saint. Being so young at the time I noticed this the more. He had some five or six cartoons on view, all of the same size, about 24 inches by 30, all sacred subjects. I noted that where any naked flesh was shown it looked exactly like wooden dolls' or lay-figures'. I heard him explain that he never drew these parts from nature, on the principle of avoiding the sensuous in religious art. In spite of this, nevertheless, the sentiment—as depicted in the faces—was so vivid, so unlike most other art, that one felt a disinclination to go away. One could not see enough of it. To-day, more than forty years afterwards, when coming suddenly on one of these de- signs in a print-shop window, I again experienced the same sensation. Cornelius was different: short with red hair and keen eyes under. When I called at his studio he was showing his large cartoon of *Death on the Pale Horse*. As this large canvas was between him and the door I suppose I did not hear his sum- mons to enter, for he came out sharply, and said petulantly, "*mais, entrez donc.*"

He was explaining his great work to some ladies, with a stick in his hand and an old brown paletot as painting-coat. The studio was a waste, as painting- rooms were in those days, when *bric-à-brac,* Oriental rugs, or armour were not much thought of.

He was explaining his picture exactly as a showman would, and I have re- membered the lesson since. Some twenty years ago I saw this cartoon again in London, and it produced on me exactly the same effect it did at first. Full of action and strong character, it was everything reverse of that dreadful common- place into which Art on the Continent seems to be hurrying back.

But Cornelius was no commonplace being; with his small fiery eyes and his lump on his cheek, like David's, he was the man of genius, the man of the unexpected emphatically.[54]

Brown's Roman sojourn of eight months naturally reinforced the archaistic trend in his art. He there designed *The Seeds and Fruits of English Poetry* (Fig. 13), which exhibits the Gothic enframements, symmetry, minimal modeling, and severity of Nazarene images. The subject matter of this altarpiece-like production, which Brown conceived in London, before his departure for Rome, was especially suited to the nationalistic tone of the Parliament decorations. It is a celebration of Britain's great poets, a tribute to the English language, with Chaucer portrayed in the center as its first master. The medieval subject of the main panel also allowed Brown to emphasize Parliament-appropriate Gothic costume and detail.

The *Seeds and Fruits* was later reduced to just the Chaucer subject (Color Plate II, Fig. 14), and it is impossible to judge fully the original appearance of his first concep- tion. The oil sketch for the *Seeds and Fruits* (Fig. 13) was retouched and colored years later. Pre-Raphaelite realism assuredly entered into such revisions, especially as re- gards lighting. But after 1845 archaism obviously remained his primary interest. *James Bamford* has already been mentioned as an archaistic experiment, and related tendencies can be seen in *Oure Ladye of Saturday Night* (1847; Fig. 16), *Wycliffe*

Reading His First Translation of the Bible to John of Gaunt (1847–48; Color Plate I, Fig. 14), and *Lear and Cordelia* (1848–49; Fig. 21). All these post-Roman works attest to a Nazarene disposition toward pattern, limited spatial recession, firm drawing, and medieval subject. Even a sixteenth-century Renaissance subject such as *William Shakespeare* of 1849 (Fig. 22) possesses the stilted, rigid qualities of early art. Brown claimed that this image of the Bard, commissioned by the Dickinson Brothers, printsellers, was a collation of the known portraits of Shakespeare.[55] But he allowed the seams, as it were, to show. The head and torso and arms do not seem in harmony or proportion. The image looks like a primitive compilation of parts.

Like the Nazarenes, Brown borrowed freely from the Italian primitives in these works of the 1840s. The outstretched figure of Lear in *Lear and Cordelia* (Fig. 21) appears to depend upon the figure of Noah in Benozzo Gozzoli's fresco of the drunken patriarch at the Campo Santo in Pisa (Fig. 103).[56] Noah, like King Lear, is in a distressed state, at odds with his children. Another primitive touch in *Lear and Cordelia* is the strip of drapery behind Lear's head, which is based on the Bayeux Tapestry.[57] *Oure Ladye of Good Children* (1847; Fig. 16) similarly harks back to early art. Brown apparently visited the art collections of Christ Church College, Oxford, in 1847, and may have been inspired by such primitive paintings as the *Virgin and Child with Young Saint John and Angel,* then attributed to Filippo Lippi (Fig. 104).[58] In 1865, however, Brown described his picture as a general reflection of his experience of early art in Italy in 1845.[59]

Although specific borrowings from "primitive" art have not been discovered in Brown's *Wycliffe* (Color Plate I, Fig. 17), its symmetry, arched canvas with roundels, stilted postures, linearity, and patterning make it, like the foregoing images, an example of Nazarenesque archaism. Even though *Wycliffe* was retouched in later years, it bears little evidence of the close study of nature, little evidence of those tinges of realism that differentiate Pre-Raphaelite archaism from that of earlier revivalists in both England and Germany.

Nowhere in works before 1851 by Brown or the Nazarenes or their followers, including Dyce, Cope, Maclise, Thomas, or Herbert, do we find the realism of Hunt's *A Converted British Family Sheltering a Christian Missionary* (1849–50; Fig. 96) or Millais's *Lorenzo and Isabella* (1848–49; Fig. 95). The individualized blades of grass, pebbles and limbs, the blazing light, the disordered folds of drapery, the crushed groupings, compositional voids and unconventional facial types, seemingly taken from life, are the innovations of the young Pre-Raphaelites in the world of archaistic painting. As best as can be determined, Brown, for all his intimacy with the Pre-Raphaelites, did not complete any similarly realist image on a major scale until 1851. In that year, *Chaucer* was essentially finished and *Pretty Baa-Lambs* undertaken (Color Plates II and III, Figs. 14 and 23).

A number of small landscapes by Brown, which were begun in 1846, 1848, and 1849, do have some Pre-Raphaelite light and the smack of on-the-spot paintings (Figs. 19 and 20). But Brown worked on these pictures for years afterward, and their original appearance remains uncertain.[60] In any case, the early works that putatively dis-

played such realist tendencies were hardly major, ambitious canvases. Also on a small scale (and this time probably not retouched by Brown) is the disarmingly fresh and straightforward portrait of Millie Smith of 1846 (Fig. 15). The unpretentiousness and seeming candor of this child portrait can perhaps be considered realist. But even here, how much seriousness of purpose can we attribute to a $9 \times 6\frac{7}{8}$ in. painting on paper, which in 1858 Brown called "a terrible daub"?[61]

Brown claimed in 1865 that *Manfred on the Jungfrau* (1840; Fig. 3) was his first effort at outdoor lighting, an unsuccessful manifestation of proto–Pre-Raphaelitism, but he also noted that he had repainted all the color as late as 1861.[62] Its companion painting, *Manfred in the Chamois Hunter's Hut* (Fig. 4) is probably unretouched and remains bascially Rembrandtesque in tone. Demonstrations of Brown's realism prior to 1851, we must conclude, are weak indeed. Brown's realism, unquestionably present from 1851 onward, was quite evidently largely derived from the young Pre-Raphaelites. He gradually made their aims and methods his own. But the question still stands: even if Brown were merely following the example of Hunt and Millais, what made these young men adopt a generally Brownian archaistic style and add to it a strong dose of realism?

The simplest answer would be to cite the influence of Ruskin. Holman Hunt in his reminiscences certainly attributed the realism of Pre-Raphaelitism to Ruskin's ideas. But Hunt did not explain why those ideas should be applied within an archaistic style.[63] Millais's son, in the standard early biography of his father, denied great importance to Ruskin.[64] But because Millais had run off with Ruskin's wife in 1854, the painter's relationship to the critic was naturally viewed with a certain bias. Allen Staley has documented most thoroughly the evidence for Ruskin's influence on Pre-Raphaelite realism, and most recent studies of the movement acknowledge Ruskin's importance.[65] On the other hand, the Pre-Raphaelite Brother who eventually became closest personally to Ruskin, and enjoyed his patronage most fully, was Rossetti, who was the least realist and most archaistic of the group. About the only realist touches in Rossetti's first Pre-Raphaelite painting, *The Girlhood of Mary Virgin* (Fig. 94) are the study of vine leaves and the unprepossessing figure of Joachim. The painting seems inspired primarily by Brown's *Oure Lady of Saturday Night* (Fig. 16), a not unnatural development because in March 1848 Rossetti had sought out Brown as a tutor, and studied under him for a few weeks.[66] Except for a large canvas of a modern moral subject in the 1850s, which Rossetti never completed, those vine leaves of 1848 were just about Rossetti's last effort at the careful scrutiny of nature.

Even admitting Ruskin's ideological influence, the combination of archaism and realism is troubling. If, following Ruskin, the artist should just try to replicate what he perceives, then why work in an archaic mode at all? If, again following Ruskin, the artist finds great truthfulness in the sweet simplicities of the Italian primitives, then why alter their art by adding all those nonarchaic, realist details and compositional methods? And, if the young Pre-Raphaelites were so taken with Ruskin's preachings, why didn't they emulate Ruskin's chief exemplar of realist truth, J. M. W. Turner?

Perhaps the most important point to keep in mind is that archaism preceded the introduction of Pre-Raphaelite realism. Brown, as well as Dyce, Herbert, Maclise, and

so forth, had already developed a full-fledged Nazarene style in England by the autumn of 1848. Before the foundation of the Brotherhood there was little in the works of its future members to suggest an interest in realism, but archaistic leanings were already noticeable. Rossetti's copy of a lost painting by Brown, and several outline drawings made by Rossetti and Hunt in the spring and summer of 1848 at an informal drawing club, the Cyclographic Society, are very Nazarene-like. And there are related drawings by Hunt and Millais, angular, severe, Gothicized and cramped, that conceivably date back to 1847.[67] Archaism, I would suggest, was a necessary prelude to Pre-Raphaelite realism. Archaism became a scaffolding for realism, because this relatively new style in England challenged prevailing taste, and defied the authority of the art school and the art establishment. Archaism acted as a purge, as a destructive force, providing a way, despite its historicism, to represent the world without conventional mannerism.

Brown himself described this very process at the moment of the Brotherhood's founding, in his *Builder* article of 4 November 1848. He wrote of the Nazarene taste for early Italian art:

> Opinions have altered, and become more mature since the days of Sir Joshua Reynolds. Diligent inquiry in London would show that there is no longer any fear of Fuseli being mistaken for a Michelangelo, and at Munich he might learn that Overbeck did not study Raffaelle; that he was one of four young men who sought to attain a like perfection by following the footsteps of that great master and his contemporaries, for which purpose *they reverted to his predecessors, because in their less sophisticated works they found a powerful antidote to the false taste and pseudo classical style then every where prevalent; when having accomplished this object, they abandoned the study of those imperfect though truthful masters, and have since relied solely on nature and the emulation derived from contemporary efforts.*[68]

What Brown ascribed here to Overbeck and the Nazarene Brotherhood was actually what occurred in the development of the Pre-Raphaelite Brotherhood. Archaism acted as an "antidote to the false taste," and once that false taste had been replaced by a reliance on Raphael's predecessors, an art based "solely on nature" was born. This was how archaism led to realism. Brown perhaps overstated the case in claiming Overbeck's eventual abandonment of primitivism for realism. And at the outset of the Pre-Raphaelite Brotherhood, realism did not replace archaism, but mingled with it. But the decisive role of archaism was clearly perceived by Brown. Archaism was the important preliminary to realism not because it was essentially realist, but because it demolished false conventions and cleared the decks.

Although Maclise, Dyce, and other archaists experienced considerable professional success in the 1840s, the majority of ambitious paintings exhibited at the Academy, and the sorts of art and ideas favored in the Academy schools were decidedly non-archaistic. The kinds of earlier art respected were of the High Renaissance and the

Baroque, and the ideals of generalization and grandeur upheld by Sir Joshua Reynolds were still revered.[69]

Outside of the Parliament competitions, archaism in the 1840s represented a radical departure from the norm. In the Royal Academy, William Etty produced Rubensian nudes in rhythmically intertwined arrangements (Fig. 105). Edwin Landseer painted animal dramas with Baroque spatial recession and flickering chiaroscuro (Fig. 107). Young genre painters such as William Powell Frith, J. C. Horsely, Augustus Egg, and E. M. Ward (Fig. 109) depicted historical anecdotes or lighthearted scenes from literature in the style of David Wilkie (Fig. 108). Wilkie's darkly nuanced brushwork and delicately turned figures, from the first decades of the nineteenth century, were based on the art of the Little Dutch Masters of the seventeenth century. The highly respected William Mulready, with somewhat brighter color and a miniaturist's handling of pigment, also depended on Wilkie in his charming genre and literary subjects. In the 1840s, young artists such as William Edward Frost achieved critical success by emulating Etty's works. Others made a hit by painting a grand historical subject in the style of Raphael. Thus Paul Falconer Poole's Raphaelesque *Solomon Eagle* (Sheffield City Art Galleries) won acclaim in 1842. Landscape artists, including the aging J. M. W. Turner and those painters in his wake such as John Martin, David Roberts, and Clarkson Stanfield, created atmospheric or shadowed or spatially flamboyant images, unarchaistic in the extreme.

Brown and the Pre-Raphaelites sought out the archaistic alternative to the standard fare of English art. But they did so with some admiration for what they were rejecting. The Pre-Raphaelite Holman Hunt, for example, exploited Landseer's moody and ennobled animals in *Strayed Sheep* (1852; Tate Gallery, London) and *The Scapegoat* (1855, Lady Lever Art Gallery, Port Sunlight).[70] Augustus Egg was a friend and supporter of the Pre-Raphaelite Brotherhood, and Mulready's relatively tight and colorful art was not totally inimical to the Brotherhood's interests.[71] Brown's portrayal of amusing pigs and gamboling sheep in several works over his career also suggest the influence of Landseer (for example, *Pretty Baa-lambs, Cromwell on His Farm, The Expulsion of the Danes from Manchester;* Color Plate III, Figs. 23, 31, and 74). Even the horizontal vista of Brown's *Windermere* (Fig. 20) bears some resemblance to Landseer's *Sanctuary* (Fig. 107). And it will be shown in the next chapter that Brown borrowed figures from Wilkie in the 1850s and later.

Furthermore, Brown was not above seeking the approval of Etty, who had visited the young artist in Paris in 1843.[72] In 1844, Brown showed his Nazarenesque sketch of the *Spirit of Justice* (Fig. 12) to both Etty and John Martin, a painter of scenes of extravagant destruction.[73] What is perhaps most surprising is that Brown took one small backward step into the standard Baroque manner even after he had become an archaist. In 1848, having already designed such images as *The Seeds and Fruits of English Poetry* and *Oure Lady of Saturday Night,* Brown painted *The Young Mother* (also called *The Infant's Repast;* Fig. 18). No hint of spiky Gothic outlines or flat pattern appear here. The picture of a nursing mother in eighteenth-century dress is directly based upon a painting by C. W. Cope, *The Young Mother* (Fig. 106), exhibited at the Royal Academy in

1846.[74] Cope himself employed an archaistic style in his Parliament entries. But here and in many other canvases, he worked in a dark and painterly manner. Brown, at this point, may have felt that he too could dabble in old and new forms of English art. Or, he may have even questioned the validity of archaism. But whatever doubts about archaism Brown harbored in 1848, they did not affect the Pre-Raphaelite Brotherhood at its inception. By 1849, obvious and fundamental links to academic art and academic idols largely ceased. Rossetti wrote "spit here" every time the name Rubens was mentioned in Anna Jameson's *Sacred and Legendary Art*.[75]

It is significant that Brown's archaism ebbed as his realism grew. The *Last of England* (1852–55; Color Plate VI, Fig. 29) still bears the smack of the fifteenth century, a modern tondo version of The Flight into Egypt as Filippo Lippi or one of his contemporaries might have carried it out. But *Work* (1852–65; Color Plate IV, Fig. 27) and *An English Autumn Afternoon* (1853; Color Plate V, Fig. 28) do not appear particularly archaistic, and the complex atmospherics of *Waiting* (1851–55; Fig. 25), and *Walton-on-the-Naze* (1859–60; Fig. 38) mark Brown's evolution away from archaism. Archaism came before realism, and when it had effectively stifled the academic conventions of the day, it withered while realism succeeded.

This gestation is important for its negative character. The power of negativism to topple false idols and thereby find a true god, would have been brought home to Brown by the very development of Pre-Raphaelitism. His analysis in 1848 of Overbeck's development from archaist to realist indicates Brown's early awareness of the process. Yet a destructive attitude can be seen at work in several aspects of Brown's art predating Pre-Raphaelitism and beyond the issue of archaism. This negative, combative spirit is perhaps most incisive and pervasive in the case of Brown's pictorial humor, which is the subject of Chapter 2.

2

Humor

When Ford Madox Brown was a young man his favorite book was *Till Eulenspiegel,* an anonymous collection of humorous tales first published in the sixteenth century.[1] Although the prankster Eulenspiegel's medieval adventures are a standard part of German culture, Brown's biographer and grandson, Ford Madox Hueffer, was not impressed by the artist's early literary taste. He sadly remarked that Brown in Paris in the 1840s admired only Byron and Dumas, and really hadn't read much of anything else except *Till Eulenspiegel,* and the few historical works needed for his pictorial subjects.[2] Much should not be made of this youthful reading matter. But Brown's enthusiasm for these stories of mischievous comedy does indicate an early appreciation of humor, as well as an attraction to the Middle Ages.

Eulenspiegel's merry adventures, even in the numerous bowdlerized editions, devoid of feces, snot, and other lewdnesses, would have introduced Brown to slapstick comedy. Eulenspiegel is a jolly no-good. He is deceitful, thieving, pugnacious (to the point of sadism), and devastating to the places he visits. The hypocrisy, pride, and greed of Eulenspiegel's victims are consistently unmasked. But moralizing is not a major feature of Eulenspiegel's humor. If nothing else, *Till Eulenspiegel* clearly repre-

sents the damaging force of humor. Till leaves in his wake sullied monarchs, penniless artisans, humiliated priests, and disrupted societies.

Although *Till Eulenspiegel,* like *Mother Goose,* belongs to people's literature in many nations, it is not much part of English culture, and it is hard to come up with any British prankster to compare. Brown's taste identifies his foreign background, his upbringing and education in France and Belgium. Nevertheless, un-tragic British literature also attracted Brown in his early years. While still in France, he painted a scene from Oliver Goldsmith's *Vicar of Wakefield: Dr. Primrose and His Daughters* (1840–41; Fig. 5). Goldsmith's book had been mined for decades by English artists, and the moralizing, sentimental charm of the novel had been emphasized. In Brown's image, something more outlandish and barbed is immediately suggested. The caricatural style evokes the tradition of Hogarth and the early caricatures of Reynolds. Indeed, Brown seems to have applied a mild dose of Eulenspiegel sting to Goldsmith's story.

Dr. Primrose, in the novel, has lost all his wealth, but ever cheerfully stoic, finds moral worth in humble pleasures after a day's hard work. According to Lucy Rabin, the passage illustrated by Brown occurs after the vicar and his family have had to move to a modest country district, and given up all their luxuries: "In this manner we began to find that every situation in life may bring its own peculiar pleasures: every morning waked us to a repetition of toil; but the evening repaid it with vacant hilarity."[3]

The simple pleasures in the novel take place in a common country landscape. But in Brown's painting the woeful Dr. Primrose (what happened to his cheerfulness?) incongruously sits upon a throne-like chair decked with ermine. A rich carpet lies at his feet. A grand lion fountain spews water, and one of his daughters is fashionably dressed and sports a parasol. Oh yeah, this guy is really poor! The material impoverishment of Dr. Primrose, the very source of his spiritual renewal in Goldsmith's tale, is amusingly brought into question by Brown. Dr. Primrose, the man of virtue, becomes false and ridiculous.

The French Rococo landscape in *Dr. Primrose* adds to the tone of frivolity and falsity. Holman Hunt saw Brown's painting as representing that hollow age, "when Fragonard held the field with his tapestry cupids and dry flower wreaths, and when Dresden china artificiality were in favor."[4] The moral point of Goldsmith's novel gets gently slapped in the face.[5]

Dr. Primrose and His Daughters is a small and minor painting, but the humorous undercutting reappears even in some of Brown's most ambitious historical works. *The Body of Harold Brought Before William the Conqueror* (Fig. 11), for example, was Brown's chief entry in the Parliament fresco competition of 1844, and is aggrandized by some borrowings from Delacroix, Raphael, and Fuseli.[6] The noble subject is 1066, when Saxon and Norman cultures mingle by force, and the course of English history is profoundly altered. But in Brown's image the only thing the conquerors concern themselves with at the moment of victory is the huge size of dead Harold's body. The Normans laugh and strain to see the giant corpse, complain about its weight, compare the dead man's large hand to the skinny one of a page boy, and essentially end their

day of triumph by saying "what a big, big fellow!"[7] Only a German reviewer in 1845, however, remarked upon the "peculiarity" of Brown's treatment, and commented that "something else than the enormous gigantic size of the adversary could have been exhibited; and the ridicule . . . could have been introduced as secondary in a poetical historical representation."[8] Even assuming Brown's pro-Saxon stance (a common English point of view, in which the Normans are seen as violators of native Saxon liberties and decencies), Brown's emphasis makes a great historical event laughably undignified.[9]

Brown's comic touches were not limited to his early years. In the Manchester Town Hall murals at the end of his career (1879–93), the final fulfillment of his quest for great public commissions, the grandeur of history is deflated by humorous additions. In one scene (Fig. 74), the Danes are expelled from medieval Manchester. As they flee, the Danes trip over squealing pigs, and get hit in the head by bricks and water. In another (Fig. 76), the amateur astronomer William Crabtree observes the transit of Venus, but drops his instruments, forgets to record his observation, and is accompanied by squalling children.

The inventor of the fly-shuttle, John Kay, is shown in another of the murals (Fig. 81). Kay is not in triumph at Manchester, but hounded by a mob of obsolescent weavers, and carried off to safety, ridiculously wrapped in sheets. Kay's great technological invention lies pathetically on the floor. The atomic theorist Dalton appears in another mural (Fig. 80) incongruously collecting marsh gas with playfully taunting children. In the *Opening of the Bridgewater Canal* (Fig. 82) in the same series of historical paintings, the Duke of Bridgewater, whom Brown claimed was a teetotaler, seems tipsy, as his engineer fills his glass with brandy. A dog falls into the canal, and the largest figures in the scene are a bargewoman with huge twin children. This pair of identical kiddies is so strikingly abnormal that the supposedly major meaning of the scene is lost. Naughty children and unseemly animals at the margins of other of the Manchester murals similarly distract the viewer from the titular subject.[10]

Humor also rears its silly head in the middle periods of Brown's career. Oliver Cromwell (1853–74; Fig. 31), deep in thoughts of his destiny and God's will, is overrun by pigs and sheep, and loudly called to dinner, as a herd of cattle invades his front yard. The great man, as it were, walks into a lamppost. In *Romeo and Juliet* (1867; Fig. 53), as the lover departs from the balcony, his descending foot appears to miss the rung of his rope-ladder. No doubt he will end up in the next act splattered on the ground. In *The Death of Sir Tristram* (1862; Fig. 42), the caricatural style of *Dr. Primrose* (Fig. 5) returns to depict a ludicrous death scene with wild grimaces and expostulations. A fluffy lapdog sits calmly during the violence. Also present are yowling witnesses, and a peculiarly dressed murderer with a sword dangling between his legs.[11]

Brown's masterpiece, *Work* (1852–65; Color Plate IV, Fig. 27), is filled with satire. A middle-class religious lady's do-goodism is rejected by a ditch-digger, a rich gentleman is prevented from going down the street, a lecturer on domestic cats is protested by howling pussies, a parvenu sausage-maker runs for office, and philosophers look like

idlers.[12] The collection of figures as a whole, including a retarded ragamuffin, wild children, an overzealous cop, snoozing vagrants, and a hunchbacked beer boy, as well as the central construction workers, is so motley and conflicting that the suburban street representing England looks like a madhouse.

Brown's other famous painting, *The Last of England* (1852–55; Color Plate VI, Fig. 29) depicts a scene of desperate emigration. The artist declared the whole English migration a "tragic" historical movement.[13] But as we look at this tearful Holy Family forced to leave its homeland, we notice the carefully described cabbages hanging from the railing in the foreground. The cabbages, Brown claimed, indicate a long voyage. But they are really obtrusive details that distract from the central theme. And what's more, the cabin boy in the background is engaged in retrieving vegetables from the lifeboat![14] What kind of ship is this? These foodstuffs in odd places become ridiculous, and surely diminish the grand tragedy of the topical subject. I have yet to find any nineteenth-century image of a ship decked with vegetables, and lifeboats certainly were not used as salad bowls.

Even Brown's religious paintings are not immune from comic touches. In *Jacob and Joseph's Coat* (1863–66; Fig. 44), the profundity of Jacob's mourning is deflated by the obvious fakery that has led him to believe that his son Joseph is dead. The dog in the center of the painting, Brown noted, immediately recognizes that the bloodstains on Joseph's coat are forgeries, and the brothers stand around the deceitful object like obviously lying idiots.[15] How could Jacob not realize that he was being fooled? Even a dumb animal knows better. The patriarch becomes not just a stricken father, but a dupe. The meaningless large feet of someone in the background, which visually jut into Jacob's head, further weaken his appearance of dignity.

In *Elijah and the Widow's Son* (1864; Fig. 45), the mother's thankfulness for the resurrection of her son is undercut rather than enhanced by the silly-looking mother chicken and her brood at the lower right. One chick curiously rides on the back of the hen. The barnyard addenda give the image of miraculous action a comic tinge.[16] Frederick Craven, who commissioned the watercolor of *Elijah,* was unhappy with the picture, and complained to Brown specifically about the unseemly chickens.[17]

Animal life, it is obvious, constitutes one of Brown's most frequent means of comedy. And thus we are not surprised to find a sentimental vision of a family jaunt in the country, *Out of Town* (1843–58; Fig. 7), invaded by a turkey at the lower left. The turkey tries to gobble up a little boy's snack. Like so many of the other comic passages in Brown's art, the turkey is a relatively minor element in the picture, a peripheral detail hardly noticeable at first. But the bird nevertheless serves to humorize or undermine the main subject. In the right foreground of the small landscape called *Walton-on-the-Naze* (1859–60; Fig. 38), to give another example, a "gentleman descants learnedly on the beauty of the scene."[18] But also present, in the left foreground, is a pair of field mice. One of the mice stands with paw extended, a mirror reflection of the gesticulating gentleman on the other side of the canvas. Sniggering mimicry thus appears, and when Mickey Mouse plays a gentleman, the gentleman loses some respectability.

Many of Brown's comic injections, it must be admitted, are so small, marginal, or

understated that most reviewers from Brown's day to the present have ignored them. There are occasional mentions of things "grotesque," "queer," and "exaggerated," but nothing more elaborate.

Only Ford Madox Hueffer and Brown's son-in-law, William Michael Rossetti, have given any serious attention to Brown's comedy. Hueffer pointed out in his biography of his grandfather, here and there, the ludicrous elements, and summed up the strain of humor in his art in an assessment of Brown's development:

> In the *Romeo and Juliet* [Fig. 53], the *Don Juan* [Fig. 55], and the *Cordelia's Portion* [Fig. 52] there are none of the touches of purposely bathotic humour that so strongly distinguishes Madox Brown's work. There are no girls with ducks under their arms to call the Cromwells from their grim musings to the immediate necessity of the dinner that waits.
>
> The frescoes [at Manchester Town Hall] on the other hand, are full of such episodes. Roman children kick litter-bearers, thurifers deride each other, pigs upset ferocious warriors, or children mock great scientists, and seem to utter the continual "after all" of Nature herself.
>
> In his art Madox Brown's attitude toward life was two-fold.
>
> In the conception of his pictures he entirely identified himself with the hero of the picture, and seemed to become for the time a grim mystic, a passionate lover, or an abstracted scientist. But once the central idea was evolved and embodied, he sympathised with the unsympathetic outer world—the unconcerned, wondering child of the *Entombment* [Fig. 50], or the laughing, ignorant cook-maid of the *Cromwell on his Farm* [Fig. 31].[19]

Ultimately, I agree with Hueffer's first suggestion regarding Brown's humor: it utters "the continual 'after all' of Nature herself." It is an aspect of realism, cutting down pretentiousness and idealization. Isn't reality like this, Brown's humor asks, with stupid irrelevancies and blunderings rising up in the midst of serious events? If bathos is the ludicrous descent from the elevated to the commonplace, then Hueffer was right to label Brown's humor bathetic.

Hueffer's second point is also valuable, even if this portrait of the artist as a man who gradually changes his sympathies is largely a fantasy. Hueffer's remarks indicate the basically contradictory nature of Brown's humorous elements; they represent a point of view at odds with the hero or the main subject. Hueffer's comments also suggest the addendum-like character of Brown's comic details. In so many of the paintings, the cabbages, pigs, and so forth seem like afterthoughts. Extant preliminary drawings in most cases indicate, however, that the humorous elements were present at the earliest stages of his pictures.[20] The marginal comic elements, nevertheless, appear as if they were final alterations.

This time-suggestive facet of Brown's humor naturally does not occur in those few pictures, such as *The Body of Harold* and *Work,* where the comedy is built into the central subject. But it does arise in most of the other examples of humor in his art. We

apprehend a painting more or less at once, unlike a play or a book. But by making many of his humorous "additions" so small and peripheral, Brown succeeded in achieving a certain kinship with the more time-bound humor of the written and spoken word. His funny details, easily overlooked, eventually become noticeable and then function like punchlines.

Even more important than Hueffer's commentary is an article by William Michael Rossetti, "Ford Madox Brown: Characteristics," published in the *Century Guild Hobby Horse* in 1886.[21] Unlike Hueffer's book, this essay was written during Brown's lifetime; what is more, Brown probably had some say about its contents. W. M. Rossetti only agreed to write the article after receiving Brown's approval.[22]

Rossetti began his article by considering the fundamental "motive forces" of artists, and quickly focused on Brown's humor: "one of his most marked characteristics is that of combining with elevated subject-matter, and a passionate dramatic, and impressive general treatment, a considerable spice of the familiar, or even the grotesque or semi-grotesque. He will be dignified, but "stuck up" he will never be." Here again is that realist facet of humor: passion and drama are leavened with "the familiar," or even with that kind of comedy called "the grotesque." As examples of this characteristic Rossetti cited Brown's recent Manchester murals, where (Fig. 73) "the [Roman] general's wife has dyed her hair, and his small boy kicks out at a 'nigger': if King Edwin is baptized in York [Fig. 72], there is an old Saxon nobleman who cannot manage to kneel down without the aid of two crutches: if the Danes are driven out of Manchester [Fig. 74], a sow and her litter bear their part in overthrowing the invader; and so on constantly in Brown's compositions."

This painter of "true historical perspective," wrote Rossetti, "is original without being wiredrawn, and can be serious, solemn, or impassioned, without burking that sense of humour which used always to be regarded as an English characteristic, but which theories of art, and the interminable palaver of critics, tend to suppress or to undervalue." Rossetti thus touched upon the fact that Brown retained something of the dignity of his subject, while subjecting it to peripheral comedy, and that comedy could be viewed as a nationalistic, ethnic trait of Englishmen. Rossetti went on to claim that Brown's depiction of the "dramatic and often tragic, without ignoring an element of comedy—bears an obvious resemblance to our Elizabethan playwrights, with Shakespear as the sun in their solar system: from this point of view, his art might be called Elizabethan art, and as such essentially English." Brown is placed here in some pretty good company, and the literary character of his humor is implied.

Rossetti also remarked that "any question as to the compatibility of the grotesque with the tragic . . . was not solely Elizabethan: it was a leading doctrine of the French romantic movement—the dominant influence in the opening years of Mr. Brown's professional career." Well, there go the nationalistic associations. But Brown's comic method is given an international flavor, and related to his own particular cultural background. Rossetti went on to link Brown with the great humorist William Hogarth, whose "pictures deal with the oddities and frivolities of society, high and mostly low, of his day: their substratum is the life or death of body and soul. Mr. Brown [on the

other hand] does not paint pictures of which the external aspect is mainly comic, satirical or burlesque: but he likes very much to call a spade a spade (pictorially) even when the main subject is of a highly elevated or exalted kind." Here is once again an awareness of the curious marginal nature of Brown's humor. Brown brings forth realist truths (calling a spade a spade), yet does not turn the main subject into a complete satire. This distinguishes Brown's comedy from that of such forebears as Hogarth.

Rossetti reiterated this point, adding another intellectual connection: "While occupied with the large outlines of subject-matter large and grave, [Brown] can relish none the less what is peculiar in itself, or what, from familiarity of association, appears peculiar or even odd in relation to historic dignity; an interest which, being real and personal, neither disdains this subsidiary familiar element, nor forces the ampler dignified element into artificial and bloodless pomposity. There is a decided touch of the Carlylean in Mr. Brown's interpretation of history."

Rossetti's essay implies that Brown could have his cake and eat it too. Brown could be a serious painter of dignified history pictures, but also make his subjects comically familiar and "real." I am not so sure that the central subjects of Brown's paintings remain as unscathed as Rossetti claimed. It is a bit difficult to accept the heroic dignity of the Mancunians, when the pigs are entering the fray. Then again, perhaps Rossetti was right, for modern scholars have written about the *Cromwell* (Figs. 30 and 31) and the Manchester murals with hardly a mention of those works' humor.[23] But if nothing else, the mixed-message, double-edged nature of Brown's art becomes clear from Rossetti's article. This 1886 essay also tells us that humor was central to Brown's art.

William Michael Rossetti did not distinguish different periods or any gradual development of humor in Brown's art. He saw it as a permanent feature. Hueffer did discern rises and declines of comedy over the course of Brown's career, but was not quite discerning enough. He missed some of Brown's jokes. For example, Hueffer did not consider *Romeo and Juliet* (Fig. 53) humorous (it's so easy to miss the rung on the ladder), and he saw nothing amiss in *The Last of England* (Fig. 29). Although by no means are all of Brown's paintings comic, humor does appear in every decade of his working life. Comedy was a consistent interest. And after noting some of the more obvious comic passages (for example, *Cromwell* and the Manchester murals), one begins to see other, more subtle manifestations elsewhere.

Pretty Baa-lambs (1851; Color Plate III, Fig. 23), for example, could be pointedly amusing. This first Pre-Raphaelite painting to display figures painted out-of-doors, in glaring sunlight, may primarily be a realist work, dedicated to on-the-spot painting, and unconventional lighting. Yet the child-language title immediately lightens the seriousness—and how funny to garb these realist figures in Rococo costume. Brown did not depict just an ordinary scene in his backyard. He dressed up his models in eighteenth-century fashion and brought in by wagon every morning the flock of sheep.[24] He deliberately created a kind of Boucher or Fragonard pastorale. The Rococo, as Hunt's comments cited earlier indicate, was perceived in the Pre-Raphaelite circle as the height of artificiality, of nonrealism. So Brown took the falsest motif

imaginable and treated it with the most trenchant realism possible.[25] In *Pretty Baa-lambs* the comedy is not only combative, challenging Rococo pastoral idealization, where pretty shepherdesses routinely traipse about, but amusing. The maidservant's delightfully silly efforts to collect grass in a basket for the sheep is an additional comic note (can't these animals feed off the lawn themselves?). Perhaps Brown here alluded to the ridiculous activities often shown in Rococo rural scenes. Is *Pretty Baa-lambs* a truculent declaration of realism, or a humorous spoof? Yes!

A humorous reversal may be present too in *Waiting,* which was also titled *An English Fireside in the Winter of 1854–55* (1851–56; Fig. 25). This seemingly unproblematic painting depicts a mother sewing by lamplight, with a child on her lap.[26] The image, however, is a well-ordered and middle-class redoing of the nocturnal seamstress subject, which from the 1840s on was a virtual symbol of social oppression. Richard Redgrave had exhibited the key image of the downtrodden seamstress in 1844 and many others followed.[27] How laughable that Brown's first modern life subject portrays a warm, well-furnished, and well-fed domestic vision of a young woman sewing! Even though sewing was a standard female occupation in all nineteenth-century households, the specific associations of that activity at midcentury, especially when shown at night (for poor seamstresses were forced to toil till dawn to make a miserable living), must be taken into account. It's as if Auschwitz were painted as a charmingly bucolic landscape.

Another tinge of sour humor may appear in *Chaucer* (1851; Color Plate II, Fig. 14), where the first great English poet is celebrated. The court is assembled, finery abounds, Chaucer reads his verses from a high podium. But most of the audience doesn't pay attention. As described by Brown himself, everybody is gabbing and flirting, except for a few decent souls, a nasty critic, and a plagiarist.[28] Significantly, the jester, at the right side of the composition, is one of the few characters to view the poet with admiration. Chaucer doesn't get any real respect. The Black Prince, supposedly ill, looks rather as if he's bored to death. We have a devotional image of a master poet, and a romantic suggestion of the artist as an unappreciated outsider. But we also have a humorously tinted picture, in which grand dignity is undercut.

Even smaller features of other works may be evidence of Brown's wit. In a stained-glass design for Saint Oswald's, Durham, of 1864, *Oswald Receiving Bishop Aidan, and Sending Missionaries to Scotland* (Fig. 48), we see at the upper right a mildly ludicrous donkey carting a whole pile of crosses on its back. Also present is a small, rather modern-looking signpost with two systems of numerals: "Durham $\frac{1}{2}$ mile / Pictland LX miles." It's a silly detail. And in a stained-glass design of 1869 (Fig. 59), the angel who miraculously leads Saint Peter from jail evidently lacks supernatural powers, for there's a key in the lock of the open jailhouse door. What's the matter, can't the angel pass through doors without a key?

In *Wycliffe Reading His Translation of the Bible to John of Gaunt* (1847–48; Color Plate I, Fig. 17), the proto-Protestant Wycliffe holds his weighty translation with solemn majesty (while John of Gaunt seems another bored listener). But the Bible on the lectern behind Wycliffe is upside down. Why? Is this some meaningless slip on

Brown's part? Some obscure contrast to the books of Gower and Chaucer held by a pageboy at the left? Or does this inverted Bible gently prick the formal stature of Wycliffe? The old boy sometimes turns things on their heads, perhaps, just as Cromwell doesn't always look where he's going. Such marginal notes of incongruity disturb the ideal presentation of the subject, and there are many similar ones in Brown's art— even in his landscapes.

In a late work, *Platt Lane* (1884; Fig. 69), we have a modest twilight suburban view in Manchester. As Allen Staley has pointed out, *Platt Lane* probably depends upon the paintings of John Atkinson Grimshaw.[29] However, in Grimshaw's popular works, with similarly curving roads, soft light, and dreamy atmosphere, the small, shadowy figures are generally well-dressed, incidental strollers. Brown, however, inserted a garishly black-and-yellow striped fellow carrying a lacrosse racket. Yes, there is a notice on the fence in Brown's painting announcing a lacrosse match, and such a sporting figure is not impossible on a suburban street. But the young man disrupts the lyrical quiet of this Grimshaw-like vision, and again can be interpreted as a humorous touch.

Perhaps also mildly amusing is Brown's self-portrait at the lower left of *The Hayfield* (1855–56; Fig. 34). A nocturnal agricultural scene of great beauty unfolds. The haymakers are going home after a hard day's work, with children in a wagon. But the one figure who exhibits fatigue is the artist, who collapses in a heap, with arms and legs sprawling in exhaustion. The painter's work may indeed be physically enervating, but still, in the context of the labors of the fields, Brown's depletion is slightly ludicrous.

The kinds of humor employed by Brown are varied. The comedy of *The Body of Harold* (Fig. 11) could be labeled irony, for the characters do not recognize the import of the event. The humor of *Pretty Baa-lambs* (Color Plate III, Fig. 23) could be called reverse travesty, or parody, for Brown took a frivolous motif and treated it in the most unrelenting, realist manner. *Work* (Color Plate IV, Fig. 27), in holding up so many elements of modern society to humorous scorn, can be considered satire. The less-pointed mocking of *The Death of Sir Tristram* (Fig. 42), in which everyone looks somewhat ridiculous, but no great moral point is made, might be labeled sardonic humor. And the pigs, cabbages, turkey, chicken, silly children, and other peripheral elements of humor in Brown's art could be described merely as grotesquerie. They distort the natural or ordinary into absurdity. None of these categories of humor, used most frequently in literary criticism, is always firm or distinct. Irony slips easily into satire, and grotesquerie can involve travesty, parody, or other forms of comedy. I am not sure that such labels help us understand Brown's humor at all. Theorists of humor are not much help either.

The literature on humor is a laugh, despite its tediousness (as the reader doubtlessly realizes already, the analysis of humor kills humor). The whole field is filled with potholes. No concept of the character, function, meaning, or range of humor, from the ancient Greeks onward, seems entirely satisfactory or universally applicable. And considerations of physiological laughter, visual caricature, verbal jokes, and narrative comedy in theater and novel are often intermingled indiscriminately in the literature.

Plato introduced a censorious note, claiming that laughter convulses the soul, leads to pride and vulgarity, and should be avoided.[30] But in contradiction (and contradiction seems to be the rule in comic theory), he also declared that comedy is a valuable foil to the serious and the tragic, establishing a balance in the soul, and providing harmless diversion.[31] The study of comedy as a psychological phenomenon thus commenced, and the contrast of humor to seriousness was set. From that contrast, ideas of comic relief were later propounded, especially with regard to Shakespeare's plays, where humor often crops up amid tragedy. Comedy, according to this view, not only offers some break from the emotional strain of tragedy, but can also make the seriousness of the drama all the more powerful by contrast.[32]

Aristotle, like Plato, also disapproved of humor at times—if it caused pain.[33] But in a lost lecture on comedy, known now only from later references, Aristotle apparently also applied his theory of catharsis to comedy. He claimed that the comic produced a happy benevolence as repressed emotions were released in laughter.[34] Aristotle thus touched upon the power of humor to unleash the hidden or constrained.

Dio Chrysostomus was perhaps the first writer to perceive the moral value of comedy, as a means to reveal the false, the ugly, and the sinful. This beneficial social role for humor was elaborated by many later writers, including Plutarch.[35]

The positive and negative views of laughter and humor were given prominence in seventeenth-century England by the Earl of Shaftesbury and Thomas Hobbes. Shaftesbury claimed that amiability was produced, while Hobbes (ever the pessimist) declared that a feeling of pride and condescending superiority was generated.[36]

In the nineteenth century, Charles Baudelaire for once gave some emphasis to the visual arts in discussions of the comic. Although he followed Hobbes in describing the sense of superiority embedded in laughter (what we might call *Schadenfreude*), he also elaborated upon Aristotle's points, seeing some kinds of laughter and grotesquerie as a revelation of man's inner demons, and symbolic of his inner fearfulness.[37] Baudelaire also defined two types of the comic: the significative comic, which depends upon the transformation of things already in existence; and the absolute comic, which is based in fantasy and creates its own humor without reference to anything else. Baudelaire viewed fantastic grotesques as examples of the absolute comic. I doubt, however, that a grotesque figure or beast, which according to Baudelaire is "absolutely" comic, would be comic at all if we did not see it as a deformation of, or contrast to, "normal" or "ideal" figures and beasts. This aspect of his argument is highly doubtful; indeed most of the theories of comedy down the centuries seem inadequate and incomplete. Questions of amiability and superiority, for example, simplify the human mind and emotions ridiculously.

In our sampling of theory, mention should also be made of Ralph Waldo Emerson's view that comedy is essentially the expression of the disparity between the ideal and things as they are.[38] This is a realist interpretation, somewhat related to Champfleury's concept of caricature as a means to liberate the artist from ideal form.[39] And both these mid-nineteenth-century views ultimately stem from Plato's perceived opposition of comedy and seriousness.

Of twentieth-century analyses, Sigmund Freud's study of jokes is by far the most influential.[40] The psychological aspects of humor, even if one does not accept Freud's overall concepts, here received a more profound probing than in any previous work. Freud spent a good deal of space on questions of measuring the energy release of laughter, a highly dubious "scientific" approach to humor developed by Herbert Spencer.[41] And Freud made distinctions among "jokes," "the comic," and "humor" that are not very clear (at least in English). But Freud did bring into play some new analyses of the methods and purposes of humor. He discussed displacement, substitution, and indirect representation in jokes, the same techniques at work in his interpretation of dreams. And he saw jokes similarly as a means of unconscious wish-fulfillment. In jokes, inhibitions break down, hostility against authority breaks out, and the freedom of childhood play is recaptured. In some humor, according to Freud, the restraints of decorum, rationality, and morality can be challenged (sometimes in disguised form), and pleasure thus achieved through a kind of Aristotelian catharsis. In other forms (for example, gallows humor), the sources of pain and fear are mocked or displaced by humor, as the most abhorrent conditions become a bearable laughing matter. This is a variation on Shaftesbury's conception of humor.

Freud also discussed jokes as a symbolic means of sexual seduction, the necessity of second and third parties to make some kinds of humor function, and the aggressive nature of even seemingly innocent jokes. The last point may be particularly relevant to Brown's art. Is there any joke or comic touch, no matter how light and smiling, that doesn't defame or belittle something? Doesn't humor always play with something already in existence (despite what Baudelaire claimed), and in so doing, transform our perception of that something? A normally understood situation or character is changed by humor, and that alteration can always be viewed as an aggressive act.

Of course, no comedian needs theory to create comedy, and Brown, I am sure, was never influenced by any theoretical writings on humor. The only "theoretical" statement on humor by Brown appears in his 1865 description of *Work* (Color Plate IV, Fig. 27). The Victorian sage, Thomas Carlyle, stands at the lower right of that painting, and Brown noted this smiling philosopher's "wild sallies and cynical thrusts." Brown explained, "for Socrates at times strangely disturbs the seriousness of his auditory by the mercilessness of his jokes—against vice and foolishness."[42] This one small passage in Brown's writings certainly tells us that Brown was aware of the social-benefit conception of humor that began with Dio Chrysostomus. He attributed that justification for satire to both Socrates and Carlyle. The beneficial role can be seen in Brown's *Work,* where the many wrongheaded characters of society (which includes just about everyone except the construction workers) appear silly, and thus condemned. But can that moral and socially improving motive be seen in Brown's other comic works? The turkey in *Out of Town* (Fig. 7), the nonsense in *Cromwell* (Figs. 30 and 31), and the sheet-wrapped John Kay (Fig. 81) do not seem to vilify vice and foolishness. There appears no moral point to such comic images—only the deflation of hype and dignity.

Work alone can be easily perceived as a morally charged satire. More significant is Brown's mention, in his description of Carlyle's and Socrates's humor, of "merciless-

ness" and the disturbance of "seriousness." Here is a recognition of the aggressive, negative character of comedy. This does not mean, however, that we must accept all of Brown's humor as consciously tormenting, or that he systematically applied some theory of humor in his art. Brown seems on the whole distinctly untheoretical.

Theorists nonetheless might offer plausible explanations of his comic touch. Why did Brown, for example, depict those fleeing Danes in Manchester falling over pigs? (Fig. 74). Concepts of comic relief would seem particularly inappropriate here. The banana-peel antics do not offer an emotional pause, or serve to heighten by contrast the dramatic power of the subject. If some form of Aristotelian or Freudian catharsis is at work, what emotions are unleashed in the spectator? Fearfulness? Excitement? Xenophobia? Delight at seeing overlords overthrown? Is this gallows humor, making bearable a desperate historical episode? Or does this humorous scene unlock unconscious yearnings to destroy epic heroism, daddy figures, or civic duty, in order that we (and Brown) can reexperience our days of nonsensical infantile playfulness?

Is there some moral point made by Brown's comic addenda? Does the painting of the Danes bring grand history down to earth with a bump, erasing ideal visions of medieval life? Does it make us feel superior to these olden Vikings and Mancuneans? They are such ninnies, really. Or does it make us more amiable toward the characters? We might, after all, have viewed the subject as a serious image of British racial origins, Viking migration and economics, patriotism and violence. But in its humorous guise, perhaps the painting generates no more than a Shaftesburian benevolent smile. Does the humor lead us astray from what is significant, or to what is truly important in the explusion of the Danes from Manchester? (It would seem hard to maintain the latter.)

The trouble with selecting any of these explanations is the marginal character of Brown's humor. The entire painting is not comical, only a few small passages. This peripheral comedy acts as a wry aside, rather than a full-blown guffaw. The main subject is allowed to stand as a "straight" representation, but the humorous details provide a caustic, or grotesque, or lighthearted tempering of that subject. And so too in Brown's written description of *The Expulsion of the Danes from Manchester*.[43] Brown informed the reader straightforwardly, for example, of the plundering habits of the Norsemen, their wearing of gold bracelets to display wealth, that the spear was the national Saxon weapon, and pointed out the ad hoc stretcher used to carry the wounded Danish chieftain. But amid this dry information, he humorously remarked that the Vikings "used to begin their apprenticeship to rapine very early," and noted that "in the background the soldiers of Edward the Elder are seen smiting the unfortunate loiterers in the race for life." As in the mural, the main body of the text is primarily straight-faced, but a few tickles appear at the edges. The humorous touches in both painting and description only briefly inspire second thoughts about the prowess of the Mancuneans, or about the wicked ferocity of the Norse looters. The extravagant, even caricatural, expressions of some of Brown's figures also give pause to the spectator's admiration for the grand drama of Manchester history. This kind of sidetrack humor permitted Brown to work on two levels simultaneously, affirming the serious yet qualifying that seriousness. Ambiguity of intention and effect results.

A number of the ideas discussed by theorists of comedy can apply to Brown's paintings; in most cases, however, the humor must be seen only as a modifier, not the primary focus. Whether the humor represents a sneering putdown of the subject, or an amiable lightening of it, the main theme is undercut—but not devastated or totally transformed. In every instance of Brown's marginal comedy, the subject of the picture is gently questioned. What this questioning ultimately performs is a modest lessening of dignity, grandeur, seriousness, idealism, tragedy, and other high-minded qualities.

I believe that Brown's conscious thrust was to make his image more realist. Brown's realist phase has frequently been limited by scholars to the 1850s, when detailed studies of seemingly unprettified forms appear. But Brown's comments in his exhibition catalogue of 1865 and later remarks still claim the importance of unvarnished truthfulness in art. If Brown's paintings of the 1860s and later are sometimes rhythmic visions of beauty and evocation, part of the Aesthetic Movement, the humor in them can still be seen as a realist tool. Comedy weakens their high-flown ideals, and thus brings the subject down to earth, suspending pure fantasy, or moral points, or noble historical events.[44] The funny (and paradoxical) part is that even 1850s realism is made more humble and realist by Brown's humor. *The Last of England*'s comedy (Color Plate VI, Fig. 29) may include a challenge to the very notion of maniacally painting everything from nature in fabulous detail. Those silly objects, the cabbages, rise up to question the value of indiscriminate attention to every minute particle in the artist's field of vision. And does not *Pretty Baa-lambs* (Color Plate III, Fig. 23) lose some of its power as a realist essay by being based on frivolous Rococo precedents, and possessing a childish title?

The realist interpretation of Brown's humor was noted briefly by Hueffer, and implied by W. M. Rossetti. The interpretation can be related to the concepts of Emerson and Champfleury, both of whom formulated their ideas in the mid-nineteenth century—the great period of realist issues. But Brown's humor can also be seen as exemplary of some other theories. Pointed moral fervor appears lacking, except in *Work,* but the negativism of Hobbes's view seems relevant too. Our reverence for Cromwell or John Kay, or the medieval citizens of Manchester is diluted by Brown's comic embellishments, and we might link this to a Hobbesian sense of self-superiority. Those fellows are not so wonderful, not better than ourselves. On the other hand, perhaps the dilution of respect creates a Shaftesburian friendliness in the spectator—or the artist—making these worthies more approachable and human. How would one "prove" either of these psychological scenarios? A poll perhaps? In either case, however, the subject has undoubtedly been subtly altered, and an ambiguous point of view fostered by humor. Brown's marginal approach does not encourage black and white responses, but rather, uncertainty. And perhaps this is the most realist aspect of his comedy. The world in Brown's pictures is not one-dimensional, absolute, or simple. It is muddied and various, and as the next chapter will explain, this mottledness can be interpreted as a kind of realism.

The views on comedy of Baudelaire and Freud also deserve attention, as we ask why Brown humorized so many of his paintings. Even if one accepts the realist interpreta-

tion that has already been spelled out, deeper questions of motive might be involved. In Brown's little jolts of laughter, is some demonic outpouring of repressed hostility or fear at work? Hostility (which may be Hobbesian superiority by another name) seems certainly part of Brown's comedy. In the manner of Freud, perhaps we should look beneath conscious intentions, and seek explanations in Brown's cantankerous personality and private history.

There are many testaments of Brown's friendliness, love, and sense of group solidarity, hardly the characteristics of a dyspeptic loner at war with his surroundings. The reminiscences of his grandchildren, F. M. Hueffer and Juliet Soskice, generally portray Brown as wonderfully kind, generous, open-minded, and strongly attached to home life.[45] His letters to artist-friends such as William Davis and Frederic Shields are evidence of altruism and a warm heart.[46] Brown also actively participated in numerous clubs, societies, and exhibition groups. Yet his daughter Catherine, in middle age, complained that her father's boisterousness could be frightening, and that this supposedly kindly man, in Catherine's view, cruelly neglected his daughter after the birth of his son, Oliver.[47] Even his doting grandchildren noted the artist's furious reactions to perceived enemies and insults, and his feelings of me-against-the-world, which in his last years bordered on paranoia.[48] In a letter of 1869 to Frederic Shields, for example, his sense of persecution and conspiracy is evident: "However things look too threatening—nothing less than a combination of all England against one or two poor devils, even the Edit'r of the Athenaeum seems now to cut out anything [F. G.] Stephens attempts to write about me or any of my name."[49] Brown's diaries and letters contain bitter remarks against Ruskin, critics, Royal Academicians, and the society that hindered his professional and financial success.[50]

On one occasion, Brown reacted with outrage when his widowed daughter was offered £100 from the Queen's Bounty instead of a pension; and Brown attended a Lord Mayor's banquet in 1892 just so he could sit next to, and abominate various academicians.[51] For all his friendliness and clubbism, wasn't Brown essentially an uncongenial outsider and misfit? He was a Pre-Raphaelite who never became a Pre-Raphaelite Brother, an Englishman raised abroad, a foreign-trained artist in England, a founder of the decorating firm of Morris, Marshall, and Faulkner who was eventually cut out of the business, and a founder of the Hogarth Club who was forbidden to display furniture designs at its exhibitions.[52] He was also frustrated in love in the 1860s, when he desperately yearned for his pupil, Marie Spartali, but never openly declared his passion, and never received any encouragement.[53] Brown was an artist who never achieved great public acclaim, and a man of middle-class upbringing, who was often close to abject poverty, married to the daughter of a bricklayer.[54]

Certainly these points make the latent hostility of Brown's humor likely. When the dignity of Cromwell, or the sweetness of a family outing, or the desperation of emigration are made slightly silly, isn't this, underneath, evidence of Brown "getting even"? He could, on occasion, be openly hostile toward the subjects he depicted. In an article of 1890, for example, Brown half-heartedly defended Cromwell's appreciation of art, but bitterly mocked and attacked the art-destroying attitudes of Cromwell's people.[55]

We might take this further, with a dose of Freudianism, and tie this hostility to Oedipal attacks. Those great English heroes in Brown's canvases, perhaps father figures, are all somewhat besmirched—symbolically destroyed. And might not the emigrating couple in the *Last of England,* although the models were Brown and his wife, be likened to Brown's parents, leaving their homeland for a better life elsewhere? Brown's parents left England for the cheaper living conditions of France, where Brown was born. Don't all those little vegetable jokes in the painting modestly denigrate the couple? The warriors, scientists, and even English landscapes, which are slightly demeaned, might all be eruptions of deep-seated childhood antagonisms. Or perhaps they are symbols of anxiety, safely turned into mirth. It may be significant that Brown's images of a deranged, selfish father, his paintings of King Lear (Figs. 21 and 52), are devoid of humor, as if these visions did not require assault. But such arguments are too strongly locked into Freud's larger concepts to be wholly convincing to any but ardent believers. Whatever its deepest sources, it seems to me that some hostility in the form of undercutting humor is present in Brown's art. On a conscious plane, however, the humor is essentially realist in function. Belittled or humanized, the subject is taken off its ideal pedestal, and this form of art can be called comic realism.

Brown's comedy must also be seen in a broader art-historical context. Humor had long been a major force in English art, and his work participates in that tradition. Satirical anti-Catholic prints had appeared in the Reformation and during the English Civil War. But humorous graphic art only became widespread and notable in England when the caricatures of Annibale Carracci and Pier Leone Ghezzi were seen in the early years of the eighteenth century.[56] The Italian influence mostly led to satirical prints, with vituperative force growing through the eighteenth century. Hogarth stands as the great master of English satire, and he tied his humorous scorn to the narrative methods of the novel and the theater, giving English art something of the greatness already achieved in English comic literature.[57] Hogarth, indeed, can be understood as one of Brown's chief inspirations. Already in his *Builder* article of November 1848, Brown voiced his reverence for the comic master as a great realist. Brown wrote three poems in praise of Hogarth in 1853, expressing his feeling of kinship with this eighteenth-century artist, whom he described as an unappreciated and rebellious painter of nature.[58] Brown named one of his paintings, *The Stages of Cruelty* (Fig. 36), after Hogarth's print series. The vaguely Hogarthian character of Brown's *Dr. Primrose* (Fig. 5) has already been mentioned, and Brown's use of poor dog and rich dog comparisons in *Work* (Color Plate IV, Fig. 27) and *The Establishment of Flemish Weavers in Manchester* (Fig. 75) are among his more obvious borrowings from Hogarth. *Work,* the most satiric of Brown's paintings, has rightly often been seen as Hogarthian in its overall character, with a complex arrangement of social types, moral righteousness, topical references, and characterizing details in the form of printed material.[59]

Despite these links, the violent destructiveness and moral underpinnings of satire in general and Hogarth's satire in particular are rare in Brown's comedy. What's the

moral point of mocking the scientist Crabtree? (Fig. 76). Brown's attraction to Hogarth may in part be tinged with patriotism. In nineteenth-century art literature, Hogarth was repeatedly memorialized as the father of British painting, and Brown's nationalistic leanings, which will be discussed in a later chapter, would have made Hogarth and therefore comic art particularly appealing.[60] The comic literature of Britain—by Shakespeare, Swift, Fielding, and Sterne, for example—already accorded respect to humor. But without Hogarth's introduction of satire into the visual arts with higher pretensions than earlier caricaturists, it is unlikely that comedy would have been so acceptable in English fine art. It is also unlikely that Sir Joshua Reynolds, so concerned with the dignity of art in his discourses, would have dabbled in humorous art had he not had Hogarth's productions before him.

Reynolds's humor appeared not merely in his youthful painted caricatures, such as the spoof of Raphael's *School of Athens* (National Gallery of Ireland, Dublin), but also in a good many of his mature paintings. The playfulness and wit of the art-historical allusions in *Garrick Between Comedy and Tragedy* (private collection, England), and the charmingly obscene humor of *Cupid as a Link Boy* (Albright-Knox Art Gallery, Buffalo) indicate how acceptable comic art could be even for the distinguished president of the Royal Academy.[61] Sexual humor petered out of English art in the early nineteenth century. James Gillray, whose rowdy prints are shot through with bawdiness, died in 1815. George Cruikshank's graphic works, going far into the nineteenth century, became depleted of groin laughs as that century progressed. Thomas Rowlandson, who died in 1827, provided the last public displays of such matter in England, and like Gillray and Cruikshank, not in the august medium of oil painting. Certainly Brown displayed none of the erotic gusto of either Hogarth or Rowlandson, and never devoted himself to the popular art of satirical prints.

A less barbed and less indecorous brand of humor, however, became more prominent in the first years of the nineteenth century, and this time in oil paint. David Wilkie was its most successful practitioner (Fig. 108). Wilkie sweetened the seventeenth-century Dutch comic genre. He depicted common people as charmingly jolly and innocently amusing in most cases. His Dutch sources—such as Jan Steen, Adrian Brouwer, and David Teniers the Younger—had created a vulgar comedy of stupid wretches and sexual naughtiness. Wilkie's art seems exemplary of Shaftesbury's amiable view. One can, however, interpret the pleasant folk of Wilkie's canvases, who gab and tipple and make music, as demeaning portrayals. The gentle jolliness perhaps ultimately destroys the esteem and power of the subject. The tough, oppressed underdog of society becomes a delightful, untruculent fellow through such images.[62] The power of comedy, even the seemingly innocent comedy of Wilkie, to inflict damage, or to defuse the anxiety induced by a threatening underclass (to give the issue a Freudian and Marxist coloration), can possibly be perceived.

Brown borrowed from Wilkie on several occasions. The group of children in the foreground of *Work* (Color Plate IV, Fig. 27) was taken from Wilkie's *Village Festival* (1811; Fig. 108), and *Chetham's Life Dream,* one of the Manchester murals (Fig. 78), contains a figure from Wilkie's *Blind Man's Buff* (1812) (Collection of H. M. Queen

Elizabeth II).[63] But Brown's comedy rarely presents a simple, happy overall appearance. His humor resides not in the main theme, but in the margins. Brown's humor gently mocks the central subject, whereas Wilkie's *Blind Man's Buff* or *Blind Fiddler* (1806; Tate Gallery, London) are lightly comic as a whole, and, at least on the surface, remain undemeaning.

Wilkie's jolly comedy without sting, as mentioned in Chapter 1, lay behind most genre painting in England in the 1840s, when Brown matured. Frith, Egg, Ward, and so forth were adept prospectors of the Wilkiesque vein (Fig. 109). But if the comic tendencies of the 1840s in painting remained sweet and gentle, a slightly harsher satirical bent is apparent in the same period in a host of illustrated magazines. *Punch*, founded in 1842, was the foremost of these publications. The sexual humor of Rowlandson had disappeared from the world of graphic satire, but delightful social and political mockery remained, including parodies of high art, as well as caricatural portraits and farcical narratives. *Punch*'s humor bears some semblance to the ironies and absurdities found in Charles Dickens's and W. M. Thackeray's contemporary novels—monomaniacs, ludicrous happenings, and sarcastic seriousness frequently appear in this enormously successful literature and magazine illustration of midcentury. Surely such material formed a rich background for Brown's humorous endeavors. Genre painters of the period often borrowed directly from *Punch*. Frith's famous *Derby Day* (1858; Tate Gallery, London), for example, clearly depended on Richard Doyle's humorous drawing of the same subject in *Punch*.[64] Likewise, Brown seems to have developed his image of an orange-seller harassed by a cop in *Work* (Color Plate IV, Fig. 27) from a *Punch* cartoon (Fig. 110).[65] And indeed, the satiric structure of *Work*, depicting good guys surrounded by a sea of silliness and falsity, is a frequent comic format in *Punch* drawings. Perhaps the novelists' humor was occasionally also directly inspirational; Brown's ridiculous cabbages in the *Last of England* (Color Plate VI, Fig. 29) may have stemmed from the famous vegetable fight involving Dickens's Mrs. Nickleby.[66] Foodstuffs, like animal imagery, however, are such a standard vehicle of both verbal and visual comedy that a specific source is difficult to pinpoint. Nevertheless, Brown was assuredly familiar with Dickens's humor, and quoted the novelist's comic characters on occasion. In 1864, for example, he wrote to his patron George Rae about his soon-to-be completed painting of Sir Tristram (Fig. 42), "When you like to favour me with a cheque on his account, I shall be found agreeable, like Sam Weller when the gentleman offered him a sovereign."[67]

Dickens's powers as a humorist were well appreciated in the nineteenth century. The completely comic *Pickwick Papers* (1836) was his first great success. Many of Dickens's absurd minor characters and episodes are so memorable in his serious novels, even when they contribute nothing to the narrative, that they act (as do some of Brown's comic additions) as distracting forces, modestly devaluating the supposedly chief thrust of the story.[68] Thackeray's humor more usually takes the form of wholly comic set-pieces, many of which were published in *Punch*. Literary comedy probably served Brown largely as a general example of the worth and dignity of humor. The comic was a major feature of the most lauded fiction of his day, and thus not inimical to great art. It

may be recalled that William Michael Rossetti in 1886 likened Brown's humor, mingled with exalted drama, to that of Shakespeare.[69] Although Brown's *King Lear* subjects seem devoid of humor, his *Romeo and Juliet* (Fig. 53) is touched by comedy, and it is likely that he was aware of, and influenced by, the Bard's "comic relief" in a general way. It is doubtful that he studied Shakespeare with scrupulous care and insight. But like his contemporary Ruskin, he probably would have interpreted those Shakespearean combinations of tragedy and comedy, that wild and changeable diversity, as truthful representations of Nature unadulterated by the falsely purifying constructions of literature.

The literary character of Brown's humor, sometimes akin to punchlines and thus seemingly unfolding in time, has already been noted. But there are fundamental differences between verbal and visual comedy. The more-or-less immediate apprehension of a pictorial image can never quite match the temporal character of words. Puns, dialects, malapropisms, and so forth can only be loosely likened to visual comedy.

Brown's subtle, peripheral humor finds its closest parallels not in the realm of writing, but in the works of various Old Masters. In such famous works as Raphael's *Sistine Madonna* (Dresden Gemäldegalerie), for example, the formality of the Virgin and Child and saints, their august dignity of expression, posture, and composition, is playfully softened by the angelic little putti at the bottom edge of the painting. The charming angel kids are in attitudes of boredom, and apparently find the exalted sacred scene really rather tedious. This comic touch is certainly not a belly laugh, but an amusing sidelight, which brings the heavenly personages slightly down to earth.

The august art of the sixteenth and seventeenth centuries frequently includes such wry asides. Simon Vouet's *Circumcision of Christ* (San Arcangelo a Segno, Naples, on loan to Museo di Capodimonte, Naples), for example, is generally grand and serious. But in the foreground is the small figure of a boy who, for no narrative or symbolic reason, starts putting his head in an urn.

In Rembrandt's *Christ in the Storm on the Sea of Galilee* (Isabella Stewart Gardner Museum, Boston) it is appropriate that the horrors of the storm be depicted. But the apostle who is shown vomiting over the side of the boat is a tiny incident in the composition that adds a note of vulgar comedy in the otherwise grandiloquent scene. And Albrecht Dürer in a number of his woodcuts for the Great and Small Passion, inserted a ridiculously mannered dog, too frisky and fluffy to act seriously as some traditional symbol of faithfulness. Dürer's doggie poses in the foreground of the Flagellation (Bartsch, 8), staring at the viewer; he trots and wags his tail as Christ bears the Cross (Bartsch, 10), and wakes from a snooze as Christ stands before Caiaphas (Bartsch, 29). Dürer's incongruous beast seems to have inspired Brown's own woof-woof in *The Death of Sir Tristram* (Fig. 54), who sits obediently as the knight is murdered. Brown's humor is not unique. Rather, it is a continuation of a little-studied, yet long-lived tradition in Western art. Brown merely made this humor a more persistent and consistent part of his art, and it cannot be ignored as some insignificant nod to convention.

The Western tradition of presenting comic elements at the margins of serious im-

ages seems to have its origins in the Middle Ages, in the subsidiary drolleries of Gothic manuscripts, and the borders of Romanesque art. There, religious texts and sacred scenes are embellished with decorative enframements. And amid this ornament appear funny figures and beasts, naughty vignettes, secular stories, obscene events, monstrosities, and fables. The meaning and purpose of this marginal humor has received varied and contradictory interpretations from scholars. The relation of the comic border to the main text or central image has been seen by some as vital and by others as nonexistent.[70] There are many questions regarding exactly who was meant to see this medieval comedy tucked away in private volumes, or beyond most eyes in the cathedral, and exactly how much freedom was allowed the artist. Such important problems, however, need not concern us here; we are only interested in Ford Madox Brown in the nineteenth century.

Medieval comedy, however, is also significant as a direct source of inspiration for Brown. His archaistic taste and the doings of his acquaintances would have familiarized him with medieval marginal humor. We know that Brown consulted mid-nineteenth-century publications of medieval images to learn the proper dress, and accessories for *Chaucer* and *Wycliffe*.[71] In the 1830s and 1840s, a whole range of books were published in England that reproduced in full, or provided excerpts from, various manuscript illuminations. And we know that the Pre-Raphaelites consulted such publications, or were friendly with their producers.[72]

Furthermore, it is not impossible that Brown visited the British Museum's collection of medieval manuscripts, even though he tended to use secondary sources for his medieval material.[73] In 1854 Brown noted in his diary a trip to the British Museum "about a french Bible," which may well have been a medieval manuscript.[74] And in 1869, he had his children hard at work, making drawings at the British Museum.[75] Not only the general mode of medieval comedy—in the margins—likely influenced Brown, but also specific examples. That odd hen with a chick riding on her back in the corner of Brown's *Elijah* (Fig. 45) may have its origins in the British Museum's Luttrell Psalter, where the very same subject appears at the bottom of a page.[76] And all those animals—pigs, mice, sheep—who enter into Brown's pictures to form the comic elements, are akin to the incongruous beasts that so frequently crop up in medieval borders. We know also that Brown was familiar with the Bayeux Tapestry, either from the original or publications. Brown included a detail of one of the main scenes from the famous medieval textile behind the head of Lear in *Lear and Cordelia* (Fig. 21).[77] The Bayeux Tapestry, like manuscripts of the Middle Ages, includes marginal humor and distractions. On the lower border, often in complete contrast to the mighty scenes above, monsters, fantasy, and sexual delight appear.

Brown's good friend Rossetti certainly studied manuscripts closely; his *Fra Pace* of 1856 (Fig. 111) depicts a monk of the Middle Ages in the act of painting a manuscript border decoration.[78] Amusingly, Rossetti's artist-monk uses a dead mouse as a model for one of the border drolleries that he is painting. This is a celebration of both medieval realism (the monk uses a model from nature) and the kind of marginal

animal humor that probably also inspired Brown. Here is clear evidence that Brown's closest artist-friend was well aware of the imagery of medieval margin decoration.

John Ruskin, although disliked by Brown, was very close to Rossetti in the 1850s, and in all likelihood encouraged Rossetti's interest in manuscript illuminations. Ruskin was a keen collector of missals in that decade, and among his chief possessions was the *Hours of Marguerite Beaujeu* (today in the Pierpont Morgan Library, New York), which is alive with some of the most rude and delightful of marginal humor.[79] What Ruskin particularly appreciated, he claimed, was the free imaginative play of the medieval missal painters, which he referred to as "the grotesque."[80] The humorous aspects of Rossetti's *Fra Pace* (doesn't that ridiculous dead-mouse model at the edge of the picture diminish something of the artist-monk's dignity?) reveal Rossetti's underlying kinship with Brown, and underlines the importance of medieval comedy for both painters.

Rossetti's medievalizing watercolors of 1856–57, in particular, are very Brown-like in their peripheral nonsensical touches. *The Wedding of Saint George and the Princess Sabra* (1857; Tate Gallery, London), for example, includes the slain dragon's head in a little crate by the side of the seated lovers, as if it had been packed and delivered by Fortnum and Mason. The dreamy quaintness and rhapsodic atmosphere of love triumphs in Rossetti's indoor scene. But the dragon's head adds a Brown-like giggle. And Rossetti's contemporaries noted such amusements. The painter James Smetham saw the *Wedding of Saint George* in 1860, and praised it lavishly in a letter, as "like a golden dim dream" with "a sense of secret enclosure"; but "there was also a queer dragon's head which he had brought up in a box (for supper possibly) with its long, red arrowy tongue lolling out so comically, and the glazed eye which somehow seemed to wink at the spectator, as much as to say, 'Do you believe in St. George and the Dragon?' If you do, I don't. But do you think we mean *nothing*, the man in gold and I?"[81] Doesn't Brown's similar humor produce similar reactions? But we don't have such detailed appreciations from his contemporaries, only more general and brief remarks of a critical tone. Brown's friend and patron, Charles Rowley, for example, wrote: "Some of Madox Brown's really powerful designs have passages so queer, so exaggerated and wanting in control, that even his best friends 'cannot abide them.' "[82]

Even Rossetti could find Brown's comic oddities distasteful and irritating. He could understand why William Morris (nicknamed Top) threw Brown out of the reorganized Morris Company in 1874–75. Rossetti wrote to Mrs. Morris in early 1879:

> Some cartoons of Old Brown's (made as I find for Top's firm [Fig. 64]) are being published in an architectural paper. Really I must say they are inconceivable. Every figure (it is a long series) is passing one hand through the stone mullion of the window into the next panel of glass!!—each panel containing one figure. It is called the Story of St. Edith. I must say if this series was what reduced Top to desperation, I think every one wd have sympathised with him [in firing Brown] if he had only shown the cartoons. However, if too public, the incident might have ended in a strait waistcoat for old B.[83]

William Butler Yeats, in 1890, was also put off by the absurd details of a version of *The Baptism of Edwin* (Fig. 72), "a picture that I cannot persuade myself to like chiefly, I think, because I have taken a violent hatred for 'Eadwins' himself, with his clerical beard, and because I do not know what he has done with his feet in that very small fount they have immersed him in."[84] The critic in the *Saturday Review* in 1867 complained of Brown's *Cordelia's Portion* (Fig. 52): "That Mr. Madox Brown is an artist of real genius every good judge must be ready to admit, but his energy is not accompanied by moderation and good taste. . . . There is an overcrowding and obtrusiveness of minor material which, though common in the [Pre-Raphaelite] school to which Mr. Madox Brown belongs, is a fault and a hindrance. What is the use of the dog's paws under the table? The picture would have been better without them, and the dog's head does not easily explain itself; many spectators fail to see what it is?"[85] The dogs in *Cordelia's Portion* are perhaps intrusive details. But are they humorous distractions, or merely realist accessories, part of the overall clutter that makes the scene look random and therefore realist? Comedy and realism can be confused and intertwined.

The mingling of realism and comedy was probably what Brown saw in medieval margins. Many of those nineteenth-century publications by Henry Shaw, Joseph Strutt, and others, which were consulted by Brown and the Pre-Raphaelites, reproduced portions of those Gothic margins, alive with humor. And these publications did so to give factual information about the medieval world. The pedestrian reality of the Middle Ages lay amid all those comical details at the edges of medieval art, not in the grand religious images at the center. Most of these books were published not to illustrate the glories of art, but to document the actuality of life.[86] In support of this, nineteenth-century writers on medieval marginal humor, such as Champfleury and Sir E. Maunde Thompson, tended to perceive the jolly marginalia as glimpses of the real Middle Ages: its folklore and ordinary activities, unsymbolic, unpsychological, and unrelated to the main texts and images.[87] For a medievalizing nineteenth-century painter, interested in realism and searching for historical authenticity, comedy would have seemed enormously important. Reality, so it appeared, resided with the comic and grotesque at the periphery and in the minor details. Reality, so it seemed, lay outside the convention-ridden, high-minded imagery of the central image in the Middle Ages.

Brown understood the deep divide between the grand and the pedestrian, which he humorously bridged in so many works. In 1873, while at work on *Cromwell* (Fig. 31), with its heroic theme invaded by barnyard capers, Brown wrote to George Rae:

> I am going to lecture to the members of the Birmingham and Midland Institutes (if you have ever heard of such society) in February next—I have chosen for subjects—*The Latest Phase of Modern Art* and *Style in Painting*. In the first I propose to show that the innovations so much talked about of myself or others are nothing more than the rule at present with all leading European artists. In the second I wish to call attention to the difference between historic art (so called) that is *devoted* and *elevating* art and the commonplace so affected by our blessed English public, plebeian or patrician."[88]

Brown's combination of high and low, with all its humorous effects, obviously did not arise from some misunderstanding of the distinctions between these categories of art. Brown's remarks about a now-lost design illustrating Beauty and the Beast are also telling: " 'Beauty' pleases me, though I shall not paint the picture, the Idea is now safe and intelligible. I intend it for what the story is, a jumble of Louis XV and Orientalism. The glories of eastern luxurience mix't with household common appurtenances to tickel the fancy at both ends, nothing serious yet nothing without purpose. Works of this kind should be intentionally full of anachronism. To endeavour after unity is to injure the subject and not illustrate it."[89]

This willful "tickel," made of glory and "household common appurtenances," "full of anachronism," and deliberately disunited, was applied by Brown to subjects other than airy fairy tales. It appears in a majority of his works. The comic desire for "nothing serious yet nothing without purpose" underlies not only Brown's peripheral humor, but also his realism. Existence itself could be perceived by Brown as an entertaining farce. When the painter William Bell Scott complained in 1881 that he was tired of life, Brown replied that "you are not the man to lose all interest in this extraordinary puppet-show that is always going on around us."[90] Silliness thus was not necessarily unreal; in turn, even the silliest details of Brown's art had to have the smack of reality. He noted in his diary in 1854, while at work on the *Beauty and the Beast* design, "Scraped out puss and put in one with a more satisfactory miow."[91]

3

Realism

Realism has figured prominently in the preceding chapters, but a
firm definition or extensive discussion of this slippery term has
yet to be given. The unselective representation of what lies before
the artist's eyes was proposed as a sufficient working definition of
realism in Chapter 1. The notion that realism can involve the
deflation of an ideal was presented in Chapter 2.

To say that a depiction is realist would seem to mean that the artist accurately
depicted the reality lying before his eyes, without idealization or other bias. The
problem with such a statement is that you would have to know what reality looked
like to claim that the artist's representation was accurate.

It has become a commonplace among art historians in recent years to claim that
"reality" is essentially an interpretation made by the onlooker (or, as used to be said,
"beauty is in the eye of the beholder"), and does not verifiably exist beyond the mind of
the onlooker. This concept, which in its most extreme form is properly termed solip-
sism, denies the reality of anything outside of the observer. Such an imprisoned
viewpoint is at the heart of many of the writings of the French theorists that have
been embraced by a wide range of scholars in the humanities. If nothing else, this
development has beneficially thwarted easy and unquestioning notions of realism.
Something that "looks real" is no longer a simple description. Some writers have

enlarged (or compromised) the purity of their solipsistic view by claiming that the observer's culture—his nationality, race, class, gender, and so forth—rather than just the isolated observer, determines and biases his perceptions. But this wider approach still affirms the impossibility of ever understanding anything outside of one's own cocoon. One can play delightful games to try to refute these concepts (say, if you perceive that you cannot perceive beyond your own mind, then that perception must also be self-limited or biased). But I would prefer to consider this matter on a more pragmatic level. Solipsism, if accepted, short-circuits all scholarly activities. If we can know nothing beyond ourselves, if there is no objective reality but only our imaginations, then all descriptions or interpretations of the stuff out there usually called reality are just fictions, one as good as the next. Why bother to study or write about any of these will-of-the-wisps, and for whom?

In their everyday, practical lives, solipsists, if they exist, go about eating lunch, let us say, even though that lunch may be a phantasm. Presumably, in such ordinary matters, solipsists take a blind leap of faith and eat lunch. Why should scholarly (or any other) endeavors be more pure, more philosophically rigorous, than our daily occupations? To draw an analogy, even though Einstein's theories of relativity blur distinctions among past, present, and future, few people in their earthly lives (including physicists) feel it necessary or even possible to apply such scientific visions of time to their activities. Pure science and pure philosophy do not necessarily affect the practical workings of human life, and I would contend they should not unduly affect the workings of art historians.[1]

For several millennia philosophers have argued about the nature of reality and how it can be known, and it seems inappropriate to take up these probably unanswerable questions in an art history book by a nonphilosopher. I cannot claim to know what reality looks like. I might resort to "commonsense" definitions of realism, and permit, for example, photographic representations of the world to be considered models of the accurate recording of observable reality. But even the most naive of observers would still face problems. Does that blurred hand in some portrait photograph mean that the "hand" of the represented figure is actually without fingers or firm definition? Our common experience would tell us no. Is that blur in the photograph then more true to "perceptions" of reality, rather than to reality itself? If yes, then whose perceptions? The perceptions of that mechanical black box? The perceptions of the person who pressed the shutter release? And how is it that we can recognize the style of an individual photographer? Can reality have a style? More and more trouble.

Maybe we should think of realism as an ideal, rather than a reality. Mention might be made of the Platonic definition of the "real" as "idea," or the ideal, essential representation of nature, devoid of irregularities. But this ideal notion of realism, which underlies a great deal of art theory from the Renaissance onward, seems directly opposed to the "copying" of irregularities, imperfections, and disorder that was claimed as realism by Brown and so many other self-styled realists of the mid-nineteenth century. In Brown's *Builder* articles of 1848, and in the Pre-Raphaelite magazine, the *Germ,* in 1850, and in Ruskin's writings from 1843 through at least the

1850s, this unrefined recording of "Nature" appears as the realist aim. Maybe we should call realism of that sort an unidealized ideal? Are we just playing with words?

Maybe we could easily solve the problem of defining realism by considering realism just a matter of relationships, of contrast, or comparison. Something is realist only in relation to something else, which can be called artificial. E. H. Gombrich's discussion of pictorial realism and its relationship to formulae of representation is relevant here.[2] Gombrich sees the depiction of reality as a matter of making or borrowing a "schema" or convention of representation, and then adjusting or "matching" that basic structure to the perceived scene. A stereotype or standard must exist first, which the artist can then gradually alter or challenge. This conception of realism through comparison and contrast, Gombrich remarks, permits us to recognize how such disparate artists as Giotto and Velázquez both could be declared realists at various times. They began with different schemata, and the development of realism is a progressive history.[3]

Gombrich notes that nineteenth-century art can be looked upon as a constant battle to remove the schematic underpinnings of representation, to see truthfully, even though Gombrich believes (and it is hard not to agree) that it is impossible to see anything without previous models or artificial scaffoldings of representation.[4] Brown and the Pre-Raphaelites seem to exemplify the Gombrichian conception of the nineteenth century perfectly. They changed the schematic constructions of their day, and evidently hoped to remove artificial formulae entirely in order to depict true "Nature." This approach to realism takes into account the changes of history, the changing perceptions of schemata and the real. It also obviously fits neatly with the previous chapters of this book. Archaism was defined largely in terms of contrast—in opposition to other forms of art in England in the 1840s. Archaistic artists essentially adopted a new schema in an attempt to break away from conventional formulae. And in Chapter 2, much of Brown's humor was portrayed as a counterthrust, a contrast or reaction to the main subject of his paintings. It could be likened to an attack on, or adjustment of, an established convention.

How convenient to have Gombrich's cogent discussion of realism affirm our approach. But isn't all this too typically academic—the old dialectical dispensation? Take an idea, find its opposite, then play one against the other and mix and match. Although Gombrich offers some wonderful insights into the psychology and philosophy of realism, let us step away from grand abstractions, at least temporarily. Let us merely note that Brown considered his Pre-Raphaelite works examples of realism. Let us merely try to distinguish the characteristics (the style, if you will) of this art, which was certainly widely considered to be realist. This attempt diminishes the rhetoric that so often attends realism, and merely considers Brown's "realism" a specific style of a particular period in history.

In the view of most scholars and many Pre-Raphaelites themselves, the 1850s represented the maturity of Pre-Raphaelite realism.[5] Let us tentatively accept that claim, and take the works by Brown conceived and/or largely carried out in that decade as exemplary of his realist art. The paintings included in our examination of this realist style thus include: *Chaucer* (Color Plate II, Fig. 14), *The Last of England* (Color Plate

VI, Fig. 29), *Pretty Baa-lambs* (Color Plate III, Fig. 23), *Out of Town* (Fig. 7), *An English Autumn Afternoon* (Color Plate V, Fig. 28), *Work* (Color Plate IV, Fig. 27), *Jesus Washes Peter's Feet* (Fig. 24), *Carrying Corn* (Fig. 32), *The Hayfield* (Fig. 34), *Waiting* (Fig. 25), *Walton-on-the-Naze* (Fig. 38), *The Brent at Hendon* (Fig. 33), and *Portrait of William Michael Rossetti* (Fig. 35).

Almost all these works display brilliant color, whether they represent glaring sunshine or nocturnal lighting. These colors seem bright, not just because they form a contrast to Brown's earlier works or more conventional images of the time, but because there is no uniformity or harmony of coloration. Violent changes of color, rather than symphonies in red and yellow, occur within each canvas. Warm and cool colors stand side by side, without gradation. The sunny yellows and pinks of *Pretty Baa-lambs* (Color Plate III, Fig. 23) scream out against the green grass and blue sky. There is no envelope of soft atmosphere or nuanced tonalities to quiet the strident color contrasts here. And the glowing hay wagon, stacks, distant house, and sheep in *The Hayfield* (Fig. 34) do not melt into the surrounding landscape. They stand out against the fields and hills, no matter how diffused the moonlight might appear. *Work* (Color Plate IV, Fig. 27) is a welter of fighting colors, and the dominating foliage in *An English Autumn Afternoon* (Color Plate V, Fig. 28) is not some grand, single form, but a wild tangle of hues. The acid yellow grain and red roofs in *Carrying Corn* (Fig. 32) have no strong connections to any other colors in the painting, and stand out disharmoniously. In *Jesus Washes Peter's Feet* (Fig. 24), the background gloom absorbs the distant figures. But the sharp greens and yellows of the foreground jump out from their surroundings and diminish any sense of unity. Even the Turneresque darkling atmosphere of *Walton-on-the-Naze* (Fig. 38), at the end of the 1850s, the most unified of these Brown paintings, is broken by the isolated white building in the center, and by the other small, brightly colored forms that sporadically disorder the calm view. In *Waiting* (Fig. 25), the contrasting kinds of lighting (lamp and fire) create some pictorial dissension. But more important in dislocating the image are such pockets of complex color and shape as the sewing bag and carpet at the figure's feet.

The conflicts of color are matched by other conflicts of form. Lines do not flow into one another, but meet at angles or in opposing directions. Large shapes and small stand next to one another, without elements of transition. The ultimate effect is of disjunction, stop-and-go movement, dissimilarity. Even when lines echo one another in a composition, such as the repeated circular lines and encompassing oval format in the *Last of England* (Color Plate VI, Fig. 29), the unity provided by this repetition is challenged and countered by such features as the motley group of figures behind the foreground couple. Similarly, the circular umbrella, which handsomely encloses the couple, contributing to the play of curves, combats the harmony by including spiky details, angularities, tangled netting, and splashing raindrops that work against the overall shape. *The Brent at Hendon* (Fig. 33) does not display glaring color conflict. But the creeping roots, clotted branches, broken pathway, scattered patches of sunlight, complex water reflections, and web of sinuous lines create an impenetrable jungle out of a suburban landscape meant to be a nostalgic vision of untainted woods.[6]

In *Work* (Color Plate IV, Fig. 27), the basically symmetrical arrangement of figures, not really very different from art-school exercises in unity derived from Raphael's *School of Athens,* loses its integrity, because the forms are so shot with conflicting patterns. And the similarly symmetrical composition of *Chaucer* (Color Plate II, Fig. 14) becomes lost amid the writhing multiplicity of colorful details. A sense of overwhelming variety and abundance obscures the underlying structures of coherence in many of these teeming works. Even those images with fewer forms, however, lack unity. The portrait of William Michael Rossetti (Fig. 35) presents just head and wallpaper, yet neither dominates. No similarities arise. Visual conflict occurs.

The deliberateness of Brown's disordering is evidenced by his criticisms of other painters. In 1856, Brown was deeply impressed by William Holman Hunt's *The Scapegoat* (Lady Lever Art Gallery, Port Sunlight). But he also noted in his diary, "in pictorial composition the work sins, however, the goat being right in the middle of the canvas, and the two sides repeating each other too much, which is always painful, and gives a studied appearance."[7] And in a letter of 1857, Brown advised his friend William Davis how to improve his picture. Brown wrote, "One more thing however that is very unpleasant is that the rainbow and the tree repeat each other too much, so that the tree seems to want filling up more, or the rainbow reduced in size." Brown added little sketches to his letter, making rainbow and tree more varied in scale and not aping each other's curve.[8] Both these commentaries indicate Brown's unfavorable view of coherence. Hunt had compromised the smack of reality in his work by allowing symmetry to dominate the canvas, giving a "studied appearance." Davis, in echoing rainbow and tree, had made his image too perfectly harmonious. The look of randomness was obviously central to Brown's idea of the look of reality.

One of the primary features of Pre-Raphaelite art, minute detail, further assisted Brown's yen for disorder. The general shape of every figure and object is fought by the wealth of minutiae. And the presentation of near and far in nearly the same degree of focus diminishes coherent spatial recession. Furthermore, shadows that might have unified separate elements, or clarified a form against its surroundings, are absent. Instead, contiguous forms eat each other visually throughout the 1850s.

All this conflict creates dynamism. The viewer's eye must move constantly to apprehend the image. The overall effect is of a dynamic, ungraspable mélange. This impression is not just a twentieth-century perception. Hueffer described *Work* in 1896: "When one stands before the picture it is difficult for the eye to find a point on which to settle. The colour, too, is not 'colourist's colour,' at least as I understand the words; it is wanting in harmoniousness, disturbing, and what not."[9] And the *Art Journal* reviewer in 1851 wrote of *Chaucer:* "The figures are struggling for precedence to the eye; for instance, the hat of the cardinal is as near to us as Froissart, properly a nearer figure; and again, the drapery of the Black Prince comes forward with equal force, although yet further off."[10] Well, then, here is the appearance of reality supposedly unencumbered by ideals of beauty or taste or bias in Brown's Pre-Raphaelite art: a seething mass of dislocations.

The style of these Brown images, strangely enough, is very close to the style of mid-

nineteenth-century British decorative arts, where issues of truth to appearances and realism are hardly relevant. How funny! Brown and the Pre-Raphaelites peer into reality, supposedly without preconception, and produce works basically similar to the contemporary design of furniture and interiors, the decoration of glassware, jewelry, and wallpaper. If one looks at midcentury British interiors, as shown in photographs and paintings (for example, Fig. 112), one finds a delight in abundant variety. Pockets of space in a room do not cohere with one another, and points of spatial transition—doorways, corners, partitions, windows—are obscured by hangings, ornaments, and carving.[11] Divisions of the room are diminished or confused by numerous patterns or piles of bric-a-brac. There is no grasping of the whole of a midcentury interior. Even a single milk jug, silver goblet, or glass decanter at this period is a visually complex item. The transition from base to mouth is neither smooth nor quick. Little pictures may open up midway to distract the eye. Changes of decoration, surface texture, material, and color help deny the coherence of the overall shape of the object or the direction of the viewer's gaze.

A chair in the 1850s (for example, Fig. 113), whether neo-Rococo or neo-Gothic, is a writhing mass of varied forms, richly decorated to the point of obscurity, and composed of visually separable parts. Carpets at this period do not have small repeated decorative patterns (which would permit the viewer to see the floor as one grand vista), but rather, have large and complex medallions that force the eye to concentrate for a time on a specific area of the floor. The larger lay of the ground is lost. The furniture in a midcentury room does not all line up against the walls, or organize itself in some symmetrical configuration. Isolated groupings of furniture float amid the space. When a sofa is placed against a wall, we do not see a stark silhouette against a plain backdrop, but a wild conflict of shape and pattern. A woman's dress in the 1850s is not some single color or shape, but a sea of changing forms. In almost every product of midcentury England brilliant color and strong pattern appear. One could go on and on in describing the tendencies toward complexity and disunity in the period. And again, this is not just a twentieth-century perception. In 1851, Richard Redgrave wrote *A Supplementary Report on Design,* appended to the jury reports of the Great Exhibition of that year. Redgrave complained of the poor quality of British decorative arts, and particularly lamented "that mixture of styles, and that incongruity of parts, which, perhaps is itself 'the style' of this characterless age."[12]

Does the visual connection between Brown's realism and general mid-nineteenth-century decorative taste make a mockery of Brown's realism? Was Brown just seeing the world through the fashionably colored glasses of 1850? Or were those common stylistic features merely a scaffolding to hold Brown's probing perceptions of reality? In the last analysis, we really should not care. It is enough that Brown and his public accepted his images as unidealized records of reality. That the same structure of "reality" is to be found in dinnerware and carpets, in coaches and chairs, merely informs us how important those characteristics were to the British in the middle of the nineteenth century.

Our question should be, What was so attractive about these features, and what do

they tell us about Brown and his era? For one, they tell us that there was no high regard for, or belief in, simple order. Symmetry, geometric organization, reductiveness, strict uniformity were disregarded. There was plenty of bright and detailed clarity, but it resided only in particulars, while the borderless overall design disappeared beneath the ocean of minutiae. Movement, change, and the passage of time were also prominent, as the viewer's eye and mind flitted from one varied part to another. Perhaps the dominant characteristic of this style and this perceived reality was the sense of powerlessness. How little control the viewer must have felt over these ever-changing fields of complexity. The psychological effect of Brown's *Chaucer* (Color Plate II, Fig. 14) is not that different from a chair at the Great Exhibition of 1851 (Fig. 113)—a variety so rich that we cannot comprehend or govern the whole.

This effect need not be considered some pessimistic expression of helplessness. It would be so nice to conclude that Brown's art reveals that inmost Victorian disquiet, the anxiety of living in a godless, meaningless universe.[13] To shore up this interpretation, we could offer the preachings and writings of hundreds of Victorian worthies, rabid in their desire to patch over the abyss of faithless disorder in the modern world. It may, however, be difficult to believe that such basic fears or beliefs would exert themselves in the choice of furniture and textiles or the design of cutlery. Conventional disdain for the decorative arts leads us to deny them great social meaning. This is probably a great mistake. The design of everyday household objects would seem to present a far broader and deeper picture of a society's ideals and concerns than the fine-art creations of a few painters working for a limited number of patrons. In any event, that sense of helplessness might be interpreted as an expression of comfort, of infinite abundance, and of freedom from responsibility. As we look at Brown's vision of reality or sit within an 1850s interior, there might be a certain joy in allowing our eye to run free in a realm where everything is boundless and unstructured, and we are not forced to follow a particular path or put things together in a definite way. We can merely sink comfortably into the unfathomable interior and forget about trying to control it or understand it. One might propose that the complexity of mid-nineteenth-century taste portrays a *horror vacui,* a desperate attempt to fill up the terrifying emptiness of perceived reality. But still, the visual disorder and ungraspability in that scenario would be acknowledged as a soothing facade, something pleasing, even if false.

Whether the effect is viewed positively or negatively, it represents a fundamental manner of perception, a basic way of understanding how things relate (or fail to relate) to one another. And one could make a good case for labeling such a general vision a concept of reality. Crisply defined detail, movement and change, uncertain structure, engulfing complexity and uncontrollability were what Brown and his midcentury contemporaries perceived as essential, beautiful, and "real."

The presentation of such a view of the world took an extraordinary effort of will on Brown's part, departing as it did from so many traditions of ordered, clarified art. Brown and the Pre-Raphaelites had to break down the habits of hierarchical seeing and representation, the habits of emphasizing what is most important, and the habits of diminishing what is less important. In the decorative arts, with traditions of rich embellishment,

the departure from clarity and unity would not have been so difficult. In *Work, Chaucer, An English Autumn Afternoon,* and *Waiting,* minutiae and seemingly unimportant objects and passages distract us from what we might presume are the most important elements in the painting. Incidental, peripheral forms—a pot, a billboard, a carpet—are given as much attention as a protagonist or a central narrative event.

Such bold treatment of trivia is not entirely novel in Western art history. Seventeenth-century painters, for example, would often present insignificant figures or objects prominently in the foreground. But the difference is that those Baroque painters utilized those unimportant elements as directional gateways to the significant subjects beyond. The foreground table or dwarf or dog or broom is angled, or darkened, or placed in such a way that the viewer immediately looks over this entrance mat to see what lies beyond. In Pre-Raphaelite realism and Brown's art in particular, however, the viewer's eye does not move onward in a direct and revelatory course. The supposedly minor feature does not always function in a properly minor way. The wheelbarrow in *Work* (Color Plate IV, Fig. 27), the birdhouse in *An English Autumn Afternoon* (Color Plate V, Fig. 28), and the Turkey carpet in *Waiting* (Fig. 25) are not highly meaningful emphases or structural devices. The portrait of William Michael Rossetti (Fig. 35) might be titled *Wallpaper with Head.*

This method of squashing hierarchies relates strongly to what we saw in the chapter on Brown's comedy. There too, marginal elements rose up to distract us from the purported dignity or importance of the main theme. Preconceptions were questioned. And the ambiguity of Brown's humorized paintings (are they straight? satirical? hostile? amiable?) produces an ideational disunity akin to Pre-Raphaelite visual disunity.

The use of comedy to promote this realist dislocation is what differentiates Brown's art from that of the other Pre-Raphaelites. On a purely visual level, Millais and Hunt and several associates of the Brotherhood (for example, J. W. Inchbold, John Brett, and Arthur Hughes) produced equally disunited images. But only Brown (and occasionally Rossetti) reinforced the perceptual dissonance with humorous dissonance. The denial of structural coherence is actually a commonplace of midcentury realism internationally. Gustave Courbet's realist art has long been linked to such qualities, and Linda Nochlin has rightly noted that randomness is one of the essential characteristics of nineteenth-century realist art throughout Europe and America.[14]

The instability, multiple points of focus and dislocation in the works of such realist painters as Edouard Manet have led some scholars to see these realist features as precursors of abstraction in art. Others have identified these same characteristics of dislocation as expressions of social uncertainties, class conflict, and the disorienting effects of modern urban society.[15] Pre-Raphaelite realism is only different from these similar tendencies of midcentury in degree and method. The use of color and niggling detail to break up the image is a specifically English—Pre-Raphaelite—approach. And it could be argued that the dissolution of firm structure fostered by such means is more effective than that produced by other methods elsewhere. The realist works of Courbet, J. F. Millet, and Manet are in many ways much more unified than Pre-Raphaelite art. The French artists' use of general tonalities and uniform facture ties

the parts of their pictures together, even if problems of scale and spatial definition remain. The spatial disjunctions of Manet's images from the 1860s to the 1880s may not be more radical than the collapse of legible distance that occurs in Brown's *Work*.

In comparing the Pre-Raphaelites to their French contemporaries of similar persuasion, it should be noted that Brown was not entirely alone in inserting humor into realist images. Courbet's *The Drunken Curés* (1864; destroyed) was bluntly satirical. Manet's *Déjeuner sur l'herbe* (1863; Musée d'Orsay, Paris) and *Olympia* (1863; Musée d'Orsay, Paris) have been interpreted as realist jokes, as spoofs of the Old Masters: Raphael's river gods ridiculously go out for a Sunday picnic in modern France, and Titian's Venus comes down to earth in nineteenth-century Paris as a high-class whore.[16] The hostility of humor, its ability to bring down ideals and idealization with a crash, would seem to operate in all these realisms. But then again, only Brown's *Pretty Baa-lambs* (Color Plate III, Fig. 23) can truly be likened to Manet's two famous paintings of 1863; it too is, as a whole, a parody of a traditional image. Brown's 1870–78 cartoon depicting Cicero (Fig. 60) incidentally is also of this ilk; the pagan classical author mimics the pose of Jesus in Holman Hunt's earnest *Light of the World* (1851–53; Keble College, Oxford). But this kind of comedy is not two-sided. It is not like Brown's more prevalent marginal humor, which allows a serious statement to stand and then adds a half-giggle. That kind of humor is more devastating to the certainty of meaning and structure.

Brown's art was intended as a representation of reality, and not just as a configuration of lines and shapes and colors. And to comprehend the meaning of such art fully, I think Gombrich provides the most sensible framework. Brown's pictorial randomness seems realist in part because he worked against all those devices of harmony and coherence that are so apparent in so much earlier art. Brown even utilized the balanced compositional structures of High Renaissance art in *Work* (Color Plate IV, Fig. 27) and *Chaucer* (Color Plate II, Fig. 14), for example, but destroyed them through color, detail, and other additions. The standard way of viewing the world, the established schema, is challenged, stretched, and altered to heighten, by contrast, the "realism" of the painting.

But it is not only the randomness of Brown's midcentury art that fights stereotypes and thereby defines its truthfulness. Brown's lighting and color also became realist factors because they challenged convention. The brash brightness of Pre-Raphaelite paintings and Brown's art in particular departed from the dark tonality that had been common in a great deal of European art from the sixteenth century onward. Traditional methods of underpainting and building up an image from dark to light were abandoned, making the practice as well as the appearance of Pre-Raphaelite painting run counter to the productions of the past. Brown even claimed to be an innovator at times, suggesting that he had represented bright natural lighting in some of his youthful works of the 1840s.[17] There seems no hard evidence, however, that Brown ever used any sort of brilliant color for any large-scale work before 1851, and in that year he learned about using a plain white ground to heighten color intensity from Millais and Hunt.[18]

Underpainting requires the artist to produce his painting in stages, separated from his experience of the object in nature. The traditional painter may see a red flower, but begins the coloration of his representation of that flower by painting the image green, or grey, or brown, etc. The Pre-Raphaelites and Brown rejected that method, and saw themselves in contrast, directly setting down their immediate perceptions. And of course abandoning the studio for the outdoors reiterated this lust for immediacy. All this, however, is questionable as necessary for realism. It should be kept in mind that one could easily make a dark, muddy painting on a white ground, and that the act of painting out-of-doors does not guarantee authenticity. Couldn't it be argued that the screaming light of *Chaucer* and *Work* and *Pretty Baa-lambs* is as unreal as the Rubensian ruddiness of William Etty's nudes, or the Rembrandtesque browns and golds of various works by David Wilkie (Figs. 105 and 108)?

In looking over these oftentimes ferociously sunny English scenes by Brown and friends in the 1850s, we should ask ourselves, Doesn't it all seem the most blatant lie to anyone who has lived for some time in Britain, and realizes that such intense sunshine manifests itself in England probably no more than three full days in every year? How false this Pre-Raphaelite art appears. But again, the contrast of this coloration to the artistic formulae of the day made that intensity of light seem "real."

It may be significant that critics hostile to Brown and the Pre-Raphaelites in the 1850s blasted their art as both terribly real and terribly unreal. In 1851 the critic in *The Times* accused the Pre-Raphaelites of "that morbid infatuation which sacrifices truth, beauty, and genuine feeling to mere eccentricity." He also noted the Pre-Raphaelites' realist lack of idealization, their "singular devotion to the minute accidents of their subjects."[19] A rational dissection of this critic's words would undoubtedly raise numerous questions and contradictions. Perhaps it is the reviewer's hostility that was most significant and not his justifications for condemnation. His arguments (and those of other antagonistic critics in the 1850s) nevertheless indicate that merely breaking conventions does not guarantee the quality of "reality." Eccentricity and untruthfulness could be perceived in the Pre-Raphaelite departures from habit and tradition. It was, however, undoubtedly easy to see the particularized realism of Brown, the Pre-Raphaelites, and Ruskin as opposed to Platonic and Reynoldsian understandings of realism.

The problem of defining realism more precisely is particularly apparent in an essay by Coventry Patmore. In the *Saturday Review* in 1857, Patmore wrote an unsigned review of the Pre-Raphaelite exhibition in Russell Place, London.[20] Brown was apparently keenly interested in this critique by a friend of the Brotherhood; he copied out the essay, word for word.[21] Patmore defined the consistent aim of the Pre-Raphaelites as realism, truth to nature (just as Ruskin had in 1851). But Patmore qualified that aim: "one property common to all, or very nearly all the pieces displayed . . . [is] that resulting from the artist's simple and sincere endeavour to render his genuine and independent impression of nature. From [Thomas] Seddon and John Brett, whose eyes are simple photographic lenses, to Gabriel Rossetti and Holman Hunt, who see things in 'the light that never was on sea or land,' but which is, for all that, a true and

genuine light, everything as a rule, and so far as it goes, is modest, veracious and effective." Veracious indeed! Patmore found himself in a mire, having to discern realist aims in all the exhibitors.

Rossetti was obviously the most difficult obstruction: he stood as a prime, founding Brother of the group, and yet his art seemed quaintly archaic, without any hint of natural observation. Patmore tried to yoke Rossetti to Hunt, in contrast to the "merely photographic" art of Brett and Seddon. Patmore grasped onto an idea that would be voiced widely in France among the Impressionists later in the century: realism is the representation of nature filtered through a personality, through a private sensibility.[22] How individualized realism becomes when it is described as "the artist's simple and sincere endeavour to render his genuine and independent impressions of nature." Sincerity and truth to personal vision have replaced factual representation.

Patmore elaborated this concept later in his review, when lauding Rossetti's works. He mentioned Rossetti's use of symbolic color, and declared, "In this and in some other parts he is entirely opposed to the other leading members of the Pre-Raphaelite School, of which he is reputed to have been the founder. But he is a true Pre-Raphaelite nevertheless, for if, with Fuseli, he 'damns nature,' as we suspect he sometimes does in his heart, it is only in order to be more simply and devotedly true to that in his mind's eye, which is more beautiful than nature." Ruskin in fact had understood realism in a very similar manner, and recognized truthful seeing as an imaginative act.[23] But in his defense of Pre-Raphaelitism in 1851 and a good deal of his art criticism in that decade, the unadulterated representation of physical facts is often uppermost in the discussion. Ruskin's belief in truth to the mind's eye must be searched for with effort.

Patmore's review of 1857 probably reflected the current views of the Pre-Raphaelites themselves. He was close to the group from its earliest days, and Patmore's lengthy description of Brown's *Last of England* (Color Plate VI, Fig. 29) in the review was probably taken directly from Brown. Almost the exact same description would appear in Brown's catalogue of his one-man show in 1865. Patmore's difficulties were the Pre-Raphaelites' difficulties. He had to define Pre-Raphaelitism so as to encompass its varied strands. Sincerity and simplicity were among the qualities espoused in the *Germ* and other early documents of Pre-Raphaelitism. But in Patmore's review of the Russell Place exhibition, these values, suggestive of religion and morality, have replaced, rather than merely modified, an understanding of nature as observable fact. If Rossetti were to be accepted as a Pre-Raphaelite, then such explanations had to be provided.

We of course do not have to recognize this review of 1857 as anything more than a brave attempt to unify different kinds of art. The historical tie of archaism and realism, discussed in Chapter 1, was the real connection. Patmore's review attests, however, to the central importance of realism to any conception of Pre-Raphaelitism. The movement of which Brown was a part still stood for devotion to natural truth. This was the pivotal idea of Brown's art, reiterated in his catalogue of 1865, when he described his development. And no matter how distant from 1850s realism Brown's art from 1860 onward may appear, his concern with truthfulness and reality evidently

remained. In 1872, when he sketched out a history of art in his address to the vice-chancellor of Cambridge University (a vain attempt to be appointed Slade Professor), Brown's definition of the "modern" movement, and his praise of earlier artists, were still dominated by notions of realism.[24]

The 1850s realism of Pre-Raphaelitism and Brown included not only disunity, but also certain facial types, figural postures, and subject matter. These aspects of Pre-Raphaelitism further defied tradition and helped generate accusations of ugliness by critics in the 1850s. The contemporary ideal of female beauty, round-faced, cupid-bow-lipped, and doe-eyed, was avoided by the Pre-Raphaelites. Those sweet and pretty faces, atop gracefully intertwined figures in the genre paintings of Mulready and the history paintings of Etty, for example, disappeared from most Pre-Raphaelite paintings. The stilted postures of Pre-Raphaelite figures, at least in the early 1850s, stemmed from Nazarene archaism (how quaintly stiff and awkward and isolated are the figures of John of Gaunt in *Chaucer* [Color Plate II, Fig. 14], the mother in *Pretty Baa-lambs* [Color Plate III, Fig. 23], and Jesus in *Jesus Washes Peter's Feet* [Fig. 24]). But instead of the Nazarenes' bland, perfectly oval, and generalized heads, the Pre-Raphaelites depicted what seemed highly individualized characters—with imperfect noses, squinty eyes, pointed chins, and disordered hair. The models for these figures—realist by contrast to contemporary conventions—were often the friends and family of the artist. Rossetti, for example, was the model for Brown's Chaucer, and for the fool in *Lear and Cordelia* (Fig. 21). Brown's second wife, Emma, appears in the *Last of England, Work,* and *Pretty Baa-lambs*. Various other close acquaintances crop up in *Jesus Washes Peter's Feet*. The use of such models was not just a matter of economics, it was in deliberate defiance of standard ideals—and thus a means to give that accent of truth. Brown reportedly was the least adamant in the Pre-Raphaelite circle in copying such unorthodox models exactly, down to the last hair.[25] But this evidently did not stop him from employing similarly unconventional figures.

Some scholars of Pre-Raphaelitism neglect the realist purpose, and see the portrayal of friends as personal references—revelations of the conflicts, characters, love affairs, and factions of the Pre-Raphaelite circle. Much of this is ridiculous. Certainly some concern with the suitability of the model for the character to be portrayed was involved (the process can be likened to the task of a casting director who must choose an appropriate actor for a part). Truly private references, however, if present at all, were probably on an unconscious level.

Some intimate knowledge did color Brown's selection of models. In continuity with Romanticism of the earlier nineteenth century, Brown believed in personal experience as the springboard of his art. In an article in the *Germ* in 1850 he recommended that the historical painter avoid "ordinary paid models." He should instead delve into his own feelings, actions, and expressions in order to portray those of his depicted character more faithfully, "searching for dramatic truth internally in himself."[26] But this reliance on the self is not an aggrandizement of the intimate so much as it is a utilization of the personal to obtain greater factual accuracy. Brown's article of 1850 is not about the significance of private feelings, but rather, in a more

objective, realist vein, about how to produce a competent history painting and avoid vapid conventionalities. Brown provided straightforward mechanical advice, and his essay is a far cry from proclaiming personal goings-on in himself or among friends as the basis of his art.

The fact that Brown portrayed, for example, his wife Emma as the spoiled, uncaring rich lady in *Work,* and at one point used himself and his daughter Cathy as models for the lovers in *The Stages of Cruelty* (1856–90; Fig. 36) may indeed open a door into the artist's inner world. But Freud's authority has disappeared, and any investigation into unconscious urges is bound to be a dubious affair.

The more obvious rationale behind Brown's models was their unconventional appearance. The break with formula was most important to define realism. Yet we should not turn Brown into some absolute theorist, stridently breaking every standard artistic rule to achieve the appearance of truthfulness. Brown was a painter often concerned with handsome picture-making. In a letter of 25 January 1857 to the painter William Bell Scott, Brown praised one of Scott's paintings for its "air of startling reality (one of the great charms and causes of popularity with all serious historic works) . . . giving at 1st sight a sort of impression that the painter must really have seen the thing take place." But Brown noted two slight defects in Scott's picture, "owing chiefly to the directing principle of the new english style of painting [that is, Pre-Raphaelitism] of making truth paramount and disregarding somewhat the experience of art. There is something disagreeable in the way in which some of the lines of of [*sic*] the 3rd figure cross behind that of the rest."[27] What Brown complained of here is that dizzying complexity of Pre-Raphaelite realism. His recommendation to Scott was to clarify his image.

Certain kinds of subject matter smelled of realism. Modern subjects, inglorious subjects, and pictures of the disreputable, the ugly, and the ordinary were associated with realism at midcentury throughout Europe.[28] There could be multiple associations. For example, in Protestant Britain, ugliness could also be connected to Roman Catholicism—as a celebration of mortification of the flesh.[29] Those unbeautiful characters in Pre-Raphaelite art helped generate accusations of popish sympathies. Even Brown's *Oure Lady of Saturday Night* (Fig. 16) was suspected.[30] But such implications did not necessarily nullify the realist meaning.

Realist subjects could of course be found plentifully in art before the mid-nineteenth century. Genre painting had provided pictures of the mundane, the unbeautiful, and the indecorously poor for centuries. And history painting had frequently portrayed disreputable characters and contemporary events. Nevertheless, at midcentury such subjects could take on the mantle of realism, especially when painted in a realist style. Brown's *Last of England* (Color Plate VI, Fig. 29) exemplifies the modern subject, and its topical theme, emigration, enhanced its realist pretentions. Brown's efforts at topicality were part of a trend in Pre-Raphaelitism in the early 1850s. Hunt and Rossetti took up the depiction of modern prostitution, and Millais made drawings of modern domestic dramas and poverty.[31]

The social implications of Brown's realist subjects will be discussed in Chapter 5,

but it should be mentioned here how very alert to current issues and events Brown was in the 1850s, giving a frisson of realist immediacy to his images. According to Brown, emigration was at its height in 1852, when he commenced the *Last of England*.[32] At the same time, Carlyle's *Latter-Day Pamphlets,* published in 1850, which celebrated the exodus of malcontents, elicited a great deal of hot discussion in England. In 1855 Brown took up *Waiting* (Fig. 25), a subject designed in 1851, and pumped contemporaneity into what had been his first effort at modern subject matter. He added references to the current Crimean War by inserting a portrait of a soldier and a letter from the front on the table.[33] There are allusions to the threat of French invasion in *Walton-on-the-Naze* (Fig. 38) that echo contemporary calls for defensive readiness in 1859, when Brown began the painting.[34] *Work,* which attempted to sum up the state of society in 1852, probably reflected the summational fervor of the Great Exhibition of 1851, where the state of world progress and manufacture was illustrated.[35] The references in *Work* to contemporary thinkers, specific educational and social institutions, and Irish emigration further assisted the appearance of modernity. Neither pristine nature nor urban civilization is portrayed in *Work,* but an in-between place, Hampstead, connected to London by convenient railroad, but not quite part of it. That mingled world of suburbia speaks of recent demographics. This was the exact type of place that grew by leaps and bounds as England's population expanded in the nineteenth century. Just as the formal character of Brown's realist works of the 1850s suggest movement and change, so too such up-to-the-minute subjects emphasize the passing moment, a sense of fleeting time, rather than some ancient or permanent state of affairs.

Modernity of subject, however, was hardly a consistent feature of Brown's oeuvre, even in the 1850s. Images of Christ, the eighteenth century, and the Middle Ages appeared in the same decade. A different kind of realism appears in those historical paintings, where events of earlier centuries do not speak immediately of the nineteenth-century world. In *Jesus Washes Peter's Feet* it is the humility of the subject that assists the impression of realism. The slave-like submission of Christ to his menial task deflates epic grandeur or godlike power.[36] Brown's choice of a socially demeaning episode in Christ's life gives a realist tone, which a picture of Christ as suffering martyr, or performer of miracles, or divine orator, or oppressed convict would not. That pedestrian element acts as humor often does in Brown's art, puncturing the grandiose. But in this case, there is a long-standing theological point to the pedestal toppling.

Brown's most forceful depiction of the plebeian is *Work,* where virtually the only worthy characters in a satirical scene of modern social ills, chicanery, and iniquity is a shining group of road laborers in the center of the canvas. The place of the general, saint, monarch, or god in a traditional history painting has been here usurped by a crew of hard-working and leaderless ditchdiggers. The subject of common people was very much associated with realism. This was true from the time of Wilkie in the early nineteenth century to the 1870s, 1880s, and 1890s, when paintings of poor fisherfolk, the unemployed, and the homeless appeared repeatedly in English art.[37] *Work* may be

the most radical of such realist subjects; Brown's workers are triumphant figures, neither sentimentally charming folk, nor desperate victims. They look forward to the heroicizing monuments to labor that appeared at the end of the century (for example, Constantine Meunier's sculpture, *The Stevedore,* Antwerp) and became standard in Communist states after 1917. The fact that in midcentury England so many organizations, movements, and publications had arisen to alleviate the poverty, ignorance, and circumstances of the lower class (and several of these reform efforts are alluded to in *Work*) of course heightened the immediacy, the realist tone of such imagery.[38]

In *Chaucer* and *Pretty Baa-lambs,* it is humor that gives a realist bent, undercutting the pomp or fantasy of the subjects. The minutely detailed and complex picturing of the world would disappear from Brown's art after 1860, and so too would subjects from current events. But comic realism remained, diluting the dignity of kings, saints, and historical worthies. Even in Brown's most artificial and Aesthetic concoctions after 1860 (which will be considered in Chapter 4), humor creeps into the chambers of beauty and reverie to break the spell and bring things down to common reality.

Landscape subjects could also possess realist associations, and Brown is perhaps at his greatest in such disarmingly unpretentious views as *An English Autumn Afternoon* (Color Plate V, Fig. 28). Ruskin had complained to Brown that this painting was "such a very ugly subject," and Brown replied that he had chosen it "because it lay out of a back window."[39] Brown's remark no doubt was intended to be a sarcastic retort. But his choice of subject is nevertheless amazingly offhand-looking, and that informality is a significant aspect of the picture's realism. Who else but a realist would find worthwhile subject matter in such an undramatic suburban scene in Hampstead, consisting of tangled foliage, backyard outbuildings, and unexciting sky? Robert Adam's Kenwood House appears in the far distance, but it is a tiny speck in a landscape of no great artistic or historical meaning. Here is the epitome of ordinariness, studied with scrupulous care. The modest foreground lovers and the nesting birds, which echo the figures, are hardly visions of grand passion. The small incidents of chicken-feeding and fruit gathering in the landscape also fail to enliven this remarkably unremarkable image.

Brown nearly equaled the sense of everyday informality of *An English Autumn Afternoon* in *Hampstead from My Window* of 1857 (Fig. 37). But the modesty of the medium here, watercolor, and the modesty of size, $5\frac{1}{2} \times 8\frac{1}{2}$ in., reduce the realist power. Such intimacy makes unpretentiousness seem appropriate. Likewise, the tiny scale of *Carrying Corn* of 1854 (Fig. 32) diminishes any realist thrust provided by the uneventful scene of agriculture. But in *Carrying Corn* there also appear some rather monstrous turnips in the foreground, glowing with acidic purples and greens. A sudden gleam of oddity enters the painting, and we are back in our familiar world of comedy. Brown's other tiny landscapes of the period, *The Hayfield* of 1855 and *Walton-on-the-Naze* of 1859–60 (Figs. 34 and 38) are too hauntingly lighted to suggest a prosaic realist subject. But still, the comic elements of those works throw us off suddenly. Of all Brown's realist devices, comedy is perhaps the most forceful in creating that experience of disorder and unconventionality that lie at the core of realism.

E. H. Gombrich recalled at the very end of *Art and Illusion* that his earlier book, *The Story of Art,* had already suggested his present theme, and he quoted from that previous volume:

> The artist who wants to "represent" a real (or imagined) thing does not start by opening his eyes and looking about him but by taking colours and forms and building up the required image. The reason why we often forget this simple truth is that in most pictures of the past each form and each colour happened to signify only one thing in nature—the brown strokes stood for tree trunks, the green dots for leaves. Dali's way of letting each form represent several things at the same time may focus our attention on the many possible meanings of each colour and form—much in the way in which a successful pun may make us aware of the function of words and their meaning.[40]

The last remark about a "successful pun" gives us one further understanding of the link between comedy and realism. Humor can force us to reconsider that which we are viewing. We can be made acutely aware, as Gombrich claims, of the mechanics of picture-making, for humor can short-circuit the suspension of disbelief and bring us back to the humble components that create the illusion of reality. Brown's comedy can be seen as Gombrich's trial-and-error testing method of realism. Once the ridiculous field mouse or turkey had been noted, we must then reprobe the picture for its meaning and truthfulness. We are led by humor to think about the degree of reality offered to us by the artist.

This discussion of realism perhaps has led us to view Brown as too single-minded, as if he were a monomaniac forever concerned solely with realism, realism, and more realism. Let us end this chapter by remarking upon an aspect of the artist that runs counter to our interpretation of his central aims. This supposed adherent of realism could also rhapsodize about the imagination of the artist, his dreamy inventiveness in the face of varied nature. In his 1865 description of a version of *Windermere* (Fig. 20), which included a grand array of clouds, Brown wrote:

> Both in the extremes of serenity and of disturbance, the clouds have a tendency to take fantastic and imitative shapes. In the most calm of beautiful days, distant pink cloudlets will move statelily along the horizon, looking like swans, like balloons, like pillars of Hercules, like cameleopards, slow, sad, and beautiful, one will follow another; then, by moments, one will alter the pose of its head, but sadly, like a ghost, or lycanthropically change to some other animal. In stormy skies on the other hand, we have ranges of pinnacled mountains, intersected by impassable ravines, capped by enchanted castles; with all that is wizard-like in the shape of birds, beasts, fishes, and winged reptiles coursing in affright over the troubled and compressed vault of heaven, or the continually increasing smoke of ten thousand pieces of meteorological artillery.[41]

4

Aestheticism

Brown changed his art in the 1860s, adding deeper colors, weightier figures, broader forms, simpler compositions, and wavering curvilinear contours that suggest rhythmic movement. In addition, narrative scenes from modern life and topical subject matter disappear from his newly conceived works.

This direction accorded with a widespread development in British art called Aestheticism. Aestheticism was a tendency that arose in the 1860s, achieved great notoriety in the 1870s and 1880s, and remained a marked presence in the English artworld right up to the First World War. Brown was especially linked to this movement through his relationship to Dante Gabriel Rossetti and William Morris, both of whom were perceived as pioneers of Aestheticism.

The character and underlying ideas of Aestheticism or the Aesthetic Movement have often been misrepresented by commentators, both scholarly and popular, who define the movement too narrowly. Aestheticism gathered to itself a great many concepts, styles, and attitudes. Aestheticism was a branch of European Symbolism, and encompassed the Arts and Crafts Movement, Art Nouveau, post-1860 Pre-Raphaelitism, Queen Anne architecture, Japonisme, Gothic Revivalism, classicizing Renaissance revivals, and both elitist art attitudes and socialist art agendas. There is

a natural desire to clarify later nineteenth-century English art by compartmentaliz-ing these seemingly diverse concerns and styles and media. But the mingling was present throughout the growth of Aestheticism; to separate medievalists from classi-cists, or designers of quaintly vernacular English furniture from decorators of rarefied exotic interiors is really to miss the essential character of Aestheticism.

We can grasp something of the flavor of Aestheticism by consulting Walter Hamil-ton's *The Aesthetic Movement,* published in London in 1882. This publication appeared when Aestheticism was in full swing and derided as fashionable nonsense by *Punch* and Gilbert and Sullivan. It was also published before the trial (in 1895) of the Aesthete Oscar Wilde for homosexual offenses, which gave the movement a very bad name in England. Hamilton was a rather pedestrian writer and translator with an interest in literature, who was neither a fanatical defender nor virulent critic of Aestheticism. His book was intended as a guide for the general reader.

Hamilton defined the Aesthetic Movement as "a Renaissance of Medieval Art and Culture," and set its origins in the medieval enthusiasms of Ruskin and the early Pre-Raphaelite painters.[1] Ruskin's criticism of modern industrial society, implicit in his appreciation of Gothic, is seen as significant. But only because Ruskin "has made us acknowledge that in olden times people did many noble things better than we can do them" (15). The Pre-Raphaelite painter and poet Dante Gabriel Rossetti, more than Ruskin, was identified by Hamilton as the prime mover of Aestheticism (5). The taste of Rossetti and his two followers, Edward Burne-Jones and William Morris, for the fairy-tale–like imagery of Arthurian legend in particular became so influential among Aesthetes that by the 1870s the term Pre-Raphaelitism became synonymous with Aestheticism. It was apparently forgotten that the realism that preoccupied such Pre-Raphaelites as Hunt, Millais, and Brown from 1848 through most of the 1850s was antithetical to Aestheticism. While quaint medieval archaism was a major force in Rossetti's art from early in his career, Hamilton failed to note that Rossetti's later busts of long-haired, long-necked beauties (Fig. 114) were far more High Renaissance than medieval. Titian, Giorgione, and Veronese were the key inspirations of these most influential Aesthetic works by Rossetti.

Medievalism, in any event, is not really a consistent theme in Hamilton's book. This claim for the centrality of medievalism was merely, one feels, a desperate attempt to find some coherence in the movement. Hamilton noted that many of the Aesthetic paintings exhibited at the Grosvenor Gallery resembled "the Japanese style of art—a resemblance also found in the furniture and costumes adopted by people of Aesthetic taste."[2] Japonisme would hardly seem a medieval style. And J. A. M. Whistler, who was a Japoniste to a degree but not at all a medievalist, was considered by Hamilton an artist of the Aesthetic school (25). To make matters even more complex, Hamilton also referred to Whistler as an "Impressionist," without further explanation (17). And Hamilton also tied to the Aesthetic Movement such classicizing artists as Frederic Leighton and Lawrence Alma-Tadema, and not just because of their early works, which had dealt with medieval subjects (22 and 27).

Although Hamilton clearly recognized all these un-medieval elements of the Aes-

thetic Movement, he still declared the preeminence of the Middle Ages as its inspira-
tion. He wrote,

> With the exception of the numerous paintings by J. A. Whistler, whose works
> have principally been noted for the affected titles bestowed upon them, the
> pictures [of the Aesthetic Movement exhibited at the Grosvenor Gallery] are
> noticeable for the prominence given in them to the Union of poetry and paint-
> ing, their topics being frequently selected from the works of the poets of the
> Aesthetic School; they are next remarkable for the skill and care bestowed upon
> the colouring, the tints usually being of a subdued, often of a sombre nature, as
> more suited to the weird and mournful character of many of the compositions.
>
> A weird sensation of being carried back to the Middle Ages is engendered by
> long gazing at these pictures, for in the temple of art of which Burne-Jones is
> the high priest, one seems to feel the priestly influence stealing over one, as
> when standing before some piece of glorious glass-painting in an old Gothic
> cathedral. (23–24)

Hamilton touched here upon some of the truly fundamental features of Aestheti-
cism, although medievalism is not one of them. The "weird sensation," the feeling of
"being carried back" to some distant time or place, the "mournful character," the
religious suggestion of temples and priests and cathedrals of art, and the mingling of
the arts are significant. The last attribute is repeatedly emphasized by Hamilton. He
wrote of the correlation of not only poetry and painting (which after all is an old idea),
but of painting, poetry, the decorative arts, music, sculpture, architecture, and cloth-
ing. Hamilton praised the poet and designer William Morris's firm of decorators (estab-
lished in 1861 with Rossetti and Brown among the founders) as the highest example of
the "Aesthetic union between painting, sculpture, the decorative arts and poetry"; he
also noted the firm's abolishment of the division between art and craft (60). Hamilton
viewed the musical titles of Whistler's paintings as another indication of this inter-
weaving of the arts.

Hamilton's visit to the Bedford Park housing estate on the outskirts of London
afforded an additional opportunity to point out the *Gesamtkunstwerk* tendency in the
Aesthetic Movement. Queen Anne architecture on the estate mingled medieval ver-
nacular forms with Georgian detail. And textiles, woodwork, tiling, fireplaces, furni-
ture, and clothing, as well as architecture, were seen here by Hamilton as working
together, without one medium dominating the others. Despite the combination of such
diversities as quaint "Old English" furniture and "panels with Classical subjects
marked in gold on ebony" in this hotbed of "most pronounced Aesthetic taste," Hamil-
ton was impressed with the overall harmony (126–28).

Like numerous other critics, Hamilton harped on the supercilious and elitist bent of
Aesthetes. He remarked upon their distaste for "democratic sentiment," their sneer-
ing view of the vulgar crowd of "Philistines," who could not perceive or worship beauty
and art (22). But true to his own inconsistency (and to that of Aestheticism), Hamilton

also noted that William Morris "advocates the opening of our art collections and museums to the public every day in the week, and the more general training of the people in the rudiments of artistic work," and that he sets about helping the poor with revolutionary political fervor (58–59). Hamilton had his ear to the ground; Morris's full-fledged socialism had only crystallized around two years before the publication of Hamilton's book.[3]

For those commentators who would tightly define Aestheticism primarily as a devotion to "art for art's sake," and a push toward "abstract art," in which formal characteristics reign supreme, Hamilton's book is a challenge. Whistler certainly voiced such modern formalist ideas loudly in the 1870s and 1880s, and they became commonplace by the end of the century. As early as 1865 F. G. Stephens had described Rossetti's *The Blue Bower* (Barber Institute of Fine Arts, Birmingham), a sensuous bust-length vision of a dulcimer-playing beauty, as essentially abstract: "There is nothing to suggest subject, time or place. Where we thus leave off, the intellectual and purely artistic splendour of the picture begins to develop itself. The music of the dulcimer passes out of the spectator's cognizance when the chromatic harmony takes its place in appealing to the eye."[4]

But such formalist ideals are not particularly prominent in Hamilton's *Aesthetic Movement*. A worship of beauty is clearly present in Hamilton's description, and the desire to make art aspire to the abstract character of music is implied. But they do not appear as dominating themes. Well, maybe Hamilton missed the boat—he was not the most astute of observers and couldn't perceive how important such ideas would become in the twentieth century. But I think that Hamilton rightly placed those abstracting tendencies in a rich, multifarious, and emotive context. The escapist visions of something untouchably beautiful, or long-past or far away, the aura of mystery and irrationality, the meditative and religious air, and indiscriminate cross-fertilization of the arts surrounded those ideas of a pure art. Those surrounding tendencies are the essence of Aestheticism. The materialism, rationality, and inexpressiveness of various modern theoretical constructs of abstract art are foreign to Aestheticism.

Hamilton displayed an un-Aesthetic relish for precision when he delineated some of the insignia, leitmotifs, and idols of the Aesthetic Movement: the lily, the sunflower, the peacock feather, the bust-length dreamers of Rossetti, dark moody colors, Botticelli, and Wagner. He even gave detailed particulars of Aesthetic female beauty (all highly Rossettian): "A pale, distraught lady with matted dark auburn hair falling in masses over the brow, and shadowy eyes full of love-lorn languor or feverish despair; emaciated cheeks, heavy jaw, protruding upper lip, long neck, flat breasts and nervous hands."[5] He also pointed out the fundamentally artificial impression of Aesthetic poetry—devoted to love, and "delighting in somewhat sensuously-suggestive descriptions of the passions, ornamented with hyperbolical metaphors, or told in curious archaic speech; and dressed up in quaint medieval garments of odd old ballad rhymes and phrases."[6]

All this fits very well with that broader movement of the later nineteenth century, Symbolism. Symbolist art includes classical visions and medieval fantasies, religious

longings and cries of nothingness, utopian dream worlds of beauty and deformed expressions of unspecified pain, sexuality and abstraction, childlike primitivism and exotic luxury, Gustave Moreau, Edvard Munch, Puvis de Chavannes, Ferdinand Hodler, and Paul Gauguin. The diversity of Symbolism, however, is tied together by a yen for grandiose philosophizing, a taste for evocation rather than precise definition, and by a neo-Romantic distaste for realism. Symbolists rejected the objective, small focus, material present, the pedestrian and topical, and rationality. Unlike Romanticism of the late eighteenth and early nineteenth centuries, however, energy and drama have drained away. In Symbolist art, figures barely move: they exist but do not act; stare, but do not see. In European Symbolism, too, the undulant rhythms of Art Nouveau intertwine with a dozen different styles, and the distinctions between the fine and decorative arts become blurred as painters made pottery and sculptors designed textiles.[7]

Aestheticism is a form of Symbolism, enclosed in a temple of beautiful art. Aestheticism, above all, is the antithesis of realism. Vernon Lee published a putdown of Aestheticism in 1884, a novel called *Miss Brown*. In that book, the "Pre-Raphaelite" poet and painter protagonist, an Aesthete to the core, suddenly does an about-face and writes a realist poem about an ordinary couple in pedestrian circumstances: "It was beginning to be obvious, to every one who was not an aesthete, that the reign of the mysterious evil passions, of the half-antique, half-medieval ladies of saturnine beauty and bloodthirsty voluptuousness, of the demigods and heroes treated like figures in a piece of tapestry, must be coming to a close; and that a return to nature must be preparing."[8]

Brown does not seem to fit the mold of the Symbolist Aesthete. Those rollicking Manchester murals, and solemn Oliver Cromwell beset by beasts are not the stuff of Aestheticism. Yet Brown is mentioned with praise by Hamilton as Rossetti's teacher and friend, as a Pre-Raphaelite (and thus part of the source of the Aesthetic Movement), and as one of the founders of that triumph of Aesthetic decorative art, the firm of Morris, Marshall and Faulkner. Brown's *Chaucer* (Color Plate II, Fig. 14) is also described as "one of the treasures of modern English art."[9] Although the *Chaucer* certainly cannot be considered an Aesthetic work, Brown was an important (but curious) contributor to the Aesthetic Movement. He first of all admired the Aesthetic art of Rossetti, and obviously responded to its incipient Art Nouveau curvilinearity, shallow space, female beauty, and love-soaked dreaminess in many of his own works from the 1860s onward (for example, Color Plates VII and VIII, Figs. 39, 41, 46, 54, 57, 58, 63, and 66). He also reacted favorably to that mingling of fine and decorative arts that had been initiated as early as 1856 by Morris and Burne-Jones.[10] Brown designed some of the most radical furniture of the Arts and Crafts Movement (which was essentially a development of Aestheticism in emulation of Morris's ideas and productions. It grew by leaps and bounds from the 1880s to 1914).

But Brown's appreciation of Aestheticism was tempered, and not all aspects or practitioners of the movement met with his approval. Just after Rossetti's death, in a letter of 1882, Brown described British art as facing a bleak future, made up of two

contrasting forces: "Herkomerism" and "unsubstantiality and affectation."[11] The latter qualities were undoubtedly meant to describe the hundreds of Aesthetic images of the period imitative of Rossetti, Burne-Jones, and Whistler. Opposed to such idealizing visions of beauty were the paintings of Hubert Herkomer and other artists associated with the *Graphic* magazine in the 1870s. These were pictures of grim reality and social conscience, dark and tough and firmly modeled in their portrayal of the downtrodden and impoverished. Superficiality and faddishness were in fact standard taunts leveled against Aestheticism in *Punch* and other journals, and Brown's comments are in keeping with those views.

The opposition of realism and Aestheticism, apparent in Brown's remarks, could also be found in the popular press. A *Punch* cartoon by George Du Maurier in 1876 (Fig. 115), for example, shows a melancholic Aesthete surrounded by "artistic wallpapers, blue china [which had been first enthusiastically collected by Rossetti and Whistler], Japanese fans, Medieval snuff-boxes, and his favourite periodicals of the eighteenth century." Du Maurier's Aesthete boasts that the events of the outer world possess no interest for him. In the other panel of the cartoon, a poor charwoman expresses courageous stamina in the face of disease, war, bankruptcy, and the menacing forces of natures.[12] The antirealism that is at the heart of Aestheticism was here clearly recognized. But more often the cartoonists harped solely upon the hypersensitivity and frills of Aestheticism.

In 1881 a Du Maurier lady Aesthete in *Punch* (Fig. 119), dressed in a Burne-Jones–like gown, and accompanied by Japoniste furniture, confides her hopes for the frugal, simple life in Kensington: "everything is so cheap there, you know! —Peacock feathers only a penny a piece!"[13] Repeatedly Aesthetes are branded as silly folk, lost in a world of fripperies, with Burne-Jones and Whistler set up as gods. *The Colonel,* a play by *Punch*'s editor Francis Burnand, and *Patience,* the Gilbert and Sullivan operetta (both 1881), similarly make light of the Aesthetic Movement. *Punch*'s review of *The Colonel* by "a Philistine" mentions "the anatomical curiosities of Mr. Burne-Jones," a Whistlerian painting titled "Arrangement in Gold," an Aesthete who comforts himself with "cold lily and Mr. Pater," and the finale of the play, wherein is shown "the discomfiture of the Aesthete, and the triumph of common sense."[14]

As early as 1865, *Punch* had been poking fun at what would become synonymous with Aestheticism. In that year one of its cartoons described a piece of Gothicized furniture, in the manner of the Morris, Marshall and Faulkner Company, as a "rabbit-hutch."[15] In 1866 George Du Maurier, who was also responsible for most of the Aestheticism cartoons in *Punch* in the 1870s and 1880s, lampooned the taste of Rossetti and Morris and friends for Arthurian romances and long-haired goddesses of beauty.[16] His five-part article, titled "Legend of Camelot," displayed incredibly hirsute damsels and overly quaint medieval fantasies of murk and desire (Fig. 116). Leonee Ormond rightly sees the Pre-Raphaelites' illustrations for the Moxon edition of Tennyson's poems (1857) as one of Du Maurier's sources here, and admirably points out the subtle jabs at Morris and Rossetti.[17] But she tries to separate the Pre-Raphaelites, even the later, nonrealist Pre-

Raphaelites of the 1860s, including Burne-Jones, from Aestheticism. She rails against nineteenth-century critics (such as Hamilton) who lump everyone together.[18]

But the later works of Rossetti and such followers as Burne-Jones, and even Rossetti's Arthurian knights and ladies of the 1850s, were indeed the sources of much of what came to be called Aestheticism in the 1870s and 1880s. Pre-Raphaelitism may have begun as a realist movement in 1848, but it was also an archaizing movement with dreams of purity. Its development after 1860 is inextricably part of Aestheticism. Furthermore, if one probes into Rossetti's sources, one will find that John Everett Millais's *Autumn Leaves* of 1856 (Lady Lever Art Gallery, Port Sunlight) and probably his *Bridesmaid* of 1851 (Fitzwilliam Museum, Cambridge) are the earliest expressions of Aesthetic beauty, reverie, and suggestiveness. And they arose right in the center of early Pre-Raphaelitism.[19]

No matter how closely Pre-Raphaelitism was tied to Aestheticism, Brown could certainly see the ridiculous side of the latter movement. Indeed, Brown's own Aesthetic pictures seem to be double-sided, only half-serious, or mixed with contradictory suggestions—in short, we are back in the arena of comedy.

Look what Brown did to Arthurian romance in *The Death of Sir Tristram* (Fig. 42), first designed for stained glass in 1862. The passion is comically caricatural. Isolde yowls, King Mark grunts, and Tristram looks like a ninny. Any haunting mood of ancient Nordic saga is exploded by ungainliness and silly accessories. Du Maurier didn't have to burlesque the Aesthetic–Pre-Raphaelite dream; Brown had already done so. It is no wonder that the Liverpool Academy rejected the painting in 1865, and George Rae, who commissioned the work from Brown, wanted to return it. Brown's defense of *Sir Tristram* in several letters to Rae, as an exquisite bit of color and drawing, could not obscure its uncouth mockery.[20]

Also among Brown's early Rossettian-Aesthetic efforts is *The Writing Lesson* (1863; Fig. 43), where at first sight all seems well. A handsome, exotic-looking girl, adorned with neck-ribbon and earrings, suggestively bites into an apple. Echoes of such Rossetti bust-lengths as *Bocca Baciata* of 1859 (Museum of Fine Arts, Boston) with inviting apple and sensuous mouth, and *Girl at a Lattice* of 1862 (Fitzwilliam Museum, Cambridge), with its dark-haired, childlike model, are evident.[21] But Brown's girl differs from Rossetti's beauties in her mischievous glance. There is also no moody or somnolent air, no inexplicability. And Brown's little girl is engaged in a humdrum penmanship exercise; her desk is carved with her name, Mary, and a caricature of a sailor. This sort of charming domestic vision of the labors and naughtiness of sweet children is the stuff of Robert B. Martineau's *Kit's Writing Lesson* (1853; Tate Gallery, London) and so many earlier sentimental narratives of childhood by Wilkie and Mulready. These touches are not just a failure on Brown's part to break with tradition. They are a basic contradiction. They make an otherwise Aesthetic picture mundane.

Rossetti's women hint at magisterial or magical powers, secret despair, sensual luxury, or untouchable spirituality. The Eve-like action of Brown's girl is a quick snack to break the tedium of schoolwork. When a Rossetti woman, such as the one in

La Bella Mano (1875) (Delaware Art Museum, Wilmington), performs the simple task of washing her hands, it becomes a strange ritual and an allegory of purity.[22] Doesn't Brown's *Writing Lesson* possess a kind of humor?

More fully Rossettian, so it seems, is Brown's watercolor of 1864 titled *Myosotis* (Fig. 46). It has a narcatose female with long neck and clutched hands, an undoubtedly symbolic flower, and a crowded, spaceless setting. But even here, perhaps, a snigger creeps into the picture. *Myosotis* is the Latin name for forget-me-nots, the flower that is held by Brown's woman and that grows in the background of his watercolor. The flowers, with their suggestion of eternal love, are quite suitable for a Rossettian work. Allegorical blooms sprout everywhere in Rossetti's later paintings (and Latin titles were his forte). But in Brown's watercolor, the tiny blue forget-me-nots in the background pot are sparse and clearly wilting. Remembrance of love is pooping out. And Brown further degraded any depth of feeling in his 1865 catalogue description of *Myosotis*. He there noted that the image "represents a French maiden of rank and fashion, *fille de bonne maison,* in slight mourning, grieving for some lost friend, not an *affaire de coeur.* In her class of life, dress being the affair of the lady's maid, is no criterion to test the spirits by."[23] Ah yes, "slight mourning"—how un-Aesthetic.

Not all of Brown's Aesthetic single females are infiltrated by contrarieties. The pastel portrait of Iza Hardy (1872; Fig. 63) is an unadulterated Aesthetic image. The intense and slightly doleful lady novelist appears in loose garb, with far-away gaze and nervously clutched hands. Brown's pastel portrait of his wife in 1869 (Fig. 57) displays some of these same Rossettian fundamentals, and adds a Japoniste–Whistlerian–Art Nouveau–like branch at the upper left of the flattened background. But in *May Memories* (1869–84; Color Plate VIII, Fig. 58), a picture of the same model and of the same ilk, a mild pollution occurs. In *May Memories,* we see a Rossettian woman, bejeweled and beflowered, and lost in thought. She would seem to be a personification of spring. But this personification is brought down to earth with a bump by the mundane umbrella on her lap. This is no Aesthetic-Japoniste parasol of the sort mocked in *Punch* cartoons (Fig. 117). Could one imagine such an accoutrement in a Rossetti painting? Or a Whistler? Hardly. Albert Moore, another major Aesthetic master, might perhaps have included a humble umbrella in one of his perfectly balanced and colorful figure compositions; he placed badminton equipment in two images of Venus de Milo–like females.[24] But Moore's entire paintings are filled with deliberate, large-scale anachronisms and multiculturalism. Classical Greek figures, Japanese fans and textiles, and modern musical instruments are mingled in his works. The overall impression of a Moore is of an exquisite, timeless collection of diverse motifs of beauty. Whereas in *May Memories,* the dissonant object is but one small note in the design, and functions like a kicker.[25] In Brown's painting, the grim reminder that all these May blossoms depend on dull rain breaks the Aesthetic spell.

Another of Brown's floral Aesthetic females appears in *The Nosegay* of 1865 (Fig. 51). This image shows Cathy Brown gathering a bouquet from a flower bed by a garden wall. It was commissioned by Frederick Craven as a pendant to a watercolor of a praying boy by William Henry Hunt.[26] Brown devised the subject on his own, and

there may be something a bit coy about this kneeling woman paired with Hunt's work. The Hunt lad prays to God, while Brown's daughter plucks lovely flowers in a prayerful posture. The *Nosegay* may be a typical Aesthetic conceit in which the new religion of beauty is portrayed. Or is it a more amusing contrast to Hunt's earnest subject?

Cathy's décolletage does not suggest great moral rectitude or religious decorum, and sensuality was an endemic and often condemned part of Aestheticism.[27] How funny to see a spiritual boy paired with a sensual female; his rectitude comes into question. Even before Robert Buchanan criticized the "fleshly" poetry of Rossetti and Algernon Swinburne in 1871, Rossetti's languid females were marked as morally lax, sensual indulgences. The comments of William Holman Hunt on Rossetti's first bust-length beauty, *Bocca Baciata* (1859), are notable: "I will not scruple to say that it impresses me as very remarkable in power of execution—but still more remarkable for gross sensuality of a revolting kind peculiar to foreign prints, that would scarcely pass our English Custom house from France even after the establishment of the most liberal conditions of Free Trade. I would not speak so unreservedly of it were it not that I see Rossetti is advocating as a principle mere gratification of the eye and if any passion at all—the animal passion to be the aim of Art."[28]

Perhaps Brown was playing naughtily on those fleshly associations in the *Nosegay*. The brick wall in Brown's watercolor might enrich the amorous air of the picture. Although such an object was a standard early Pre-Raphaelite motif, it appeared most prominently in Pre-Raphaelite paintings of erotic subjects: Rossetti's *Found* (1854; Delaware Art Museum) (an image of a prostitute); Millais's *A Huguenot* (1852; Makins Collection) (an image of star-crossed lovers); and Brown's own *The Stages of Cruelty* (1856–90; Fig. 36) (a picture of love and sadism).[29] The playful pussy in the *Nosegay* may add yet another erotic implication to Brown's Aesthetic image.[30] Well, whatever the sexual suggestions of the *Nosegay,* laughingly in contrast to its pendant, they are not some lewd revelation of the sort that made the Aesthete Swinburne notorious. The innuendoes of the *Nosegay,* if present at all, are sotto voce, and the work in general is a happy Aesthetic vision of untroubled prettiness. Indeed, if there is any counterthrust to Aestheticism in the *Nosegay,* it is its lighthearted spirit. The mysterious mournfulness of the Aesthetic Movement as described by Hamilton and so many others is lacking in Brown's watercolor. Brown so often seems to get his Aestheticism a little bit wrong, and it thereby becomes comical.

Among Brown's Aesthetic portraitlike busts, derived from Rossetti, is a pair of images of children: *The Irish Girl* (Color Plate VII, Fig. 39) and *The English Boy* (Fig. 40). These paintings of 1860 are two of Brown's first responses to the type of picture that commenced with Rossetti's *Bocca Baciata*. The girl more properly fits the mold, with distant glance, mass of unbound hair, deep red background, and a defensively clutched hand. She grasps simultaneously flowers and an ornate shawl. The close-up frontality and contradictory suggestion of psychological withdrawal seen here are the Rossettian qualities that would be widely imitated by Aesthetic painters of the 1870s and 1880s. Only the ethnic title, young age, and commonplace British paisley textile make the *Irish Girl* very slightly at odds with Rossetti's conception.

The *English Boy* diverges more radically: here we have a homage to hard-nosed Holbein invading the Aesthetic format, expelling any moodiness with a direct gaze, incisive contours, and powerful forthrightness. Holbein's *Portrait of Edward VI as a Child* (Tate Gallery, London) appears to be the chief inspiration. As in that sixteenth-century work, Brown's child (a portrait of his son, Oliver, age five) is dignified and monumentalized. Like Edward VI, he holds his toys as if they were scepter and orb. All these sharply defined aggrandizements and Tudor portrait allusions remove the *English Boy* from the newly formed Aesthetic vision (and the male sex of the model doesn't help much either). The nationalistic tinge further distances Brown's painting from Rossetti prototypes, exotic and apolitical. Yet the image still bears similarities to the Rossettian model, especially when paired with the *Irish Girl*. Well, perhaps Brown in these early moments of Aesthetic taste was unsure of its direction and could not swallow whole his friend's influence. But given the sometimes amusing unorthodoxies of his later Aesthetic images, the contrarieties in the *English Boy* may already be deliberate shots to knock the dreamy conception off its pedestal. The very fact that Brown concentrated on unblemished children in these works, and would continue to do so in such paintings as *La Rose de l'infante* of 1876 (Fig. 66), further distanced his art from Rossetti's Aestheticism. These little people, even when dressed in the sumptuous Rossettian Renaissance attire of *La Rose de l'infante,* possess no sexual innuendo or otherworldly spirit.

Love and beauty are the recurrent themes of Rossetti's art and a good deal of Aesthetic painting. Brown's *The Finding of Don Juan,* first composed in 1869 (Fig. 55), incorporates both these motives: a rather elegant male nude and a handsome, ornate woman in a tale of love at first sight. The exotic realm and eerie landscape of Etretat-like rocks and spiraling mist round out this Aesthetic vision. Yet Brown's painting is so much more muscular and active than the usual Aesthetic image. The source of Brown's subject, Byron's *Don Juan,* is also out of step with Aesthetic taste. Byron's verse was too racy, rushing, and violent for the precious silences of Symbolist artists. Brown must have been one of the few nineteenth-century painters after 1850 to find Byron worthy of attention.[31] And *Don Juan,* an epic satire with many burlesque elements, was hardly the material for worshipers of refined mystery.

Brown's *Finding of Don Juan* should be seen in relation to his *Dream of Sardanapalus* (Fig. 54).[32] Both works were first conceived in 1869 as wood-engraved illustrations to an edition of Byron's works.[33] Both these Oriental Byron subjects show women in control, lovingly contemplating unconscious male nudes. The quiet of Brown's *Sardanapalus,* with its dreaming monarch and rich Mesopotamian carvings (reflective of the British Museum collections) creates a more complete Aesthetic picture. The relevant passage from Byron's tragedy, *Sardanapalus* (act 4, scene 5) reads, "I must awake him, yet not yet, / Who knows from what I rouse him." Brown's own earlier painting of Cordelia rousing Lear (Fig. 21) lies behind Brown's *Sardanapalus.* But that work is quaintly stiff. The *Sardanapalus* also possesses none of the Rubensian gusto of Delacroix's famous painting of the Eastern monarch (1827; Musée du Louvre, Paris).

Another Aesthetic rhapsody of love and beauty is Brown's *Romeo and Juliet* of 1867 (Fig. 53) And here, as has already been mentioned, Brown's comedy surfaces: the passionate lover misses the rung on his rope ladder. Additionally, the stiff limbs, entangled bodies and energetic gestures run counter to the grandly frozen, heroic passion in contemporary narratives by Leighton, not to mention such full-blooded Aesthetes as Burne-Jones. Such compromises with Aesthetic sensibility were not unique to Brown. Lawrence Alma-Tadema, for example, on the fringes of Aestheticism, married visions of ancient, indolent luxury, beauty, and artistic contemplation to amusing anecdotes of lovers' tiffs and domestic life. One can see Brown's Aesthetic tendencies, perhaps, as diluted by conservatism. He refused, perhaps, to give up either the intense Pre-Raphaelite dramas of the 1850s, or the charming tone of earlier English genre painting. But his compromises with Aesthetic taste are more likely all of a piece with his persistent comic realism. Just as *The Body of Harold* in the 1840s was slightly marred by guffaws, and the *Last of England* in the 1850s tickled by cabbages, Brown's Aesthetic efforts are often gently polluted—and thus brought down to common reality from their highfalutin pretensions.

Un-Aesthetic narrative strength as well as humor also appear in Brown's murals for the Town Hall of Manchester (1879–93; Figs. 72–83), and why not? These assuredly are not Aesthetic subjects or themes, but historical scenes of trials and battles and commerce and science.[34] Yet the style of the murals reveals Brown's ties to Art Nouveau, a decorative manner, flat, undulant and redolent of vitalist undercurrents, that was inextricably part of Aestheticism. In the *Romans Building a Fort at Mancenion* (1880; Fig. 73), the rippling cloaks that rise up in the center of the mural to form a sinuous pattern, and the rhythmic responses of the curving bodies to one another are evidence of the Art Nouveau style. The sweeping, serpentine lines of the *Establishment of Flemish Weavers in Manchester* (1882; Fig. 75), and the overall compositional undulations of *Dalton Collecting Marsh-Fire Gas* (1887; Fig. 80) similarly display this novel style. Such wavering forms are apparent in Brown's art as early as the mid-1860s (in *Cordelia's Portion* [Fig. 52], for example).

This exquisite and sensuously artificial manner, however, blossomed most powerfully in the Manchester murals, perhaps because the provincial city provided an uncritical and unsophisticated setting for unconstrained explorations. Art Nouveau (a term that arose from the name of Siegfried Bing's Paris shop, established in 1895) became an international Symbolist tendency by the later 1880s. It invaded every medium of art, high and low, and reached its height in France and Belgium in the 1890s. But its origins lie in the art of Rossetti.[35] It is worthwhile to digress a little in order to clarify the English aspects of this powerful style and Brown's relation to it.

The two-dimensionality and sumptuously curving lines, taking off on their own, apparent in such Rossetti works of the 1860s as *Lady Lilith* (1868; Fig. 114) are the starting points of Art Nouveau. The rhythm of the amebic forms creates an overall pattern that dominates spatial illusion and any composition of counterthrusts. The precious color and surface, and the decorative embellishment in such Rossetti works of the 1860s also became common in the fully developed Art Nouveau style. What was

implied in Rossetti's art was made forceful in the works of his admirers. Arthur H. Mackmurdo was the first designer to develop a full-fledged Art Nouveau vision in the productions of his Century Guild company of craftsmen. This firm was established around 1882 in emulation of William Morris's company.[36] Mackmurdo's title page for his book on Wren's city churches (1883; Fig. 118) is well known, and the flat, serpentine plant-life of that distinctly Art Nouveau page is also seen in his furniture and textile design of the same approximate date.[37] Mackmurdo was an ardent Ruskinian, a follower of Morris, and a great admirer of Rossetti, who was much discussed and illustrated in Mackmurdo's magazine, the *Century Guild Hobby Horse*.[38] In 1883 there was no Continental or British artist or designer who even came near Mackmurdo in developing the style that would later be called Art Nouveau.

There seems little doubt that Mackmurdo's Art Nouveau grew from the hints laid down in the works of Rossetti. The stained-glass designs of Morris, Marshall and Faulkner, beginning in 1862, likewise influenced by Rossetti's flat and sinuous style, probably also stimulated Mackmurdo (Figs. 47 and 59). The technical requirements of stained glass did not determine the Art Nouveau style: it appeared first in Rossetti's watercolors, and in any event, previous stained-glass makers had managed for centuries to ignore strong, simple patterns and curvilinear rhythms.[39]

Nevertheless, the bold style that emerged in the Morris firm's glass productions, some of which were designed by Rossetti himself, was highly effective for works meant to be viewed from afar in churches.[40] The early shoots of the Art Nouveau style in stained glass perhaps led to its subsequent prominence in England in the minor arts. Metal, glass, ceramics, and graphic design were the areas where Art Nouveau eventually flourished—as part of the Arts and Crafts Movement, tied to Aestheticism. And its first flowering in Mackmurdo's Century Guild reinforced the connection of Art Nouveau to the decorative arts. In British painting, however, Art Nouveau rarely went beyond the modest undulations of Rossetti's art. In sculpture, Art Nouveau suggestions can be seen in the works of Alfred Gilbert and other practitioners of the New Sculpture at the end of the century. In British architecture, Art Nouveau is virtually absent, unless you count C. R. Mackintosh's buildings. The style thus remained most firmly entrenched in the decorative arts.

The serpentine rhythms of Brown's *Entombment* (Fig. 50), which first appeared as a stained-glass design in 1865, do not outstrip those of Rossetti's art. Nor do Brown's Manchester murals, such as *Romans Building a Fort at Mancenion* of 1880 (Fig. 73) and *The Expulsion of the Danes from Manchester* of 1881 (Fig. 74). Even the later murals, such as *The Opening of the Bridgewater Canal* of 1892 (Fig. 82), are hardly more vigorously Art Nouveau than such late Rossettis as *Astarte Syriaca* (1877; Manchester City Art Gallery). And the full-fledged Art Nouveau works of such contemporary Continental painters as Gauguin, Hodler, and Munch make Brown's efforts in the style seem cautious indeed.

Brown of course had commenced this style early in its development: in the 1860s, almost as soon as Rossetti had initiated it. Yet by the mid-1880s, Brown was in close contact with the leading light of Art Nouveau design, Mackmurdo, who had carried

the style to far greater heights. The two men met around 1885, and Mackmurdo helped Brown decorate his new London home at 1 St. Edmund's Terrace in 1887.[41] William Michael Rossetti wrote his wife on 5 January 1886 that Mackmurdo had called on him, at Brown's suggestion, to obtain a photograph of the *Entombment* (Fig. 50). Mackmurdo wanted to reproduce it in his magazine, the *Century Guild Hobby Horse,* and asked Rossetti to write an accompanying article on his father-in-law, Brown. A lengthy excerpt from that letter provides us with some sense of Mackmurdo and Aestheticism, at least as perceived by William Michael Rossetti deep in the circle of Pre-Raphaelitism:

> You may I think recollect a rather funny and unmeaning magazine of which a specimen No. reached me (say) 1 1/2 years ago: it was called the *Century Guild Hobby Horse,* and was of the ultra-Aesthetic kind, in a sort of travestie-combination of [William] Blake and [Burne-] Jones. It is only now, I gather, that this magazine is beginning to come out regularly. Some evenings ago the Editor, Mr. Mackmurdo an Architect, called on me from your father, wanting to see the photograph of the *entombment* of Christ, as he wished to get the subject autotyped. . . . Yesterday he returned, presented me with a copy of his magazine, explained that the autotype is to appear in the April No. of the publication, and asked me to write something, to accompany it, about the typical characteristics of your father's art. I explained to him that discredit might attach to such a transaction, owing to the family-connexion, and I mentioned [Frederic] Shields as a suitable writer free from such an objection: however Mackmurdo stuck to his text, and left me on the understanding that he would again write to your father (for whom he appears to entertain a particular admiration), and, if your father is in favour of my doing the article, I will assent without further ado. Of course payment in such a matter is of no consequence either way: there will or *may* however be some payment—computed on the socialistic principle that the profits of each No. of the magazine are reckoned up, and then each contributor is paid his proportional share of said profits. The No. which Mackmurdo left with me is not so merely freakish or childish a product as that old specimen No.: still I confess I doubt whether any artistic or professional advantage can accrue to your father from association with such a performance. An exclergyman who has turned painter, Selwyn Image, is the artist-in-chief and poet-in-chief of the magazine—a quarterly, exceedingly handsome in paper, type, and general get-up.[42]

William Michael Rossetti's article on Brown duly appeared in the *Hobby Horse* (it concerns Brown's humor, and has already been discussed).[43] In subsequent issues of Mackmurdo's magazine, Brown's cabinet panel of *King René's Honeymoon* (Fig. 41) and Brown's stained-glass window designs for Saint Michael's, Brighton, were illustrated and praised.[44] Rossetti may have been put off by Mackmurdo's precious Aesthetic freakishness, but evidently Brown wasn't. In 1887 Brown exhibited his own furniture designs on Mackmurdo's stand at the Manchester Jubilee exhibition.[45] In 1888, Brown

visited the country home of his patron, Henry Boddington, which had been decorated by Mackmurdo with Art Nouveau fabrics and metalwork two years before.[46] There is no doubt, therefore, that Brown was familiar with the most forceful expression of the Art Nouveau style in England while he was at work on the Manchester murals.

Brown gave his Art Nouveau style in the murals an individual twist, essentially creating a spatial Art Nouveau. The space of the *Romans Building a Fort* (1880) (Fig. 73), *Expulsion of the Danes* (1881; Fig. 74), *Proclamation of Weights and Measures* (1884; Fig. 77), and the *Trial of Wycliffe* (1886; Fig. 79) curves back and stretches at the lateral edges. These rubbery recessions create a warped and sinuous depth that can be read as Art Nouveau in three dimensions. The lunging curvilinearity of *Chetham's Life Dream* (1886; Fig. 78), *Dalton Collecting Marsh-Fire Gas* (1887; Fig. 80), and *Bradshaw's Defence of Manchester* (1893; Fig. 83) exhibit this highly original serpentine space even more dramatically.

However idiosyncratic or limited Brown's acceptance of Art Nouveau, its presence in the murals is still notable. Indeed those murals stand as the earliest large-scale wall paintings in that style. And this novel formal expression was surely an identifiably Aesthetic feature. Yet the elegant Art Nouveau qualities of Brown's murals are a little out of place. They are mildly disconcerting when applied to bargewomen, fort builders, and tradesmen. Isn't this once more an example of Brown's humor? Brown dressed tough athletes, as it were, in frilly tutus. On the other hand, the two-dimensional emphasis common to Art Nouveau could be of benefit to mural painting by affirming the nonillusionistic character of the wall. Brown himself supported this familiar view in an article, "Of Mural Painting," published in a volume of Arts and Crafts essays in 1893: "The very essence of the wall-picture is its solidity, or, at least its not appearing to be a hole in the wall."[47] But don't the lunging perspectives of the murals compete with, or deflate whatever flattening is produced by the relatively two-dimensional and chiaroscuro-less figures?

In the same 1893 essay, Brown wrote about appropriate mural subjects: "Much depends on whom the works are for; if for the general public, and carried out with their money, care (it seems to me but fair) should be taken that the subjects are such as they can understand and take interest in." More cultured people, Brown continued, might prefer such mythological subjects as "Eros reproaching his brother Anteros for his coldness." "But for such as have not been trained to entertain these refinements, downright facts, either in history or in sociology, are calculated most to excite the imagination."[48] The Eros and Anteros subject is ridiculous, satirizing Aesthetic themes and reminiscent of the sculptor Alfred Gilbert's efforts.[49] Brown mocked the highfalutin stuff of Aesthetic art, and attributed the unrefined nature of his own Manchester murals to the needs of the general public. Brown would undoubtedly have realized how his Aesthetic–Art Nouveau suggestions, despite their wall-emphasizing flatness, played against the "downright facts" of his murals' subject matter. And how aware he is in this essay of class distinctions. His sympathies in this case were evidently on the side of the uneducated masses.

Although first designed in 1861 and untouched by Art Nouveau, Brown's *King*

René's Honeymoon (Fig. 41) is in some ways more fully Aesthetic than his murals, painted when Aestheticism was in flower. The *King René* picture was originally conceived as a panel for a cabinet, thus wedding painting to the decorative arts, and the subject, which deals with love and art, is suitably Aesthetic.[50] The medieval historical figure, René, is represented by Brown as the total devotee of art and beauty. He appears as both lover and lover of art, a luxurious practitioner of architecture, smiling down at his plan for a palace. As in J. A. D. Ingres's paintings of Raphael and the Fornarina, however, the artist René pays most attention to his design, rather than to his woman. The superiority of art to all else is proclaimed. Brown's later versions of the subject (Fig. 41) add some quaint, *Très riches heures* landscape elements, and the architectural plan takes on some of the flavor of Philip Webb's Arts and Crafts buildings. But the story remains the same: the joyous production of beauty, and the ultimate isolation of the creator. The tinge of tristesse fits perfectly with later Aesthetic images of the 1870s and 1880s. *King René* in its earliest form was an uncertain object, half-painting, half–decorative embellishment of furniture. The ambiguity is important, because the decorative arts played a vital role in the Aesthetic Movement, and were there deemed the equal of the fine arts.

Morris very consciously promoted the idea that makers of glass, furniture, textiles, ceramics, metalwork, and so forth, were in no way inferior to creators of painting and sculpture and architecture. In 1883, for example, he wrote:

> In those times when art flourished most, the higher and the lower kinds of art were divided from one another by no hard and fast lines; the highest of the intellectual art had ornamental character in it and appealed to all men, and to all the faculties of a man; while the humblest of the ornamental art shared in the meaning and deep feeling of the intellectual; one melted into the other by scarce perceptible gradations: or to put it into other words, the best artist was a workman, the humblest workman was an artist.[51]

The fully socialist viewpoint only appeared around 1880. But the social implications of the elevation of the decorative arts were already understood when Morris, Burne-Jones, Rossetti, Webb, Brown, and friends founded their company in 1861, and dirtied their artistic hands in the making of utilitarian objects. Architects such as the Neoclassicist Robert Adam and the Gothic Revivalist A. W. N. Pugin had earlier designed furniture, metalwork, and wall decoration. But such objects were more-or-less unique items made to harmonize with specific buildings by those architects. The productions of Morris, Marshall and Faulkner, on the other hand, were not always intended for particular architectural projects, and were sold as independent materials. For painters, more than for architects, the descent into craft had a special resonance. It was a fundamental renunciation of aristocratic rank, above mere usefulness. This crucial change in social attitude among artists pervaded Aestheticism and was at the heart of the Arts and Crafts Movement. Terms like "art pottery," "art glass," "art furniture," and "artistic interior" proliferated in the 1870s and 1880s. Although some commercial

manufacturers used such phrases merely as a form of salesmanship, the names still indicate the broad tendency to consider the minor arts as equal or intimately related to the fine arts.

Renaissance painters, sculptors, and architects had taken pains to distance themselves from bricklayers, carpenters, plumbers, and so forth, intellectualizing their profession. They strove for a social status above that of the manual laborer. Certainly by the nineteenth century those aims had been brilliantly achieved. Artists were no longer workmen.[52] But Morris argued for a reversal of this discrimination, and the products of his firm, designed by Brown among others, essentially expressed that revisionist view. Those products were for the most part handmade—like paintings. But handicraft was justified by Morris (and before him, Ruskin) as opposition to the dehumanizing effects of machinery.[53] The happy handworker, proud of his labor, was to be the brave new man in an envisioned utopia free of industrialization.

It may seem odd that Aestheticism, so often accused of elitism and disdain for the vulgar masses, should find within its ranks the Arts and Crafts Movement. But such was the case. The followers of Morris and Ruskin were devoted to the common man. William Michael Rossetti, in the letter of 1886 quoted above, noted the socialist payment system of A. H. Mackmurdo's magazine, the *Century Guild Hobby Horse,* and such attempts to incorporate socialist ideals in the workings of Arts and Crafts associations were legion. C. R. Ashbee and Walter Crane were dedicated socialists, but the political tilt of the movement could in some ways be quite superficial.[54] Certainly W. M. Rossetti, a firm leftist, was not seduced by Mackmurdo's politics. His letter of 1886 does not take Mackmurdo's efforts seriously. In a letter of 1887, Rossetti complained that the *Hobby Horse* smelled "too much (for my taste) of the aesthetico-purist cliquism."[55] But for all its cliquishness and preciousness, the Arts and Crafts Movement, squarely part of the Aesthetic Movement, was securely associated with socialist ideals.

The products of the Morris firm and Morris-inspired groups were the stuff of Aesthetic interiors. Morris company designs appear repeatedly in George Du Maurier's Aestheticism cartoons in *Punch*. Especially prevalent in the cartoons are the black, spindly, rush-bottomed Sussex chairs, manufactured by Morris from c. 1865 onward (Fig. 93). And in 1880 Du Maurier advised Francis Burnand on the stage sets for that spoof of Aestheticism, *The Colonel:*

> Try and have a room papered w. Morris' green daisy, with a dado six feet high of green-blue serge in folds—and a matting with rugs for floor (Indian red matting if possible)—spider-legged black tables and side board—black rush bottom chairs and armchairs: blue china plates on the wall with plenty of space between—here and there a blue china vase with an enormous hawthorn or almond blossom sprig . . . also on mantle piece pots w. lilies and peacock feathers—plain dull yellow curtain lined w. dull blue for windows if wanted. Japanese sixpenny fans now and then on the walls in their picturesque unexpectedness.[56]

Not everything in this ultra-Aesthetic stage set was of Morris appearance. The Whistlerian Japonaiserie, blue-and-white china, and other details are foreign. But Morris was certainly present, particularly in the rush-bottomed Sussex chair. One might attribute the Aesthetes' enthusiasm for the Morris firm's productions to a penchant for the medieval. The company's stained-glass designs are indeed tied to Gothic Revival taste. But Morris's wallpapers are not overly medieval. The Daisy pattern (of 1864) favored by Du Maurier has the sweetness and unsophisticated character of folk art. In like manner, the famous Sussex chair (Fig. 93) is based not on medieval furniture, but on common eighteenth-century and early nineteenth-century furniture, of the sort made in rural districts.[57]

Morris was antiurban as well as antimachine, and what such productions speak of is simple country existence and vernacular traditions. This taste is another example of the Symbolist-Aesthetic longing for some distant ideal, some dream of contentment. But still, the plebeian associations of those Morris items add a jarring note to the sophisticated elegance of Aestheticism. Into the midst of things delicately Japanese, or Italian Renaissance, or Greek antique, comes the unrefined stuff of the English farmer. And Brown played an important part in the whole development of the Aesthetic decorative arts.

Brown's work as a furniture designer is significant. Our knowledge of his productions in this field, however, is limited. Two rather clumsy and breezy articles published shortly after Brown's death are primary documents and contain illustrations: "Madox Brown's Designs for Furniture," by an unnamed author, appeared in *The Artist* in May 1898;[58] and E. M. Tait's "The Pioneer of Art Furniture: Madox Brown's Furniture Designs" was published in *The Furnisher: A Journal of Eight Trades* in October 1900.[59] The minutes of Morris, Marshall and Faulkner company meetings, 1862–74, provide no significant information on Brown's furniture for the firm.[60]

The extant furniture by Brown includes an "Egyptian Chair" in the Victoria and Albert Museum, manufactured by Morris, Marshall and Faulkner (Fig. 84). This had been in Brown's studio, and is illustrated in the *Artist*. The illustrations in the *Artist* and the *Furnisher* have also led to the identification of a group of bedroom furniture found at William Morris's Kelmscott Manor as the work of Brown (Figs. 87 and 88).[61] This consists of three beds, a towel horse, a washstand and two dressing tables. A table with X-shaped legs by Brown, made for William Holman Hunt, appears in both the *Artist* (Fig. 89) and the *Furnisher,* and according to Diana Holman-Hunt is today owned by the Stirling Foundation. She also notes that this table was inspired by a Gothic Revival chair in the manner of A. W. N. Pugin, which was in Hunt's possession.[62] Brown's designs for Hunt also figure in Hueffer's brief description of Brown's furniture:

> He had designed his own furniture long before the firm of Morris and Co. was thought of, and subsequently he designed a great many household articles for his friends. That his designs were, to a certain extent, in demand, I am led to believe by the fact that, in the year preceding [1858], Mr. Holman Hunt, in a

letter, mentions incidentally a number of articles of furniture for which he would be glad to receive sketches. The table made to his own design is mentioned by Madox Brown in the diary, and is a characteristically substantial piece of furniture, with top in shape like a vertical section of a barrel, and with pierced lockers beneath [this table is reproduced in the *Artist* and the *Furnisher* (Fig. 90)].

These designs for furniture led to Madox Brown's first open rupture with the Hogarth Club, to the Summer exhibition of which he this year [1859] sent them, with the idea of rendering the exhibition a sort of precursor of those of "arts and crafts" that are now a sufficiently familiar feature of art-life.[63]

In another passage, Hueffer also mentioned that in 1862, Brown produced "several designs for furniture."[64] Also attributed to Brown is a ladder-back chair (Fig. 92). This countrified piece of furniture is illustrated in the *Furnisher,* appears in several late nineteenth-century photographs, and examples are extant.[65]

If we are to believe the *Artist* and *Furnisher,* the Morris firm's Sussex chair (Fig. 93) was also designed, or discovered by Brown. There are several variants of this vernacular piece of furniture, some with round seats and others, square. All possess the thin, slightly curved sticklike and spindle members, which were ebonized. And many examples exist today in public and private collections (for example, Wightwick Manor, Wolverhampton). Brown's central role in the development of the Sussex chair, however, is an unproved assertion worth questioning. Those magazine articles are just too offhand and unscholarly.

One small note, however, that may reinforce the attribution of the Sussex chair to Brown is Brown's self-portrait of 1877 (Fig. 65). He is shown seated in a Sussex chair, and with a very Arts-and-Crafts style decorative screen (which also appears in his painting of Cromwell [Fig. 67]). The presence of the Sussex chair in the portrait might appear as insignificant. But it isn't. The self-portrait was given to Theodore Watts-Dunton in gratitude for handling Brown's claims against Morris and Co. When Morris forced Brown out of the firm in 1874–75, Brown reacted bitterly, cut off all relations with Morris for ten years, and requested more money in compensation for all his work for the firm.[66] It is likely that Brown conceived his self-portrait, presented to the man who stood by him in this acrimonious dispute, as a picture of himself as an important decorator, as a master of crafts, and not just painting. It suggests that he was the one who had developed the Sussex chair.

From the two magazine articles, drawings, photographs, and written sources, we know of several more Brown designs. Photographs exist of a "Workman's Chest of Drawers," designed by Brown and made by the socialist laborer Joe Waddington in Manchester (Fig. 86). This was exhibited on Mackmurdo's stand at the Manchester Jubilee Exhibition in 1887 and at the Arts and Crafts Exhibition Society shows in London in 1888 and 1890.[67] The chest was praised by the Arts and Crafts architect John Sedding.[68] We have Brown's drawings for the panels of an unlocated bookcase

manufactured by Morris (and exhibited by the firm in the International Exhibition, London, in 1862). The panels illustrated the life of an English family from 1810 to 1860.[69] And we have a wash drawing for a decorated "Lohengrin Piano" (Fig. 85), dated 1873, and apparently never carried out.[70] This was illustrated in the *Artist*. And so too was an unadorned square cabinet for paints and books (Fig. 91). Finally, Brown's one-man show of 1865 included no. 96: "Frame of Designs for furniture. In part designed for Messers. Morris, Marshall, Faulkner, and Co., and the remainder the property of Charles Seddon and Co."

Brown's own comments on his furniture designs are few. In his diary entry of 16 March 1857, Brown noted that a young distiller named Burnett "promises to call again with his wife and if he buyes I make a vow to purchase Nolly [Brown's son] a purambulator and myself a glass house with a revolving floor, and 2 chairs for the parlour, item, a table which by the bye, I have designed among other work."[71] On 17 January 1858, Brown wrote in his diary that "since about the 3 weeks in november I have now been making a copy of Christ and Peter in water colors which I finished yesterday, also 4 designs for chairs (500 hours)."[72] The entries confirm that Brown was designing furniture long before the establishment of the Morris firm in 1861. In addition, the entry for 5 October 1849 reads, "Begun a portrait of Mr. Seddon [Thomas Seddon Sr., furniture manufacturer] to be painted and that of Mrs. Seddon, for a sofa."[73] Newman and Watkinson have interpreted this to mean that the Seddon firm would make a sofa to Brown's own design in exchange for the portraits.[74] But Virginia Surtees, in editing Brown's diary, states: "In exchange for the portraits (private collection), Mr. Seddon was to give Brown a sofa from his own works."[75] The latter interpretation is slightly ambiguous, but seems to credit the design of the sofa in question to Seddon's company. The 1865 catalogue of Brown's exhibition indicates that Brown did provide furniture designs for the Seddon company, and Brown did compose *King René's Honeymoon* (Fig. 41) for a chest by John Pollard Seddon (Thomas Sr.'s son). But the piece of furniture mentioned in 1849 was probably just one of the firm's regular products, and without further information, Brown's activities as a furniture designer at this very early date must remain highly speculative.

In a letter of 1 December 1890 to Herbert Gilchrist, Brown remarked that "the only thing at all new in the artistic world (at least to me) is "the Arts and Crafts Exhibition to which I have contributed a second time, at the risk of being mistaken for an Upholsterer and Decorator. I had some of my Manchester work there this time—and a piece of furniture I had made in Manchester for a workman's 'chest of drawers.' "[76] This letter shows Brown's enthusiasm at the end of his life for the Arts and Crafts Movement, which was then in full swing, but also, perhaps, his (sarcastic) fear that he will be thought an upholsterer. Despite Hueffer's comments, maybe Brown was not quite so radical in his appreciation of the decorative arts as his experience at the Hogarth Club back in 1859 would indicate. That incident challenged the "lower-class" status of the decorative arts, placing such designs in the context of a "high art" exhibition space. But as in so many things, Brown's comments of 1890 make absolutes a wee bit uncertain.

Brown need not have feared that he would be considered a déclassé craftsman; when William Butler Yeats reviewed the 1890 Arts and Crafts Exhibition, he only discussed the pictorial works of "the Father of the Pre-Raphaelites."[77]

Brown also commented generally on the decorative arts in his "Address to the Very Rev., the Vice-Chancellor of the University of Cambridge," part of his vain attempt in 1872–73 to obtain the Slade Professorship: "Nor should be forgotten, as too often forgotten now, ornamental art, shuddering in bondage to mechanical neatness, and the question why while it flourishes amid the lowest on the ethnological scale, it fails and pales before the ethics of civilisation."[78] I think that these remarks in Brown's rather pompous address reflect the desperate salesmanship of professorial job-hunting, rather than his deepest concerns. They echo standard points so often voiced in the wake of the Great Exhibition of 1851, bewailing the low state of modern industrial ornament and lauding the beauty of ornamental taste in "primitive" cultures.[79] His reference to the horrors of "mechanical neatness" echo the ideas of Ruskin and Morris. The whole pamphlet smells of intellectual borrowing. Nevertheless, Brown's familiarity with such concepts is important, and the very fact that Brown felt compelled to discuss "ornamental art" in his proposed teaching curriculum for university students does imply his high regard for the decorative arts. And Brown was, after all, a founding member of Morris, Marshall and Faulkner. He must have been in sympathy with the ideas of Morris concerning the low quality of modern furnishings and the need for solid, handmade, "pre-industrial" designs.

The articles in the *Artist* and the *Furnisher* remain the most substantial sources of information on Brown's furniture, but they're so flimsy and chatty that one hesitates to accept them as serious documents. The author of the 1898 essay is unidentified, but he seems to have been firmly rooted in the Arts and Crafts Movement, and spent most of his article mouthing well-worn, Morris-inspired generalities: "We know that in old days before us they had good workmanship to set against our slipshod machineship. What became of the love for solid bureaus, heavy oak chairs, and the broad manly utensils and chattels of our great-grandfathers?" He condemned the Great Exhibition of 1851 because it "aided the invention of man-destroying machines." And he defined the good designer as one who can produce something that functions usefully, is inexpensive, and is beautiful. All these general observations, he claimed, were suggested by Brown's furniture and the author's contemplation, by way of contrast, of the "Victorian," "abominably artless" furnishings depicted in Brown's *Waiting* (Fig. 25) and Holman Hunt's *Awakening Conscience* (1853–54; Tate Gallery, London).[80]

At last the author turned to Brown, and "the large number of things designed by him between 1856 and 1862." Only one of those items, he felt, completely stood "the test of time": "the table in the possession of Edward Garnett" (Fig. 90). He gently criticized Brown's other designs because they "had rather a 'topical' cast about them, grew to look old-fashioned, lacked the curves, corners and grooves in which pleasant associations are caught and cling." He still saw Brown as a pioneer: "As the early nineteenth century artist, striving towards realism, had to cut himself adrift from existing tradition, so the designer of furniture." And the author contrasted Brown's

works favorably with 1850s " 'exercises' after Sheraton and Chippendale." He continued: "Madox Brown sought inspiration from things to be seen in old country inns. He persuaded the 'firm' to manufacture the Sussex chairs which are probably the most popular products of Morris & Co., even at this day." The writer added that the Morris firm employed Brown to design "eight different couches, wall-papers, embroideries, stamped velvets, tiles, wineglasses and decanters, and silk and 'two sets of worsted bell ropes.' "

The author of the 1898 article went on to remark that in the early years of the firm, Brown was one of the chief furniture designers, but in later years, he only designed stained-glass cartoons. This development, he claimed, was due to Brown's increasing prosperity, numerous commissions for paintings, and "as the firm grew older its tastes became more and more definedly mediaeval and more exuberantly decorative, until Madox Brown's work, which aimed entirely at simplicity and good workmanship, fell very much out of line with that of the rest of the 'firm.' " In a note that suggests personal acquaintance with the artist, the writer added that Brown "actually possessed a certain amount of china and glass that was too costly for everyday use, and which in his house reposed on his mantelpieces or in prominent glass cupboards. His own wall was formed by pictures set on a suitable background." The "workman's chest of drawers" is described, and "as far as he himself was concerned, he was socialist enough in theory and practice to consider that what was good enough for an artisan's house was fit for his own." Brown is credited in the article with devising "the green stain that now forms so considerable a part of the colouring material of the upholsterers."

E. M. Tait, the author of the *Furnisher* article of 1900, is also an unknown quantity. There was a writer of popular novels and detective mysteries, active from 1910 to the 1940s named Euphemia Margaret Tait, whose fiction was published under the pseudonym John Ironside. It is conceivable that this is the E. M. Tait in question. She evidently had varied interests, for she also published a book of Bible selections in 1933. But there are no known works by this writer as early as 1900, and the identity of the writer of the *Furnisher* article remains mysterious.

This author, like the writer of the article in the *Artist,* was in tune with the Arts and Crafts Movement, which she saw as a "Renaissance of art as applied to domestic furniture." She labeled Brown "one of the first among the chosen band who set their faces against the banality of early Victorian furniture design and became the pioneers of 'art in the home.' " She also designated Brown as the originator of green-stained furniture, the severely simple lines of Morris productions, and the first Sussex chair. This writer added some details to the information in the *Artist*. She remarked that Brown's "furniture was always more or less experimental, and for the most part specially made for his own house or for personal friends," which might explain why so few objects securely designed by Brown have come to light. She noted that Brown's washstand and towel horse (most likely the same ones illustrated in the *Artist*) were still being copied, but with different proportions, by various art-furniture companies of the day. The X-legged table illustrated in the *Artist* is here called "A Saxon Dining-Table," and identified as the one designed for Holman Hunt. The author of the *Fur-*

nisher article pointed out the "twisted" iron bar connecting the two X's of this table, and added that later designers replaced this metal "screw" with a wooden beam. The table with lockers, seen in the *Artist* (and described by Hueffer), is also illustrated and praised for simple, square legs. The workman's chest of drawers appears here too. Tait noted that Brown "designed many items for an ideal 'artisan's cottage.' " The illustrations in the *Furnisher* are fairly rough line drawings and not all that helpful for purposes of detailed identification.

Although Tait did not imply that she knew Brown or his house, she apparently was acquainted with his family and circle of friends: she noted that the workman's chest of drawers was owned by "his daughter," and that the ladder-back chair and Sussex chair illustrated were in the possession of Harold Rathbone, Brown's pupil.

The works ascribed to Brown in these two turn-of-the-century magazine articles should probably be accepted as his work. The essays were published not all that long after Brown's death in 1893, when his family and friends (for example, Hueffer and Rathbone) were still very much in evidence, able to advise and correct. There are, also, indications that these two authors had been in contact with Brown's circle, if not with the artist himself.

If you remove the prolific Sussex chairs from Brown's authentic oeuvre, his known output is reduced to a few works, which seem not to have been manufactured in great numbers, and may have been, as the author of the *Furnisher* article stated, experimental productions for his own house and those of his friends. Is it even worth discussing this minuscule and mostly lost aspect of Brown's career? Yes. Those few objects tell much about him and the rest of his art. They also were apparently influential. The ladder-back chairs of Ernest Gimson at the turn of the century, for example, look very much like those by Brown.[81] And a dining-room table designed by C. R. Ashbee in the 1890s for his house in London appears similar to Brown's X-leg table.[82]

As far as dates are concerned, we know from Brown's diary that he designed furniture years before the founding of Morris, Marshall and Faulkner in 1861. But there is little evidence that he planned anything in that field before 1856 (except maybe the ambiguous Seddon sofa of 1849). The year 1856 was when Brown met William Morris (who immediately purchased Brown's *Hayfield* [fig. 34]); it was also the year that Morris and Edward Burne-Jones, friends at Oxford, settled in Red Lion Square, London, and began to design furniture for their rooms. Brown and Morris were close in those days, and Brown later even gave Morris painting lessons.[83] Most probably, Morris's and Burne-Jones's attempts at furniture design at Red Lion Square in 1856, notably a large settle that was eventually installed at Morris's home, the Red House, stimulated Brown's endeavors in the decorative arts.[84]

The one other member of the Pre-Raphaelite circle who may have influenced Brown to take up furniture design was Holman Hunt. After his return from the Middle East in 1856, Hunt designed an Egyptian chair, which was carried out by Crace and Co., London (Walker Art Gallery, Liverpool). It is very similar to the one designed by Brown (Fig. 84). In a letter of 4 December 1857, Hunt wrote to Brown, "In the mean-

time can you come and see my beautiful Egyptian chairs one day say tuesday evening next," which seems to confirm Hunt's precedence in the matter.[85] The Egyptian chair is a unique production by Brown, and obviously stemmed from Hunt's concerns and enthusiasm. Brown's additions of Near Eastern textiles to his paintings of *Jesus Washes Peter's Feet* (Fig. 24), *Elijah and the Widow's Son* (Fig. 45), the *Entombment* (Fig. 50), and *Jacob and Joseph's Coat* (Fig. 44) similarly represent his dependence on Hunt's Oriental experience.[86]

The design for the Lohengrin piano (Fig. 85) is another work that probably arose from someone else's enthusiasms, and merely attracted Brown for a moment. Brown's son-in-law, the music critic and Wagnerian Franz Hueffer, was the likely stimulant in this case.[87] Beyond this personal connection, Wagner eventually became a cult in English Aesthetic circles, and the Lohengrin piano is thus a perfect example of Aesthetic taste. It is related to Brown's other furniture productions, however, because its decorative subject is of course medieval and the style of that decoration is slightly primitivized, almost folk art–like. And medievalism and folksiness are the leitmotifs of Brown's furniture. Like many of Philip Webb's productions for Morris, Marshall and Faulkner in the 1860s (for example, those at the Victoria and Albert Museum, London), some of Brown's designs are vaguely medieval. They are examples of Gothic Revival furniture, but exceedingly plain. The Brown bed posts at Kelmscott Manor (Fig. 88) have some slight upward tapering, revealing the links to Gothic style. The other pieces at Kelmscott and the table made for Hunt (Figs. 87 and 89) also half-suggest the Middle Ages, and perhaps depend upon the medieval furniture that appears in fifteenth-century woodcuts.

Morris's admiration for the Middle Ages, and the fact that the Morris firm exhibited its works for the first time in the Medieval Court at the International Exhibition in London in 1862, underline the importance of Gothic precedents for Brown and his circle of acquaintances.

One can see this medievalism as just a continuation of Pre-Raphaelite taste from the 1840s, and a continuation of Pugin's Gothic Revival productions from the 1830s to the 1850s. But there is something new in Brown's and Webb's loosely Gothic furniture designs: they are not just medieval, but humble and plain. Pugin's furnishings had usually displayed rich carvings and complex patterns, as did the Gothic furniture that appeared in Brown's paintings of the 1840s and 1850s (Figs. 14 and 17).[88] Even the roughly drawn thrones in Brown's early Lear drawings (Fig. 8) are more ornate and grand than his own furniture designs. And the portable bed in *Lear and Cordelia* (Fig. 21) is richly embellished. All the elegance, the slenderness, the refinement of Gothic Revival taste disappeared from most of the designs of Webb and Brown.[89]

The immediate stimulus for this stark variation of Gothic was probably the designs of the Gothic Revival architect G. E. Street. Morris and Webb had worked together under Street in 1856, just after Street had completed Cuddesdon Theological College, Oxon. (1852–54). The Gothic furniture that Street produced for the dormitories and study rooms of that Gothic school are astonishingly austere (Fig. 120).[90] The plainness

in this case was evidently to encourage the Spartan atmosphere of English education. Webb and Brown took up this new austerity and made it the essence of their work. And when they moved into non-medieval forms. the plainness clearly remained.

But what does this austerity signify? The answer, I think, lies in class associations. What Webb's, and even more so, Brown's furnishings suggest most often is humble cottage life. Their productions, whether medieval or otherwise, speak of peasant qualities. Brown's "workman's chest of drawers," or the "cottage furniture" by Ambrose Heal, Ernest Gimson, or other Arts and Crafts designers at the end of the century, by name as well as appearance, reaffirm that lower-class connection.[91] What harmonizes Morris's wallpapers with the vaguely medieval furniture of Webb and Brown is not any historical rectitude; the wall decorations are not medieval at all. The unity resides in social class. Morris's early wallpaper designs in the 1860s, such as Trellis, Daisy, and Pomegranates, are charmingly simple, folksy, and "primitive."

Morris's home, the Red House, Bexley Heath, designed by Webb in 1859, is of a similar order. It's Gothic in many features, but without tracery or crockets or any of the elaborate complexities that mark Pugin's Scarisbrick Hall, Lancashire (1837–62). It is not the Georgian windows and other non-Gothic aspects that differentiate the Red House so strongly from Pugin's ambitious buildings. Rather, it is its quaintly humble, vernacular character.[92]

Similarly, Brown's ladder-back chair (Fig. 92) is not medieval, but a plebeian form first seen in England in the seventeenth century, and still prevalent in lower-class households in the mid-nineteenth century.[93] The Sussex chair is a form of the vernacular spindle-back, manufactured in England at least since the eighteenth century, and unrelated to medieval furnitures.[94] Brown's bed at Kelmscott Manor may have some slight Gothicisms, but what it really resembles is the sort of humble furniture found in charity hospitals and other institutions for the poor.[95] His X-leg table, perhaps vaguely like the table in Dürer's engraving of Saint Jerome (1514), more closely resembles the common tavern furniture of eighteenth- and early nineteenth-century English villages. And look how deliberately unrefined, how peasantlike, are the proportions of Brown's cabinetry at Kelmscott (Figs. 87 and 88). The heavy top boards and modest sawhorse-like legs make the furniture stout and ungainly. Brown's music cabinet, known from illustrations (Fig. 90), is equally chunky and inelegant—and without even the slightest Gothic precedent to give the dignity of age.

This celebration of the plebeian accords with the whole social temper of Morris's and Brown's descent into the decorative arts. The centuries-old elevation of the fine arts above the minor arts was challenged by the Morris firm and Brown. In the very first prospectus of Morris, Marshall and Faulkner in 1861, that aim was implied: "The growth of Decorative Art in this country, owing to the efforts of English Architects [an allusion to Pugin and Street?] has now reached a point at which it seems desirable that Artists of reputation should devote their time to it."[96]

What a lowering of class Morris's and Brown's decorative work represented! A stockbroker's son and a painter in oils were dirtying their hands with the design of common household items. And Brown made the first great challenge to traditional distinctions

when he attempted to exhibit his furniture at the Hogarth Club in 1859. In this case, it was not just the act of an artist making furniture that generated hostility, but the attempt to display those efforts of craftsmanship in the halls of fine art.

The supposed simplicity of common people's lives had often been embraced by the wealthy and the nobility in previous centuries (Marie Antoinette's delightful dairy comes to mind). Brown's and Morris's and the Arts and Crafts Movement's peasant enthusiasms are a recurrence of this attitude. As with earlier tendencies in this direction, a certain ludicrousness arises. Customers had to pay considerable sums for Morris productions, and common people could not afford them. Nor could they afford the handmade furnishings of Arts and Crafts makers in the wake of Morris. Ernest Gimson's country pieces were bought not by the folk of his quaint village, but by types such as William Rothenstein, sophisticated intellectuals and artists who moved to Gimson's district to live the simple life.[97] Morris was certainly aware of the problems, and eventually felt that only a socialist revolution would create the society in which his goods could be produced and used properly. Certainly, the Arts and Crafts Movement differed from previous lusts for the simple life in its radical political aims. But still, the thought of wealthy ladies and the earl of Carlisle avidly decorating their abodes in humble cottage taste can be laughable. Nevertheless, Brown's efforts at furniture design express his social conscience, which is the subject of Chapter 5.

5

A Social Conscience

The negativism that underlies Brown's comedy, realism, and archaism conceivably had its roots in his views of society. The presumed discontent that led him to reject academic standards, tack giggles onto serious subjects, and make visual fields incoherent may have arisen from social and political dissatisfaction, rather than from purely artistic and personal concerns. It is perhaps an unwarranted bias to attribute deepest causes to social forces. But even if Brown's perceptions of class conflict, poverty, male-female relations, politics, religion, and nationalism are not the prime movers of his art, they were important.

Brown's political convictions were generally what today would be called liberal. He certainly had some leftist tendencies. In Brown's 1865 catalogue description of *Work* (Color Plate IV, Fig. 27), he remarked in an aside that the pastry-cook's assistant in that painting, who carries goodies to wealthy customers, always gave Brown "a certain socialistic twinge."[1] William Michael Rossetti described Brown in a letter of 1871 as one of his "decided republican" acquaintances, who would probably be interested in a new newspaper of leftist persuasion.[2] As early as 1847, in a poem on Ireland, Brown accused England of ill-treatment of that country, and mentioned the dire effects of tyranny (although he stopped short of calling for Irish home rule).[3] Brown's

sonnet expressed not just pity for the land beset by the potato famine, but also a reformist political outlook.[4] Outbursts against the nobility and the wealthy appear repeatedly in Brown's diary in the 1850s, further testifying to his general attitude. In 1854, for example, Brown decried the "Torpedo influence" of the English aristocracy, "be it in war, literature, art, or science we are great if great, in spite of them—and the depressing influence of established authority taking precedence of merit and justice."[5] After visiting ostentatious Stafford House in 1855, Brown wrote, "is it for this that a people toils and wearied out its miriad lives, for such heaping up of bad taste, for such gilding of hidiousness. . . . Oh how much more beautiful would 6 model labourers cottages be, built by a man of skill for £100 each."[6]

In Manchester in the 1880s, Brown helped establish an employment bureau for the poor, addressed mass-meetings of workmen, and wrote to Frederic Shields in 1886, "I believe the manufacturers look upon a good broad margin of starving workmen as the necessary accompaniment of cheap labour."[7] After reestablishing his friendship with William Morris in 1885, Brown told his daughter Lucy that "I have been thinking seriously of turning communist." He also wrote, "many people seem in want whom one cannot relieve at the present rate of living, that it seems a duty to avoid expensive entertainments." Brown subsequently subscribed to *Commonweal* and attended some of Morris's socialist get-togethers.[8] In an article on history painting in the *Universal Review* of 1888, Brown declared that "socialism will do much to check the upholstery, soft-cushioned, cabinet gallery, selfish plutocratic littleness of art."[9] Brown also visited the impoverished home of Joe Waddington in Manchester in 1886, and thereafter employed this activist workman as a handyman to construct furniture from Brown's designs.[10] In old age, Brown cheerfully encouraged his grandchildren's homemade publication of an anarchist newspaper.[11] In summing up his former colleague, Philip Webb asked, "Was Brown a Socialist?" and answered, "It was after his time, but he was a great radical with a hatred of class superiority. Worshipped all nobleness, he loathed nobility and the Renaissance."[12]

In addition, numerous passing comments suggest Brown's ever-present concern for social equality in even very small matters. J. Phillips Emslie, for example, remarked in a memoir of Brown's teaching methods at the Working Men's College in London in 1859 that "Messrs. Allen and Ward had long been pupil-teachers under Mr. Ruskin, but Mr. Brown was the first to have his assistant's name placed on the prospectus beside his own."[13] The Working Men's College itself, founded by the Reverend F. D. Maurice in 1854 to provide common people with some liberal arts education, was a modestly leftist institution, breaking down social barriers in education.[14] Brown's participation suggests a devotion to working-class betterment.

Despite all this, it would be incorrect to label Brown a fanatical leftist. Ford Madox Hueffer summed up his grandfather's politics: "In his early days he was nearly a Whig; in later life he was by temperament a good deal of a 'Tory of the old school,' but his intellect made him a Socialist of an extreme type. To this, of course, his desire to better the lot of the poor contributed largely."[15] Brown, as will be shown later, seems to

have had some patriotic sentiments and a Tory-like appreciation of English traditions. Brown's leftist tilt, at any rate, did not prevent him from declaring in a letter of 1886 that Morris's radical political views "lacked balance."[16] Socialist sympathies were, after all, an almost fashionable facet of the Arts and Crafts Movement in the 1880s and 1890s, when Brown was active in the field, and such socialists as Walter Crane and C. R. Ashbee, not to mention Morris, were leading lights.[17]

Back in the 1850s, however, one might attribute Brown's class attitude not to radical chic, but to private experience. He reacted with bitterness and anxiety to the downward trend of his own social status, strengthening his identification with the downtrodden. When forced by financial necessity to give art instruction to the daughters of General Sir Robert Slade in 1855, Brown confided to his diary, "Gave my first lesson for a guinea & am no longer a gentleman."[18] The fact that his wife, Emma, was a bricklayer's daughter, who apparently worked sometimes as a servant, and that Brown's first child by Emma was born out of wedlock, no doubt diminished Brown's claims to decent social rank.[19] And Brown, with his lack of professional success in mind, recognized a personal basis for his social sympathies. He wrote to the unsuccessful Liverpool painter William Davis in 1857: "But my own life has been chiefly one of drudgery and disappointment so much so that I look upon every other unlucky man as a brother."[20]

Brown's father, who had been a ship's purser, and his mother, who came from a landowning family in Kent, would certainly have defined Brown as middle class.[21] Brown's parents moved to France after the Napoleonic Wars to live inexpensively on Mr. Brown's half-pay pension and Mrs. Brown's income from rental properties. Brown was thus born into very modest, but still middle-class, circumstances in Calais in 1821. However unluxurious the situation, no one in the Brown family had to work. Brown tried to subsist in the 1850s on the properties inherited from his mother. His labor as a hired drawing master to the daughters of Sir Robert Slade was probably socially demeaning, although his comments about ungentlemanly employment may have been sarcastic. Diary entries reveal that Brown was living from hand to mouth, down to his last shilling, on numerous occasions in the early and mid-1850s, and mention of social indignity may be taken as a bit of self-mockery. The words of humorists, even in the privacy of a diary, can never be taken absolutely as straightforward.

The surprising thing is that Brown did not react to his descending status with pompous declarations of superiority and pedigree. Whatever disappointment he may have felt, he seems to have embraced the lower classes with sympathy. At the moment of his keenest poverty, in 1854, however, he did respond with some callousness, and fired a maidservant for insolence.[22] Albert Boime sees this incident, recorded in Brown's diary, as indicative of the artist's lack of understanding and true commitment to socialism.[23] Well, yes. Brown assuredly was not politically pure, and he seems to have had no grand systematic view of class struggle in the manner of Marx. But then again, Brown also felt shame and regret at his treatment of the servant—and this too was recorded in his diary.[24] His concern, ultimately, was moral and emotional. How-

ever untheoretical, his social view was also not wholly based in personal history; it appeared in his art long before he had experienced critical indifference, financial crises, or an "unsuitable" marriage.

One of Brown's earliest paintings depicts a blind beggar and his child (Fig. 1). Dated 1837, it reveals Brown's training in Belgian art academies run by Davidian masters.[25] The picture seems like a Neoclassical image of blind Belisarius, but the ancient references have been obliterated, and we are left with an unhistorical scene of pathetic poverty. Such a painting was not that unusual at the time. Leopold Robert's *A Neopolitan Woman Weeping over the Ruins of Her House After an Earthquake* (1830; Musée Condé, Chantilly), for example, is an equally pitiful representation of misery among common people. The poor folk in such images are not necessarily victims of an unjust society—what is one supposed to do about blindness or earthquakes, after all, except provide charitable relief? These kinds of paintings from the 1830s, although descended in part from the picturesque beggars and streetpeople of Murillo and other Baroque masters, are essentially manifestations of Romantic passion. The distraught figures raise high emotion: sympathy, horror, despair, and so forth The feelings rather than the conditions play the key role, although Brown's beggar still attests to the painter's early interest in the dispossessed. The *Blind Beggar* should be seen as part of a whole group of youthful pictures by Brown of underdogs and common people. The works are now lost, but their titles are revealing: *Friday Among the Poor* (1837), *Head of Flemish Fish Wife* (1836), *A Fleming Watching the Duc d'Albe Pass By* (1837).[26] The last named work, a drawing, depicted Flemish hatred for a brutal overlord.

Several years later, a critical stance appears in Brown's depiction of poor folk. His entry in the Parliament fresco competition of 1845, *The Spirit of Justice* (Fig. 12), is particularly notable in this respect, and seems attuned to the rising concern among both Continental and English artists for pressing social issues. The 1840s produced such paintings as Richard Redgrave's *Poor Sempstress* (1844; 1846 replica in Forbes Magazine Collection), Peter Fendi's *The Distraining Order* (1840; Vienna, Österreichische Galerie), and Carl Wilhelm Hübner's *Silesian Weavers* (1844; Düsseldorf, Galerie Paffroth), all of which raise cries of alarm. Brown described his design for *Justice* with a keen awareness of social inequality: "the two figures in the foreground are indicative of power and weakness. An unbefriended widow is seen to appeal to Justice against the oppression of a perverse and powerful Baron."[27] In this intended government mural, Justice may be impartial, but the representation of unbalanced class conflict is powerfully presented, and English nobility in the image appears ignoble. The established powers of society are condemned, as the desperate widow accuses (with Fuseliesque drama) the arrogant, armored Baron. And standing between these two figures and the personifications of Justice, Mercy, Erudition, Truth, and Wisdom at the top of the composition is a set of obstacles: a rich man who grasps his money bags, a prince who appears bored, and ecclesiastics who look on with complacency. The picture of the Spirit of Justice eventually carried out in the Houses of Parliament by Daniel Maclise (1845–49) possesses none of Brown's disturbing social references. Was Brown's image too tendentious or uncelebratory to gain the approval of the commissioners?

The critical tone of Brown's *Justice* is part of the growing social conscience of art in the 1840s. Depictions of the poor in that decade and afterward differ from earlier works of the genre, not so much in the subject matter per se, but in the social context in which they appeared. Endless associations, movements, legislation, and political groups had developed to cure the ills of society. Social reform became a persistent and public issue in the 1840s. In England after the Reform Bill of 1832, poverty was no longer an incorrigible or minor affair that could be viewed in an offhand manner.[28] There were images that suggested social criticism before 1840. David Wilkie, for example, produced some, and several of Turner's works have been interpreted by some recent art historians as at least subtly or clandestinely engaged to radical politics.[29] But most reviewers of the day, before 1840, failed to dwell on such matters vigorously. Redgrave's *Sempstress,* however, brought to mind issues of reform and politics, as did paintings of the poor by Jean François Millet and Gustave Courbet in the same period, and the subject matter itself became embedded in realism.[30]

Between the *Blind Beggar* of 1837 and the *Spirit of Justice* of 1844–45, Brown produced two scenes from Byron's play, *Manfred,* which may also suggest Brown's sympathetic attention to the lower classes. Byron's hero, Manfred, of course is the aristocratic protagonist in Brown's *Manfred on the Jungfrau* and *Manfred in the Chamois Hunter's Hut* (Figs. 3 and 4), both of 1840. But an Alpine peasant huntsman also appears here—and in a rather handsome light. In the *Jungfrau* he is about to rescue the distraught Manfred from suicide. In the other, the caring peasant offers comfort and advice to the unaccepting Manfred. The humble huntsman is brave, rational, and humane, while the noble Manfred is chaotic and self-absorbed. Brown's choice of incidents from the play make the lower-class man seem superior.

Wycliffe Reading His Translation of the Bible (1947–48; Color Plate I, Fig. 17) is more subtle in its reference to the lower classes, yet more politically resonant. The hero of the work is primarily a religious figure, but Wycliffe also played the part of social leveler, energizing the poor. His followers, the much-persecuted Lollards, spread rebellious sentiment among the lower classes, and threatened the established powers of England. Brown remarked in 1865 that Wycliffe's "reforming tendencies seem to have embraced social as well as religious topics."[31]

In the 1850s, *Jesus Washes Peter's Feet* (1852; Fig. 24) is Brown's most socially conscious image, presenting the Son of God as a menial servant. The discomfort in the apostles' expressions portrays the distress of social upheaval. The picture presents divine authority for the abolishment of class distinctions.[32]

A radical view is also expressed in *Work* (Color Plate IV, Fig. 27; 1852–65), which depicts common workers in heroic terms, as has already been noted. The navvies in *Work* appear superior to every other character in this vision of English society, and certainly are Brown's boldest break from traditions of representing such people. Middle-class ladies, the wealthy, the powerful of society, and intellectuals are all mocked or of lesser grandeur than the construction crew. On the other hand, the *Lumpenproletariat* in *Work*—the unemployed Irish immigrants, the retarded flower-seller, the neglected children, sandwich-board carriers and deformed beer boy—are

not idolized by Brown. In his sonnet accompanying *Work,* Brown urged well-to-do ladies to help the ragamuffin children, and in his description of *Work,* accused the police of brutalizing the poor orange-seller in the right distance.[33] But these sufferers are not noble characters. Brown described the flower-boy as wrongheaded and wrongly directed, the placard-bearers are the poor dupes of an unscrupulous businessman, and the humpbacked beer-seller is a vulgarly loud middleman of unsavory character. While some of these figures may be pathetic, they do not express an admiration for the lower classes. Brown evidently did not consider all the poor equal, and in this he was very much of his time.

Public discussions of the New Poor Law of 1834, both before and long after its passage, frequently centered upon distinguishing the working poor from paupers, who could not or did not want to work. Differing value judgments and remedies were often applied to each group, and the law's effect, in some observers' eyes, was to criminalize pauperism.[34] Even Henry Mayhew (whose *Morning Chronical* articles on poverty appeared in 1849–50, and whose writings on streetpeople were published as *London Labour and the London Poor* in 1861–62) discriminated between the deserving poor and the barbaric idler. Mayhew wrote, "I am anxious that the public should no longer confound the honest independent working men, with the vagrant beggars and pilferers of the country; and that they should see that the one class is as respectable and worthy, as the other is degraded and vicious." Mayhew also remarked, "It is impossible to make labourers of the paupers of an overpopulated country without making paupers of the labourers."[35] Mayhew's description in 1849 of his methodology included reference to "the metropolitan poor under three separate phases, according as they *will* work, they *can't* work, and they *won't* work."[36] And Brown seems to have echoed Mayhew in his 1865 description of *Work,* which included mentions of those who "can't work," "have been taught to work" "never have been taught to work," and "have no need to work."[37] Brown's references to education here may also stem from Mayhew's concerns.

Brown's attitude toward the varieties of the poor is not easy to assess, and we cannot assume that he took the exact same view as Mayhew. In Brown's sonnet accompanying *Work,* the primary theme follows the lead, not of Mayhew, but of Thomas Carlyle, celebrating "Work!, which beads the brow and tans the flesh / O lusty manhood, casting out its devils."[38] Carlyle's references to the morally purifying effect of labor are innumerable.[39] But for Carlyle, those who do not work, even the sort of vagrant Irish poor who appear in *Work,* deserve neither charity nor pity: "He that will not work according to his faculty, let him perish according to his necessity: there is no law juster than that."[40] We do not have to assume, however, here again, that Brown swallowed Carlyle whole. His view of the sage was surely mixed. In one passage in his diary, Brown praised the nuggets of truth espoused by Carlyle, yet at the same time called the thinker an obscurantist windbag. And in an article of 1890, Brown viewed Carlyle as a devotee of the Puritans, who "settled like locusts, on the arts and fair joys of our green country, and left it much as those voracious orthoptera leave a once green field."[41] And for all the Carlylean elements of *Work,* its glorification of labor, its

references to the insidious parvenu sausage-maker, Bobus, a character in Carlyle's *Past and Present* (the sandwich-board carriers in *Work* are advertising Bobus's election campaign), and its generally sneering, satirical tone, Carlyle appears in the right foreground of the painting as an idler. He chats leisurely with F. D. Maurice, the founder of the Working Men's College.

Carlyle is described by Brown in his catalogue entry for *Work* as a "brainworker," who "may already, before he or others know it, have moulded a nation to his pattern, converted a hitherto combative race to obstinate passivity, with a word may have centupled the tide of emigration, with another, quenched the political passions of both factions—may have reversed men's notions upon criminals, upon slaves, upon many things, and still be walking about little known to some."[42] Did Brown really favor reducing the English to passivity? Did Brown really support Carlyle's approval of slavery (as stated in Carlyle's *Latter-Day Pamphlets* of 1850), when Brown himself would later begin a design depicting the abolitionist John Brown rescuing black slaves?[43] And certainly Brown did not approve of Carlyle's encouragement of emigration, a subject that Brown portrayed as a tragedy in the *Last of England*. No. Brown's description of Carlyle in *Work* is filled with humorous condemnation. The term "brainworker" applied to both Carlyle and Maurice must, I think, be tinged with sarcasm.[44] We cannot accept Brown's vision of the varieties of the lower class as necessarily the same as Carlyle's.

Brown's sonnet for *Work* gives us the best indication of how he viewed those vagrants and paupers, those undeserving poor, different from the glorified construction workers. Brown claimed in his poem that if people such as the wealthy lady in the foreground ignore the plight of the *Lumpenproletariat,* these paupers will become "dreaded midnight robbers breaking through" the houses of the rich.[45] Helping the poor is presented as a defensive action to prevent crime. The fear of the social unrest that poverty can produce was expressed often in the popular press (for example, *Punch* [Fig. 121]), and I would suggest that that was Brown's feeling as well.

Brown returned to lower-class images in the Manchester murals late in his career. And we see in the *Romans Building a Fort at Mancenion* (1880; Fig. 73) a reprise of the construction subject of *Work*.[46] The British slaves or "impressed" laborers are the mighty constructors here. The Roman general, his family and assistants, are ninnies, as Brown's comic touches take effect. Amid the building operation, the Roman leader is interrupted by, and preoccupied with, his fashionable wife. Despite the messy site in the middle of a primitive country, Brown noted, the general's Mrs. is dressed in the height of luxurious fashion with dyed yellow hair, and her obstreperous, horn-tooting child has a tantrum and kicks a black slave.[47] The general's centurion aide spends most of his efforts trying to hold on to the building plans in a stiff wind; he uses his chin as a "paper clip." Similarly, a humble bargewoman becomes a monumental figure, while the diminutive Duke of Bridgewater appears drunk and silly in *The Opening of the Bridgewater Canal* (1892; Fig. 82). The poor scholarship boys in *Chetham's Life Dream* (1887; Fig. 78) are an undiluted vision of energetic joy, a warm and optimistic portrayal of working-class lads.

Nevertheless, just as some of the poor are treated in a less than glorious manner in *Work,* so too in *The Proclamation Regarding Weights and Measures* in the Manchester murals (Fig. 77), the poor beggar girl is depicted in a less than glowing light. Brown remarked on how well-fed the girl's fat baby is, suggesting that the girl's needs are hardly desperate.[48] The beggar girl is no better, really, than the cheating shopkeepers above. They quickly scrape the weight-increasing butter off their scales as the new laws regarding weights and measures are proclaimed in Manchester. In this picture of laughable universal corruption, the miscreants, both middle-class and poor, probably need not fear the new laws. The government's agent, the town crier, who announces the regulations, appears to be blind. His gaze is unfocused, and he holds his staff as if tapping the ground. Furthermore, his dog is muzzled. An old man without sight and a dog without bite are the guardians of rectitude!

Brown's impure view of the proletariat in the Manchester murals is also seen in *John Kay* (1890; Fig. 81), where the ill effects of "great" labor-saving inventions on the working class is illustrated. The inventor of the fly-shuttle, John Kay, appears absurd, but the mob of poor workers, made obsolete by the new machine, are a less than savory crew as they storm Kay's workshop.[49] Still, *John Kay* deals incisively with the pain of industrial progress, illustrating the human impoverishment that can result from modern machine production. This was an important theme in Manchester, the most industrialized city on earth, and may be related to all those nineteenth-century castigations of inhumane machine labor by Ruskin, Morris, and others. But the humor of *John Kay* lessens the condemnatory point, doesn't it? Brown never took up such a subject again, and even seems to have celebrated modern machinery in his portrait of seven-year-old Madeline Scott in 1883; Fig. 68). The charming young girl sits on the most up-to-date of tricycles, surrounded not just by metal and gears, but also by a lovely wooded landscape.[50] This velocipedic portrait undoubtedly stemmed from the enthusiasms of the sitter's father, C. P Scott, editor of the *Manchester Guardian,* who joyously bicycled to his office every day.[51] The vehicle was probably seen as a marvelous, modern means of healthful exercise by both Brown and Scott, not much different from the sanitary blessings of the water pipes installed by Brown's heroic navvies in *Work.*

A yearning for preindustrial life, in the manner of Morris and the leaders of the Arts and Crafts Movement, was apparently not very strong in Brown. He even claimed to find great landscape beauty in the industrialized suburbs of Newcastle and Manchester.[52] It is hard to discover any consistent or obvious distaste for machinery in his career. Still, he tellingly avoided any reference to machine production in his Michael-angelesque decorations for the Manchester Jubilee Exhibition of 1887, which depict the commercial labors of the city (Figs. 70 and 71).[53] Textile and mining production, and so forth, were all illustrated there with figures engaged in old-fashioned handlabor. The navvies in *Work,* it should be noted, also toil without any modern machinery. Perhaps Brown chose such subjects in order to avoid portraying working folk as miserable victims. Given the widespread description of factory conditions as an unmitigated horror, the depiction of machine laborers might have immediately suggested the suffering multitude. If Brown had a Luddite sensibility, it was expressed merely by what he

left out, rather than what he included in his images, and this seems unlikely. He was not afraid to declare his social views forcefully. In the Manchester Jubilee decorations, for example, he depicted not just joyous and hardworking laborers (Fig. 70), but also a merchant, who appears as a pinched and unsympathetic fellow in Medici costume, scrutinizing his account book while a money bag rests on his lap (Fig. 71).

At one point in the early development of the Manchester murals, Brown had wanted to depict the Peterloo massacre, the famous Manchester incident of 1819 when government troops killed protesting workers.[54] Now that would have been a leftist subject! But given Brown's tendencies to downplay the worker as victim, and his capability of viewing the lower class as not always wonderful, even his representation of Peterloo might have been double-edged. Nevertheless, Brown's interest in the Peterloo subject affirms his persistent concern with the lower classes, and may reflect a deep-seated antagonism toward authority. That, in turn, may tell us something of what generated Brown's humor.

Brown dwelled throughout his career on images of mothers and children. This interest no doubt expresses some deeply personal concerns. But maternal glorification, after all, has been such a commonplace in art and society for so long that it hardly constitutes a distinctive characteristic of his art. Brown's treatment of motherhood, furthermore, respects standard attitudes of admiration, whether mommyhood appears in ordinary country outings or historical dramas (Figs. 7, 16, 17, 18, 25, and 76). Brown's mothers are nearly always caring, protective, sweet-tempered, and handsome. The conventional Madonna rules, and no Medea enters Brown's pictorial world.

Yet Brown's vision of womanhood is not completely clichéd. There is an unusual preponderance of dominating women in his art, dwarfing their male companions by height or size or gesture or position. Juliet stands grandly over Romeo (Fig. 53), and Byron's first love, Mary Chaworth in *Byron's Dream* (Fig. 56), towers above the poet (whom she rejects in favor of another). In other Byronic subjects, Haidée looks down on the supine Don Juan (Fig. 55), and the sleeping Sardanapalus is similarly under the control of a woman (Fig. 54). In *King René's Honeymoon* (Fig. 41), it is the wife who clasps and kisses the husband, playing the active partner, and even *Down Stream* (Fig. 61), an illustration to a poem by Rossetti, gives a certain superiority to the female half of an embracing couple. The woman in *Down Stream* is manfully caressed by the male, but the sheer bulk of the female, and her responsive grip of both the man's hand and the controlling oar of their rowboat gives this woman a masterful presence. Brown's portrait of the blind professor and politician Henry Fawcett (Fig. 62) shows the statesman being helped and guided by Mrs. Fawcett, who sits in a superior position.[55] In *Lear and Cordelia* (Fig. 21), the old king asleep is like Sardanapalus and Don Juan, under the gaze and power of a woman. And in *Cordelia's Portion* (Fig. 52), Cordelia upstages and turns away from her ardent suitor, the king of France. Perhaps Brown's repeated depictions of *King Lear* reveal an appreciation of not only the play as a whole, but in particular, its noble and strong-willed heroine. It is as if the motherly role, portrayed so often by Brown—in *Waiting* (Fig. 25) and *Out of*

Town (Fig. 7) and dozens of other canvases—was extended by him, so that adult men became children too, under the sway of kindly or dutiful women.

To be sure, women and mothers take up stereotypical cheerleader positions at the margins of many of Brown's paintings, particularly in the Manchester murals. A woman's place is at the sidelines of important events and as the helpmate of important men. But even at Manchester, the large bargewoman in the scene of the Bridgewater Canal (Fig. 82), for example, is unduly prominent. John of Gaunt's wife in the *Trial of Wycliffe* (Fig. 79) pulls her husband back with dictatorial force. And Queen Philippa in *The Establishment of Flemish Weavers in Manchester* (Fig. 75) is the pivot of the action, as well as the highest-placed personage in the scene. Among Brown's more dominating womenfolk is the mother in *Take Your Son, Sir* (Fig. 26), an unfinished painting. Several writers have extravagantly interpreted this image as a picture of a kept woman, illegitimacy, guilt, and feminism. But at the very least it shows one more large female towering above a teeny male, who is visible only in the mirror reflection.[56] Rossetti also created images of powerful women, but they are entirely different from Brown's. Rossetti's endless stream of women are rarely mothers, but instead, seductive beauties, sexually charged, or untouchable, or fearsome, or mysterious— forebears of those femmes fatales who populate Symbolist art at the end of the century. Brown's potent females are great mothers, protecting and directing all men. They are secular versions of the Madonna.

Brown treated women's controlling character in several of his comic passages: John of Gaunt's wife, for example, really is ridiculously intrusive, and so too is the general's fashionable wife in *Romans Building Mancenion* (Fig. 73). Such wife jokes, of course, may be charmingly amiable, or genuine complaints. Or are we to understand such images as conscious depictions of forceful, liberated womanhood? Brown would have been aware of the ideals of women's liberation through his friendship with William Bell Scott, who had feminist leanings. In 1856, Brown noted in his diary a conversation with Scott about women's rights, and specifically mentions Mary Wollstonecraft.[57] That is, however, but one passing reference, and even there Brown voiced no opinion on the matter.

Personal history rather than sociopolitical aims probably lie behind Brown's imagery (although the two can never be easily separated). The dominant women in Brown's paintings may not be homages at all. They may be symbols of an uncomfortable sense of male inferiority, or an unpleasant feeling of dependence. This artist, after all, continued to live off his mother's properties, and his first wife was his mother's niece. Other factors that might have contributed to a negative view of women include Brown's second wife, Emma, who was an alcoholic; and Marie Spartali, who showed Brown no close affection in the 1860s, when he was passionately, but undeclaredly, in love with her.[58] Marie fell in love with the American William J. Stillman in 1869 (they became engaged in January 1870), and Brown's *Byron's Dream* (Fig. 56), commenced in 1869, appears to represent the artist's own lovelorn state: the painting is about Byron's rejection by Mary Chaworth.[59] In the painting, giant Mary barely holds little

Byron's hand. She looks not at the poet, but at her approaching lover in the valley below.

Only one woman in Brown's art is clearly and undilutedly vicious and overbearing—the character in the *Stages of Cruelty* (1856–92; Fig. 36), which Brown worked on for nearly forty years. Here is a disturbing woman without touches of ever-ambiguous humor, who is comparable to some of Rossetti's femmes fatales. The original title of Brown's painting, *Stolen Pleasures Are Sweet,* had been changed to *The Stages of Cruelty* by 1860. The new title allied the picture with Hogarth's famous print series of the same name.[60] Like Hogarth's images, Brown's picture presents the same person at various stages of development (although one can read Brown's image as representing two different females at different stages of life—practicing the same sort of cruelty). As in Hogarth's work, the child who begins by hurting animals, ends by hurting humans. Brown's little girl smacks a bloodhound with the plant called love-lies-bleeding, and the young woman turns her back on a pleading lover.

Brown's painting was first inspired by Arthur Hughes's *April Love* (1856; Fig. 122), which was bought by William Morris and praised by Brown.[61] Hughes's painting depicts a lovers' tiff, or a too-amorous male: an upset woman turns away from her ardent paramour. The picture concentrated on the female's modest despair (the shadowy male, who clutches the hand of the departing woman, is hardly visible). The turning away of the female from the male, as presented in Hughes's work, remains in Brown's painting, but the emotions have changed. The woman now rejects the man without pity, indulgence, shame, or difficulty. In fact, Brown's woman enjoys his torment, and the male in Brown's painting is extravagantly distraught. This is Brown's most vivid image of a controlling female, and for once she is neither mother nor protectress, but a singularly cruel mistress.

When Brown began this work in 1856 such a vision of hardened womankind would have been unusual in England. But when he completed it in 1892, Salomes, Judiths, Delilahs, and various evil offspring of Eve were to be found everywhere in the artworld. We can suggest that Brown's mothering (smothering) types, towering over their menfolk in Brown's art for decades, were but modest versions of the girl in the *Stages of Cruelty.* And that Brown could only bring his more powerful expression of the idea to fruition in a sympathetic artistic climate.

More significant, however, than the woman in the painting is the child. Brown's little girl, coldly striking a pathetic dog, is truly extraordinary. It is hard to think of any other nineteenth-century image of a cruel child. One must go back to Hogarth to find a precedent. Even the bullies and tough kids in William Mulready's paintings of childhood from c. 1810 to the 1850s are mischievous rather than wicked. In the *Stages of Cruelty* Brown radically challenged the standard vision of children of his day. And the cruel child in the picture was not some later, fin-de-siècle addition, but was present in Brown's conception of the painting from its early stages.[62]

All Brown's other depicted children are delightful, if sometimes naughty. The child who kicks a black slave in *The Romans Building a Fort at Mancenion,* for example, is

so cranky that he becomes amusing. The slave smiles at the offending child—no harm has been done. Brown's Aestheticized, costumed children such as those in *La Rose de l'Infante* (Fig. 66) and *William Tell's Son* (1877; Fitzwilliam Museum, Cambridge) also appear sinless. But the girl in the *Stages of Cruelty* stands as something different—a recognition, in the footsteps of Hogarth, that children can be evil. Hogarth worked at a time, however, when conceptions of childhood as a state of pure innocence were rare. But by the end of the eighteenth century and throughout the nineteenth century, childhood was widely regarded as a morally ideal stage of life.[63] Brown's cruel little girl was a brash affront to the attitudes of his time (and a foretaste of Freud's penetrating study of childhood). It is significant that, unlike Hogarth, Brown made his wicked child a girl rather than a boy. Rossetti is often seen as a major progenitor of the femme fatale theme in late nineteenth-century Europe, and to be sure, he was directly influential in many cases.[64] But Brown conceived the idea earlier, in the *Stage of Cruelty*, and we can suggest that it arose from Brown's subtle but persistent visualization of dominating womanhood. If Brown's underlying negativism sprang from some anxious dissatisfaction with a social condition, then female power is a likely candidate.

Ford Madox Brown was something of a nationalist. Britain was his focus even before he settled in England. His early enthusiasm for English literary and historical subjects such as *The Execution of Mary Queen of Scots* (Fig. 2) and *Dr. Primrose and His Daughters* (Fig. 5) might be attributed to the popularity of such topics in Belgium and France in the 1830s and 1840s, when Brown was studying art. Paul Delaroche, Eugène Delacroix, and Brown's teacher, Gustave Wappers, had all dwelled on such subjects. Brown's subsequent depiction of *The Body of Harold* (Fig. 11) and *Chaucer* (Color Plate II, Fig. 14), both exhibited in London, might likewise be chalked up to outside influence, to the Parliament fresco competitions in the 1840s, which encouraged nationalistic themes. But Brown's attraction to themes from English literature and history persisted long after such widespread fads of the first half of the nineteenth century had faded. His entire career was devoted to British heroes, British history, British poetry, British theater, and British life.

Brown's *Seeds and Fruits of English Poetry* (Fig. 13) was intended to be not merely a lineup of great British writers, but a portrait of the origins and sanctity of the English language.[65] *Wycliffe Reading His Translation of the Bible* (Fig. 17) is again a tribute to English speech, as well as a celebration of English Protestantism. Even *Oure Ladye of Saturday Night* (Fig. 16) is an Italianate Madonna with English overtones. "In idea," wrote Brown of *Oure Ladye*, "the children are modern English, they are washed, powdered, combed and bedgowned, and taught to say prayers like English Protestant babes."[66] Brown went on to represent Shakespeare and Cromwell in paintings, and a host of early English saints in stained-glass designs (Figs. 22, 30, 31, 47, 48, 49, and 67). Brown produced some foreign and ancient subjects too, but almost all were drawn from Byron (For example, *Manfred on the Jungfrau, Don Juan Found by Haidée, Sardanapalus;* Figs. 3, 4, 54, and 55). His landscapes are all of English countryside, and his modern-life scenes, such as *Waiting* (Fig. 25), *Work* (Color Plate IV, Fig. 27),

The Last of England (Color Plate VI, Fig. 29), and *The Stages of Cruelty* (Fig. 36) are also specifically English. *Work,* indeed, was meant to be a grand summation of the state of the nation—its classes, character, problems, and heroes.

A nationalistic spirit was at work. A painting such as *Waiting* (Fig. 25) (which in its final form was titled *An English Fireside in the Winter of 1854–55*), presents a wife waiting for her military husband, who is fighting for England in the Crimea, and adds a martial vigor to Brown's nationalistic tendencies. *Walton-on-the-Naze* (Fig. 38) is another cry of militaristic national pride. In 1859, when Brown began the painting, a French invasion of England was widely feared. Brown, along with many other artists, formed a militia company, which drilled and took shooting practice in preparation for defense of the realm.[67] In *Walton-on-the-Naze,* the male figure (Brown himself) gestures toward the background, where is seen a British man-of-war and a Martello tower topped by the Union Jack. The tower was part of a whole line of defense works constructed during the Napoleonic Wars to ward off French invasion.[68] Brown's vision of a placid and fertile landscape, graced by a rainbow of peace, is a place protected by British might and military preparedness. The Englishwomen in the foreground, who have been engaged in the peculiarly English pastime of sea-bathing (note their letdown hair), will not have their healthful exercise and way of life defiled by foreign invaders.[69]

The foreign birth and training of Brown should be mentioned in this context. Brown's nationalism can in part be explained as a needed psychological affirmation of roots. Doesn't his outsider history in all likelihood account for his concentration on all things English? Certainly it was a factor. But then again, look how questioning and double-edged are many of Brown's national images. *Work,* for example, is not some undiluted glorification of England. The worker-heroes are surrounded by chicanery, stupidity, unemployment, greed, crime, and injustice. *The Last of England* presents economic travails and desperate remedies. And if the *Stages of Cruelty* is a picture of English domestic life, then the nation is in trouble. Brown may have focused upon nationalist themes, but his vision of England was not necessarily one of optimism and satisfaction. In 1854, at least, he lambasted the whole country, presenting such intense distaste that the basis of Brown's humor in social life is hardly to be doubted:

> To what pitch is England destined to soar in the History of the world. Externally a far shining glory to all the Earth and an example, internally a prey to snobbishness and the worship of gold & tinsel—a place chiefly for sneaks and lacqueys, and any who can fawn or clutch, or dress clean at church, and connive. . . . And yet every one would avert revolutions as still worse. Abroad somehow things are managed with more of the feeling of modern improvement & commonsense justice; even, amid the crash of breaking up governments & violations of personal liberties & rights. Here the Government with our boasted nobility the greatest in the world takes the lead in all that is dullest and stupidest, and the genius of the nation with utmost effort can allone force the improvements of art & the dictates of commonsense on it long long after date,

after patience is exhausted & frequently not before a press feeling has again sprung up, and yet such is the vital energy of the nation & the stubborn irristable patience of Englishmen that improvements keep pace almost with other nations in all except such branches of art as are especially government reared, such as architecture, sculpture, music & High art. Alas for the latter . . . but were the Napoleonic spirit of promoting and evoking merit the rule with us in lieu of *family interests* what heighth should we attain to in the scale of glory & the worlds wonder, but the world is a mere mousetrap—a trap baited to catch poor greedy selfish stupid man, who thinks himself so precious clever while damming his soul to feed his guts.[70]

Quite evidently a nationalist ideal failed to match up with reality, and that failure could have generated a spirit of negativism in Brown.

In describing *An English Autumn Afternoon* (Color Plate V, Fig. 28) Brown made one of his most curious remarks about Englishness. He wrote in 1865 that the couple in the foreground of that painting was "peculiarly English"; the young man and woman were not lovers, but merely neighbors and friends. Only in England (and perhaps America), he wrote, can women freely interact with men in unprotected circumstances without sexual danger. The painting is, apparently, a triumph of English gentlemanliness, and also a triumph of independent English womanhood. Brown further noted the ancient Icelandic forebears of the English, whose women would wander all about on horseback for months without interference—before returning to their "much tolerating husbands."[71] One can take Brown's words at face value, and relate them to all those large, superior, and commanding females in his art. His comments can also be taken as evidence of his serious interest in Britain's Nordic racial lineage. But Ford Madox Hueffer interpreted Brown's words here as nothing more than "amusing discursiveness," a facetious commentary.[72]

Here is a case where one must put one's understanding of Brown's humor into action. Is *An English Autumn Afternoon* really about the gentlemanly manners of the English and the long-standing liberties of Nordic womanhood? Or is such an interpretation from the pen of the artist a sniggering send-up? I think Brown was being humorous. He claimed that the young couple in the painting is not a pair of lovers. But surely this boy and girl next door, seated next to a dovecote with birds fluttering together, nesting and cooing, are indeed courting. The figures' hands are entwined, which is surely more than a handshake. What happens to all that stuff about high-minded English character, if the couple is really amorously engaged? It gets slapped in the face. And doesn't Brown's humor also bring into question most of those other nationalistic images? If the man in *Walton-on-the-Naze* is digressing upon British might, what does the little field mouse who mimics him do to the theme? Isn't the man made slightly ridiculous? Just so, the great English hero, Cromwell, is made to look silly, and nobody pays much heed to the great English poet, Chaucer. It is difficult to accept Brown's nationalism without question.

Beyond such social questions, *An English Autumn Afternoon* is also part of a por-

trait of the seasons of the nation, begun in the early 1850s. *Pretty Baa-lambs* (1851; Color Plate III, Fig. 23) (which was also titled *Summer Heat*) depicts summer. *An English Autumn Afternoon* (begun 1852) represents autumn. *The Last of England* (begun 1852) portrays winter. And *Oliver Cromwell on His Farm* (Fig. 31) (begun as *Saint Ives An. Dom. 1635* in 1853) shows spring. This too is a nationalistic record of England, but uncontentious and mingled with a realist's scrutiny of meteorology.

What about religion? Were Brown's religious beliefs and practices in some way connected to his general negativism or humor? Ford Madox Hueffer said of his grandfather, "In his early days he was a conventional member of the Church of England; in later years he was an absolute Agnostic, with a great dislike for anything of the nature of priestcraft."[73] We have but one extended statement regarding God in Brown's diary, part of the same 1854 diatribe about the state of England quoted above:

> Alas the poor selfish man is baited on all sides—Gluttony, leachirry, glory are the least chances of destruction, where a wretch may serve two ends the safety of a nation & his own damnation or thinks still more cunningly to save his selfish soul by selfish religion and giving up of man for God & thinking to win Gods notice & refuge by forced marches, leaving all others behind—alas! man shall forget himself in the community of being. Woe to the temerity that would call down the searching eye on his individuality. Therefore is the Eternal shrouded in impenetrable mistery otherwise who but themselves would be first to seek him. Whoever feels a tenderness for a fellow being worships God in the act, nay a kind of feeling for a dog or a cat shall not pass unnoticed, but woe to the selfseeker & him who despises the poor
>
> > "Whose belly with thy treasure hid
> > Thou fillest: they children have
> > In plenty; of their goods the rest
> > They to their children leave.
> > But as for me, I thine own face
> > In richousness will see
> > And with thy likeness when I wake
> > I satisfied shall bee.[74]

This fascinating outburst about God primarily blesses Brown's worldly social concerns: "whoever feels tenderness for a fellow being worships God," and "woe to the selfseeker & him who despises the poor." The language is religious, but the meaning is secular. Indeed, this passage in Brown's diary contains more condemnation of the hypocritical religious-minded than praise for the righteous. And God's will remains "shrouded in impenetrable mistery."

From his diary we know that in the 1850s Brown attended Church of England services on Sundays.[75] But according to Hueffer and the remembrances of Brown's granddaughter, Juliet Hueffer Soskice, the tenor of the Brown household at the end of

his life was distinctly irreligious.[76] Furthermore, Brown was buried in 1893 without any Christian ceremony.[77] In the nineteenth century, going to church on Sunday hardly constituted a sign of religiosity. It was a social decency. Did Brown have any firm religious beliefs beyond the justification of helping the poor expressed in his 1854 diary entry?

Without further documentation, perhaps we should take the dubious path of likening his religious views to those of his friends. One of Brown's companions in the 1840s in London was William Cave Thomas, who was strongly associated with the neo-Catholic party of the Church of England. This was called High Church Anglicanism, or the Oxford Movement, or Tractarianism. And Thomas devoted much of his Nazarene-inspired art to Christian subjects and church decoration.[78] Rossetti, Millais, and Hunt have also been linked to High Church Anglicanism in the early years of the Brotherhood. Millais's *Christ in the House of His Parents* and Rossetti's *Ecce Ancilla Domini* (both works 1850; Tate Gallery, London), for example, have been interpreted as Tractarian declarations.[79] And as has already been pointed out in Chapter 1, Nazarene-like archaism itself could be associated with Catholicism or Tractarianism.

None of the three main Pre-Raphaelite Brothers, however, seems to have remained long in the Tractarian fold. Hunt became a dedicated Low Church Protestant, without any Catholic-like, Tractarian overtones. Indeed, his highly successful *Finding of the Saviour in the Temple* (1855–60; Birmingham Museums and Art Gallery) can be interpreted as a Protestant reworking of Millais's Tractarian *Christ in the House of His Parents*.[80] Rossetti's religious beliefs, if he had any, are up for grabs. His attraction to anything more Christian than quaint symbolism, the mysteries of ritual, and female spirituality is doubtful. Oswald Doughty's detailed biography of Rossetti allows the artist's religious views to remain dim.[81] A taste for Christian subjects does not necessarily indicate some deep Christian devotion. William Morris, for example, became a confirmed atheist, but continued to produce Christian stained-glass windows for churches. In any event, the religious outlook of the Pre-Raphaelites and William Cave Thomas, at best, can only tangentially tell us something of Brown's religious thought. We must turn to Brown's paintings to grasp his beliefs.

The *Execution of Mary Queen of Scots* (1840–41; Fig. 2) was Brown's major Parisian production, exhibited at the 1842 Salon, and it concerns religion as well as political history. Brown depicted the moments before the execution, when Mary's request for a Roman Catholic confessor has been refused, and a Protestant minister is sent instead. The zealous minister, according to Brown's 1842 catalogue description, "was not ashamed to insult her beliefs: he told her that outside of the Anglican Church, she would be damned. Mary begged him not to torment her any longer, but he persisted."[82] Mary appears brave and self-disciplined, as she silences the tearful outbursts of her attendants and ignores the grotesquely grimacing minister. Brown seems wholly on the side of the Catholic queen. Paintings sympathetic to Mary Queen of Scots are plentiful in English art, but still, Brown's image is so pointedly anti-Protestant that

an attraction to Roman Catholicism is suggested. In this case, the subject might have been intended to appeal specifically to the Catholic majority in France.

The style of the *Execution* bears some general similarities to that of Delacroix, a predictable source in 1840s France. The entire painting might be thought of as a particularly Frenchified production. But the rather maniacal expressions in the *Execution* also betray the influence of the Swiss-born English painter Henry Fuseli (Fig. 123). Fuseli's influence increased in Brown's subsequent works, not only in secular subjects such as *The Prisoner of Chillon* (1843; Fig. 6), but also in his next religious image, *The Ascension* (1844; Fig. 9). The subject here was dictated by the churchmen of Saint James in Bermondsey, who held a contest to commission an altarpiece for their new church.[83] Brown mentioned Fuseli in his *Builder* article of November 1848, and would have known the numerous and widespread engravings of Fuseli's works, if not the original paintings.[84] The dynamic symmetry of Brown's *Ascension,* its dramatic lighting and emotional intensity, are very much in the vein of Fuseli. One might be tempted to attribute the passionate character of the *Ascension* and its predecessor, the *Execution,* to religious enthusiasm. More likely, however, they express love of Fuseli rather than love of God. The remainder of Brown's religious images, including the numerous stained-glass designs in the 1860s and 1870s, although often vigorous and monumental, are far more earthbound and emotionally controlled than the *Ascension* (for example, Figs. 44, 45, 48, and 50). Even the frenetic *Death of Saint Oswald* (Fig. 49) is more of a confusing jigsaw puzzle than a passionate outpouring.

Oure Ladye of Saturday Night (1847; Fig. 16) is also restrained in emotion. It is a sweet Italianate Madonna, and perhaps continues the Catholic sympathies first espoused in the *Execution of Mary Queen of Scots.* In 1865 Brown pointed out the English Protestant features of the image, and declared that this Virgin "was neither Romish nor Tractarian."[85] But maybe he doth protest too much. While there certainly seem some points of Englishness present, isn't this work really quite in the Puginesque camp of midcentury art?[86] Like the Pre-Raphaelite Brothers, Brown too may have been drawn to High Church Anglican ideals, if not Roman Catholic ones, in the later 1840s. And unlike the *Ascension, Oure Ladye* was a subject devised by Brown himself.

If *Oure Ladye* does indeed suggest Tractarian or Catholic inclinations, those early tendencies were quashed immediately afterward, when Brown designed *Wycliffe Reading His Translation of the Bible* (1847–48; Color Plate I, Fig. 17). This work is staunchly Protestant. Wycliffe is the great proto-Reformation hero, performing the great Protestant act: making the Bible available to everyone. There may be leveling social ideals also associated with Wycliffe, but certainly he represents English Protestantism first and foremost. And although Brown may have toyed very slightly with the religious leader in his marginal, humorous manner, the painting's Protestant celebration dominates. The personifications of Roman Catholicism and Protestantism in the roundels of the upper section of *Wycliffe* tell all. Catholicism's Bible is closed and chained, and the ugly figure's face is shadowed and turned downward. The sweet woman representing Protestantism (at the upper right) is effulgent and holds her

Bible open. Brown originally planned to make the figure of Catholicism even more unappealing. In his diary on 28 February 1848, Brown wrote, "After dinner composed the other figure of the Romish faith, a figure holding a chained up bible and a torch— with a hood like the penitants at catholic funeras showing only the eyes, with burning fagots and a weel of torture for accessories."[87] That figure would have represented everything that midcentury English Protestants despised.[88] The *Wycliffe* of 1848 is Brown's most fervently Protestant work, but like his Catholic-tinged tendencies, this Protestant flavor also proved short-lived, unless one considers Brown's Cromwell paintings to be expressions of Protestant zeal.

Cromwell on His Farm of 1874 (Fig. 31), which began as a watercolor called *Saint Ives, An. Dom. 1635* in 1853 (Fig. 30), has already been discussed as a humorous image—with uncontrolled pigs, sheep, and cattle, and a dinner-calling servant making serious Cromwell look like an absentminded fool. The Puritan leader holds not only an oak sapling (because he has forgotten his whip), but also the Book of Common Prayer. Thus the image is not without religious reference. According to Ford Madox Hueffer, a description of *Cromwell on His Farm* by Forbes Robertson Sr. was inspired by Brown himself, and in that description, Cromwell, the unpolitical farmer, is said to be in "a religious trance." "His notions about kingcraft have been sadly shaken," and he has just read the biblical verses, "Lord, how long? Wilt thou hide thyself for ever? And shall thy wrath burn like fire?" (Psalms 89:46).[89] The will to rise up against monarchy is seen to be religiously inspired (and Cromwell's absent-mindedness is described by Robertson as indicative of the depths of his meditations). We may have here an antimonarchical painting, expressive of Brown's social views, as well as a depiction of Protestant righteousness.[90] But it seems to me that the humor in *Cromwell on His Farm* is even more intrusive than in most of Brown's other works, and that comedy robs Cromwell of much of his dignity. Can this man direct England when he can't even direct his horse? Brown's comedy here really does puncture pretentiousness and brings the big man down to earth—so much so, I feel, that we cannot finally interpret *Cromwell* as a serious glorification of either Protestantism or Puritan politics.[91]

Cromwell, Protector of the Vaudois of 1877 (Fig. 126) concerns Protestant martyrdom. Cromwell, in military outfit (because he has just been reviewing troops), dictates a letter to the King of France and the Duke of Savoy; the letter protests those parties' slaughter of the Waldensian Protestants, the Vaudois, and declares England's protection of these co-religionists.[92] It all seems a vigorous image of Protestant solidarity, prowess, and sainthood. But then again, Cromwell's protest and declaration of protection were in the end ineffective, and even in Brown's painting, we see the dilution of Cromwell's denunciation. Cromwell's evidently powerful words are being translated by blind John Milton into Latin, and then written down by the satirist Andrew Marvell. Immediacy and heat turn into finesse and bureaucracy. Milton's soft and mincing gestures are so in contrast to the muscular posture of Cromwell that all the force of the protest seems to drain away. The chamber is meant to be the home of Milton, with laurel-decorated organ, and ornate leather screen, an aesthetic milieu that further

diminishes the vociferous intentions of the Puritan leader.[93] It is difficult, ultimately, to see *Cromwell, Protector of the Vaudois* as the triumph of Protestantism.

Jesus Washes Peter's Feet (begun 1851; Fig. 77) was Brown's chief religious work of the 1850s.[94] As with *Oure Ladye,* we must be wary of accepting Brown's 1865 catalogue description at face value. Without Brown actually saying so, that description is largely devoted to positioning his painting in relation to Holman Hunt's enormous success of 1860, *The Finding of the Saviour in the Temple* (Birmingham Museums and Art Gallery). Hunt's picture was based upon extensive research and Near Eastern travel. He claimed unequaled historical exactitude, which included the orientalization of Bible imagery. Hunt utilized Arab accessories, costumes, and architecture in his canvas.[95] Brown apparently added such details as Peter's Near Eastern sash to his picture in response to Hunt's ideas. But Brown could not claim that *Jesus Washes Peter's Feet,* commenced long before Hunt's work, was as historically correct. So in 1865, Brown declared that in his painting, "general truth" and "the supernatural and Christianic" were more important than "the documentary and historic."[96] And in a later entry in the same catalogue (that for *Ehud and Eglon* of 1863, an illustration for the Dalziel Bible), Brown chipped away further at Hunt's claims of truthfulness:

> To pretend that the Semetic races to which the Israelites belong, have not changed in costume and character of appearance up to the present day, is against the evidence of our eyes, as may be readily seen by the Assyrian remains and those of their near neighbours, the Egyptians, which we have in the British Museum, to compare with the modern Arab. Englishmen should always remember that this convenient resemblance between Israelite of old, and the Arab of our days, came into vogue in France rather suspiciously, at the time of the French conquest of Algiers under Louis Philip.[97]

The last remark refers to Horace Vernet's orientalized Bible paintings of the 1830s, which preceded similar tendencies by David Wilkie and Holman Hunt.[98] All this contentiousness on Brown's part tells us how meaningful were the settings of his religious works of the 1860s. *Jacob and Joseph's Coat* and *Elijah and the Widow's Son* (Figs. 55 and 56) display Assyrian and Egyptian elements, but also some Hunt-like orientalization, despite Brown's nasty remarks in 1865. None of this, however, basically affected *Jesus Washes Peter's Feet,* which had been designed in the early 1850s. Brown's claims of emphasis on "the supernatural" must be ignored. That was the only rationale that might make his work justifiable in a period of Hunt's success. In the final analysis, *Jesus Washes Peter's Feet* is primarily about worldly matters—social humility and class consciousness.

The same worldliness appears in the human dramas acted out in Brown's religious works of the 1860s. *Jacob and Joseph's Coat* (Fig. 44) concerns paternal suffering and human deceit (with a good dose of humor). And the obscure story of *Ehud and Eglon* (Judges 3:14–21) is a spiritually uninspiring tale. The sneaky Israelite Ehud assassinates the fat infidel overlord Eglon, king of Moab. The passage deals with violent

political action against oppressive government, a theme more attuned to Brown's social interests than religious belief. Even *Elijah and the Widow's Son* (Fig. 45), which depicts a miraculous event—the resurrection of a child by the prophet—is treated coolly and in human terms. The resurrection has occurred offstage. No grand heavenly dramas appear, only the gratitude of a mother—and even that is somewhat comic. She has just been kneading dough, and is accompanied by those silly chickens.[99] Domesticity rules. Brown noted in his 1865 catalogue how amusing it must have been to see this woman who had previously upbraided Elijah, now become thankful, "and even surmise the faint twinkle of humour in the eyes with which he would receive the reply, 'Now by this I know thou art a man of God.' "[100] All this seems closer to Santa Claus than God. And Brown's touch of Hunt-like symbolism—the shadow of a swallow returning to its nest in the wall, which "typifies the return of the soul to its body"—is too small and isolated to suggest some grand underlying spiritual design.[101]

Brown evidently did not generally think in complex symbolic terms. In a note on his *Entombment* (Fig. 50), another major religious work of the 1860s, Brown remarked that a French critic had claimed that the only-half-closed eyes of Jesus in Brown's image symbolically foretold the coming Resurrection. But Brown added, "Such was not the artist's conception . . . yet it may unconsciously have guided him."[102] Despite the proto-Freudian attention to the unconscious, Brown's comment strongly suggests how foreign such conceptions were to him. With Hunt's orientalized Bible imagery in mind, incidentally, Brown told his patron George Rae in 1869 that he had improved the *Entombment* with an "orientalized" figure of Simeon.[103] The *Entombment* was a stained-glass commission, and *Elijah, Jacob and Joseph's Coat,* and *Ehud and Eglon* all were born from an 1863 commission for illustrations to the Dalziel Brothers' Bible (not published until 1881). Thus Brown's religious works of the 1860s first arose from the demands of patrons, not his own inclinations. And although Brown diligently worked them up in a variety of media over many years, the Bible, or religion, or Christianity was apparently not of overwhelming interest to him. He replied to his patron Frederick Craven around 1869, "I can't say there is any passage in the life of Christ that particularly sets my imagination going."[104]

Of Brown's later religious images, outside of the Cromwell pictures, only two are major paintings, *The Baptism of Edwin* (1879–80; Fig. 72) and *The Trial of Wycliffe* (1886; Fig. 79), both part of the Manchester Town Hall mural series.[105] The *Baptism of Edwin,* which harks back to William Dyce's *Baptism of Saint Ethelbert* (1845–49) in the House of Lords, as well as to Brown's own stained-glass design for *The Baptism of Saint Oswald* (1864–65; Saint Oswald's, Durham; Fig. 47), is hardly a celebration of Christian faith.[106] In his written description of the Edwin mural, Brown made evident that the only reason the Northumbrian ruler converted to Christianity was to meet the demands of his Christian wife, Ethelberga. And even then, Edwin did not convert until six years after the marriage.[107] Christianity is spread, so it seems, by nagging wives.

The Trial of Wycliffe is not much more ennobling as a religious expression. The hero

of Brown's earlier Wycliffe subject (Color Plate I, Fig. 17) now, at the end of Brown's career, is a defendant on the witness stand who says absolutely nothing. In Brown's words, the trial "was little less than an unseemly dispute between John of Gaunt the sovereign of Lancashire, on the one hand, the Courteney Bishop of London on the other, till the citizens of London, fancying they heard the Duke threatening their bishop: 'to pull him out of the church by the hair of his head,' began such a riot that the trial had perforce to be postponed, and Wyclif was suffered to resume his duties at Lutterworth."[108] Even as a Protestant icon, the *Trial of Wycliffe* does not speak of principle or dignity.

Brown's religious expressions, now Catholic, now Protestant, touched by comedy, compromise, and worldly meanings, often developed from patrons' demands, and at the end of his career downright unspiritual, indicate that religion was probably not the driving force of his art. Brown was just too inconsistent. If Brown's negativism derives in part from some social concern, religion is an unlikely candidate.

His view of women is much more consistent and forceful. But are those great dames truly representative of social issues? Or are they part of the private anxieties of the artist? The latter is more probable. Brown undoubtedly was nationalistically concerned, involved with the character and state of his nation. Yet he declared his distaste for English hypocrisy and injustice. Was the perceived gap between an ideal England and plain English reality enough to fuel Brown's deep-seated dissatisfaction? His intense feelings for the powerless English working class would seem a likely source of Brown's discontent. The wrong people have power. But even here, Brown's most forceful efforts speak not of victimization, but of the glory of lower-class man.

In the end, artistic aims seem of greater importance than all Brown's festering social concerns. After 1848, the desire to break down established order was primarily a realist goal. And Brown's most powerful tool in satisfying that desire was comedy. To laugh at serious subjects and dignitaries is to dim their ideal light. One sees the world in all its humdrum reality when the regalia has been dirtied. The problem is that comedians themselves are rarely taken seriously. Brown may even have employed marginal comedy to prevent his art from losing seriousness, to ensure that his main subjects were not wholly destroyed. But all those turkeys and pigs and chickens and mice and brats and cabbages and grass-gathering maids and tripping Vikings and absentminded farmers and fleeing inventors and missteps on the ladder ultimately take their toll. Brown's art is such a laughable riot that the dignity of his own productions does indeed come into question.

Comedy is an essential part of Brown's realism. He may not have known what reality looked like (I certainly don't). But Brown evidently believed that comically tearing down the facades of authority would reveal it. He may have discovered nothing. Truth, as Ibsen's Peer Gynt remarked, is perhaps nothing but a heartless onion: when you peel off one skin, there's nothing underneath but another skin. Nevertheless, as Brown relentlessly skinned, sliced, and chopped that onion of reality throughout his career, he produced great comedy—without tears.

Chronology of Ford Madox Brown's Life

1821 Ford Madox Brown born Calais, 16 April. Father: Ford Brown, retired ship's purser. Mother: Caroline Madox (married 1818). Sister: Eliza Coffin, born 1819. Family moves about in northern France several times in FMB's early years.

1825 Family resides in Dunkirk briefly.

1834 Ford Brown Sr. suffers stroke. Family resides in Dunkirk.

1835 Studies at Bruges Academy of Art (arrives in Bruges in November). Teacher: Albert Gregorious.

1836 Studies at Ghent Academy of Art (arrives in Ghent in autumn, joined by family). Teacher: Pieter van Hanselaer.

1838 Studies at Antwerp Academy of Art (FMB's parents go to England). Teacher: Gustave Wappers.

1839 FMB's mother returns to Calais, dies September. FMB attends funeral in Calais. He and sister, by terms of parents' marriage contract of 1818, inherit mother's share of Madox family's income-producing properties in England. FMB's father and sister join him in Antwerp. FMB travels to Luxembourg to paint Dembinsky family portraits.

1840 Elisabeth Bromley (FMB's mother's niece) stays with Brown family in Antwerp, after finishing school in Germany. FMB travels briefly to England to paint members of Bromley family. FMB's sister, Eliza, dies (June); her inheritance passes to FMB. Exhibits *The Giaour's Confession* at Royal Academy, London.

1841 To England (Kent) with Elisabeth Bromley; they are married at Meopham parish church 3 April. The couple moves to Paris in the summer, with Ford Brown Sr.

1842 FMB's father makes will. Child born to Elisabeth (dies within a year). Ford Brown Sr. dies November. Exhibits *Execution of Mary Queen of Scots* at Paris Salon.

1843 (Emma) Lucy Brown born to Elisabeth, July. FMB visited in Paris by William Etty (Royal Academician). Prepares submissions for Parliament fresco competition.

1844 To England, with Bromley family at Meopham, Kent. Prepares sketch of *Ascension* for Bermondsey altarpiece competition. In November FMB alone moves to studio at Tudor Lodge, London, to prepare Parliament submissions. Fellow inhabitants at Tudor Lodge include Edward Armitage, Frank Howard, Douglas Jerold, John Marshall, John Tenniel, William Cave Thomas, Charles Lucy. *Adam and Eve* and *Body of Harold Brought Before William the Conqueror* exhibited at Parliament fresco competition, Westminster Hall.

1845 Elisabeth is ill. In August, the Brown family sets off for Rome, via Ostend, Antwerp, Aachen, Cologne, Basel. By 15 September in Milan. End of September in Florence. Arrive Rome 3 October. FMB visits Peter Cornelius and Friedrich Overbeck in Rome. Works on *Seeds and Fruits of English Poetry*. Elisabeth becomes more ill. *Spirit of Justice* exhibited at Parliament fresco competition, Westminster Hall. *Parisina* exhibited at British Institution, London.

1846 Brown family leaves Rome for England in May, via Civitavecchia, Marseilles, Lyons, Paris. Elisabeth dies in Paris, 5 June (age 27). FMB goes on to England, and buries Elisabeth there. Daughter Lucy is placed with Helen Bromley at Gravesend. FMB and Lucy take short holiday at Southend. In autumn, FMB stays at various places in London, including Cheapside and Blackheath, mostly with members of Elisabeth's family.

1847 Lives in Kensington for short while. Returns to Tudor Lodge briefly. Moves to studio in Clipstone Street, Bloomsbury, in August. Visits Gravesend, Hampton Court, Oxford. Begins diary (September) *Oure Ladye of Saturday Night* rejected by Royal Academy, London.

1848 D. G. Rossetti introduces himself to FMB and asks to be his pupil (March). Rossetti given several lessons in May and June. In July, FMB visits Paris (retrieves some property, sees painter friend from Antwerp Academy, Daniel Casey). Returns to Clipstone Street in August. Meets William Holman Hunt in August. In September, visits Lake District with Charles Lucy; returns to London via Liverpool and Birmingham. Pre-Raphaelite Brotherhood formed in London (Brown not a member). Publishes two articles on early Italian art in *The Builder* (November and December). Meets model Emma Hill (who later becomes Mrs. Brown). *Wycliffe Reading His Translation of the Bible* exhibited at Free Exhibition, London.

1849 Trip to Shorn Ridgeway (July). Emma living in Hendon or Highgate (and probably working as a servant). Holiday in Ramsgate with Emma (September). In December, moves to 17 Newman Street, London. *Windermere* rejected by Royal Academy, London. *Lear and Cordelia* exhibited at Free Exhibition, London.

1850 Undertakes two commissions from Dickinson Bros. (Robert and Lowes), print-sellers, New Bond Street. Publishes etching, poem, and essay on history painting in *The Germ*, the Pre-Raphaelite magazine. Catherine Emily Brown born to Emma (November).

1851 Takes lease on cottage in Stockwell (June); keeps on Newman Street studio. In June, takes walking tour in Isle of Wight with Holman Hunt and Mark Anthony, a landscape painter. In November, visits Worcester Park Farm, Ewell, where Hunt and John Everett Millais (a Pre-Raphaelite Brother) are painting; learns their technique of painting on a wet white ground. *Chaucer* exhibited at Royal Academy, London. *Infant's Repast* exhibited at British Institution, London.

1852 Lease on Stockwell cottage expires. Emma and FMB stay at Weedington, Kentish Town (spring). Catherine Emily Brown is secretly christened at Old Saint Pancras Church (18 April; date of birth falsely given as 11 November 1851; parents recorded as

Ford and Matilda Hill). In June, takes lodgings in Hampstead (33 High Street), and abandons Newman Street studio, which he had been sharing with Rossetti. Thomas Woolner, sculptor and Pre-Raphaelite Brother, leaves England for Australia in June. Emma and Cathy spend summer in Dover. FMB takes over Cave Thomas's teaching post at North London School of Drawing and Modelling (the school, established by Thomas Seddon in 1850, shuts down in 1853). Emma and Cathy live at Hendon, where Emma is probably a servant. In November Emma moves to Highgate, attends school for young ladies. *Pretty Baa-lambs* and *Jesus Washes Peter's Feet* exhibited at Royal Academy, London.

1853 FMB marries Emma Hill, Saint Dunstan in the West, Fleet Street (5 April; T. Seddon and D. G. Rossetti attend). The couple first moves to a cottage in Highgate, but then moves to Hendon. Visits Hogarth's house, Chiswick, and writes sonnets on Hogarth (July). FMB and Emma move to 1 Grove Villas, Finchley. FMB retains painting rooms in High Street, Hampstead. *Waiting* exhibited at Royal Academy, London, and at Manchester. *Seeds and Fruits of English Poetry* exhibited at Liverpool.

1854 FMB auctions his works for very low prices in London (July; T. Seddon buys two of his major paintings). FMB and Emma visit Saint Albans (August). FMB begins to sell works to D. T. White ("Old White"), a dealer, 28 Maddox Street, London. Rossetti stays with Browns at 1 Grove Villas (October–December).

1855 Oliver Madox Brown born (20 January). FMB tries to mortgage his property at Ravensborne wharf (eventually gets loan of £500 from Madox family). FMB tries to get teaching job with Government School of Design (rejected by Director Henry Cole). FMB thinks of emigrating to India. Emma drinking heavily. Unpleasant meeting with Ruskin (13 July). In September, FMB and Emma move to 13 Fortress Terrace, Kentish Town (where they stay until 1865). Lucy Brown (who had been in the school run by Helen Bromley at Gravesend), is sent to a school run by Maria Rossetti. FMB gives drawing lessons to daughters of Sir Robert Slade. *Waiting* and *Chaucer* exhibited at Exposition Universelle, Paris. *An English Autumn Afternoon* exhibited at British Institution, London.

1856 FMB adds costumes and backgrounds to paintings based on Calotype photographs produced by the Dickinson Bros. Meets William Morris, who buys *The Hayfield*. Meets Liverpool collector John Miller, who introduces FMB to painter William Davis. Miller buys *Waiting*. FMB visits Huntingdonshire to get material for his Cromwell picture (July). *Jesus Washes Peter's Feet* gains £50 prize at Liverpool Academy (September). In September, Arthur Gabriel Madox Brown born to Emma. FMB meets Thomas Plint, a Leeds collector introduced by Rossetti; Plint commissions FMB to carry out *Work* for £400. Exhibits *Parting of Cordelia and Her Sisters*, *Waiting*, *Last of England*, and *Jesus Washes Peter's Feet* at Liverpool.

1857 FMB organizes meeting to raise funds for widow of Thomas Seddon. Funds are raised to buy Seddon's *Jerusalem from the Valley of Jehosephat* for National Gallery. For an exhibition of Seddon's works, FMB completes Seddon's *Penelope*. FMB helps organize exhibition of Pre-Raphaelite works at 4 Russell Place, Fitzroy Square, London (opens June; at least nine works by FMB included). Arthur Gabriel Madox Brown dies July.

FMB helps organize an American exhibition of Pre-Raphaelite paintings (along with works owned by London dealer Ernest Gambart), which opens in New York in October. *Lear and Cordelia, Oure Ladye of Saturday Night* and *An English Autumn Afternoon* are included in the American show. FMB visits Rossetti, Morris, and others at Oxford, where they are painting Arthurian murals in the debating hall. *Jesus Washes Peter's Feet* and *Hayfield* exhibited at Manchester Art Treasures Exhibition.

1858 Hogarth Club established (rooms leased at 178 Piccadilly in July), FMB takes leading role in the organization. Meets Major William Gillum, and designs badge for Boys' Home, Euston Road, an orphanage founded by Gillum. Exhibits at Hogarth Club. Teaches at Working Men's College, London (through 1860). *Chaucer* wins £50 prize at Liverpool Academy.

1859 Two exhibitions held at Hogarth Club. At the second one, FMB's furniture designs are rejected by hanging committee, and FMB removes all his works from the exhibition. Meets James Leathart of Newcastle, who commissions replica of *Work*, and buys *Pretty Baa-lambs*. Participates in Artists' Rifles Corps to prepare for French invasion (active into 1860).

1860 Plint agrees to new terms for the completion of *Work*. Brown instated as chairman of Hogarth club. *Walton-on-the-Naze, English Boy,* and *Irish Girl* exhibited at Liverpool Academy.

1861 Hogarth club disbanded. Morris, Marshall and Faulkner decorating company established (FMB one of the founding members). FMB gives advice on painting to William Morris. John Seddon cabinet decorated with King René paintings by FMB and other members of Morris firm.

1862 Morris firm exhibits at London International Exhibition with success. Many of the stained-glass commissions for the firm (until 1875) are carried out by FMB. Exhibits *Last of England, An English Autumn Afternoon,* and bookcase with illustrated panels at International Exhibition, London.

1863 Dalziel Bros. commission Bible illustrations (finally published as *Dalziel's Bible Gallery* in 1881).

1864 George Rae and John Hamilton Trist commission works from FMB. Marie Spartali becomes FMB's student (until 1871). Trip to Southend (summer). Meets Manchester painter Frederic Shields.

1865 FMB's self-organized one-man show, with substantial catalogue, held at 191 Piccadilly (opens 10 March; receives generally good reviews; *Work* is the centerpiece). Frederick Craven, Frederick Leyland, and William Graham become patrons of FMB. Moves to 37 Fitzroy Square, London (holds lively dinner parties there in succeeding years; guests include J. A. M. Whistler). Diary entries (abandoned in 1858) resume. Emma drinking heavily. Summer trip to Yarmouth.

1866 Summer trip to Lynemouth. Exhibits *Jacob and Joseph's Coat* at Ernest Gambart's French Gallery, London.

1867 Charles Augustus Howell helps sell some of FMB's works (and continues to act as a

dealer for FMB in succeeding years). Makes illustrations for *Lyra Germanica,* a collection of German hymns. Visit to Calais with Emma. *Cordelia's Portion* exhibited at Dudley Gallery, London.

1868 *Work* and *Jacob and Joseph's Coat* exhibited at Leeds.

1869 Commissioned to illustrate Byron for Moxon series of British poets (editor of series: W. M. Rossetti).

1871 Meets revolutionary socialist Karl Blind and his adopted daughter, Mathilde, who come to London after failure of Paris Commune.

1872 Catherine Brown marries *The Times* music critic, Franz Hueffer. Sir Charles Dilke commissions FMB to paint Henry Fawcett, MP and Mrs. Fawcett. FMB accompanies distraught Rossetti to Perthshire home of William Graham (June). FMB tries to become Slade Professor at Cambridge (writes address to vice-chancellor of the university).

1873 Emma is ill. FMB visits Rossetti at Kelmscott Manor, Gloucester, Morris's country home (June). *Cromwell* commissioned by Albert Brockbank of Manchester. Birth of Ford Madox Hueffer.

1874 Lucy Brown marries William Michael Rossetti. Emma ill. FMB suffering from gout (a recurrent malady in subsequent years). Oliver Madox Brown dies (5 November). Morris, Marshall and Faulkner reorganize, and remove FMB from the firm. FMB bitter during negotiations (that run into 1875). FMB is represented in his dispute with Morris by Theodore Watts-Dunton. Summer trip to Margate. Gives lecturers in Birmingham.

1875 Visits Antwerp and Brussels to paint background for *Rubens' Ride* (never completed). Etches portraits of Oliver Maddox Brown for the latter's unfinished novel. *Dwale Bluth.* Gives lectures at Manchester, Edinburgh, Newcastle.

1877 FMB and Frederic Shields propose mural scheme for Manchester Town Hall (the committee in charge of the decorations had previously considered hiring Belgian painters for the project). Visits Antwerp to study Henry Leys's murals in the Hôtel de Ville. Visits Thomas Gambier-Parry in Gloucester to learn his wax-and-spirit mural-painting process. Gambier-Parry's technique recommended to FMB by architect G. E. Street. Cares for Rossetti at Herne Bay.

1878 FMB and Shields commissioned to paint twelve murals in Great Hall of Manchester Town Hall. Brief trip to Paris with Emma and W. M. Rossetti (November).

1879 To Manchester in April to paint murals in situ (stays with Charles Rowley, friend and member of the committee supervising the murals). Returns to London in September.

1880 Moves to Manchester (first in Grafton Street, then Marshall Place, Cheetham Hill). Emma drinking heavily. Holiday in Peak District (June). Mathilde Blind moves to York Place, Manchester (and frequently visited by FMB). FMB champions Mathilde Blind's literary productions.

1881 Designs murals in London (spring). Delivers paper on Gambier-Parry painting process

at Royal Institute of British Architects, London (May). Sells lease of Fitzroy Square house. Moves to new Manchester suburb of Crumpsall.

1882 Rossetti dies. FMB designs Rossetti tomb at Birchington, Kent, and monument on Cheyne Walk. London. FMB suffering from gout, stays with Mathilde Blind in her new Hampstead home. Gives lecture on aesthetics to working men at Ancoats (a lecture series organized by C. Rowley).

1883 Shields officially relinquishes his share of Manchester mural project (he was originally to carry out six murals). Committee delays giving Shields's commission to FMB, but finally agrees to do so in December. C. P. Scott, editor of *Manchester Guardian,* becomes FMB patron. FMB advises Scott on decoration of Manchester City Art Gallery. FMB elected associate of Manchester Academy of Arts. Moves to Addison Gardens, Victoria Park, Manchester.

1884 Morris gives Ancoats lecture (FMB does not attend). Morris visits FMB's Town Hall murals.

1885 Friendship of Morris and FMB renewed (after 1874 break). Morris visits FMB in Manchester.

1886 Morris visits FMB in Manchester again. FMB visits workman-agitator Joe Waddington in Manchester, and hires him to work as handyman and cabinetmaker. FMB helps organize labor bureau in Manchester to assist the unemployed find work. With seven assistants, starts work on decorations for 1887 Manchester Jubilee Exhibition. Invited by Walter Crane to join proposed Arts and Crafts Exhibition Society (FMB declines).

1887 Manchester Jubilee Exhibition decorations installed. FMB's furniture designs exhibited with those of A. H. Mackmurdo at the exhibit. Henry Boddington becomes FMB patron (and eventually buys many of FMB's retouched early paintings). Moves to London, 1 Saint Edmund's Terrace (near friends Richard and Olivia Garnett). Mackmurdo helps with the decoration of the new home.

1888 Publishes "Historic Art" in *Universal Review* and "The Progress of English Art Not Shown at the Manchester Exhibition" in *Magazine of Art.* Visits Boddington at Pownall Hall, Cheshire. Lucy Brown Rossetti ill with tuberculosis. Joins and exhibits furniture at Arts and Crafts Exhibition Society, London.

1889 Publishes "Self-painted Pictures" in *Magazine of Art.* Franz Hueffer dies (January).

1890 Publishes "Our National Gallery" in *Magazine of Art.* Emma dies (11 October) Catherine Brown Hueffer and her children (Ford Madox and Juliet) move in with FMB. William and Lucy Rossetti (and children) move next door to FMB (3 Saint Edmund's Terrace). Exhibits *Baptism of Edwin* (a Manchester mural subject) and etching at Arts and Crafts Exhibition Society, London.

1891 Harry Quilter article depicting FMB as poor and forgotten appears in *Universal Review* (autumn). Edward Burne-Jones, F. G. Stephens, and Frederic Shields launch fund to raise £1000 to buy FMB painting for National Gallery. *Stages of Cruelty* exhibited at Liverpool and Birmingham.

1892 Manchester committee displeased with *Bridgewater Canal* mural, and demands right of inspection before acceptance henceforth. Jones-Stephens-Shields fund for FMB noted in *Pall Mall Gazette,* and FMB is outraged. Burne-Jones calms FMB. FMB accepts commission from the fund to paint replica of Manchester mural *Trial of Wycliffe* (never completed; fund posthumously purchased *Jesus Washes Peter's Feet* for National Gallery). Attends Lord Mayor's banquet in honor of art and literature. Designs sets for Henry Irving's production of *King Lear* at Lyceum Theatre, London.

1893 Publishes "On Mural Painting" in *Arts and Crafts Essays.* Suffers stroke (paints thereafter with left hand). FMB refuses to allow Manchester committee to inspect *Bradshaw's Defence.* Takes back the mural and threatens to sell it to private collector, but the committee finally accepts the mural. FMB dies 6 October. Funeral without Christian ceremony. Buried in Saint Pancras Cemetery.

Chronology of Ford Madox Brown's Works

The chronology includes major paintings, drawings, and stained-glass designs. Because Brown frequently painted and retouched works over long periods, and produced replicas and other versions of many of his works in several media, the dates given below are the years when the subjects were begun. Alternative titles are in parentheses. Glass designs are accompanied by the site they were first intended for, and those glass designs that were also carried out in other media are in boldface italic.

1836 *Head of Flemish Fish Wife*
 Study of a Pony (Major Freulich's Horse)
 Fisher Boy
 Showing the Way

1837 *Blind Beggar with Child*
 Friday of the Poor
 Job Among the Ashes
 F. H. S. Pendleton
 Flamand voyant passer le Duc d'Albe

1838 *Colonel Kirk*

1839 *Giaour's Confession*

1840 *Execution of Mary Queen of Scots*
 Manfred on the Jungfrau
 Manfred in the Chamois Hunter's Hut
 Bromley Family portraits
 Dr. Primrose and His Daughters (scene from *Vicar of Wakefield*)

1842 *Adam and Eve*
 Parisina's Sleep

1843 *Body of Harold Brought Before William the Conqueror*
 Prisoner of Chillon (1st version)
 Out of Town
 Head of Baby
 Mr. James Fuller Madox

1844 *Spirit of Justice*
 Ascension
 Portrait of Bromley Family
 King Lear drawings
 Portrait of Lucy Madox Brown

1845 *Chaucer at the Court of Edward III (Seeds and Fruits of English Poetry)*
 Portrait of Elisabeth Madox Brown
 Portrait of Lucy Madox Brown

1846 *Mr. James Bamford*
 Southend
 Seraph's Watch
 Millie Smith
 Two Views of Millie Smith (Two Studies of a Little Girl)
 Portrait of a Boy

1847 *Oure Ladye of Saturday Night (Oure Lady of Good Children)*
 Wycliffe Reading His Translation of the Bible to John of Gaunt

1848 *Lear and Cordelia*
 Windermere
 Infant's Repast (Young Mother)
 Portrait of Richard Bromley's Little Girl

1849 *Shakespeare*
 Lord Jesus
 View from Shorn Ridgeway
 Beauty Before She Became Acquainted with the Beast
 Portrait of a Baby
 Mr. Thomas Seddon, Sr.
 Mrs. Thomas Seddon, Sr.

1851 *Pretty Baa-lambs (Summer Heat)*
 Waiting (An English Fireside in the Winter of 1854–55)
 Take Your Son, Sir!
 Jesus Washes Peter's Feet

1852 *An English Autumn Afternoon*
 Work (Workers and Idlers)
 Last of England

1853 *Cromwell on His Farm (Saint Ives, An. Dom. 1636;*
 Saint Ives, An. Dom. 1635)

1854 *Carrying Corn*
 Brent at Hendon

1855 *Hayfield*

1856 *Stages of Cruelty*
 William Michael Rossetti by Lamplight
 Prisoner of Chillon (2d version)

1857 *Hampstead from My Window*
 Transfiguration (glass design)

1859 *Walton-on-the-Naze*

1860 *English Boy*
 Irish Girl

1861 *King René's Honeymoon*
 Les Huguenots (At the Opera)

1862 *Miss Louie Jones*
 Death of Sir Tristram (glass design for Harden Grange, Bradford)
 Saint Michael, Saint Uriel (glass designs for Saint Michael's, Brighton)
 Christ and Little Child (glass design for Saint Peter's, Cranborne, Berks)
 Sowing (glass design for Vicarage, Onecote, Staffs)
 Adam and Eve; Gideon (glass designs for Saint Martin's-on-the-Hill, Scarborough)
 Christ on Cross; Nativity (glass designs for All Saints, Selsey, Gloucester)
 Saint Mark (glass design for Christ Church, Southgate)

1863 *Writing Lesson (Mauvais Sujet)*
 James Leathart
 Abraham and Isaac; Saint Elizabeth; Isaac; Saint John the Evangelist; Saint Matthew;
 Saint Paul (glass designs for Bradford Cathedral)

1864 *Toothless*
 Myosotis
 Dalziel Bible Illustrations: *Jacob and Joseph's Coat; Elijah and the Widow's Son;*
 Ehud and Eglon
 Legend of Saint Oswald (glass designs for Saint Oswald's, Durham)
 Saint Andrew (glass design for Bradford Cathedral)
 Alfred; Charlemagne; Constantine; Ethelbert; Saint Helena; Saint Louis (glass designs
 for Saint Edward the Confessor, Cheddleton, Staffordshire)
 Saint Simon (glass design for Saint Stephen's Parish Church, Guernsey)
 Adam and Noah (glass design for All Saints, Middleton Cheney, Northamptonshire)
 Saint Martin Cutting His Cloak; Saint Martin in Heaven (glass designs for Saint
 Martin's-on-the-Hill, Scarborough)
 Christ Walking on Water; Christ Watching Disciples in Storm (glass designs for Saint
 Mary and All Saints, Sculthorpe, Norfolk)

1865 *Nosegay*
 Legend of Saint Oswald (glass designs for Saint Oswald's, Durham [cont.])
 Entombment (glass design for Saint Olave, Gatcombe, Isle of Wight)
 Virgin and Child (glass design for Saint Mary's, Wolverton, Warwickshire)

1866 *Cordelia's Portion*
 Sacrifice of Cain and Abel; Sacrifice of Zacharias (glass designs for Saint Edward the
 Confessor, Cheddleton, Staffordshire)
 David and Goliath (glass design for Townhead Blochairn Parish Church, Glasgow)
 Saint Wilfrid (glass design for Saint Wilfrid's, Hayward's Heath, Sussex)
 Melchisedek Blessing Abraham (glass design for All Saints, Middleton Cheney,
 Northamptonshire)

1867 *Romeo and Juliet*
 The Traveller

1868 *Nehemiah* (glass design for Saint John the Evangelist, Tuebroook, Liverpool)
 Saint Anne (glass design for All Saints, Middleton Cheney, Northamptonshire)

1869 *May Memories*
 Mrs. Ford Madox Brown
 Marie Spartali at Her Easel
 Illustrations for Moxon Byron:
 Jacopo Foscari in Prison
 Don Juan Found by Haidée
 Dream of Sardanapalus
 Childe Harold
 Corsair's Return
 Byron's Dream
 Hugo de Balsham; Edward I (glass designs for Peterhouse, Cambridge)
 Good Shepherd (glass design for Saint James the Greater, Flockton, Yorkshire)
 Saint Luke (glass design for Saint Ladoca, Ladock, Cornwall)
 Expulsion of Adam and Eve; Finding of Moses; Moses and Burning Bush; Samuel and Eli (glass designs for Holy Trinity, Meole Brace, Shropshire)
 Liberation of Saint Peter (glass design for Saint Peter's, Stepney, London Docks)

1870 *Aristotle; Francis Bacon; Roger Bacon; Cicero; Eleanor; Homer; Newton* (glass designs for Peterhouse, Cambridge)
 Christ's Charge to Saint Peter (glass design for Saint Peter's, Stepney, London Docks)
 Saint Andrew (glass design for Savoy Chapel, Westminster, London)

1871 *Down Stream*
 Phryne Sitting to Apelles
 Hugo de Balsham; John Cosin; Edward I; Saint Ethelreda; John Whitgift (glass designs for Peterhouse, Cambridge)
 Saint Thomas (glass design for Saint Saviour, Leeds)
 Supper at Emmaus (glass design for Church of Jesus, Troutbeck, Westmorland)

1872 *The Convalescent*
 Henry Fawcett and Wife
 Iza Hardy
 Agony in Garden; Christ Scourged; David and Goliath; Solomon Building the Temple (glass designs for Jesus College, Cambridge)
 Cardinal Beaufort; Cavendish; Richard Crashaw; Chancellor Holbrook; Milton; Spenser; John Warkworth (glass designs for Peterhouse, Cambridge)
 Sacrifice of Abraham; Brazen Serpent; Christ Bearing Cross (glass designs for Holy Cross, Haltwhistle, Northumberland)
 Elkanah; Hannah; Zacharias (glass designs for Saint John Baptist, Knareborough, Yorkshire)
 Saint Philip (glass design for Saint Michael and All Saints, Waterford, Hertfordshire)

1873 *Portrait of Mr. and Mrs. David Davies*
 Legend of Saint Editha (glass designs for Saint Editha, Tamworth, Staffordshire)
 Thomas Gray (glass design for Peterhouse, Cambridge)

Elizabeth Woodville; Queen Margaret (glass designs for Queens College, Cambridge)
Anna Prophesying; Simeon (glass designs for Saint John Baptist, Knaresborough, Yorkshire)
Milton (glass design for "Cragside," Rothburg, Northumberland)
Christ Healing Woman with an Issue of Blood (glass design for Chapel of Saint Luke, Royal National Hospital, Ventnor, Isle of Wight)

1874 *Portrait of J. O. Riches*
Portrait of A. Allott
Oliver Madox Brown on Deathbed
Dorcas (glass design for Holy Trinity, Habergham Eaves, Burnley, Lancashire)
Christ and Saint Mary Magdalene; Incredulity of Saint Thomas (glass designs for Jesus College, Cambridge)
Lord Grafton (glass design for Peterhouse, Cambridge)
Saint Jude; Miraculous Draught of Fishes; Saint Paul Shipwrecked; Saint Simon (glass designs for Llandaff Cathedral, Glamorgan)

1875 *Surrey and His Mistress*
Rubens' Ride
John Brown Rescuing Negro Slaves

1876 *La Rose de l'infante (Child with Rose)*
Portrait of Miss Blind
Portrait of Mrs. W. M. Rossetti and Daughter

1877 *Self-Portrait*
Cromwell, Protector of the Vaudois
William Tell's Son

1878 *Baptism of Edwin* (mural completed 1880)
Shakespeare; Michelangelo; Beethoven; Joan of Arc (cartoons never translated into stained glass)

1879 *Romans Building a Fort at Mancenion* (mural completed 1880)

1880 *Expulsion of Danes from Manchester* (mural completed 1881)

1881 *The Establishment of Flemish Weavers in Manchester* (mural completed 1882)
Crabtree Watching the Transit of Venus (mural completed 1883)
Proclamation Regarding Weights and Measures (mural completed 1884)
Head of Mrs. Pyne
Head of Mrs. Robinson

1883 *Madeline Scott*

1884 *Platt Lane*
Head of Juliet Hueffer
Head of Mary Rossetti

1885 *Chetham's Life Dream* (mural completed in 1886)
Trial of Wycliffe (mural completed in 1886)

Portrait of Charles Rowley
Ford Madox Hueffer

1886 *John Dalton Collecting Marsh-Fire Gas* (mural completed 1887)
 Decorations for Manchester Jubilee Exhibition: *Farrier, Merchant, Fisherman, Collier,*
 Sheep Shearer, Spinner, Harvester, Weaver, Trumpet-blowing Angels

1887 *Lady Rivers and Her Children*

1888 *Boddington Family Group*
 John Kay, Inventor of the Fly-Shuttle (mural completed 1890)

1889 Illustrations to F. M. Hueffer, "The Brown Owl"

1890 *Opening of the Bridgewater Canal* (mural completed 1892)

1891 Frontispiece to Mathilde Blind, "Dramas in Miniature"

1893 *Bradshaw's Defence of Manchester* (mural completed 1893)

Appendix 1

[Ford Madox Brown] "Modern v. Ancient Art," *The Builder* (4 November 1848): 530–31.

Sir, —As a second letter, signed "Amateur," has appeared in your journal, directed against the papers of Mr. Cave Thomas on the fine arts, I feel it a duty to attempt a refutation of it (in the shape of argument, if possible); but I confess, at starting, that to do so appears a task of no small difficulty, as, to refute the letter *in toto,* would be to denounce both parties, while to disentangle each ramification of error would be a wearisome task.

In his second letter, "Amateur" starts with triumphantly drawing a comparison between the National Gallery and the exhibition of the Royal Academy adjoining. He does not, however, on this occasion, make any display of aesthetic reasoning, but is content to refer the decision to "any unprejudiced critic." I have been myself, this year, more than once to the National Gallery, to admire the "Bacchus and Ariadne" of Titian, and the "Julius II." of Raffaelle, or that which is a copy of it, and so at present will not contest the point with him, but will simply remind him that, whereas the old gallery is formed of a selection from the best masters of every school ranging over a period of three centuries, the modern exhibition consists of works by artists of nearly every grade of *one* country, and the produce of *one* year! "Amateur" next satisfies himself that, because Mr. Thomas does not deny the merit of certain great masters, therefore his only objection is to the money that they cost. It may appear hard to reconcile this assumption with the fact that more than a third of that gentleman's papers is taken up in advocating the theorem, that "art cannot be founded on art," —a principle which he insists on for reasons unconnected with the economy of the question; but this "Amateur" seems to forget, although his letter is in refutation of it.

He next proceeds to consider the patronage bestowed on modern pictures in this country, and becomes slightly more consistent. From the fact of the "Distraining for Rent" of Sir David Wilkie having recently fetched 1,200 £, and a painting the work of an artist under the age of two-and-twenty having been purchased for 400 £, he infers that patronage in this country is perfectly adequate to the production of any style of art that may most do honour to it. I should be sorry to deny that considerable sums are expended every year on pictures, —unless there were, I very much doubt that there would be artists to paint them, —but I would caution "Amateur" against hastily drawing inferences from facts the result of individual experience, and would advise him, if he wishes to arrive at the truth, to make inquiries respecting the amount of Government patronage bestowed yearly upon art in countries where, like France and Germany, historical painting flourishes, and then to compare it with the amount which, at a fair calculation, may appear to be expended on pictures in this country, —which, I maintain, would not, *altogether,* stand comparison with the Government patronage of the King of Bavaria. In France, the annual sum expended on the fine arts by the central Government has been for many years 40,000 £, —which, if added to municipal patronage, would more than double the sum. Would "Amateur" venture to continue the comparison? Does "Amateur" believe that if the money of the King of Bavaria had been expended on old paintings, that little

country could now boast more than any other of a race of historical painters? Does he believe that if the 4,000 £ or 5,000 £ be given in premiums at Westminster Hall had been laid out on a Correggio, it would have been attended with a like result? Does he think that if 30,000 £, which, within the last two months has been spent on old paintings at two sales, had been employed on the decoration of the many architectural works springing up around us, it would have been attended with no beneficial effect? Does he hold up to us the knowledge derived from experience, and would he deny it in this particular instance? Let him turn to the life of Lorenzo the Magnificent, and read the answer of that great man to those who told him that there were no artists capable of carrying out the works he proposed—"We have money enough to make them." Lorenzo was a merchant, but "Amateur" tells us that "commerce has but little affinity with the higher aspirations of art."

I cannot make use of many individual cases strongly illustrative of the impossibility of carrying on historical painting in this country, being debarred from that species of evidence, so I will hastily glance at two or three more of our opponent's inconsistencies. He regrets the trifling nature of modern works, and wishes for the importation of Tintoret's large painting, apparently that we may be induced to do the like, yet he confesses that he would *not* advocate the introduction of such works into churches, the very nature of which patronage gave birth to them! He next laments what he calls "the drawing-room taste for finikin pictures," as if one of Mr. Thomas's stanchest supporters. He grieves that an eminent artist should employ his time upon dogs, lions, and parrots, after having produced two such pictures as—one would think he was going to mention a "Last Judgment" and a "Last Supper," but no—"The Shepherd's Grave" and "The Shepherd's Chief Mourner"—two dogs! We advert to this curious piece of logic without intending the least disrespect to the very popular artist in question.

Perhaps of all that "Amateur" has said which tends to strengthen Mr. Thomas's case, there is nothing more striking than his lamentations over the decline of the taste for ancient art; this has been a fact known and understood for some time by every one awake to the rising taste for art in this country, and is alone sufficient to render unnecessary Mr. Thomas's efforts to hasten it, and unavailing his opponents to retard it.

I must now make a few remarks bearing on "Amateur's" taste and knowledge in matters of art. After assuring him that I have heard of such a name as Tintoret, I must inform him that it is not customary at this period to praise at one breath masters such as Fra Angelico, Perugino, and the Bellini; and then again, Tintoret, Guido, and the Caracci; it is not at present customary to express equal pleasure at the guileless inexperience of the one school and the pedantic incapacity of the other; neither is it common at this moment to hear historical painters mention Domenichino and the eclectic school as if their efforts were either to be admired or imitated; it is not prudent to make such a display about Tintoret merely because a graduate of Oxford has lately made a great fuss about him, while the men of most note throughout Europe show nothing but indifference towards him.

Opinions have altered, and become more matured since the days of Sir Joshua Reynolds. Diligent inquiry in London would show that there is no longer any fear of Fuseli being mistaken for a Michelangelo, and at Munich he might learn that Overbeck did not study Raffaelle; that he was one of four young men who sought to attain a like perfection by following the footsteps of that great master and his contemporaries, for which purpose they reverted to his predecessors, because in their less sophisticated works they found a powerful antidote to the false taste and pseudo classical style then every where prevalent; when having accomplished this object, they abandoned the study of those imperfect though truthful masters, and have

since relied solely on nature and the emulation derived from cotemporary efforts: for a better explanation of which see "Hand Book for Painting in Italy," edited by Eastlake. If the Bavarian painters still borrow any thing from the Italian, it is merely the external characteristics which they consider belong by precedent to Christian art, which they are chiefly employed upon, not the artistic qualities; but as no one will affirm that there is any request for that style of art in this country, or that antidotes are required for bringing back a taste for nature, at least with the more popular artists, so is there even less necessity for the study of any old masters than in Catholic countries where mysticism flourishes. "Amateur" quotes some lines from Sir Joshua advocating the study of the ancients: let me remark that the study of Raffaelle and Michelangelo occasioned the Caracci to leave behind them the insipid trash that has been imported into this country, while the study of nature has produced within a few years a race of artists, if not the equals of the painters of the court of Leo X., at least their equals in many things, and often their superiors: need we turn the attention to names like Lessing, Cornelius, Sheffer, Ingre, yea, and even in our own country names that we may be proud of, only one of whom, M'Clise, ought to act like a talisman, in spite of his defects. France and Germany testify their admiration for the old masters, having full-sized copies made of those works which money will not buy, such as the Last Judgement and the Stanze of Raffaelle, instead of importing doubtful Corregios and puddingy Guidos. I could, if required, point out a *few defects* among the Italian and Flemish pictures at the National Gallery; I could also point out some merits in Hogarth, who, in an age of the greatest mediocrity, studied nature unassisted. I can also revert to the trash exhibited this summer at the British Institution—but enough for the present.

In conclusion, I would add a few remarks on the third, and certainly the most startling maxim inculcated in Mr. Thomas's lectures—I mean that belief which he expresses, in the existence of rules to art which alone ought to be sufficient to it. Let me candidly state that I myself belong to the hair-brained and poetic race, that is but little disposed to submit to the shackles of self-constituted legislators, but I am not deaf to the promptings of reason and common sense; and I aver it as my belief that there are certain comprehensive rules which we all *feel* and work by, although as yet undefined; we feel these rules become more circumscribed in measure as our aspirations become higher. I know by experience that from originality to eccentricity there is but one step, one step out of the ruled circle of perfection. I believe that Shakespeare himself is great from his beauties, and that his few defects are unallied to those beauties, and consist in his having sometimes overstepped, not the rules of Aristotle, but those unyielding yet invisible rules which encompass art whatever be it object; and, in conclusion, I will say that it is of rules to art as it was of medicine, they have been so long in the hands of quacks that mankind have despaired of finding any truth in them; yet, as in medicine, they are believed in; but first we must find some one with power of mind to define them. Mr. Thomas, in his lectures, has given good proof of ability. Let us hope that having thrown down the gauntlet, he will take it up again, and that he may eventually do something towards untying this "gordian knot."

An Artist

Appendix 2

[Ford Madox Brown], "The Influence of Antiquity on the Arts of Italy," *The Builder* (2 December 1848): 580–81.

The following reflections on the influence of antiquity on the literature and arts of Italy are submitted by the writer, as appearing to offer evidence in support of objections to the study of the old Masters.

Since the days of Cosmo de Medicis, when the taste for Greek literature revived in Italy, bearing along with it the taste for Greek architecture and Greek sculpture, the records of the effects of that diversion having been handed down to us by men themselves under the influences of it, there is little reason to be surprised at historians in our own country having attributed to that account the excellence attained by the Italian nation, particularly when we reflect to what an extent the pseudo classical taste pervaded Europe a few years ago, and how at this moment the classical and mediaeval feeling is balanced in all that relates to aesthetics; the artist, however, who can appreciate the character which alike pervades Grecian and Gothic remains, and the philosopher who loves to trace the progress of a people towards maturity, may find matter in this subject for far different reflections, and while the one must lament that want of consistency which from that time forth was to characterize Italian art, the other ought to regret that so gifted a race was not suffered to work out alone that idiosyncrasy which forms the strength of nations and periods, as well as individuals, and which operated so powerfully in bringing to a glorious climax the arts of ancient Greece.

Literature, which affects more our moral qualities, and bears less on external characteristics than her sisters, the plastic arts, may be supposed to have suffered least from the admixture, nevertheless it would be easy to trace the downfall of Italian poetry from this source, although not in immediate connection with it; for, notwithstanding that the love of nature in the first instance may have enabled Lorenzo di Medicis and some few others to keep pace with the current, yet that it ultimately proved too strong is attested by the misdirected efforts of the Latin poets of the fifteenth and sixteenth centuries, to revive a literature in a language foreign to their feelings, and by the subsequent falling off of Italian poetry from all the manly and truthful qualities, which once formed its strength. Nor ought the examples of such men as Ariosto and Tasso, who, for a while, stood forth resplendent amid the symptoms of decay, to be opposed to these truths, because men, peculiarly gifted, will flourish on a system which is bane to the multitude; and we should rather inquire what talents, like those of Tasso, might have effected had he treated his great Christian epic with a truly Christian and Gothic feeling, instead of resorting to pagan imagery to illustrate his Christian incidents,—a custom then so common as to be introduced by churchmen in their discourses. The writer was lately favoured by Mr. G. Rosetti [*sic*], a son of the popular Italian poet, with some translations which he had made from the early poets before the time of Dante, wholly unknown in this country, as they are unappreciated in their own, and could not but wonder at the precocious genius of this people, exemplified in the exquisite tenderness, richness, and truth of these effusions of an age

150 years anterior to that of our Chaucer. What might such a race not have attained to, had their development been attended with less fortuitous circumstances?

Not to omit architecture (a subject to be *delicately handled* by one, not of the craft, writing to THE BUILDER), I must say that it might appear like sectarianism to complain of the change which, in this case, the love of antiquity has effected, great excellence having been arrived at in the Italian style, which in itself is well adapted to the beauty of the climate and materials there employed;[1] while, on the other hand, the mission of Gothic architecture has been fulfilled in other countries; nevertheless, if we reflect on all the instances of fulsome interpolation and idiotic restoration for which the classical style is responsible, the numbers of basilicas, churches, and other noble edifices, which have either made way for it, or still suffer from its pitiless embellishments, if we consider the ignominious results to which it ultimately led, and all the handy work of the eighteenth century, exemplified in the churches of Rome and other cities, I might be allowed to revert with displeasure to the first order which Bruneleschi received from the Medici, to build a palace in the classic style, and lament the want of harmony which must have been felt on the introduction of this forerunner of an entire change in the character of Florence, for till then everything in it was Gothic, the houses, the pageantry, the tournaments, works of art and furniture, arms, and dresses, nothing was wanting to the uniformity of feeling. But a change was preparing for the scene, the wrench was already applied to the bars and fastenings that encompassed antiquity, and the past was revealed in all its splendour! The first to appreciate, this ardent people could not rest satisfied with admiration, but emulous, they must enter the arena to strive with the past at its own games; vain struggle with phantoms which elude the grasp!

But let us hasten from this *delicate* topic of architecture to the subject of painting, and submit it to the same train of reasoning. From the period when Giotto first impressed on the childhood of art the character of true pathos and dignity, up to the decoration of the Brancacci Chapel by Masaccio and Tilippino Lippi [*sic*], the evidence of one continual state of progression is afforded the archaeologist, unimpeded, as it was unassisted, by foreign influences. As perfection was not yet attained, we may justly infer, as well from this previous improvement, as from the necessity of art having risen, at *some time,* unassisted, that progress would not have stopped with Masaccio, but that, under equal encouragement, painting would ultimately have arrived at perfection, while from the quality of excellence displayed by that master, we may also conclude that the desired period could not be very far removed.

About this time the rage for disentombing antique statues began to show itself, and their influence to be felt. Andrea Mantegna, an artist who little awakens our sympathies, had already strongly imbibed the feeling; Masaccio was never influenced by it, but several of his cotemporaries exhibit at times a feeble and even ludicrous effort to combine the drawing and costume of the old statues with designs of a very different nature. In the meantime the rage for antiquity continued to gain ground; under the pontificate of Leo X., it had reached such a height, that in the words of the historian Roscoe, "he who could bring to light an antique bust, might consider himself provided with a competency for life, while the discovery of an entire statue was deemed equivalent in value to a bishopric." This fashion, like all others which combine novelty with a love of the beautiful, took stronghold on men's minds, till it became a passion and a creed. Now, it is not to be supposed that men like Raffaelle and Michelangelo,

1. It has always struck the writer that classical buildings require sunshine to display them to advantage, whereas Gothic structures show best in gloomy weather.

would be loath to avail themselves of the impetus thus given, or the advantages it held out to them; none are so easily led as the inexperienced, and till then art had been in its childhood. What, in fact, did they want? they who, early inured to the severe study of nature, had imbibed the vital qualities of individuality and expression which can be obtained from that source alone; they who had inherited a simple and pure taste from their predecessors; they who had surpassed them; what more could they require, if not a greater perfection in drawing, and a bolder outline? This was ready prepared for them in the works of antiquity daily brought to light, and is it to be supposed that, contrary to the spirit of the times, and incapable of foretelling the consequences, they should refuse the proffered boon, the ready chance of improvement, and devote themselves laboriously to extort from nature that which apparently lay beneath their grasp? The shortest route sufficed *their* purpose; they took it. Italian art reached its highest state of development, and the causes of its decline alone remain to be considered. It may be easily understood that these great men, in their reverence for those examples by which they had been enabled to outstep all previous efforts, would forget much of the gratitude due to those who had early directed their steps in the right way, of the numerous windings by which they had ascended the eminence, they were most likely to remember the last by which they had gained the summit, their admiration for the antique is known, but they forgot how little their works evinced of the study they so affected. The pupils and followers of these two painters, although they little noted their career, hoarded their precepts, and were little loath to carry them out: their masters had achieved what appeared to them perfection by the study of the antique, *they* would study the antique and their masters, —it was more expeditious than the study of nature, and each man by these means would become a Michelangelo: thus was the study of nature supplanted by that of art. The masters had strained the band that held them to nature to the utmost tension, —their successors broke it; and through all the phases of the decline of art, the less nature was resorted to, the lower the degradation, till general disgust brought about a reaction which now is beginning to bear fruit.

The review of sculpture in Italy would be little more than a repetition of that of painting in the same country, —gradual progression in the first attempts—sudden and fearful development under Michelangelo and antique influences—the abandonment of nature for the study of art, and consequent decay, with this difference, that it appears from the beginning to have been more dependent on the works of antiquity, and that it never reached a degree of excellence equal to that attained in painting by the Italians; and if we are to believe the words of an illustrious sculptor of our own country residing in Rome, "the Italians never were sculptors."

An opinion is now beginning to gain ground that Michelangelo was not quite immaculate as a sculptor; and that he who had gathered from the antique the true principles of art, displays in his works what might be better termed an exaggeration of *some* of the qualities of the antique allied to a wonderful knowledge of nature, but more of the painter than the sculptor. The impression which the writer received from his works in Italy was, that he was the Rubens of that country, —an opinion which he has since heard corroborated.

Before concluding, let us give a few examples to elucidate the view which is here taken of Italian art. Leonardo da Vinci flourished many years before Raffaelle, although in his old age a contemporary of that master, we may therefore expect to find less of the spirit of antiquity in his works, an assumption which they justify on inspection; nevertheless, in perfection, his individual figures are considered superior rather than inferior to Raffaelle, that master only surpassing him in imagination and activity, which helps to prove that perfection would have been attained independent of antique examples. As an instance of how much artists deceive

themselves, may be adduced the case of Raffaelle, who being appointed to the conservation of the remains of antiquity under Leo X., conceived such an affection for them, that, writing to his friend Agostino Chigi, he complains of not being able to succeed with the head of his Galatea, because nearly all the old statues wanted heads; nevertheless, his claims to the admiration of posterity depend far more on the admirable character of his heads than the drawing of his limbs. As an instance of how much both he and Michelangelo owed to their predecessors, may be noticed the facts of their plagiarisms from the Campo Santo and the Brancacci Chapel. In support of the study of nature, there is the fact of Leonardo having in his latter days wasted much time running after models; and finally, in support of that study being the strongest safeguard against decay, there is the example of Leonardo's pupils, one of whom, Luini, almost rivals the master, while all bear a better proportion to him than the followers of Raffaelle do to their master: there is also the example of the Venetian school, which, from having more need of the aid of nature, as colourists, resisted longer the degeneracy of the times.

In the hasty sketch thus drawn of the effects of "looking backwards" in Italy, the object has been little more than to direct attention to the subject, and there was not room to take notice of individual cases, which may require explanation, nor has the writer pretension to do justice to such a subject; but wishes it to be understood that he confines himself to all that strictly relates to aesthetics, for necessarily the principles of ethicks and positive science must be of equal value, from whatever source they may be derived. But as it would appear that whatever the Greeks knew of real science had already reached Europe through Arabian sources, to sum up, it may be asked—What was the real benefit conferred by this all-reversing revolution in mediaeval aesthetics? Setting aside the preservation of some classic authors, the answer might be summed up in few words, a race of pseudo Latin poets, whom nobody reads, and a great amount of disputation on the Aristotelian and Platonic systems of metaphysics, and then with Lord Bacon all to begin afresh!

I will address my concluding remarks, with your permission, Mr. Editor, to our fellow-students in the plastic arts, and will beg not to be misunderstood with reference to the study of nature; her principles must be investigated, as well as her appearance imitated, and this is the point least understood at the present moment; for, since the excellence attained by the Dutch, many artists, looking at nature through the medium of Rembrandt or Sir David Wilkie, cannot persuade themselves that Leonardo da Vinci can be also like nature: to solve the difficulty, they denominate the latter high art, whereas, in point of fact, that master is as much an imitator of the generalities of nature as Teniers is of her particularities. For nature is the stay of the artist: she is our kind mother, and she will never desert us if we trust in her; seek her, and she will ever appear before you beautiful; question her diligently, and she will answer. She alone can reconcile the differences of conflicting schools, and by her sanction alone does the minister of every calling share the rewards due to fidelity, —Wilkie and Burns in the throng, with Michelangelo and Shakespeare. Let us, then, never neglect her worship for idols of wood and stone, nor, from a selfish motive, seek to obtain by stealth those merits for which we should labour honestly. Let us think of what we owe posterity; and while we take hand-in-hand the slow and sure road that leads to excellence—

<div style="text-align:right">

"Learn to labour and to wait."

An Artist

</div>

Appendix 3

THE EXHIBITION

OF

WORK, and other Paintings,

BY

FORD MADOX BROWN,

AT THE GALLERY,

191, PICCADILLY

(OPPOSITE SACKVILLE STREET).

A.D. MDCCLXV.

"Lo que empieza el hombre para sí mismo
Dios le acaba para los otros."
—*Victor Hugo (corrected)*

LONDON:

Printed by M'Corquodale & Co., 18, Cardington Street, N.W.

PRICE SIXPENCE.

CATALOGUE.

N.B.—The works being contributed, in almost every case, by the kindness of the owners, the Exhibition can only remain open for a limited period.

1. CHAUCER AT THE COURT OF EDWARD III

The sketch for this picture was painted, and the picture itself commenced, in the year 1845, at Rome. Circumstances, however, which required my immediate return home, caused me to abandon that first beginning. This present work was begun in London in 1847, and finished early in 1851. During this interval, however, the pictures of *Wickliff, King Lear, The Infant's Repast, Shakespeare, Windermere,* and other works not here exhibited, were painted. As the sketch shows, the picture was originally designed as a triptych, figures of other great English poets occupying the wings. But this idea was conceived abroad at a time when I had little opportunity of knowing the march of literary events at home. On my coming to England, I soon found that the illustrious in poetry were not all among the dead, and to avoid what must either have remained incomplete, or have appeared pretentious criticism, I gave up the idea indicated

in the side compartments. The picture as it now stands might be termed the *First*, or, *First Fruits of English Poetry*. Chaucer, along with Dante, is one of the only two supremely great mediaeval poets who have come down to us, at least by name. But Chaucer is at the same time as much a perfect English poet—I am almost tempted to say a modern English poet, as any of the present day. Spelling, and a few of the minor proprieties apart, after a lapse of five hundred years, his delicate sense of naturalistic beauty and his practical turn of thought, quite at variance with the iron grasp of realism, the deep toned passionate mysticism, and supersensual grace of the great Italian, comes home to us as naturally as the last volume we hail with delight from the press.*

Chaucer is supposed to be reading these pathetic lines from the "Legend of Custance:"—

> "Hire litel child lay weping on hire arm,
> And, kneling pitously to him she said,
> Pees litel sone, I wol do thee no harm!
> With that hire couverchief of hire hed she
> braid
> And over his litel eyen she it laid,
> And in hire arme she lulleth it ful fast,
> And unto the hevens hire eyen up she cast."

Edward III. is now old, Phillippa being dead; the Black Prince is supposed to be in his last illness. John of Gaunt, who was Chaucer's patron, is represented in full armour, to indicate that active measures now devolve upon him. Pages holding his shield, etc., wait for him: his horse likewise in the yard beneath. Edward the Black Prince, now in his fortieth year, emaciated by sickness, leans on the lap of his wife Joanna, surnamed the Fair Maid of Kent. There had been much opposition to their union, but the Prince ultimately had his way. To the right of the old King is Alice Perrers, a cause of scandal to the Court, such as, repeating itself at intervals in history with remarkable similarity from David downwards, seems to argue that the untimely death of a hero may be not altogether so deplorable an event. Seated beneath are various personages suited to the time and place. A troubadour from the south of France, half jealous, half in heart-struck admiration; a cardinal priest on good terms with the ladies; a jester forgetting his part in rapt attention of the poet. This character, I regret to say, is less mediaeval than Shakespearian. Two *dilettante* courtiers learnedly criticising; the one in the hood is meant for the poet Gower. Lastly, a youthful squire of the kind described by Chaucer as never sleeping at nights, "more than doeth the nightingale," so much he is always in love.

Sitting on the ground being common in those days, rushes used to be strewn to prevent the gentlemen from spoiling their fine clothes.

This picture is the first in which I endeavoured to carry out the notion, long before conceived, of treating the light and shade absolutely, as it exists at any one moment, instead of approximately, or in generalised style. Sunlight not too bright, such as is pleasant to sit in out of doors,

*I need not tell most of my readers that much of the difficulty as to accent and quantity is avoidable, if the verses are read on the principle of French verse, with the final mute e syllables *allowed for* when preceding words beginning with a consonant, and *omitted* before vowels. This rule, however, does not in all cases apply, probably because some words were even then beginning to take the modern form of pronunciation.

is here depicted. The figures in the spandrils of the arch symbolize the overthrow, through Chaucer, of the Saxon Bard and the Norman Troubadour. This picture gained the £50 prize of the Liverpool Academy in 1859.

2. TWO STUDIES in Different Views Of A Little Girl. *W. Holman Hunt, Esq.*

Painted in 1846.

3. OURE LADYE OF GOOD CHILDREN. *James Leathart, Esq.*

Was first executed in black chalk, as a cartoon, soon after my return from Italy in 1847. The colour was only added in 1861; 14 years later. During my sojourn, Italian art had made a deep, and as it proved, lasting impression on me, for I never afterwards returned to the sombre Rembrandtesque style, I had formerly worked in. I must observe that this composition was little more than the pouring out of the emotions and remembrances still vibrating within me of Italian Art. To look at it too seriously would be a mistake. It was neither Romish nor Tractarian, nor Christian Art (a term then much in vogue) in intention; about all these I knew and cared little, it was merely *fanciful,* just as a poet might write some Spencerian or Chaucerian stanzas. On the other hand, if imitative of Italian Art in certain respects, it is original in others. The defined effect of light intended for just after sunset, is not Italian. In idea the children are modern English, they are washed, powdered, combed, and bedgowned, and taught to say prayers like English Protestant babes. The colouring added in 1861 did not affect the system of light in the work, which always indicated twilight in the cartoon treatment.

4. WICKLIFF Reading His Translation of the Bible to John of Gaunt, in the presence of Chaucer and Gower. *John Heugh, Esq.*

Wickliff, whose reforming tendencies seem to have embraced social as well as religious topics, like most of the other great religious innovators, used to inculcate contempt of mundane cares and vanities, going barefooted and in cassock of the coarsest material. Chaucer is taken from the small portrait existing of him, in illumination, by his pupil, the poet Ocleve. Gower's effigy is to be seen, or was, on his monument in St. Saviour's Southwark. This picture was painted in 1848, and re-touched in 1861.

5. WINDERMERE. *Mrs. Seddon.*

A Study, painted from nature, in the autumn of 1848. Made into a picture, and the cattle added in 1854.

6. THE INFANT'S REPAST. *Mrs. Gibbons.*

Painted at the same time with the "King Lear," in 1848. With the single remark that "doggy is jealous," this little picture, I think, needs no explanation. Never re-touched.

7. CORDELIA AND LEAR. *James Leathart, Esq.*

Painted in 1848–9, considerably re-touched in 1854. This picture, though one of the earliest of my present, or *English* style, as I may term it, I have always considered one of my chief works. The subject is too well known, and the picture itself has been too often seen and commented on, to require much description by me. The outline of the tragedy, for such as may not have it vividly present to their minds, is briefly this—*Lear*, King of Britain, wishing to abdicate, sends for his three daughters, and challenges them to say which loves him the best, in order to deserve a larger share of his kingdom. Cordelia, disgusted by the hypocrisy and daring flattery of her elder sisters, remains silent. At length she declares she loves him *as in duty bound.* Lear, incensed, disinherits her, and she departs, chosen in marriage by the King of France. Once possessed of power, the true character of the elder sisters discloses itself, and Lear, ill-used, aged, and helpless, goes mad. Cordelia, now Queen of France, returns with an army to rescue him. Found wildly running about the beach at Dover, he is secured, put to sleep with opiates, and the physician, who is about to wake him by means of music, has predicted that his reason will return with consciousness. Cordelia, at the foot of the bed, awaits anxiously the effect of her presence on him, and utters the touching soliloquy, beginning—

> "Had you not been their father, these white flakes
> Had challenged pity of them."

Now would she recall the moment, when honesty, stiffened to pride, glued to her lips the soft words of flattery expected by the old man, and perhaps after all his due, from her who was the best beloved of his three. So virtue, too, has its shadowed side, pride—ruining itself and others.

Having its origin in the old ballad, Shakespeare's King Lear is Roman-pagan-British nominally; mediaeval by external customs and habits, and again, in a marked degree, savage and remote by the moral side. With a fair excuse it might be treated in Roman-British costume, but then clashing with the mediaeval institutions and habits introduced: or as purely mediaeval. But I have rather chosen to be in harmony with the mental characteristics of Shakespeare's work, and have therefore adopted the costume prevalent in Europe about the sixth century, when paganism was still rife, and deeds were at their darkest. The piece of Bayeux tapestry introduced behind King Lear is strictly an anachronism, but the costume applies in this instance, and the young men gaily riding with hawk and hound, contrast pathetically with the stricken old man. The poor fool who got hanged for too well loving his master, looks on with watery eyes. The Duke of Kent, who, though banished, disguised himself in order to remain with the king, is seen next the fool, having a wig on to alter his appearance. The physician, with his conjuring book, was magician also in those days.

8. PORTRAIT OF A LITTLE GIRL. *Mrs. Bromley.*

Painted in 1849.

9. PORTRAIT OF THE LATE THOMAS SEDDON, Esq. *Mrs. Seddon.*

Painted in 1849.

10. WILLIAM SHAKESPEARE. *Lowes Dickinson, Esq.*

Painted in 1849–50.

Carefully collated from the different known portraits, and more than any other from the bust at Stratford. This picture is an attempt to supply the want of a credible likeness of our national poet, as a historian recasts some tale, told long since by old chroniclers in many fragments.

11. THE PRETTY BAA-LAMBS. *James Leathart, Esq.*

This picture was painted in 1851, and exhibited the following year, at a time when discussion was very rife on certain ideas and principles in art, very much in harmony with my own, but more sedulously promulgated by friends of mine. Hung in a false light, and viewed through the medium of extraneous ideas, the painting was, I think, much misunderstood. I was told that it was impossible to make out what *meaning* I had in the picture. At the present moment, few people I trust will seek for any meaning beyond the obvious one, that is—a lady, a baby, two lambs, a servant maid, and some grass. In all cases pictures must be judged first as pictures—a deep philosophical intention will not make a faire picture, such being rather given in excess of the bargain; and though all epic works of art have this excess, yet I should be much inclined to doubt the genuineness of that artist's ideas, who never painted from love of the mere look of things, whose mind was always on the stretch for a moral. This picture was painted out in the sunlight; the only intention being to render that effect as well as my powers in a first attempt of this kind would allow.

12. JESUS WASHES PETER'S FEET. *James Wyllie, Esq.*

St. John tells us that Jesus, rising from supper, "laid aside his garments," perhaps to give more impressiveness to the lesson of humility, "and took a towel and girded himself," poured water into a basin (in the East usually of copper or brass), "and began to wash the disciples' feet, and *to wipe them with the towel, wherewith he was girded.*" Then Peter said, "Lord, doest thou wash my feet?" And again Peter said unto him, "Thou shalt never wash my feet." The purposely assumed humility of Jesus at this moment, and the intense veneration implied in the words of Peter, I have endeavoured to render in this composition. The very simple traditional costume of Jesus and his disciples, which seems, moreover, warranted by modern research, as also the traditional youthfulness of John, curly grey hair of Peter, and red hair of Judas, which I should be loth to disturb without having more than my own notion to give in lieu, I have retained— combined with such truth of surroundings and accessories as I thought most conducive to *general truth,* always intending, however, in this picture, the documentary and historic to be subordinate to the supernatural and Christianic—wherefore, I have retained the nimbus. This, however, every one who has considered the subject must understand, appeals *out* from the picture to the *beholder*—not to the other characters *in* the picture. Judas Iscariot is represented lacing up his sandals, after his feet have been washed. This picture was painted in 1851–52. It was subsequently worked over, and in certain respects altered in 1856, in which year the £50 prize of the Liverpool Academy was awarded for it, in exclusion of the picture of the "Last of England," which formed part of the same exhibition.

13. ENGLISH AUTUMN AFTERNOON. *George Rae, Esq.*

This was painted in the autumns of 1852 and 1853, and finished, I think, in 1854. It is a literal transcript of the scenery round London, as looked at from Hampstead. The smoke of London is seen rising half way above the fantastic shaped, small distant cumuli, which accompany particularly fine weather. The upper portion of the sky would be blue as seen reflected in the youth's hat; the grey mist of autumn only rising a certain height. The time is 3 P.M., when late in October the shadows already lie long, and the sun's rays (coming from behind us in this work) are preternaturally glowing, as in rivalry of the foliage. The figures are peculiarly English—they are hardly lovers—more boy and girl, neighbours and friends. In no other country would they be so allowed out together, save in America, where (if report says true) the young ladies all carry latch-keys: both of us true inheritors from the Norsemen of Iceland, whose ladies would take horse and ride for three months about the island, without so much as a presumptuous question on their return, from the much tolerating husbands of the period.

14. THE LAST OF ENGLAND *John Crossley, Esq.*

Sonnet.
"The last of England! o'er the sea, my dear,
 Our home's to seek amid Australian fields.
 Us, not the million-acred island yields
The space to dwell in. Thrust out! Forced to hear
Low ribaldry from sots, and share rough cheer
 With rudely nurtured men. The hope youth builds
 Of fair renown, bartered for that which shields
Only the back, and half-formed lands that rear
The dust-storms blistering up the grasses wild.
 There learning skills not, nor the poet's dream,
 Nor aught we loved as children shall we see."
She grips his listless hand and clasps her child.
 Through rainbow-tears she sees a sunnier gleam,
 She cannot see a *void*, where *he* will be.
F.M.B. Feb., 1865

This picture is in the strictest sense historical. It treats of the great emigration movement which attained its culminating point in 1852. The educated are bound to their country by quite other ties than the illiterate man, whose chief consideration is food and physical comfort. I have, therefore, in order to present the parting scene in its fullest tragic development, singled out a couple from the middle classes, high enough, through education and refinement, to appreciate all they are now giving up, and yet depressed enough in means, to have to put up with the discomforts and humiliations incident to a vessel "all one class." The husband broods bitterly over blighted hopes and severance from all he has been striving for. The young wife's grief is of a less cankerous sort, probably confined to the sorrow of parting with a few friends of early years. The circle of her love moves with her.

The husband is shielding his wife from the sea spray with an umbrella. Next them in the back ground, an honest family of the green-grocer kind, father (mother *lost*), eldest daughter,

and younger children, makes the best of things with tobacco-pipe and apples, &, &. Still further back a reprobate shakes his fist with curses at the land of his birth, as though that were answerable for *his* want of success; his old mother reproves him for his foul-mouthed profanity, while a boon companion, with flushed countenance, and got up in nautical togs for the voyage, signifies drunken approbation. The cabbages slung round the stern of the vessel indicate to the practised eye a lengthy voyage; but for this their introduction would be objectless. A cabin-boy, too used to "leaving his native land," to see occasion for much sentiment in it, is selecting vegetables for the dinner out of a boatful.

This picture, begun in 1852, was finished more than nine years ago. To insure the peculiar look of *light all round,* which objects have on a dull day at sea, it was painted for the most part in the open air on dull days, and when the flesh was being painted, on cold days. Absolutely without regard to the art of any period or country, I have tried to render this scene as it would appear. The minuteness of detail which would be visible under such conditions of broad day-light, I have thought necessary to imitate, as bringing the pathos of the subject more home to the beholder.

15. AN ENGLISH FIRESIDE IN THE WINTER OF 1854–55. *Peter Miller, Esq.*

Needs no explanation. The scene was, no doubt, not uncommon during that calamitous winter.

16. CARRYING CORN *B. G. Windus, Esq.*

This small landscape was painted at Finchley in 1854.

17. THE PARTING OF CORDELIA AND HER SISTERS. *B.G. Windus, Esq.*

Sketch for a picture not painted; originally etched in the *Germ* in 1850: painted in 1854. Cordelia about to depart with her affianced husband, the King of France, pronounces the somewhat tart admonition to her sisters—

> "Use well our father:
> To your professed bosoms I commit him:
> But yet, alas! stood I within his grace
> I would prefer him to a better place.
> So, farewell to you both!"

For genius, however gentle in disposition the owner, must out with the sharp stinging reproof at the fitting and rightful moment. Goneril and Regan, with appropriate female powers of rejoinder, reply logically, if not convincingly:—

> "Let your study
> Be, to content your lord, who hath receiv'd you
> At Fortune's alms. You have obedience scanted,
> And well are worth the want that you have
> wanted."

Cordelia responds—

> "Time shall unfold what plaited cunning hides;
> Who cover faults, at last shame them derides,
> Well may you prosper!"

18. ON THE BRENT, HENDON. *B.G. Windus, Esq.*

Views near London so often become "dissolving views" now-a-days, that I can hardly affirm that this most romantic little river is not now neatly arched over for 'sanitary reasons;' but ten year ago, it presented this appearance, and once embowered in the wooded hollows of its banks, the visitor might imagine himself a hundred miles away. (1854).

19. THE HAYFIELD. *Major Gillum.*

Was painted at Hendon late in the Summer of 1855. The stacking of the second crop of hay had been much delayed by rain, which heightened the green of the remaining grass, together with the brown of the hay. The consequence was an effect of unusual beauty of colour, making the hay by contrast with the green grass, positively red or pink, under the glow of twilight here represented.

20. SAINT IVES, A.D. 1636. *John P. Seddon, esq.*

This is a first sketch for a picture, not yet painted, of Oliver Cromwell on his farm. At this date, 1636, when Cromwell was engaged in cattle farming, the electrical unease of nerves which is felt by nations prior to the bursting of the psychological storm, seems to have produced in him a state of exalted religious fervour mingled with hypochondria, now, owing to the "Letters and Speeches," pretty generally understood. In my composition the farmer is intended to fore-shadow the king, and everything is significant or emblematic; but as I hope yet to produce this subject in large, I will not further describe the present sketch. (1856)

21. PORTRAIT OF WILLIAM M. ROSSETTI, Esq. *Mrs. Rossetti.*

Painted by lamp-light, as the reflection on the wall paper shows. (1857).

22. THE PRISONER OF CHILLON. *James Leathart, Esq.*

This small study for a picture, painted in 1858, from Lord Byron's poem, represents the moment when the second brother is about to be buried in the cell where the two others are confined, each chained to his pillar. "The Prisoner" entreats the jailor to bury his brother outside, where the sun might shine on his grave— "They coldly laughed and laid him there."

22A. OUT OF TOWN. *John Heugh, Esq.*

This sketch was begun in Paris in 1843, and finished in 1858.

23. SOUTHEND
T. Hedley, Esq.

This small landscape was begun at Southend in Essex, in 1846, and finished there, twelve years later, in 1858. The Nore light-ship and the Isle of Sheppy are seen in the distance. Southend is here represented as it was before the invasion of gas and railroad.

24. THE TRANSFIGURATION.
Messrs. Powell & Co.

Cartoon for stained glass.

A moment's consideration will, I think, make clear to the beholder, that the holes in our Lord's hands are not there by any oversight. Though I was not aware of it at the time, it appears to have been the customary way of treating this subject with the early masters. (1858).

25. WINANDERMERE.
J.R. Kershaw, Esq.

Seen from the water-head looking south towards Bowness. Thunder clouds, rain, and sunshine in the distance.

Both in the extremes of serenity and of disturbance, the clouds have a tendency to take fantastic and imitative shapes. In the most calm of beautiful days, distant pink cloudlets will move statelily along the horizon, looking like swans, like balloons, like pillars of Hercules, like cameleopards, slow, sad, and beautiful, one will follow another; then, by moments, one will alter the pose of its head, but sadly, like a ghost, or lycanthropiclly change to some other animal. In stormy skies on the other hand, we have ranges of pinnacled mountains, intersected by impassable ravines, capped by enchanted castles; with all that is wizard-like in the shape of birds, beasts, fishes, and winged reptiles coursing in affright over the troubled and compressed vault of heaven, or the continually increasing smoke of ten thousand pieces of meteorological artillery. (1859.)

26. IRISH GIRL
George Rae, Esq.

Study of child's head, painted in 1860.

27. WALTON-ON-THE-NAZE
Major Gillum.

A small watering place on the east coast of Essex lately of some repute. The scenery of this part of the coast is full of freshness and interest. Cliffs and ridges of clay, intercepting salt marshes, give it a certain Dutch-English character. The sea having everywhere a tendency to run inland behind the clayey barriers, which seem naturally set up against it. The "Naze" or nose seen to the left, with a tower on it for sea-mark, is one of these. The mill* is worked by tidal flow dammed up. Harwich, one of the old military ports is at hand, and still harbours its man-of-war. The martello tower is built to protect the village of Walton from any sudden boat attack up the back-water round the "Naze." The lady and little girl, by their let-down hair, have been bathing—the gentleman descants learnedly on the beauty of the scene. Painted in 1860.

*The water-mill in the centre of the composition.

28. WILLELMUS CONQUISTATOR. *James Leathart, Esq.*

Willelmus Conquistator was originally executed at Paris, in 1844, and with the cartoon of Harold exhibited in Westminster Hall. In 1861 I entirely repainted it, and as the old name Harold had become very much used up (though not the subject), I re-christened it Willelmus, who truly here is the more important of the two. Twenty years ago, extreme exactness in matters external and archaeologiccal was less in vogue than it is now; properly speaking the mediaeval feeling in art did not as yet exist—men *thought Renaissance* and *called* it *Gothic.* With me in those days, the dramatic interest in a subject outweighed every other consideration, such was the example set by Delacroix in France, and by *David Scott,* the British Delacroix here—set, though not followed. Finding by the Bayeux tapestry, that Saxon soldiers, after Edward the Confessor had so Normanized the nation, dressed precisely like Norman ones, I thought it necessary, in order to make the scene intelligible, to dress Harold in the Saxon costume of an anterior period.

Again, the Pope's consecrated banner in the tapestry, is evidently nothing but a pennon such as William's wife, Matilda, might have embroidered for him, and fixed herself to his lance. I chose to give it more prominance, and then took advantage of it, to throw a broad shadow across the figures of the conqueror and his officers. On repainting the work in 1861, I might have been tempted to give Harold a more Normanized attire, but I reflected that narrow literality of truth would be out of place, unless I at the same time changed the banner, to do which would have altered the light and shade of the whole composition. Moreover, Harold, on taking the crown, might very probably have reverted to the Saxon style of dress as chief and idol of the old Saxon party. But the human, I trust, will supersede the *sartorial* in interest in this work.

Excessive and exuberant joy is described in the old chronicles as possessing the Norman host after the victory. This is shown variously in the demeanour and expressions of the conquerors. Harold was a more than usually large and athletic man, even among Saxon heroes. Three men bear his body to the victorious Duke. All that are left alive on the scene are Normans—no prisoners were taken. Quarter was neither expected nor given. One ancient knight, somewhat of the Polonius kind, with raised hand, seems to say, "Here indeed, was a man. In my young days," &, &. Others seem of the same mind. One of William's attendants, of the waggish sort, catches a silly camp-boy by the fist, and exhibits its puny proportions alongside of the dead Harold's hand, still with broken battle-axe in its iron grasp; drawing a grim smile from the conqueror. A fair haired Norman officer, regardless of the fact that his body is gashed pretty freely with wounds, twists about to get a sight of Harold. The monk, who is dressing his wounds, tired out with much of such work, surlily bids him be quiet. Friends join hands glad to meet again after such a day. A father supports his wounded son. In one corner, embraced in death-grapple, lie the bodies of a Norman and Saxon, one has stabbed the other in the back, while he in turn has bitten his adversary's throat like a dog.

Beachy head, which is just perceptible from the scene of the battle, appears across the bay in the extreme distance. The effect is just after sunset.

29. LES HUGUENOTS.

First sketch for a picture, not yet painted, of a lady at the opera. (1861.)

30. PORTRAIT OF JAMES LEATHART, ESQ. *Mrs. Leathart.*

The lead works of St. Anthony-on-Tyne are seen in the background. The picture of "Work," of which Mr. Leathart possesses a small duplicate, is also introduced. Compared with the works of the old masters, portrait-painting in England has sunk to a low level. Emperors and kings delighted in former times to be painted by Titian and the greatest historical artists; now it is considered indispensable : (I don't know why) to sit to none but portrait-painters in the most restricted sense. These work to orthodox sizes, fixed scales of charges in proportion to size, the canvas, at least, being of satisfactory proportions. This system has proved suicidal. People have become ashamed to be painted, and photography has taken the place of portraiture. But a revival must ere long take place. Photography is but the assistant (saving the artist and sitter time) of portrait-painting, which can never exist but by the effort and will of genius. In France, Ingres and Delaroche have painted the finest contemporary portraits; in England, the late William Dyce might have, perhaps, in particular cases, has done so. As it is, the few likenesses of any interest produced of late have been the accidental works of historical painters. Of course, only people of great wealth and importance can either afford or hope to obtain such work, but the few instances where it could exist would be sufficient to set an example. The professed portrait-painter, now becoming extinct, would be enabled to return from photography to a more simple and artistic style of picture than hitherto in vogue, and on rational-sized canvasses, and assisted by photography, *now* the natural hand-maiden of portraiture, we might hope to see a school arise interesting in itself. (1863.)

31. KING RÉNÉ'S HONEYMOON. *John Hamilton Trist, Esq.*

King Réné was titular King of Naples, Sicily, Jerusalem, and Cyprus; and father of our celebrated and unfortunate Margaret, Queen to Henry VI.

He was poet, painter, architect, sculptor, and musician; but most unfortunate in his political relations. Of course, as soon as married, he would build a new house, carve it and decorate it himself, and talk nothing but Art all the "Honeymoon" (except indeed love.) It is twilight when the workmen are gone. Finished study for a picture. (1864.)

32. THE DEATH OF SIR TRISTRAM. *George Rae, Esq.*
From the Mort D'Arthur.

The romance thus called, written in English in the reign of Edward IV., by Sir Thomas Malory, Knight, was made up of several distinct French poems or *Romans* of much earlier date. The story of Sir Tristram is complete in itself in the original French, but Malory has incorporated it to a certain extent with his grand Mediaeval Epic. The bulk of the story, however, he gives massed together, in about 30 consecutive chapters, when it suddenly breaks off, giving place to fresh characters and events, the death of Sir Tristram being only mentioned incidentally later on in the history.

This story offers many points in contrast with the other leading narratives in the book. It has no theological and little explicit moral intention, save that general one inseparable from characters of innate beauty and nobleness, the deeds of knightly worth. There is but little of Christian dependence on Providence, but rather a Greek fatalism at work with the various

scenes and final catastrophe of the drama. The love-philter brewed for King Mark, but drunk by mistake by his bride Isonde and Sir Tristram her escort (before they were lovers), fatally holds their free-will in life-long fetters which they have neither the power nor the will to cast off. The lovers die unrepentant, and there seems little of hope for them but to join themselves to Dante's lovers in the eternal storm of passion. Next to Sir Launcelot, Sir Tristram was the best Knight in Christendom. Like him he erred; but he was doomed from his birth when his dying mother forenamed him Tristram, child of her sorrow. Our compassionate tolerance of the lovers is artfully kept up by the abject meanness of the character of King Mark, who labours, more-over, under the disqualification, unpardonable in knightly circles, of being a coward. The weapon, a "glaive," with which Sir Tristram was "traitoursly slayne" while sitting with Isonde, is well fitted for a coward to use on his enemy from behind. It consists of a Turkish scimitar fastened halbert-wise to a long pole. The upturned sleeve, disclosing the concealed shirt of mail, and the large butcher-like "anelace" at his girdle, more fitted for a yeoman than a knight, bespeak at once the King's blood-thirsty intention and timid disposition.

The arms of Cornwall, which consist of money, seemed most appropriate to the mean-spirited king, and the motto, "Deniers Prevoudront" (pence shall prevail), has been added as in har-mony with this coincidence. The little dog is the "brachet" given by Sir Tristram to Isonde, by which he was recognised, when sickly and half distraught, he returned from his exile in the garb of a mendicant. Like other lap-dogs, he is not unselfish nor over valiant, and without rising he only yelps languidly at his hated master. Outside is Dame Bragwain, the Queen's tirewoman, who dares not interfere.

In this work, which I offer to the public more as one of action and passion, than of high finish, I have designedly sought to reproduce something of the clearness and cheerfulness of colour of the old illuminations. As these from the inexperience of the painters, are almost without light and shade, I have represented the scene as passing in a room lighted from four sides at once,— by this means the shadows are much neutralised, and some of the appearance of mediaeval art retained, without forgetting what we owe to truth and eternal nature. So far it has been my intention to make this particular work look (as people term it) *mediaeval*, but no further. In the small picture of the Prisoner of Chillon I have in the same way been inevitably biassed by the character of the Lutheran artists of the *renaissance*, quite a change from mediaevalism, but not with a view either to imitation or to neglect of truth; were I to paint a Greek subject, I could not but act upon the same principle. (1864.)

33. ELIJAH AND THE WIDOW'S SON. *John Hamilton Trist, Esq.*

We all remember how the widow in the extremity of her grief cried out, "Art thou come unto me to call my sin to remembrance, and to slay my son?" So we can all imagine the half (or half-assumed) reproachful look with which Elijah, as he brought the child down stairs, would have said "see thy son liveth," and even surmise the faint twinkle of humour in the eyes with which he would receive the reply, "Now *by this I know* thou art a man of God." The child is represented as in his grave-clothes, which have a far-off resemblance to Egyptian funeral trappings; having been laid out with flowers in the palms of his hands, as is done by women in such cases. Without this, the subject (the coming to life) could not be expressed by the painter's art, and till this view of the subject presented itself to me I could not see my way to make a picture of it. The shadow on the wall projected by a bird out of the picture returning to its nest, (consisting of the bottle which in some countries is inserted in the walls to secure the presence of the swallow of

good omen), typifies the return of the soul to the body. The Hebrew writing over the door consists of the verses of Deut. vi. 4–9, which the Jews were ordered so to use (possibly suggested to Moses by the Egyptian custom). Probably their dwelling in tents gave rise to the habit of writing the words on parchment placed in a case instead. As is habitual with very poor people, the widow is supposed to have resumed her household duties, little expecting the result of the Prophet's vigil with her dead child. She has therefore been kneading a cake for his dinner. The costume is such as can be devised from the study of Egyptian combined with Assyrian, and other nearly contemporary remains. The effect is vertical sunlight, such as exists in southern latitudes. Finished study for a picture. (1864.)

34. MYOSOTIS. *Ernest Gambart, Esq.*

Represents a French maiden of rank and fashion, *fille de bonne maison,* in slight mourning, grieving for some lost friend, not an *affaire de coeur.* In her class of life, dress being the affair of the lady's maid, is no criterion to test the spirits by. Water colours. Painted in 1864.

35. TOOTHLESS. *Ernest Gambart, Esq.*

A modest village maidie. The doll was a prize for good conduct. The title I first gave this drawing, *Old Toothless,* was objected to by several. All I can say is, that I have heard the very words used at different times by different ladies to children, when changing their teeth; written under a picture it seems to offend. I have softened it to *Toothless.* The same remark applied to the title *Pretty Baa-lambs.* Again, I have been urged on every side to replace the *growing* tooth, by a *fully developed* one. I confess myself here at a loss. How any thinking person can in his mind confound together a law in nature that we have all undergone, in itself full of promise, and symbolic of much, with such an accident and defect as a broken tooth in a grown person is to me inexplicable. (1864, water colours.)

36. PORTRAIT OF THE LATE JAMES BAMFORD, Esq. *Mrs. D'Oliers.*

This portrait, though painted so early as 1846, I have placed last among these later works, in order to bring it in close proximity with the five works of early date, next following. It is the first evidence of an entirely new direction of thought and feeling on my part. Compared with the head of Mr. Madox and the other five works of the same period in this collection, it looks as if painted by another hand, and that of a beginner; those on the contrary, appear to realize their aim as well as the style permits. Chiefly on account of this peculiarity, I have thought it interesting to include it in this collection. To those who value facile completeness and handling, above painstaking research into nature, the change must appear inexplicable and provoking. Even to myself at this distance of time, *this instinctive turning back to get round by another road,* seems remarkable. But in reality it was only the inevitable result of the want of principle, or rather confliction of many jarring principles under which the student had to begin in those days. Wishing to substitute simple imitation for *scenic effectiveness,* and purity of natural colour for scholastic depth of tone, I found no better way of doing so than to paint what I called a *Holbein of the 19th century.* I might, perhaps, have done so more effectively, but *stepping backwards* is stumbling work at best.

WORKS OF AN EARLIER PERIOD.

37. PARISINA'S SLEEP. *D.T. White, Esq.*

Parisina in her sleep mutters a name which first gives weight and direction to the suspicions already implanted in the mind of her husband the Prince Azo—

> "He pluck'd his poniard in its sheath,
> But sheathed it ere the point was
> bare—
> Howe'er unnworthy now to breathe,
> He could not slay a thing so fair—
> At least not smiling—sleeping there
> Nay, more;—he did not wake her then
> But gazed upon her with a glance
> Which, had he roused her from her trance
> Had frozen her sense to sleep again—
> And o'er his brow the burning lamp
> Gleamed on the dew-drops big and damp
> She spake no more—but still she slumbered,
> While in his thought, her days are numbered."

This work, painted at Paris in 1842, offers a good example of my early style, it having been only very slightly retouched since. Such as it is, this style I must observe is neither Belgian, such as I learned in the school of Baron Wappers, nor that of the Parisian *ateliers;* the latter, I always entertained the greatest aversion for: cold pedantic drawing, and heavy opaque colour are impartially dispensed to all in those huge manufactories of artists, from which, however, every now and then a man of feeling or genius surges up and disentangles himself. The style had rather its origin in the Spanish pictures and in Rembrandt.

38. HEAD OF A BABY. *B.G. Windus, Esq.*

Painted in Paris 1843–4. This study (not retouched) gives a favourable idea of my powers of painting at that period.

39. PORTRAIT OF THE LATE JAMES FULLER MADOX, ESQ.
 William Jones, Esq.

Painted in 1843.

40. THE FISHER BOY *W. D. Halt, Esq.*

The head and figure were painted in 1836, and not retouched. The back-ground added in 1858.

41. STUDY OF A PONY.

Harry V. Tebbs, Esq.

Painted in 1836, when I was fifteen.

42. MANFRED ON THE JUNGFRAU.

D.T. White, Esq.

From Lord Byron's Drama.

 This work, composed in 1840, when I was nineteen, and painted the next year in Paris, belongs, with the five following examples, to the period of my Art-studentship in Belgium and Paris. In this instance, however, the picture has been much touched upon, as recently as 1861, so that the original scheme of colour is quite obliterated, little more than the dramatic sentiment and effect of black and white remaining. Such as it was, it was a first, though not very recognisable attempt at out-door effect of light. The costume is of the 10th or 11th century, to which period Byron refers his subject back, by making Manfred speak of the fall of Mount Rosenburg.

<div style="text-align:center">

Manfred.
"The mists boil up around the glaciers; clouds
Rise curling fast beneath me white and sulphury,
Like foam from the roused, ocean of deep hell,
Whose every wave breaks on a living shore,
Heaped with the damned like pebbles—I am giddy!"
Chamois Hunter.
"I must approach him cautiously; if near,
A sudden step will startle him, and he
Seems tottering already."
Manfred.
"Mountains have fallen.
Thus in its old age did Mount Rosenburg.
Why stood I not beneath it?"
Chamois Hunter
"Friend, have a care;
Your next step may be fatal!—for the love
Of him who made you, stand not on that brink."
Manfred (not hearing him).
"Such would have been for me a fitting tomb;
My bones had then been quiet in their depth;
They had not then been strewn upon the rocks
For the wind's pastime—as thus—thus they shall be—
In this one plunge!"

</div>

 The chamois hunter clutches him in the act of springing off.
 This work is intended for consideration merely by the human and dramatic side, glaciers not having formed part of my scheme of study in those days.

FIRST SKETCHES AND SMALL WORKS OF VARIOUS PERIODS.

43. FIRST SKETCH FOR THE PICTURE OF CORDELIA AND LEAR, (1848.) *C. Lucy, Esq.*

44. FIRST SKETCH FOR THE PICTURE OF WICKLIFF'S FIRST TRANSLATION OF THE BIBLE, (1847) *B. G. Windus, Esq.*

45. FIRST SKETCH FOR THE PICTURE OF CHAUCER AT THE COURT OF EDWARD III *John Marshall, Esq, F.R.S., &, &.*

Painted at Rome in 1845, showing the original idea of the subject.

46. FIRST SKETCH FOR THE PICTURE OF THE LAST OF ENGLAND, (1852.) *B.G. Windus, Esq.*

47. FIRST SKETCH FOR THE PICTURE OF WORK. *Robert Crofts, Esq.*

Designed in 1852. Coloured at intervals later.

48. FIRST SKETCH FOR THE PICTURE OF THE DEATH OF SIR TRISTRAM, (1864.)

49. FIRST SKETCH FOR A YET UNFINISHED PICTURE, CALLED "STAGES OF CRUELTY."

50. FIRST SKETCH FOR THE BACKGROUND OF THE PICTURE OF "WORK," (1852.) *Thomas Woolner, Esq.*

51. THE STORY OF THE BATTLE. *Mrs. Leathart.*

Shows a veteran officer in the army describing some battle to his grand-daughter and some youth, a friend of the family—his son and son's wife looking on, and other grand-children playing about.

Sketch for a larger picture repeated from the series on the book-case. (1864.)

DESIGNS FROM KING LEAR

These outlines, made in 1843, were never intended but as rude first ideas for future more finished designs. Since then, I have always proposed completing them as a series, but as yet I

have never found time to do so. However offensively unfinished or ill-finished these designs may appear, the ideas in them have found favour with some of my friends, which has caused me to include them in this selection.

52. In this first one Cordelia is asked to state the measure of her love, in order to deserve a larger share of the kingdom. She answers, "Nothing, my lord . ." Lear says, "Nothing! speak again, for out of nothing nothing comes."

53. Here Cordelia, disinherited, is chosen in marriage by the King of France. The Duke of Burgundy, who would not take her dowerless, is biting his nails in displeasure. Regan and Goneril sneeringly watch her. With them are their two husbands.

54. The parting of Cordelia and her sisters.

55. Regan and Goneril compare notes.

56. King Lear, who has kept nothing for himself but a retinue of 100 knights, has stipulated to live month and month about with either of his two remaining daughters. Goneril, in the absence of her father at the chase, instigates her steward to be less respectful to him.

57. Lear, returned from hunting hungry, calls the steward, who passes on with a "So please you, my lord."

58. King Lear rates the steward, who answers slightingly.

59. The Duke of Kent, banished for taking Cordelia's part, has, under a disguise, taken service with the King in a menial capacity. He trips up the steward.

60. Goneril violently rates her father—Kent sorrowfully looks on, and the Fool rails at her.

61. King Lear incensed leaves Goneril's house, her husband in vain seeking to interpose.

62. The Duke of Kent tries to pick a quarrel with Goneril's steward.

63. King Lear will not believe that his own daughter, Regan, would have his messenger, Kent, placed in the stocks.

64. King Lear gives the history of his wrongs to Regan and her husband, in the presence of the Duke of Gloucester.

65. Lear perceiving that Goneril and Regan are both agreed as to their intention, curses them, and goes off in the rising storm, shelterless.

66. King Lear with his Fool in the storm.

66a. King Lear mad on the beach at Dover.

67. EHUD, AND EGLON KING OF MOAB

"So the children of Israel served Eglon, the King of Moab, eighteen years." (Judges iii. 14) "But Ehud made him a dagger which had two edges, and did gird it under his raiment upon his right thigh," 16. "And Eglon was a very fat man," 17. "And Ehud said, I have a message to thee from God, and he (Eglon) arose from his seat," 20. "And Ehud put forth his left hand, and took the dagger from his right thigh," 21.

The costume and accessories of this cartoon are taken from Assyrian and Egyptian remains of a remote period. These alone, it seems to me, should guide us in Biblical subjects. To pretend that the Semetic races to which the Israelites belong, have not changed in costume and character of appearance up to the present day, is against the evidence of our eyes, as may be readily seen by the Assyrian remains and those of their near neighbours, the Egyptians, which we have in the British Museum to compare with the modern Arab. Englishmen should always remember that this convenient resemblance between the Israelite of old, and the Arab of our

days, came into vogue in France rather suspiciously, at the time of the French conquest of Algiers, under Louis Philip.

The Moabites having remained in Palestine from the time of Abraham and Lot, I have given a more Assyrian character to Eglon. Ehud on the contrary, I have thought necessary to represent with more of the Egyptian character, the Israelites having come from that country.

This cartoon has been executed with a view to a wood engraving for Messrs. Dalziel's illustrated Bible. (1865.)

PEN AND INK DRAWING OF

68. ELIJAH AND THE WIDOW'S SON.

Executed for the Bible of Messrs. Dalziel. (1864.)

69. JACOB AND JOSEPH'S COAT.

Pen and ink drawing for the Messrs. Dalziel's Bible.

The brothers were at a distance from home, minding their herds and flocks, when Joseph was sold. Four of them are here represented as having come back with the coat. The cruel Simeon stands in the immediate foreground half out of the picture, he looks at his father guiltily and already prepared to bluster, though Jacob, all to his grief, sees no one and suspects no one. The leonine Judah just behind him, stands silently watching the effect of Levi's falsity and jeering levity on their father; Issachar the fool sucks the head of his shepherd's crook, and wonders at his father's despair. Benjamin sits next his father, and with darkling countenance examines the ensanguined and torn garment. A sheep dog without much concern, sniffs the blood which he recognizes as not belonging to man.

A grand-child of Jacob nestles up to him, having an instinctive dislike for her uncles. Jacob sits on a sort of dais raised round a spreading fig-tree. The ladder, which is introduced in a naturalistic way, is by convention the sign of Jacob, who, in his dream, saw angels ascending and descending by it.

The background is taken from a drawing made by a friend in Palestine. The same remarks about costume apply to this as to the Ehud cartoon, only that in this one the costume is still more remote and uncertain; the loin cloth, as worn now by the negroes of Africa, is probably the garment from which all others derive themselves, and is peculiarly suited to this period. In the East, taking off shoes or sandals is equivalent to uncovering the head with us: on this account Simeon stands with his straw sandals in his hands; such also is the reason of Ehud's sandals being left at the door, lest by any breach of etiquette he might arouse, one instant too soon, the suspicions of the tyrant.

That the Assyrians and Egyptians used chairs, as we do, is quite ascertained; as also that their furniture was much more like our own, and the Greek or Roman, than like anything modern Turkish or Arab. (1864.)

70. CHALK PORTRAIT OF MRS. TAYLOR. (1862.) *Mrs. R. Minshull Jones.*

71. PENCIL STUDY FOR THE "LAST OF ENGLAND." (1852.)

B.G. Windus, Esq.

72. PENCIL STUDY OF THE HEAD OF AN INFANT
THREE DAYS OLD. (1855.)

[7]3. PENCIL STUDY OF THE HEAD OF AN INFANT
TEN DAYS OLD. (1856.)

74. CHALK STUDY OF A BABY TEN WEEKS OLD. (1857.)

75. CHALK STUDY OF A LITTLE BOY'S HEAD. (1859.)

CARTOONS FOR STAINED GLASS, AND DESIGNS FOR FURNITURE.

The following nineteen cartoons have been executed for the firm of Messrs. Morris, Marshall, Faulkner, & Co., for stained glass. With its heavy lead-lines, surrounding every part [and no stained glass can be rational or good art, without strong lead-lines], stained glass does not admit of refined drawing; or else it is thrown away upon it. What it does admit of, and above all things imperatively requires, is, fine colour; and what it *can* admit of, and does very much require also, is *invention, expression,* and *good dramatic action.* For this reason, work by the greatest historical artists is not thrown away upon stained glass windows, because though high finish of execution is superfluous and against the spirit of this beautiful decorative art, yet, as expression and action can be conveyed in a few strokes equally as in the most elaborate art, on this side therefore, stained glass rises again to the epic height. So in medals, it is well known grandeur of style arises out of the very minuteness of the work, which admits of that and little else. The cartoons for this firm are never coloured—that task devolving on Mr. Morris, the manager, who makes his colour (by selecting glass) out of the very manufacture of the article. The revival of the mediaeval art of stained glass dates back now some twenty years in the earliest established firms. Nevertheless, with the public it is still little understood. A general impression prevails that *bright* colouring is the one thing desirable, along with a notion that the brightest colours are the most costly. In an age that has become disused to colour, the irritation produced on the retina by the discordance of bright colour, is taken as evidence of the so coveted brightness itself. The result of this is, that the manufacturers, goaded on by their clients, and the "fatal facility" of the material (for all coloured glass is bright), produce too frequently kaleidoscopic effects of the most painful description.

THE LIFE AND DEATH OF ST. OSWALD.

76. Oswald, King of Northumbria in the seventh century, saint and martyr, is baptized while in exile at the court of Scotland. He and his two brothers had been carried thither when children, after Pender, pagan king of Mercia, and Cadwallader, pagan king of Wales, had killed his father, and held Northumbria in terror.

77. St. Oswald is crowned at Bamborough Castle, a stronghold that had not as yet surrendered.
78. St. Oswald, having soon after collected a small force, falls suddenly upon Cadwallader, and puts him and his host to the sword.
79. St. Oswald, having regained possession of Northumbria, marries and distinguishes himself by his piety. He sends missionaries into Scotland, apparently from a pious wish to extend the blessings of Christianity in the country, to which he himself owed that blessing as well as life.
80. St. Oswald is killed in battle by the again invading Pender, and his head and hands cut off, and presented to the Conqueror.
81. St. Oswald's head is enshrined, and translated to Durham Cathedral, where it wrought miracles.

In the monuments of the period, St. Cuthbert is always represented holding the head of St. Oswald. These subjects are in course of execution as a window for the new church of St. Oswald at Durham, (1865.)

82. ST. ELIZABETH AND ST. JOHN THE BAPTIST.

83. ABRAHAM AND ISAAC.

84. ISAAC.

85. ST. PAUL.

86. ST. JOHN THE EVANGELIST.

87. ST. MATTHEW.

88. ST. HELENA, CONSTANTINE, PEADA, ETHELBERT, ST. LOUIS, CHARLEMAGNE, ALFRED THE GREAT, AND EDWARD THE CONFESSOR.

89. CHRIST LIKENS THE KINGDOM OF HEAVEN UNTO A LITTLE CHILD.

90. MICHAEL AND URIEL.

91. THE CRUCIFIXION.

92. THE NATIVITY.

93. CHRIST SEES THE DISCIPLES LABOURING AT THE OAR.

94. CHRIST LIFTS PETER WHEN SINKING IN THE SEA.

95. VARIOUS STUDIES.

96. FRAME OF DESIGNS FOR FURNITURE.

In part designed for Messrs. Morris, Marshall, Faulkner, and Co., and the remainder the property of Charles Seddon and Co.

97. DESIGN FOR PAPER-HANGING. *Messrs. M.M.F. and Co.*

98. BOOK-CASE designed and decorated by me for the Messrs. M.M.F. and Co.'s contribution to the International Exhibition in 1862. *P.P. Marshall, Esq.*

The seven designs in the gilded panels depict the life of an English family from 1810 to 1860.

No. 1. The Proposal.
 ″ 2. The Departure for the Peninsula.
 ″ 3. The Charge.
 ″ 4. The Gazette.
 ″ 5. Wounded.
 ″ 6. The Return.
 ″ 7. The Story of the Battle (to his Grand-daughter), in 1860.

<div align="center">

WORK.
Estate of the late Thomas Edward Plint, Esq.
SONNET

</div>

WORK! which beads the brow, and tans the flesh
 Of lusty manhood, casting out its devils!
 By whose weird art, transmuting poor men's evils,
Their bed seems down, their one dish ever fresh.
Ah me! For lack of it what ills in leash,
 Hold us. It's want the pale mechanic levels
 To workhouse depths, while Master Spendthrift revels.
For want of work, the fiends him soon immesh!

Ah! beauteous tripping dame with bell-like skirts,
 Intent on thy small scarlet-coated hound,
 Are ragged wayside babes not lovesome too?
Untrained, their state reflects on thy deserts,
 Or they grow noisome beggars to abound,
 Or dreaded midnight robbers, breaking through.
<div align="right">F.M.B.—*Feb., 1865.*</div>

This picture, on account of which, in a great measure the present exhibition has been organised, was begun in 1852 at Hampstead. The background, which represents the main street of that suburb not far from the heath, was painted on the spot.

At that time extensive excavations, connected with the supply of water, were going on in the neighbourhood, and seeing and studying daily as I did the British excavator, or *navvy,* as he designates himself, in the full swing of his activity (with his manly and picturesque costume, and with the rich glow of colour, which exercise under a hot sun will impart), it appeared to me that he was at least as worthy of the powers of an English painter, as the fisherman of the Adriatic, the peasant of the Campana, or the Neapolitan lazzarone. Gradually this idea developed itself into that of "Work" as it now exists, with the British excavator for a central group, as the outward and visible type of *Work.* Here are presented the young navvy in the pride of manly health and beauty; the strong fully developed navvy who does his work and loves his beer; the selfish old bachelor navvy, stout of limb, and perhaps a trifle tough in those regions where compassion is said to reside; the navvy of strong animal nature, who, but that he was, when young *taught* to work at useful work, might even now be working at the *useless crank.* Then Paddy with his larry and his pipe in his mouth.

The young navvy who occupies the place of hero in this group, and in the picture, stands on what is termed a landing-stage, a platform placed half-way down the trench; two men from beneath shovel the earth up to him, as he shovels it on to the pile outside.

Next in value of significance to these, is the ragged wretch who has never been *taught* to *work;* with his restless gleaming eyes, he doubts and despairs of every one. But for a certain effeminate gentleness of disposition and a love of nature, he might have been a burglar! He lives in Flower and Dean Street, where the policemen walk two and two, and the worst cut-throats surround him, but he is harmless; and before the dawn you may see him miles out in the country, collecting his wild weeds and singular plants to awaken interest, and perhaps find a purchaser in some sprouting botanist. When exhausted he will return to his den, his creel of flowers then rests in an open court-yard, the thoroughfare for the crowded inmates of this haunt of vice, and played in by mischievous boys, yet the basket rarely gets interfered with, unless through the unconscious lurch of some drunkard. The bread winning implements are sacred with the very poor.

In the very opposite scale from the man who can't work, at the further corner of the picture, are two men who appear as having nothing to do. These are the brainworkers, who, seeming to be idle, work, and are the cause of well-ordained work and happiness in others. Sages, such as in ancient Greece, published their opinions in the market square. Perhaps one of these may already, before he or others know it, have moulded a nation to his pattern, converted a hitherto combative race to obstinate passivity, with a word may have centupled the tide of emigration, with another, have quenched the political passions of both factions—may have reversed men's notions upon criminals, upon slavery, upon many things, and still be walking about little known to some. The other, in friendly communion with the philosopher, smiling perhaps at some of his wild sallies and cynical thrusts (for Socrates at times strangely disturbs the seriousness of his auditory by the mercilessness of his jokes—against vice and foolishness), is intended for a kindred and yet very dissimilar spirit. A clergyman, such as the Church of England offers examples of—a priest without guile—a gentleman without pride, much in communion with the working classes, "honouring all men," "never weary in well-doing." Scholar, author, philosopher, and teacher too, in his way, but not above practical efforts, if even for a small result in good. Deeply penetrated as he is with the axiom that each unit of humanity feels as much as all the rest combined, and impulsive and hopeful in nature so that the remedy suggests itself to him concurrently with the evil.

Next to these, on the shaded bank, are different characters out of work, haymakers in quest of employment; a stoic from the Emerald Island, with hay stuffed in his hat to keep the draught out, and need for his stoicism just at present, being short of baccy—a young shoeless Irishman, with his wife, feeding their first-born with cold pap—an old sailor turned haymaker, and two young peasants in search of harvest work, reduced in strength, perhaps by fever—possibly by famine.

Behind the Pariah, who never has learned to work, appears a group, of a very different class, who, from an opposite cause, have perhaps not been sufficiently used to work either. These are the *rich,* who have no need to work,—not at least for bread—*the "bread of life"* being neither here nor there. The pastry-cook's tray the symbol of superfluity, accompanies these. It is peculiarly English: I never saw it abroad that I remember, though something of the kind must be used. For some years after returning to England I could never quite get over a certain socialistic twinge on seeing it pass, unreasonable as the feeling may have been. Past the pastry-cook's tray come two married ladies. The elder and more serious of the two devotes her energies to tract distributing, and has just flung one entitled "The Hodman's Haven, or drink for thirsty souls," to the somewhat unpromising specimen of navvy humanity descending the ladder: he scorns it, but with good nature. This well-intentioned lady has, perhaps, never reflected that excavators may have notions to the effect that ladies might be benefited by receiving tracts containing navvies' ideas! nor that excavators are skilled workmen, shrewd thinkers chiefly, and, in general, men of great experience in life, as life presents itself to them.

In front of her is the lady whose only business in life as yet is to dress and look beautiful for our benefit. She probably possesses everything that can give enjoyment to life; how then can she but enjoy the passing moment, and like a flower feed on the light of the sun? Would any one wish it otherwise?—Certainly, not I, dear lady. Only in your own interest, seeing that certain blessings cannot be insured for ever—as for instance, health may fail, beauty fade, pleasures through repetition pall—I will not hint at the greater calamities to which flesh is heir—seeing all this, were you less engaged watching that exceedingly beautiful tiny greyhound in a red jacket that *will* run through that lime, I would beg to call your attention to my group of small, exceedingly ragged, dirty children in the foreground of my picture, where you are about to pass. I would, if permitted, observe that, though at first they may appear just such a group of ragged dirty brats as anywhere get in the way and make a noise, yet, being considered attentively, they like insects, molluscs, miniature plants, &c, develope qualities to form a most interesting study, and occupy the mind at times when all else might fail to attract. That they are motherless, the baby's black ribbons and their extreme dilapidation indicate, making them all the more worthy of consideration, a mother, however destitute, would scarcely leave the eldest one in such a plight. As to the father, I have no doubt he drinks, and will be sentenced in the police-court for neglecting them. The eldest girl, not more than ten, poor child! is very worn-looking and thin, her frock, evidently the compassionate gift of some grown-up person, she has neither the art nor the means to adapt to her own diminutive proportions—she is fearfully untidy therefore, and her way of wrenching her brother's hair looks vixenish and *against* her. But then a germ or rudiment of good housewifery seems to pierce through her disordered envelope, for the younger ones are taken care of, and nestle to her as to a mother—the sunburnt baby, which looks wonderfully solemn and intellectual as all babies do, as I have no doubt your own little cherub looks at this moment

asleep in its charming basinet, is fat and well-to-do, it has even been put into poor mourning for mother. The other little one though it sucks a piece of carrot in lieu of a sugar-plum, and is shoeless, seems healthy and happy, watching the workmen. The care of the two little ones is an anxious charge for the elder girl, and she has become a premature scold all through having to manage that *boy*—that boy, although a merry, good-natured-looking young Bohemian, is evidently the plague of her life, as boys always are. Even now he *will* not leave that workman's barrow alone, and gets his hair well-pulled, as is natural. The dog which accompanies them is evidently of the same outcast sort as themselves. The having to do battle for his existence in a hard world has soured his temper, and he frequently fights, as by his torn ear you may know; but the poor children may do as they like with him, rugged democrat as he is, he is gentle to them, only he hates minions of aristocracy in red jackets. The old bachelor navvy's small valuable bull-pup, also instinctively distrusts outlandish-looking dogs in jackets.

The couple on horseback in the middle distance, consists of a gentleman, still young, and his daughter. (The rich and the poor both marry early, only those of moderate incomes procrastinate.) This gentleman is evidently very rich, probably a Colonel in the army, with a seat in Parliament, and fifteen thousand a-year, and a pack of hounds. He is not an over-dressed man of the tailor's dummy sort—he does not put his fortune on his back, he is too rich for that; moreover, he looks to me an honest true-hearted gentleman (he was painted from one I know), and could he only be got to hear what the two sages in the corner have to say, I have no doubt he would be easily won over. But the road is blocked, and the daughter says we must go back, papa, round the other way.

The man with the beer-tray, calling beer ho! so lustily, is a specimen of town pluck and energy contrasted with country thews and sinews. He is humpbacked, dwarfish, and in all matters of taste, vulgar as Birmingham can make him look in the 19th century. As a child he was probably starved, stunted with gin, and suffered to get run over. But energy has brought him through to be a prosperous beer-man, and "very much respected," and in his way he also is a sort of hero; that black eye was got probably doing the police of his master's establishment, and in an encounter with some huge ruffian whom he has conquered in fight, and hurled out through the swing-doors of the palace of gin prone on the pavement. On the wall are posters and bills; one of the "Boy's Home, 41 Euston Road," which the lady who is giving tracts will no doubt subscribe to presently, and place the urchin playing with the barrow in; one of "the Working Men's College, Great Ormond Street," or if you object to these, then a police bill offering £50 reward in a matter of highway robbery. Back in the distance we see the Assembly-room of the "Flamstead Institute of Arts," where Professor Snoox is about to repeat his interesting lecture on the habits of the domestic cat. Indignant pusses up on the roof are denying his theory in toto.

The less important characters in the background require little comment. Bobus, our old friend, "the sausage-maker of Houndsditch," from PAST AND PRESENT, having secured a colossal fortune (he boasts of it *now*), by anticipating the French Hippophage Society in the introduction of horse flesh as a *cheap* article of human food, is at present going in for the county of Middlesex, and, true to his old tactics, has hired all the idlers in the neighbourhood to carry his boards. These being one too many for the bearers, an old woman has volunteered to carry the one in excess.

The episode of the policeman who has caught an orange-girl in the heinous offence of resting her basket on a post, and who himself administers justice in the shape of a push, that sends her

fruit all over the road, is one of common occurrence, or used to be—perhaps the police now "never do such things."

I am sorry to say that most of my friends, on examining this part of my picture, have laughed over it as a good joke. Only two men saw the circumstance in a different light, one of them was the young Irishman, who feeds his infant with pap. Pointing to it with his thumb, his mouth quivering at the reminiscence, he said, "that, Sir, *I* know to be true." The other was a clergyman, his testimony would perhaps have more weight. I dedicate this portion of the work to the Commissioners of Police.

Through this picture I have gained some experience of the navvy class, and I have usually found, that if you can break through the upper crust of *mauvaise honte,* which surrounds them in common with most Englishmen, and which, in the case of the navvies, I believe to be the cause of much of their bad language, you will find them serious, intelligent men, and with much to interest in their conversation, which, moreover, contains about the same amount of morality and sentiment that is commonly found among men in the active and hazardous walks of life; for that their career is one of hazard and danger, none should doubt. Many stories might be told of navvies' daring and endurance, were this the place for them. One incident peculiarly connected with this picture is the melancholy fact, that one of the very men who sat for it lost his life by a scaffold accident, before I had yet quite done with him. I remember the poor fellow telling me, among other things, how he never but once felt nervous with his work, and this was, having to trundle barrows of earth over a plank-line crossing a rapid river at a height of *eighty feet* above the water. But it was not the height he complained of, it was the *gliding motion of the water underneath.*

I have only to observe in conclusion, that the effect of hot July sunlight attempted in this picture, has been introduced, because it seems peculiarly fitted to display *work* in all its severity, and not from any predilection for this kind of light over any other. Subjects, according to their nature, require different effects of light. Some years ago, when one of the critics was commenting on certain works then exhibiting, he used words to the effect that the system of light of those artists was precisely that of the sun itself—a system that would probably outlast, &, &. He might have added, aye and not of the sun only, but of the moon, and of the stars, and, when necessary, of so lowly a domestic luminary as a tallow candle! for tragedies dire as the Oedipus, and tender joyful comedies melting to tears, have ere now been acted to no grander stage-light, I imagine.

For the imperfections in these paintings I submit myself to our great master, the public, and its authorised interpreters, pleading only that first *attempts* are often incomplete. For though certainly not solitary, attempts of the kind have not yet been so frequent as to have arrived at being mapped out in academic plans. But in this country, at least, the thing is done, "la cosa muove," and never again will the younger generations revert to the old system of making one kind of light serve for all the beautiful varieties under heaven, no more than we shall light our streets with oil, or journey by stage-coach and sailing-packet. "Lo que empieza el hombre para sí mismo, Dios le acaba para los otros." "Ce que l'homme commence pour lui, Dieu l'achève pour les autres," being in a somewhat more Christian if less Catholic tongue, for the benefit of those who, like myself, don't read Spanish.

Finally, if in this Catalogue, I have been somewhat profuse in assigning dates, be it borne in mind that strictly, my only claim is, *not to plagiarise.* Poor must be the country that could boast of only one original thinker for each profession; but England, I rejoice to know, owns many a glorious painter!

SONNET

WORK! which beads the brow, and tans the flesh,
 Of lusty manhood, casting out its devils!
 By whose weird art, transmuting poor men's evils,
Their bed seems down, their one dish ever fresh.
Ah me! For lack of it what ills in leash,
 Hold us. It's want the pale mechanic levels
 To workhouse depths, while Master Spendthrift revels.
For want of work, the fiends him soon immesh!

Ah! beauteous tripping dame with bell-like skirts,
 Intent on thy small scarlet-coated hound,
 Are ragged wayside babes not lovesome too?
Untrained, their state reflects on thy deserts,
 Or they grow noisome beggars to abound,
 Or dreaded midnight robbers, breaking through.

Appendix 4

[Ford Madox Brown, Description of Manchester Town Hall Murals, n.d., c. 1893].

PARTICULARS

RELATING TO THE

MANCHESTER TOWN HALL

AND

DESCRIPTION OF THE

MURAL PAINTINGS

IN THE GREAT HALL.

BY FORD MADOX BROWN.

Panel No. 1—The Romans Building a Fort at Mancenion.

This subject embodies the foundation of Manchester; for although the British name "Mancenion" seems to indicate this locality as a centre for population, it is improbable that anything worthy the name of a Town existed before the Roman Mancunium.

Agricola was Governor of Britain at this date—A.D. 60—and was, as his Son-in-law Tacitus informs us, a humane as well as an energetic governor. His rule was much connected with this part of England, so that the General depicted may be considered as representative of that Governor.

A centurion holds the parchment plan of the Camp that is being fortified, while his chief, who also has hold of it, gives his orders. His standard bearer, in this instance a "Dragonifer," holds up the silken, wind-inflated, Dragon standard which the Romans, at this period, had adopted from the "Barbarians."

The Legionaries are doing the masons' work; but the bearers of stones and cement are Britons, impressed for the occasion.

The river Medlock bounds the camp on the south; the background beyond it is formed of oak-forests, red with the last leaves of November, while in the extreme distance is visible the blue streak of the distant Peak hills.

A chilling wind is depicted as agitating the garments of the conquerors, and making the work in hand more arduous to men of southern nationality.

The General's wife, with her little boy, has stepped out of her "cathedra," or litter, to take the air on the half-finished ramparts. She wears a fur cloak, hooded for the cold, and on her hands are muffles. Her naturally black hair is represented as dyed yellow—her eyebrows remaining black—to indicate the luxury of Roman living, even in a camp. Her little son, who is attired in soldier's uniform and "caliga" (boots), is mischievously aiming a kick at one of his mother's Nubian slave chair-bearers.

The interior of the camp, with the Roman four-square tents made of skins, is to be seen behind this group.

Panel No. 2—The Baptism of Edwin.

EDWIN was King of Northumbria and Deira, and was Baptized at York, his Capital, in the year of Our Lord 627, and the next day 11,000 of his principal subjects were Baptized together in the River Swale, and his dominions became Christian. Manchester formed part of the Kingdom of Deira, and was, therefore, under the rule of Edwin. Our authority for this subject is the Venerable Bede, a Monk of Jarrow-upon-Tyne, who wrote his Ecclesiastical History of England about 100 years after this event. Edwin, who in his youth had been a fugitive, and "tutored in the school of sorrow," having regained his inheritance of Northumbria, and successfully annexed the surrounding country, sought in marriage the hand of Ethelberga, daughter of Ethelbert, the Christian king of Kent. Bertha, the Queen of Ethelbert, and daughter of Clovis, the first Christian King of France, had stipulated that on marrying the King of Kent she should be allowed her Church, and the free exercise of her religion, and this being conceded, after a while she effected the conversion of her husband. Ethelberga, their daughter, before uniting herself to Edwin, demanded the same concessions, and was rewarded with a like result. She and her Bishop, Paulinus, whose appearance Bede minutely describes, persuaded the King to be converted about six years after the marriage.

WORDSWORTH, in his sonnet entitled "Paulinus," thus beautifully paraphrases the elder writer:—

> "But, to remote Northumbria's Royal Hall,
> Where thoughtful Edwin, tutored in the school
> Of sorrow, still maintains a heathen rule,
> Who comes with functions apostolical?
> Mark him, of shoulders curved, and stature tall,
> Black hair, and vivid eye, and meagre cheek,
> His prominent feature like an eagle's beak;
> A man whose aspect doth at once appal
> And strike with reverence.****"

A small wooden church, Bede tells us, was hastily constructed for the purpose; this being pulled down afterwards, a stone church was erected in its place, on the site of the present York Minster.

A Roman mosaic pavement is represented as having been used as foundation for the wooden church—as well because at this early date classical remains were frequently incorporated with pagan buildings, as to indicate the connection of this panel with the subject of that of No. 1, which is to represent the Romans in Britain. Bishops, at this date, had not yet adopted the mitre, the first indications of which are only found in 11th century monuments.

Edwin was a wise and valiant King, who, but for his death at the age of 48, in a battle with Cadwallader, King of Wales, might at this early date have united all the Kingdoms of the Heptarchy under his dominions.

Panel No. 3—The Expulsion of the Danes from Manchester.

Rushing down the narrow and winding street of a small wood-built city, the Danes are seen making for an open gateway that discloses the country outside with a Saxon church on a hill.

The Norsemen or Vikings who organised the plundering expeditions, that at this time so much harassed Europe, used to begin their apprenticeship to rapine very early. Fifteen is said to have been about the age when they would start off in quest of adventure, and of that booty on which, a few years later, they would settle down upon as respectable married men and heads of houses.

The Danes are here represented, therefore, as very young men, mere beardless boys in fact, with one or two better seasoned elders to assist them with their experience.

The wealth which they acquired they were wont to convert into gold bracelets which were worn on the right arm.

A rich and successful young chieftain, the wearer of many bracelets, but now badly wounded, is being borne past on a hastily constructed stretcher, his companions endeavouring to protect him and themselves with their uplifted shields, as they run the gauntlet of the Town's-folk's missiles. In front of these a group of four men have fallen confusedly, one over another, on the ground; the pavement consists of the polygonal blocks that the Romans had formed their road of which ran through Manchester.

From a house which faces this scene a young woman has thrown a tile that strikes down the "Raven" Standard-bearer. An aged inmate from the same window throws a spear, the national Saxon weapon, while two little boys gleefully empty a small tub of boiling water on the fugitives.

The Danes, who in a group have reached the shelter of the rampart-gate, pause for one moment to hurl back threats of future revenge on the inimical town's people, whose chained-up dogs bark fiercely at the run-aways, while in the background the soldiers of Edward the Elder are seen smiting the unfortunate loiterers in the race for life. (About the year of our Lord 910.)

Panel No. 4—The Establishment of Flemish Weavers in Manchester.
A.D. 1363

This subject commemorates the foundation of Lancashire supremacy in textile manufactures.

Philippa of Hainalt, Queen of Edward III., is said to have advised the introduction of Flemish weavers into England, and tradition mentions yearly visits which it was her custom to pay them. John of Gaunt, the seat of whose government as Earl Palatine of Lancashire was at Lancaster Castle, was the son of Philippa. Flemish weavers are said to have been established in Manchester; hence the connection of the Queen with this subject.

The season chosen is spring; still the finest part of the year in Lancashire; at which season Chaucer tells us the English people delighted "to gon on Pilgrimages."

The Queen and her attendant ladies have been in the woods "maying," according to the Old English custom, and each has broken a branch of flowering hawthorn, or may. They are habited in "Lincoln green" for the occasion. To the left, a Fleming, of somewhat careworn aspect, his Flemish beaver slung over his back, exhibits to the Queen a piece of cloth the same in colour as that she wears. He is assisted to unroll it by his wife, their child, and a workman. Behind him stands his aged father, ready with a roll of cloth of a different shade. The Queen tries the texture and substance of what is submitted to her with scrutinizing finger.

On the same side of the composition a row of street children have been tutored to kneel in presence of Royalty. One little girl, forgetting her baby's crying, all the same ventures to make faces at the Flemish girl with the wooden shoes to the right of the picture, while a ragged little boy, comfortably seated on the steps of the market cross, is admonished to go down with the other children.

To the right of the beholder, an old weaver, by the name on his cloth "Jan Van Brugge," is seated beside his apprentice at looms which are drawn out to the front of their small shop, under the shutters, raised pent-house fashion.

They are weaving, or pretending to do so, but the master is eagerly looking for the Queen, while the apprentice is as eagerly looking at his master's daughter; she, trifling with a kitten, affects to see no one. In the distance are three archers of the Queen's guard, and two Burghers of Manchester on their knees.

The Queen's palfrey is held by a foot-page, hot with keeping up beside the horses.

The sun illumes all to the left of the spectator, the figures to the right being in reflected light.

Panel No. 5—The Trial of Wyclif.

JOHN WYCLIF, to whom we owe the first translation of the Bible, was born at Spresswell in the extreme north of Yorkshire, about the year 1324.

He has been styled "The Morning Star of the Reformation," and well deserved the appellation, for recent researches in Germany show that many of the Latin tracts published by John Huss a century later were in reality composed by Wyclif; and John Huss led the way to Luther and Reformation almost another century later. But our world-renowned Englishman was not only an innovator and thinker of great originality, he was also one of the greatest scholars of his age. Master of Balliol College, Oxford, from his 37th year, and possessed, seemingly, of unlimited attainments for those times, he was not a mere student, but withal a man of the world much employed politically by Edward III. and his parliaments, being delegated as Royal Commissioner, first to the Pope at Avignon, and again to the peace-conferences at Bruges.

Gradually, as his ethical views of Christianity became confirmed, he gave up the pluralities with which the Court had rewarded his services, retired to his rectory at Lutterworth, abandoned soft living, and, going barefoot himself, began organising that company of poor itinerant preachers (somewhat on the model of the barefoot-friars), which soon was to spread itself over the length and breadth of England.

The Court of Rome at last thought it time to intervene, and caused Wyclif to be cited before Convocation in Old St. Paul's, London. On 19th February, 1377, he there accordingly appeared; but his great patron John of Gaunt, Earl-Palatine of Lancaster—son of the king and practically prime minister at that time—appeared by Wyclif's side, with Lord Percy the Earl-Marshal and soldiers for his protection. The trial, from six o'clock till nine of that winter morn, was little less than an unseemly dispute between John of Gaunt the sovereign of Lancashire, on the one hand, the Courteney Bishop of London, on the other, till the citizens of London fancying they heard the Duke threatening their bishop: "to pull him out of the church by the hair of his head," began such a riot that the trial had perforce to be postponed, and Wyclif was suffered to resume his duties at Lutterworth.

In the composition, near to Courteney on the dais, sits Simon Sudbury, the Archbishop of Canterbury, depicted as endeavouring, in whispers, to assuage the indignation of his colleague.

At Wyclif's feet are seen the five mendicant Friars appointed as his counsel, Wyclif not yet having publicly differed with them. The Earl-Marshal is represented as ordering a stool for the reformer, for, said he, "As you must answer from all these books, Doctor, you will need a soft seat," causing the Prelate still greater indignation; but Wyclif remained standing. Constance, John of Gaunt's second Duchess, a Princess of Spain, is shown plucking her spouse back by his mantle, as though in fear he might in his excitement do some injury to the Prelate. In the background Chaucer, the Duke's other protégé, is seen taking notes on his tablets.

John Wyclif died peacefully in his rectory of Lutterworth seven years later.

Panel No. 6—The Proclamation Regarding Weights and Measures.
A.D. 1556.

In the above year the Court Leet of the Barony of Manchester passed an edict directing all Measures and Weights to be sent in on a certain day to be tested, thus laying the foundation of commercial integrity in the town.

The Records of the Court Leet, or "View of Frank-Pledge," as it was also called, have been already partly published, and are again being printed with a view to their further publication by the Corporation of Manchester.

They present a striking and singular picture of English manners and customs about the 16th Century, and contain such strange and oft-repeated enactments that many reliable authorities are now of opinion they were in reality never carried out, but only represented a sort of moral force.

In the very small town of Manchester of those days there were appointed no less than Four dog-muzzlers, each responsible for the dogs of his own district. Accordingly the Bellman's, or watchman's dog is duly muzzled as by law required, and patiently attends his master, who, with his bell and his lantern, and pole of office, is seen calling out the order of the Court: that on a certain day of the Reigns of Philip and Mary "The Burgesses and others of the Town of Mancestre shall send in alle manere of Weights and Measures to be tried by their Maiesties standard." The immediate effects of this proclamation may be seen in the countenances of the master and mistress of a small sutler's, or general provision, shop depicted in the centre of the composition; the man listening in anxious and undisguised indignation, while his wife removes some butter adhering to the bottom of her scales. On the left of them, their young son, in the blue and yellow garb of King Edward's Schools, with his bow and arrows as required by law, lingers to hear; another boy attracted by the bell runs towards these. On the further side of the picture a man on crutches has left his house to listen also to the cryer.

On the door-step of the shop a beggar-girl has seated herself; near her on the ground is her porringer, or leaden-lidded clap-dish, with the clapping of which beggars seem to have been entitled noisily to arouse public attention. She is exposing to the commiseration of the charitable an exceedingly well-fed, but half naked baby.

Panel No. 7—Crabtree Watching the Transit of Venus.
A.D. 1639.

Master William Crabtree, of Broughton, draper, having been requested to assist the observations of his friend Jeremiah Horrox, the curate of Hool, watched the Transit of Venus over the

Sun, November 24th, 1639 (old style), our 6th December. Horrox, who was poor and alone, and who died before he was two and twenty, might never have made his world-renowned observation had not Crabtree assisted him by letter as to his books of tables, which were obsolete and valueless. By the aid of the new and corrected tables Horrox's calculations came right. The day for the expected event being a Sunday, Horrox asked his friend to watch for him also, lest his clerical duties should interfere with his observing the phenomenon at the right moment.

The weather being cloudy Crabtree watched through that cold winter day from nine a.m. to close upon four p.m., when suddenly a gleam of sunlight revealed the small figure of the planet crossing the sun's disc, on the paper diagram. Crabtree was so perturbed as not to be able, during the few moments the phenomenon remained visible, to take measurements scientifically, but he could corroborate Horrox's observation. The young curate's papers describing the *modus operandi* were discovered in Germany early in this century. This *modus* admitted of Crabtree's wife and children being present, and the researches of archaeologists show us that the astronomer was married some six years before the event depicted. Crabtree being but an amateur, he is represented as employing for his laboratory a sort of store-room over his shop, or counting-house; a glimpse of the latter is seen through the open trap-door, admitting some daylight, though the scene is chiefly lighted from the sunshine on the diagram.

The window-panes of the counting-house are coated with December frost.

Mrs. Crabtree, who is depicted knitting, which was accounted a lawful Sunday recreation in anti-Puritanical days, clutches her young son by the arm, in anticipation of his possible interference with his father's proceedings at such a supreme moment.

Panel No. 8—Chetham's Life Dream.
c. A.D. 1640.

The Boys' School in Manchester, which still bears the name of its founder, Humphrey Chetham, was established in accordance with the terms of his will in 1656.

The school (combined with the library, also his gift) forms no doubt a precursor in the 17th century of those schemes, educational and philanthropic, which so prominently distinguish the 19th. Like his fellow-townsman Crabtree, Chetham was a "drapier" or cloth merchant, but his wealth, great for those days, was largely supplemented by financial transactions of a nature kindred to banking or money-lending. True, however, to the ideal of his life, his will—which occupies four sheets of parchment, and was during his life frequently altered—is chiefly taken up with directions to his trustees for the purchase of the College buildings annexed to the present Cathedral, and for their conversion into a school and library. During his life he boarded out and educated twenty-two poor boys; after his death the number was to be augmented to forty—a number which is now doubled, owing to the increased value of the bequest. In the painting Chetham is represented as studying his will in the garden of the College, which in imagination he has peopled with his "forty healthy boys" and their pedagogue. The school-cook is impatiently awaiting the butcher. The scholars are engaged in drilling, reading, leap-frog, wrestling, and a game called "stools," apparently the forerunner of cricket.

Chetham had forced upon him by Charles I. the invidious honour of collecting the famous "ship-money" in the County of Lancaster, in the prosecution of which he disbursed much of his own money, a loss that he in vain petitioned to have made good to him from the amount collected. Chetham died in 1653.

Panel No. 9—Bradshaw's Defence of Manchester.
A.D. 1642.

This panel represents the defence of Manchester under Bradshaw the Regicide, who with forty musketeers defeated and put to rout between three and four thousand of King Charles's troups under Lords Robert Strange and Montague.

During the action, which took place on Salford Bridge, and for which the town received the thanks of the Parliament, two barns which were situated near the bridge took fire somehow and blazed fiercely during the engagement, much to the inconvenience of the combatants.

At the Salford or nearer end of the bridge is to be seen the small chapel which was first built for the good of his soul by a pious and wealthy yeoman of Eccles—Thomas Del Roche by name. It was latterly used as a gaol or lock-up house.

It is certain that the Gothic-arched bridge was built during Edward III.'s reign, and stood from that early date till its destruction in 1837, the year of Queen Victoria's accession.

The gentleman who has been unhorsed and is being released by his retainers may be Lord Montague, who, with Lord R. Strange, aided in the abortive attempt upon Manchester. Bradshaw, who with his musketeers so powerfully contributed to its defence, is seen in the distance firing his musket from a gun-rest, as at this date was customary.

Panel No. 10—John Kay, Inventor of the Fly Shuttle.
A.D. 1753.

JOHN KAY was born at Walmersley, near Bury, in Lancashire, about the year 1704. This great invention of the Fly Shuttle seems to have been perfected in 1733 at the latter place, where he resided. For three thousand or perhaps five thousand years the peoples of the East and West had been content to go on "throwing" the shuttle with the naked hand, and even as late as the middle of the eighteenth century, in order to weave wide blankets, a couple of weavers were needed at the loom "throwing" the shuttle from one to the other. Henceforth, through the unique intellect of this Lancashire gentleman, all was to be changed. A single one-armed weaver could now get through work that before would have needed the four arms of a pair of weavers, and this with the sole assistance of a string and a handle thereto attached. About twenty years after, however, the weaving population began to notice this fact, and rioters broke into Kay's house at Bury with the most sinister intentions. Tradition tells us that his wife saved him from their fury by having him hurried away concealed in a wool sheet.

In the composition, to the left, the rioters are seen smashing in the windows, whilst on the floor in front of them lies an exemplification of the cause of the discord—the very simple invention by means of which two boxes fastened to the loom fire the shuttle, so to say, to and fro into each other's mouths.

Kay's son Robert, a boy about twelve, is depicted cautiously watching the rioters, and hastening his parents' movements; whilst Mrs. Kay and two workmen hurry the departure of their master, for whom a cart waits at the door. Kay, with his still disengaged hands, draws his wife towards him and imprints what may be a last kiss on her cheek. His two little girls are weeping and wringing their hands.

But for Kay's simple, yet epoch-fixing invention of the shuttle which, without hands, flies backwards and forwards across the loom, all the wonders and achievements of steam-weaving would never have been perfected.

But however disastrous to him this inroad of the men might be, the combination of the masters to resist in the law courts his just claims to royalties proved even more so, and Kay retired to France a ruined man.

Panel No. 11—The Opening of the Bridgewater Canal.
A.D. 1761.

The DUKE OF BRIDGEWATER, after whom the Canal was named, undertook this great and, in those days, original work, under the advice and direction of the eminent engineer, James Brindley. The Duke was then comparatively young—20 years younger than his engineer—and he took up the work in order to facilitate the transport of the coals of his estate to the City of Manchester. During the progress of it he lived in a house near by with no companions but his engineer and his estate agent. Such was his enthusiasm for the undertaking that his only diversion from it seemed to be, every five minutes during the evening, tapping the barometer, with a view to the next day's work; a pipe and a glass of water his only refreshments. He had been engaged to one of the two beautiful Miss Gunnings, great friends of George III.; but having quarrelled with his intended about her sister, he never noticed any woman again. He died immensely rich, and collected the Bridgewater Gallery of Old Masters.

Brindley, the engineer, used to make his calculations on a method of his own, that few could understand, for he could neither read nor write. When a Committee of Parliament doubted his plans for carrying water across hills, he procured a hundredweight of clay, and, in their presence, modelled a canal with it, which held every drop of water till next day, and so convinced them. He married a schoolgirl of 15—commencing the courtship by taking her bags of sweetmeats—but she made him an excellent wife. The opening of the Bridgewater Canal took place at Barton Aqueduct, over the River Irwell, in 1761. It is represented in the fresco by the first barge starting for coal drawn by a pair of mules. The bargee's wife steers the boat, with her twin babies (got up for the occasion) tied on the cabin roof in front of her. The Duke, from one of his own barges, witnesses the proceedings. Brindley, who always had about him a wicker-coated flask of brandy, with which to lessen the severity of his arduous duties, reminds his Grace (who was not of a convivial turn) that he has omitted providing refreshments.

A boy has been sent in a boat by farm-people living down the canal to fetch coals. The Duke's orders were always to execute *the smaller orders first*.

Panel No. 12—Dalton Collecting Marsh-Fire Gas.

JOHN DALTON, inventor of the Atomic Theory, was born at Eaglesfield, near Cockermouth, in Cumberland, September 5th, 1766. As early as when only twelve he started a school in partnership with a brother only a few years older. The stronger pupils, it is stated, would challenge Dalton to fight on his offering to correct them. For many years of his life he maintained himself, in Manchester, by school-teaching, but this laborious, if honourable, occupation did not hinder him from indulging in the most abstruse and far-reaching specula-tions and researches; the result being that this Manchester schoolmaster, alone and unas-sisted, made himself the father of modern chemistry—that is, if chemistry is one of the exact sciences, and not a succession of independent experiments. How the idea of the Atomic Theory first presented itself to his mind it would be interesting to know, but we know little of it. All we hear is, that it occurred to him as required, in order to explain certain remarkable

phases of matter which combines in some proportions and not in others. Once that the idea had taken hold of his mind, he never abandoned it till he had worked it out. The natural gases presented the readiest mode of investigation: so he is represented as collecting marsh-fire gas, one of the natural and primitive forms of gas. The mode of getting it is the usual one of stirring-up the mud of a stagnant pond, while an assistant (in this case a farmer's boy) catches the bubbles, as they rise, in a wide-mouthed bottle, having a saucer ready to close up the mouth under the water when the bottle is full. A group of children are watching him, and the eldest, who has charge of them, is telling the little boy who is bent on catching stickle-backs that "Mr. Dalton is catching Jack o'Lanterns"—marsh-fire gas being, when on fire, the substance *the Will o'the Wisp* is composed of.

Dalton's Great Invention met with slow recognition at first, as is usual in conservative England; but the French Institute having made him one of their eight foreign members, and treated him with the highest distinction while in Paris, the English Royal Society gave in at length, and elected him, without his consent, and he was pensioned by the government of William IV. He died in July, 1844.

Notes

Introduction

1. *Ford Madox Brown, 1821–1893,* exh. cat., by Mary Bennett, Walker Art Gallery, Liverpool, 1964. See also Mary Bennett, *Artists of the Pre-Raphaelite Circle; the First Generation: Catalogue of Works in the Walker Art Gallery, Lady Lever Art Gallery and Sudley Art Gallery,* London, 1988, "Ford Madox Brown at Southend," *Burlington Magazine* (February 1973): 74–78, and Bennett's Brown entries in *The Pre-Raphaelites,* exh. cat., Tate Gallery, London, 1984 (hereafter cited as Tate, 1984).

2. Allen Staley, *The Pre-Raphaelite Landscape,* Oxford, 1973.

3. Lucy R. Rabin, *Ford Madox Brown and the Pre-Raphaelite History Picture,* New York, 1978.

4. Virginia Surtees, ed., *The Diary of Ford Madox Brown,* New Haven, 1981.

5. A. C. Sewter, *The Stained Glass of William Morris and His Circle,* 2 vols., New Haven, 1974, 1975.

6. Julian Treuherz, "Ford Madox Brown and the Manchester Murals," in J. H. G. Archer, *Art and Architecture in Victorian Manchester,* Manchester, 1985, 162–207; Julian Treuherz, *Pre-Raphaelite Paintings from Manchester City Art Galleries,* Manchester, 1993. On *Work,* see Albert Boime, "Ford Madox Brown, Thomas Carlyle, and Karl Marx: Meaning and Mystification of Work in the Nineteenth Century," *Arts Magazine* (September 1981): 116–25; E. D. H. Johnson, "The Making of Ford Madox Brown's 'Work,'" in I. B. Nagel and F. S. Schwarzbach, eds., *Victorian Artists and the City,* New York, 1980, 142–52; Mary Bennett, 'The Price of 'Work,'" in Leslie Parris, ed., *Pre-Raphaelite Papers,* London, 1984, 143–52; Gerard Curtis, "Ford Madox Brown's 'Work': An Iconographic Analysis," *Art Bulletin* 74 (December 1992): 623–36; Kenneth Bendiner, *Ford Madox Brown: Il lavoro,* Turin, 1991.

7. Teresa Newman and Ray Watkinson, *Ford Madox Brown and the Pre-Raphaelite Circle,* London, 1991.

8. Ford Madox Hueffer, *Ford Madox Brown: A Record of His Life and Work,* London, 1896.

9. A. S. Marks, "Brown's 'Take Your Son, Sir!'" *Arts Magazine* (January 1980): 131–41; Hallman B. Bryant, "Two Unfinished Pre-Raphaelite Paintings: Rossetti's 'Found' and F. M. Brown's 'Take Your Son, Sir,'" *Journal of Pre-Raphaelite Studies* (November 1982): 56–67; Jillian Carman, "Ford Madox Brown and 'Cromwell on His Farm': A Debt to Thomas Carlyle," *Journal of Pre-Raphaelite Studies* (November 1983): 121–31; Deborah Cherry, "The Hogarth Club," *Burlington Magazine* (April 1980): 237–38; Maria Buttafoco, "F. M. Brown o 'del meccanismo di una pittura di storia," *Annua dell istitute di storia dell arte* 1 (1981–82): 53–62; Helen O. Borowitz, "'King Lear' in the Art of Ford Madox Brown," *Victorian Studies* (Spring 1978): 323–27.

10. William Michael Rossetti, "Ford Madox Brown: Characteristics," *Century Guild Hobby Horse* 1 (1886): 48–54.

Chapter 1. Archaism

1. The four other members of the Brotherhood were Frederic George Stephens, James Collinson, Thomas Woolner, and William Michael Rossetti. Woolner was a sculptor, Collinson was a rather fitful and less-than-committed artist; Stephens and W. M. Rossetti, who would become art critics, had hardly painted at all. On the founding of the Brotherhood and its aims, see Quentin Bell, *A New and Noble School: The Pre-Raphaelites,* London, 1982; G. H. Fleming, *That Ne'er Shall Meet Again,* London, 1971; Timothy Hilton, *The Pre-Raphaelites,* London, 1970; John Nicoll, *The Pre-Raphaelites,* London, 1970; Tate, 1984; Staley, 1973; Raymond Watkinson, *Pre-Raphaelite Art and Design,* Greenwich, Conn., 1970; Christopher Wood, *The Pre-Raphaelites,* New York, 1981.

2. See Franz Kugler, *Handbook of the History of Painting,* London, 1842; Anna Jameson, *Memoirs of the Early Italian Painters, and of the Progress of Painting in Italy: From Cimabue to Bassano,* London, 1845; Lord Lindsay, *Sketches of the History of Christian Art,* London, 1847.

3. Ruskin's points of view had been presented in *Modern Painters,* the first volume of which had been published in 1843; the second volume appeared in 1846. The phrase about selecting and rejecting appears toward the end of vol. 1: John Ruskin, *The Works of John Ruskin,* library ed., ed. E. T. Cook and A. D. O. Wedderburn, London, 1903–12, 3:624.

However, the one Pre-Raphaelite who most strongly claimed Ruskin's influence, Holman Hunt, had apparently first been stimulated by his views in 1847 by reading vol. 2. See Hunt, *Pre-Raphaelitism and the Pre-Raphaelite Brotherhood,* London, 1905, 1:32, 81–91, where the passages of Ruskin's writings recalled by Hunt are mostly to be found in *Modern Painters,* vol. 2. Both volumes, however, are devoted to truthfulness in art, reject idealization, and have a realist bent.

4. See page 6.

5. See Hueffer, 1896, 63–66; Hunt, 1905, 1:225–28. For Hunt's criticism of Brown as too foreign-trained, archaistic, and indebted to German art, see Hunt, 1905, 1:125–28, 172.

6. Letter of 14 May 1851; Hueffer, 1896, 73.

7. Hunt, 1905, 1:246–47. The initials P.R.B., mentioned by Brown, stand for "Pre-Raphaelite Brotherhood," and were placed on the first canvases of the Pre-Raphaelites instead of signatures.

8. For example, Brown reacquired *The Medway from Shorn Ridgeway, Kent* (private collection) in 1873; the picture had been first painted in 1849, and Brown retouched it upon getting it back in the 1870s. See Tate, 1984, no. 20, where the 8 × 12 in. painting is reproduced. Sometimes collectors as well as Brown himself encouraged retouching. Thus the collector T. E. Plint in 1859 bought Brown's *Wycliffe* (1847–48) (Fig. 17) and had Brown freshen the color. See Tate, 1984, no. 8.

9. Ruskin, 1903–12, 12:319–23.

10. See the reviews of Pre-Raphaelite paintings gathered together in Fleming, 1971. The Brotherhood's early admiration for Paolo Lasinio's engravings after the Campo Santo frescoes in Pisa (dating from the fourteenth and fifteenth centuries), for example, is documented by most writers on Pre-Raphaelitism (see note 1). In 1893, Brown told his grandson that it was he, Brown, who encouraged Hunt and the other Pre-Raphaelite Brothers in 1848 to look seriously at Lasinio's engravings of the Campo Santo. See Hueffer, 1896, 63. The Brotherhood's magazine of 1850, *The Germ,* is also filled with enthusiastic references to the primitives.

11. Ruskin, 1903–12, 12:324–27. On the date of Ruskin's meeting with the Pre-Raphaelites, see Staley, 1973, 19.

12. For example, he wrote of the truthfulness of the quattrocento artists' representation of infinite distance in their skies: "They did it, I think, with the child-like, unpretending simplicity of all earnest men; they did what they loved and felt"; Ruskin, 1903–12, 4:83–84.

13. Ibid., 12:339–93.

14. *The Germ* 1.2 (1850):58–64. The author of the article is given as John Seward, which William Michael Rossetti informs us was a pseudonym of Stephens; see W. M. Rossetti's preface to *The Germ* (facsimile edition), London, 1901, 21.

15. Hunt, 1905, 81–91. In a conversation with Millais in February 1848 about Ruskin's *Modern Painters,* Hunt exclaimed, "passages in it made my heart thrill. He feels the power and responsibility of art more than any author I have ever read." While it is true that Hunt's recollection of conversations decades before, word for word, in *Pre-Raphaelitism and the Pre-Raphaelite Brotherhood* (1905) is undoubtedly a (somewhat biased) reconstruction rather than an exact record, his detailed presentation of the genesis and underpinnings of Pre-Raphaelitism is a primary document of the movement.

16. "Modern versus Ancient Art," *The Builder* (4 November 1848): 530–31, and "On the Influence of Antiquity on Italian Art," *The Builder* (2 December 1848): 580–81. Both essays were signed "An Artist." Brown wrote the first article between 28 and 31 October 1848; see Surtees, 1981, 49. See Appendixes 1 and 2.

17. Thomas's essays "On the Influences which tend to Retard the Progress of the Fine Arts" appeared in *The Builder* on 9, 16, and 23 September 1848.

18. Brown, November 1848; see Appendix 1.

19. Ruskin, 1903–12, 4:263–65.

20. Newman and Watkinson, 1991, 43.

21. See, for example, Ruskin's comments in *Modern Painters,* vol. 2, Ruskin, 1903–12, 4:85–86.

22. *The Exhibition of WORK, and other Paintings, by Ford Madox Brown,* exh. cat., by Ford Madox Brown, 191 Piccadilly, London, 1865, no. 36. See Appendix 3 (henceforth cited as Brown, 1865).

23. In the mid-nineteenth century, both Holbein and Dürer were frequently seen as similar to the Italian primitives in their linearity, straightforwardness, detail, and lack of gracefulness. And they were frequently contrasted to Raphael. See Franz Kugler, *Kugler's Handbook of Painting: The German, Flemish, Dutch, Spanish, and French Schools,* 1st English ed., 1846, London, 1854, 3:191 and 193. The English translation of Kugler's volumes on the Italian Schools was first published in 1842. See also William Vaughan, *German Romanticism and English Art,* New Haven, 1979, 253; John Christian, "Early German Sources for Pre-Raphaelite Designs," *Art Quarterly* 36.1–2 (1973): 68ff. Brown had been deeply impressed by the Holbeins in Basel, which he saw en route to Rome in 1845. See Hueffer, 1896, 41.

24. See Robert Rosenblum, *Transformations in Late Eighteenth-Century Art,* Princeton, N.J., 1969, 164–91.

25. Ibid., passim.

26. On the Nazarenes, see Keith Andrews, *The Nazarenes: A Brotherhood of German Painters,* Oxford, 1964.

27. See Andrews, 1964, and Camillo von Klenze, "The Growth of Interest in the Early Italian Masters, from Tischbein to Ruskin," *Modern Philology* 4 (October 1906): 207–68.

28. A. F. Rio, *De la poésie Chrétienne,* Paris, 1836, passim. See also Vaughan, 1979, 91.

29. A. W. N. Pugin, *Contrasts,* 2d ed., London, 1841, iii.

30. See Vaughan, 1979, 91; and Phoebe Stanton, *Pugin,* London, 1971, 87.

31. *The Builder* (2 August 1845), 367; see Vaughan, 1979, 91.

32. On the Parliament frescoes, see T. S. R. Boase, "The Decoration of the New Palace of Westminster, 1841–1863," *Journal of the Warburg and Courtauld Institutes* 17 (1954): 319–58; Vaughan, 1979; and David Robertson, *Sir Charles Eastlake and the Victorian Art World,* Princeton, N.J., 1978, chap. 4 and appendix D.

33. *The Execution of Mary Queen of Scots* was exhibited at the Paris Salon in 1842. The *Ascension* was a sketch submitted to a competition for the altarpiece of Saint James, Bermondsey. The contest was won in 1845 by John Wood, and his enormous *Ascension* is still in the church. Among the judges of the contest were Charles Eastlake and Benjamin Robert Haydon. See Chapter 5, note 83 where the description of the contest in the *Art-Union* (February 1845): 54, is given.

34. Brown's original cartoon of *The Body of Harold* is today in the Camberwell School of Art, London. The painting developed from the cartoon (Fig. 11) is of a later date, but follows the composition and details of the cartoon very closely. The cartoon is reproduced in Newman and Watkinson, 1991, pl. 35.

35. Brown wrote to Cornelius Gurlitt in 1891, "Before going to Rome in 1845 I had already received some considerable impulse from the German engravings in the Parisian shop windows. I and my friends, French or Belgian, often discussed them; we did not require to go to Rome for this." See C. Gurlitt, *Sir Edward Burne-Jones,* Munich, 1895, 35.

36. See Chapter 1, note 50.

37. See Robertson, 1978, 59–60.

38. See ibid., passim: and Vaughan, 1979, 180–89.

39. See Robertson, 1978, 328; it had originally been proposed that the designers of decorative art for the Palace of Westminster would be selected by competition, and such a contest was held in 1844, before Pugin's appointment to the task.

40. "Our Barry-eux Tapestry. To Charles Barry, Esq., R.A.," *Punch* 14 (1848): 33.

41. "For Parliament (a cartoon)," *Punch* 9 (1845): 150.

42. "Advice to Aspiring Artists," *Punch* 9 (1845): 103.

43. "High Art and the Royal Academy," *Punch* 14 (1848): 197.

44. *Athenaeum* (17 May 1845): 495. The paintings reviewed were Herbert's *Saint Gregory the Great Teaching a Company of Choir Boys* (no. 338; untraced), and *Portrait of A.W.N. Pugin* (no. 423; Houses of Parliament, London), reprod. on the frontispiece of Stanton, 1971. At this same exhibition, the *Athenaeum*'s reviewer, while discussing the representation of angels, described the style of Rubens and "the formalities of Young Germany" [i.e., the Nazarenes] as the most extreme opposites. See *Athenaeum* (10 May 1845): 466.

45. See Vaughan, 1979, 206–9; Robertson, 327ff. gives details of the contests; see also Boase, 1954. Brown's friendship with Armitage in Paris is noted in Hueffer, 1896, 28. Both Armitage and Brown had studios in Tudor Lodge, London, in 1844.

46. On Brown's friendship with Thomas, see the references to him throughout Brown's diary, Surtees, 1981. On Thomas's commission and its revocation, see Vaughan, 1979, 210–11. Richard Redgrave's tentative commission was also revoked; his subject, with some revision, was given to C. W. Cope, and Thomas's subject was given to Maclise. Engraved reproductions of the cartoons can be found in F. K. Hunt, *The Book of Art,* London, 1846, and J. J. Linnel and W. Linnel, *The Prize Cartoons,* London, 1843.

47. A fragment of Brown's *Justice* cartoon is in the Manchester City Art Gallery. Two other fragments were sold with the Manchester fragment in lot 26, Sotheby's, London, 2 May 1972.

48. Hueffer, 1896, 36.

49. See Vaughan, 1979, 7 n. 28.

50. According to David Robertson, 1978, 59, in autumn 1841, Cornelius happened to visit London. The prime minister, Robert Peel, met him, and asked Eastlake to seek his advice. Cornelius had already left for Ostend, but Eastlake had previously discussed fresco technique with Cornelius, and Eastlake forwarded his notes to Peel, who sent them on to Prince Albert.

51. On the proposal to include Tudor portraits, announced after the competition of 1843, see Robertson, 1978, 69.

52. *Athenaeum* (9 September 1848): 11.

53. *Art Journal* (1848): 144.

54. This recollection by Brown appears in his article "Historic Art," *Universal Review* (September

1888): 48–49. It is quoted in full in Hueffer, 1896, 45–46.

55. Brown, 1865, no. 10.

56. This famous mural was reproduced in outline engraving in Lasinio's publications on early Italian art, illustrations that the young Pre-Raphaelites admired during their formation in 1848, and which Brown recollected encouraging them to study. See Hueffer, 1896, 63.

57. This is noted in Brown's description of the work in his 1865 catalogue, no. 7. See Appendix 3.

58. This work is now attributed to Giovanni Battista Utili or Biagio d'Antonio de Firenze. The painting was acquired by Christ Church College through the Fox-Strangeways gift, c. 1834. By 1842, when Ruskin made a drawing of this work, it was attributed to Fra Filippo Lippi. Another painting in the collection by the same hand was in 1833 said to be by "Massolino de Panicale." See J. Byam Shaw, *Paintings by Old Masters at Christ Church College,* London, 1967, cat. no. 43, and Gail S. Weinberg, "First of All First Beginnings: Ruskin's Studies of Early Italian Paintings at Christ Church," *Burlington Magazine* 134 (February 1992): 111–20. Brown's visit to the Christ Church art collection, rich in trecento and quattrocento paintings, is suggested by a Brown drawing, dated 1847, *The Rest on the Flight into Egypt,* which is inscribed "Dedicated to ye Fellowes of Christ Colledge, Oxford." The drawing, in the Birmingham Art Gallery, is reproduced in Newman and Watkinson, 1991. Although the subject matter is different, this drawing strongly resembles the figural composition of *Oure Ladye. Oure Ladye,* which was originally a drawing, was apparently damaged in an American exhibition of 1857; it was reworked and color added in 1861. On the American exhibition, see Susan P. Casteras, *English Pre-Raphaelitism and Its Reception in America in the Nineteenth Century,* Rutherford, N.J., 1990.

59. Brown, 1865, no. 3. See Appendix 3.

60. In 1846 Brown painted *Southend* (Fig. 19), which was retouched in 1858; *The Medway Seen from Shorn Ridgeway* of 1849 (private collecting reprod. in Tate, 1984, no. 20) was retouched in 1873; and *Windermere* (Fig. 20), begun in 1848, was retouched in 1854–55. See the discussions of these works in Mary Bennett, "Brown at Southend," *Burlington Magazine* (February 1973): 74–78; Staley, 1973, 27, 31–33, 36–38, 97; Bennett, 1988, 25–27.

61. See Bennett, 1988, 22–24.

62. Brown, 1865, no. 42, see Appendix 3.

63. See Hunt, 1905, 1:121–26.

64. J. G. Millais, *The Life and Letters of Sir John Everett Millais,* London, 1899, 1:61.

65. Staley, 1973, 1–14. George P. Landow, in *William Holman Hunt and Typological Symbolism,* New Haven, 1979, prefers to see Ruskin's influence on Pre-Raphaelitism not so much in terms of realism, but in terms of typological symbolism. The use of foretelling "types" in religious paintings, a standard practice from early Christian times onward, is apparent in English art before Ruskin's exposition in volume 2 of *Modern Painters,* and does not appear in Holman Hunt's first Pre-Raphaelite painting, *Rienzi* (private collection), even though Hunt was supposedly thrilled by Ruskin's writings on this subject. Typological symbolism was certainly employed by the Pre-Raphaelites in the 1850s, but its importance for Pre-Raphaeliteism is, I believe, overstated by Landow, and is certainly not extolled in such Pre-Raphaelite documents as *The Germ,* as is realism and the truthfulness of the primitives.

66. Rossetti's flattering letter to Brown, introducing himself and begging for instruction, is reproduced in Hueffer, 1896, 50–51.

67. The lost Brown painting, highly Nazarenesque, was called *The Seraph's Watch;* Rossetti's copy is usually titled *Cherub Angels Watching the Crown of Thorns* (private collection, reprod. in Tate, 1984, no. 11). On the outline drawings by Hunt, Rossetti, and Millais, see Alastair Grieve, "Style and Content in Pre-Raphaelite Drawings," in L. Parris, ed., *Pre-Raphaelite Papers,* London, 1984, 23–43; *The Drawings of John Everett Millais,* Arts Council Touring Exhibition, catalogue by Malcolm Warner, Bolton, Brighton, Sheffield, Cambridge, and Cardiff, 1979; Tate, 1984, nos. 158–59.

68. Brown, "Modern vs. Ancient Art," 531 (my emphasis). See Appendix 1.

69. The Pre-Raphaelites evidently felt the doctrines of Reynolds to be still operative in the English artworld; they mockingly referred to him as "Sir Sloshua" and used the term "slosh" to denigrate the grand manner brushwork that obscured outline and detail. See George P. Landow et al., eds., *A Pre-Raphaelite Friendship: The Correspondence of William Holman Hunt and John Lucas Tupper,* Ann Arbor, Mich., 1986, Letter 3, n. 5.

70. On Hunt's dependence on Landseer, see Derek Hill, "Landseer as a Craftsman," in *Sir Edwin Landseer,* exh. cat., Royal Academy of Arts, London, 1961, xiii; Kenneth Bendiner, "William Holman Hunt's 'The Scapegoat,'" *Pantheon,* annual issue (December 1987): 124–28; Tate, 1984, no. 84. See also *Sir Edwin Landseer,* exh. cat., by Richard Ormond, Philadelphia Museum of Art and the Tate Gallery, London, 1982.

71. On Egg's friendship with the Pre-Raphaelites, see Hunt, 1905, 1:212–14. On Mulready and the Pre-Raphaelites, see Staley, 1973, 5, 12, 22, 172–73; K. M. Heleniak, *William Mulready,* New Haven, 1980, 74; Hunt, 1905, 1:49; Hueffer, 1896, 77.

72. A letter of 8 September 1843 from Etty thanks Brown for his hospitality and gives particu-

lars about the Parliament competition; see Newman and Watkinson, 1991, 19.

73. Ibid., 21.

74. There had been some other conservative works by Brown back in 1846, when he had returned from Rome and was painting the archaistic *Mr. Bamford,* such as the dark and vigorously brushed *Portrait of a Boy* in the Birmingham Art Gallery.

75. See Quentin Bell, "The Pre-Raphaelites and their Critics," in Leslie Parris, ed., *Pre-Raphaelite Papers,* London, 1984, 11.

Chapter 2. Humor

1. Hueffer, 1896, 31. For an English translation of *Till Eulenspiegel,* which includes a study of the authorship of the book, its publication history, and an analysis of its humor and innovations, see Paul Oppenheimer, ed., *Till Eulenspiegel. His Adventures,* New York, 1991.

2. Hueffer, 1896, 31.

3. Oliver Goldsmith, *The Vicar of Wakefield,* chap. 5, in P. Cunningham, ed., *The Works of Oliver Goldsmith,* New York, 1900, 1:117–18. See Rabin, 1978, 44.

4. Hunt, 1905, 1:171.

5. Brown's painting is so at odds with Goldsmith's work that Julian Treuherz has suggested, in conversation with me, that Brown's subject may not be from the *Vicar of Wakefield* at all. Holman Hunt, 1905, 1:171, had no doubt, however, and reproduced Brown's painting as *Scene from the Vicar of Wakefield.* Treuherz in *Pre-Raphaelite Paintings from Manchester City Art Galleries,* Manchester, 1993, 12, notes that no episode of the *Vicar of Wakefield* seems to correspond with Brown's scene.

6. See page 13.

7. See Brown's description of the subject in his 1865 catalogue, no. 28; Appendix 3.

8. The review by Dr. Foerster originally appeared in the *Kunstblatt* and was published in translation in the *Art Journal* (1845): 127. See Rabin, 1978, 72.

9. On the pro-Saxon bias in the nineteenth century, see Roy Strong, *And When Did You Last See Your Father,* London, 1978, and Asa Briggs, *Saxons, Normans and Victorians,* Bexhill-on-Sea, 1966. The historian quoted by Brown in his 1844 catalogue description of the cartoon, Auguste Thierry (whose relevant work was *History of the Conquest of England by the Normans,* London, n.d.), was decidedly anti-Norman. Brown's 1844 catalogue description is given in Hueffer, 1896, 33 n.

10. See Brown's descriptions of the murals in Appendix 4. The humorous aspects of other of the Manchester murals, for example, *The Proclamation of Weights and Measures* (Fig. 77) and *The Romans Building a Fort at Mancenion* (Fig. 73) will be noted later.

11. See Brown's description of this Arthurian subject in Brown, 1865, no. 32; Appendix 3.

12. See Brown's lengthy description in Brown, 1865, unnumbered entry; Appendix 3.

13. Brown, 1865, no. 14; Appendix 3.

14. Brown, 1865, no. 14; Appendix 3. Brown also noted here that the cabin boy doesn't give a hang about emigration; it's just a normal trip to him.

15. In the Brown, 1865 (no. 69) description of the pen-and-ink drawing for this subject, Brown points out the obviously lying countenances and attitudes of the various brothers; see Appendix 3.

16. The fact that elsewhere in this same image Brown included complex bird symbolism, involving the return of the soul, only makes the chicken vignette even more outlandish. On the bird symbolism, see Brown, 1865, no. 68; Appendix 3.

17. Letter from Craven to Brown, 11 December 1868, Brown family papers, notes on which were kindly shown to me by Mary Bennett.

18. Brown, 1865, no. 27; see Appendix 3.

19. Hueffer, 1896, 421–22.

20. The 1853 drawing (Fig. 30) that became the *Cromwell* (Fig. 31), for example, includes a servant calling Cromwell to dinner. One apparent exception to this process, however, is the *Last of England.* A pencil drawing, dated 1852, in the Birmingham Art Gallery is a highly finished study of the subject, devoid of cabbages, cabin boy, and the vegetables in the lifeboat. This drawing, it seems, was originally a cartoon for the Birmingham painting, but was worked on as late as 1855. See Tate, 1984, no. 178. The original oil sketch for the Birmingham painting (sold Sotheby's, London, November 1995), was worked on simultaneously with the "cartoon" drawing and the Birmingham oil. This oil sketch, finished in 1855, however, contains the cabbages in the foreground.

21. Vol. 1 (1886), 48–54.

22. See page 73, where W. M. Rossetti's letter to his wife detailing his view of the *Hobby Horse,* its editor, A. H. Mackmurdo, and the commissioned article on Brown are presented.

23. See, for example, Bennett, 1988, 22–55; Treuherz, 1985, 162–207; and *Ford Madox Brown,* Liverpool, 1964, nos. 44–46.

24. Brown, *Diary,* 16 August 1854; Surtees, 1981, 76.

25. Hunt, at the very time that Brown was starting *Pretty Baa-lambs,* was at work on *The Hireling Shepherd* (Manchester City Art Galleries), which he later described as a realist antidote to "Dresden china *bergers,*" a reference to frivolous

Rococo art. See *William Holman Hunt,* exh. cat., by Mary Bennett, Walker Art Gallery, Liverpool, 1969, no. 22. Brown visited Hunt at Ewell while the latter was painting the background of *The Hireling Shepherd.* See Hunt, 1905, 1:276–78.

26. The portrait and letters on the table, which refer to the distant fighting in the Crimean War, were added later, after the picture had been commenced in 1851.

27. On the socially engaged theme of the Victorian seamstress, see T. J. Edelstein, "They Sang 'The Song of the Shirt': The Visual Iconology of the Seamstress," *Victorian Studies* 23.2 (Winter 1980): 183–210. A replica of Redgrave's *The Sempstress* of 1844 is in the Forbes Magazine Collection.

28. See Brown's description of the picture in the Royal Academy catalogue of 1851, no. 380, and Tate, 1984, no. 7.

29. Staley, 1973, 44.

30. *Republic,* 388e, *Plato's Republic,* trans. P. Shorey, Loeb Classical Library, Cambridge, Mass., 1946, 211–12. I am indebted to the lengthy entry on "Comic Art and Caricature" by several authors in the McGraw Hill *Encyclopedia of World Art,* New York, 1960, 3:752–75, which includes an extensive bibliography. Also informative is Werner Hofmann, *Caricature from Leonardo to Picasso,* New York, 1957.

31. *Laws,* 816e, and *Philebus,* 49e; *Plato, Laws,* vol. 2, trans. R. G. Bury, Loeb Classical Library, Cambridge, Mass., 1925, 97; *Plato, The Statesman. Philebus. Ion.,* Loeb Classical Library, Cambridge, Mass., 1925, 339.

32. Ruskin, for example, makes a case for this sort of comic relief in Shakespeare. See Ruskin, 1903–12, 1:173–74.

33. *Poetics,* 1449a; *Aristotle, The Poetics. Longinus on the Sublime, Demetrius on Style,* Loeb Classical Library, Cambridge, Mass., 1932, 17–21.

34. See Aristotle, *Poetics I with the Tractatus Coislinianus,* trans. Richard Janko, Indianapolis, Ind., 1987, 43–46, and Richard Janko, *Aristotle on Comedy,* London, 1984.

35. Dio Chrysostomus, *Orations,* 2.4. *Dio Chrysostom,* trans. J. W. Cohoon, Loeb Classical Library, Cambridge, Mass., 1932, 53.

36. Thomas Hobbes, *The English Works of Thomas Hobbes,* ed. William Molesworth, London, 1839–45, 3:27 and 46. Anthony Ashley Cooper, Earl of Shaftesbury, *Characteristics of Men, Manners, Opinions, Times,* ed. J. M. Robertson, Indianapolis, Ind., 1964; on Shaftesbury's conception of humor, which also involves notions of ridicule as a test of truth, see Stanley Grean, *Shaftesbury's Philosophy of Religion and Ethics,* Athens, Ohio, 1967, chap. 8.

37. Charles Baudelaire, *De l'essence du rire et généralement du comique dans les arts plastiques,* Paris, 1855.

38. R. W. Emerson, "Comic Theory" (1843), in Paul Lauter, ed., *Theories of Comedy,* Garden City, N.Y., 1964, 378–87.

39. Champfleury (Jules Husson), *Histoire de la Caricature,* Paris, 1865.

40. *Jokes and their Relation to the Unconscious* (1905), vol. 3 of the *Standard Edition of the Complete Psychological Works of Sigmund Freud,* trans. James Strachey, London, 1960.

41. H. Spencer, "The Philosophy of Laughter," *Macmillan's Magazine* (March 1860), in *Essays,* vol. 2, London, 1901.

42. Brown, 1865, unnumbered entry for *Work.* See Appendix 3.

43. An undated pamphlet, *Particulars Relating to the Manchester Town Hall and Description of the Mural Paintings in the Great Hall by Ford Madox Brown,* is certainly by the artist himself, and contains a detailed entry on each of the Manchester murals. *The Expulsion of the Danes* is described on p. 5. A modern reprint of the pamphlet, unattributed to Brown, is still available at the Manchester Town Hall; see Treuherz, 1985, 162–207. The complete text of the pamphlet is presented in Appendix 4.

44. See the analyses of Brown's Aesthetic pictures in Chapter 4.

45. See Hueffer, 1896, passim; and Juliet Soskice, *Chapters from Childhood; Reminiscences of an Artist's Granddaughter,* London, 1921, passim.

46. Brown's letters to Davis are in Princeton University Library, some of which are published in Hueffer, 1896. Many of Brown's letters to Shields are published in Ernestine Mills, *The Life and Letters of Frederic Shields,* 2 vols., London, 1912.

47. The manuscript of Catherine's fragmentary memoirs, "A Retrospect," written c. 1912, is in the Soskice Papers, Parliament Record Office, London.

48. See Hueffer, 1896, 247–51, 336, 381–82; and Soskice, 1923, chap. 1.

49. 6 February 1869, Princeton University Library.

50. See Brown's *Diary* (Surtees, 1981) and Hueffer, 1896, passim.

51. On the banquet, see Newman and Watkinson, 1991, 192–93. On the pension and Queen's Bounty incident, see W. M. Rossetti's diary for 20 June 1889, quoted in Peattie, 1990, 535 n: "The movement . . . for obtaining for Cathy a pension . . . has failed—one statement made on the subject (it comes to me from Lucy) being that such pensions are not granted in relation to newspaper writers, but I question the strict accuracy of this. Instead of the pension, a gratuity of £100 on the Queen's Bounty was tendered, and a cheque for this sum was actually produced yesterday by [A. J.] Hipkins to Brown and Cathy: Brown repelled it rather indignantly, as being only calculated to humiliate himself and

Cathy. I hardly know whether in his place I should have done the same or not; prudence would suggest the contrary course, and Cathy is evidently not wholly at one with Brown on the subject."

52. Morris, Marshall and Faulkner was founded in 1861; Brown, through the actions of William Morris, was forced to leave the company in 1874–75. The Hogarth Club was founded in 1858, with Brown as its leading proponent. It was to be a social club as well as an exhibition venue; Brown was forbidden by the directing committee from exhibiting his furniture designs at the club's exhibition in 1859; the club, torn apart by dissension on various matters, folded in 1861.

53. Brown's crush on Marie Spartali has been detailed by Newman and Watkinson, 1991, 148–54, and was expressed by Brown in a series of love poems. Miss Spartali married William Stillman in 1871. I at first found Newman and Watkinson's interpretation unconvincing, and the poems by Brown largely rhetorical efforts in the manner of Rossetti. But Newman and Watkinson's identification of the object of Brown's yearnings is confirmed by additional poems in the Soskice papers, Parliament Record Office. One poem, titled "Her Name," reads:

Mary! Saddest of all sweet names that are,
 How more than sweet or saddest unto me
O name of her that mine can never be!
Art thou become, that so surpassest far
Each namesake. Mary of the "lingering star"*
 And Shelleys Mary** waiting by the sea
And Byrons frenzied first-love,*** —lastly she****
Scorching to lust her poet worshipper.
 These shall be famous for their lover's fame
pass
 As hapless lives—but thou more graced shall
 To future ages (with my name alas:
 Untwined) a peerless heroine without blame:
 And taught from child-learned litanies I
exclaim
"Je te salue Marie plein de graces."

* Burns's "highland Mary"
**Mary Godwin
***Mary Chaworth
****Mary Swinburne's cousin

54. The family background of Brown's second wife, Emma Hill, is detailed in W. D. Paden, "The Ancestry and Families of Ford Madox Brown," *Bulletin of the John Rylands Library, Manchester* 50 (1967–68): 131–33.

55. Ford Madox Brown, "Our National Gallery," *Magazine of Art* (1890): 134: "Sweet, virtuous, poetical Puritans: I cannot here refrain from inserting two inimitable specimens of their own hymnol-

ogy, for swing of rhythm perhaps unmatchable; first specimen:

 'He digged a pit, he digged it deep,
 He digged it for his brother,
 But by his sin he did fall in
 The pit he digged for t'other.'

. . . these dire fanatics got somehow or other inextricably mixed up and confused with the sacred cause of liberty, which even at the present moment has hardly got disentangled from them and their howlings and preachings."

56. See *English Caricature, 1620 to the Present,* exh. cat., Victoria and Albert Museum, London, 1984.

57. On Hogarth, see Ronald Paulson, *Hogarth,* 2 vols., New Brunswick, N.J., 1991. See also F. D. Klingender, *Hogarth and English Caricature,* London, 1945.

58. Brown's poems on Hogarth are in Princeton University Library, and discussed by Newman and Watkinson, 1991, 75–77.

59. See Johnson, 1980, 142–52, and the same author's *Paintings of the British Social Scene: from Hogarth to Sickert,* New York, 1986.

60. On Hogarth's reputation in mid-nineteenth-century England, see K. Bendiner, *An Introduction to Victorian Painting,* New Haven, 1985, 32–33.

61. On Reynolds, see *Reynolds,* exh. cat., by Nicholas Penny et al., Royal Academy of Arts, London, 1986.

62. John Barrell, in *The Dark Side of the Landscape,* Cambridge, 1980, dismisses Wilkie's paintings of common people as confectionery coverups, although some of Wilkie's pictures have been interpreted as rebellious social indictments; see *Sir David Wilkie of Scotland,* exh. cat., by W. J. Chiego et al., North Carolina Museum of Art, Raleigh, 1987. Certainly some of Wilkie's paintings are socially critical; for example, *Distraining for Rent* (National Gallery of Scotland, Edinburgh), and *The Village Festival* (Fig. 108), the latter being a scene of the horrors of drunkenness. But these are exceptional works in Wilkie's genre painting.

63. See K. Bendiner, "Brown and Wilkie," *Gazette des Beaux-Arts* (May–June 1993): 227–30.

64. "Manners and Customs of ye Englishe in 1849. No 12. A View of Epsom Downe on ye Derbye Daye," *Punch* 16 (1849): 218.

65. Brown's dependence on the orange-seller in *Punch* was noted by Johnson, 1980. The *Punch* image was earlier discussed by Michael Wolff and Celina Fox, "Pictures from the Magazines," in H. J. Dyos and Michael Wolff, eds., *The Victorian City,* London, 1973, 2:43–52.

66. Charles Dickens, *The Life and Adventures of Nicholas Nickleby,* London, 1839.

67. Letter to Rae, 9 March 1864, Rae Papers, Walker Art Gallery, Liverpool.

68. See Margaret Ganz, *Humor, Irony, and the Realm of Madness: Psychological Studies in Dickens, Butler and Others,* New York, 1990, 25–101. Twentieth-century critics have largely ignored Dickens's humor, but as Ganz indicates, it is a vital part of his art and one of the chief sources of his success in his lifetime.

69. See page 28.

70. See M. Schapiro, *Romanesque Art,* New York, 1977, 1–101; M. Schapiro, *Late Antique, Early Christian and Medieval Art,* New York, 1978, 196–98; L. Randall, *Images in the Margins of Gothic Manuscripts,* Berkeley and Los Angeles, 1966; L. Randall, "Exempla as a Source of Gothic Marginal Illustration," *Art Bulletin* 39 (1957): 97–107; M. Camille, *Image on the Edge: The Margins of Medieval Art,* London, 1992; and M. Hamburger's review of Camille in *Art Bulletin* 75 (June 1993): 319–27.

71. See Julian Treuherz, "The Pre-Raphaelites and Medieval Illuminated Manuscripts," in Leslie Parris, ed., *Pre-Raphaelite Papers,* London, 1984, 153–69; Strong, 1978, 65; and Tate, 1984, nos. 7 and 8. Among the books consulted by Brown were Henry Shaw's *Specimens of Ancient Furniture,* London, 1836; *Dresses and Decorations of the Middle Ages,* London, 1843; and *Handbook of Mediaeval Alphabets and Devices,* London, 1845; and A. W. N. Pugin's *Gothic Furniture in the Style of the Fifteenth Century,* London, 1835. See Brown's diary references to these authors in Surtees, 1981, 18, 28.

72. See Treuherz, 1984, 155–56.

73. Some of Brown's visits to the British Museum from 1847 to 1854 are recorded in his diary; see Surtees, 1981, 1, 17, 18, 42, 43, 84, 88.

74. 30 August 1854, Surtees, 1981, 88.

75. Letter to F. Shields, April [1869], Princeton University Library: "I am off to the British Museum to see after Lucy, Cathy and Nolly who go there twice as much now to draw."

76. Add. MS. 42130, fol. 166v.

77. Brown pointed out this source in his description of the painting in 1865, no. 7.

78. See Treuherz, 1984, 158, 70. The phials of paint attached to the furniture are key details in this case. Rossetti here probably drew inspiration from a reproduction of the initial in Shaw, 1843, 1:37.

79. See Camille, 1992, 49–50, and Pierpont Morgan Library, *Medieval and Renaissance Manuscripts: Major Acquisitions, 1924–1974,* New York, 1974, no. 29. On Ruskin's enthusiasm for medieval manuscripts, see Treuherz, 1984, 163–65.

80. See Ruskin, 1903–12, 5:137, and Treuherz, 1984, 164.

81. Letter of 25 September 1860 to "J.F.H.," in S. Smetham and W. Davies, eds., *Letters of James Smetham,* London, 1892, 102; cited in Virginia Surtees, *The Paintings and Drawings of Dante Gabriel Rossetti (1828–1882): A Catalogue Raisonné,* Oxford, 1971, no. 97.

82. Rowley, n.d. [1911 or 1912], 94.

83. John Bryson and J. C. Troxell, eds., *Dante Gabriel Rossetti and Jane Morris Correspondence,* Oxford, 1976. Letter 50. The cartoons are reproduced on 87. The letter is undated, but was undoubtedly written late 1878 or early 1879.

84. W. B. Yeats, "The Arts and Crafts; An Exhibition at William Morris's," *Providence (R.I.) Sunday Journal.* 26 October 1890, repr., Peter Stansky, *Redesigning the World: William Morris, the 1880s, and the Arts and Crafts Movement,* Princeton, N.J., 1985, 273.

85. *Saturday Review,* 2 March 1867, cited in Bennett, 1988, no. LL3640.

86. See, for example: Shaw, 1843; J. Strutt, *Sports and Pastimes of the People of England,* London, 1833; J. Strutt, *A Complete View of the Dress and Habits of the People of England from the . . . Saxons to the Present,* London, 1842; T. H. Wright, *A History of Domestic Manners and Sentiments in England,* London, 1862; and T. H. Wright, *A History of English Culture,* London, 1874. See also Strong, 1978.

87. See Champfleury (Jules Husson), *Histoire de la caricature du moyen âge et sous la renaissance,* Paris, 1870; E. Maunde Thompson, *The Grotesque and Humorous in the Illumination of the Middle Ages,* London, 1896. See also S. K. Davenport, "Illustrations Direct and Oblique in the Margins of an Alexander Romance at Oxford," *Journal of the Warburg and Courtauld Institutes* 34 (1971): 83–95.

88. Letter to Rae, 31 August 1873, Rae Letters, Walker Art Gallery, Liverpool. The distinction between "historic art" and "cabinet pictures" is also the subject of one of Brown's published essays: "Historic Art," *Universal Review* (September 1888): 38–55.

89. Diary, 12 September 1854, Surtees, 1981, 91–92.

90. Letter to W. B. Scott, 21 May 1881, Princeton University Library.

91. Diary, 15 September 1854, Surtees, 1981, 92.

Chapter 3. Realism

1. For a charming parable of baseball umpires, credited to Hadley Cantril, that illustrates the

philosophical viewpoints here in question, see M. Stacey, "Profile: Allen Walker Read," *New Yorker* 65 (4 September 1989): 64.

2. E. H. Gombrich, *Art and Illusion,* 2d ed., rev., New York, 1961.

3. Ibid., 33–62.

4. Ibid., 174.

5. See the general literature on Pre-Raphaelitism listed in Chapter 1, n. 1. See also Allen Staley's cogent discussion of Pre-Raphaelite art before 1860 and after: "Post-Pre-Raphaelitism," in *Victorian High Renaissance,* exh. cat., by A. Staley, et al., City Art Gallery, Manchester, Minneapolis Institute of Arts, Brooklyn Museum, New York, 1978, 21–31.

6. Brown wrote in his diary on 1 September 1854 (Surtees, 1981, 88), while at work on this painting, "However nature that at first sight appears so lovely is on consideration almost always incomplete, moreover there is no painting intertangled foliage without losing half its beauties. If imitated exactly it can only be done as seen from one eye & quite flat and confused therefore." And Allen Staley, 1973, 40, remarked that in *The Brent at Hendon,* "The problems of painting intertangled foliage were evidently real ones; the picture *is* quite flat and confused." In his catalogue description of 1865 (no. 18), Brown claimed "I can hardly affirm that this most romantic little river is not now neatly arched over for 'sanitary reasons;' but ten years ago, it presented this appearance, and once embowered in the wooded hollows of its banks, the visitor might imagine himself a hundred miles away."

7. Diary, 11 May 1856, Surtees, 1981, 174.

8. Letter to Davis, n.d., but from internal evidence can be dated 1857. Princeton University Library. The particular painting by Davis in question has not been identified.

9. Hueffer, 1896, 414.

10. *Art Journal* (1851): 157. See also the *Saturday Review* critic's remarks about *Cordelia's Portion,* quoted in Chapter 2. Such criticisms were applied to virtually all the Pre-Raphaelites; see the reviews given in Fleming, 1971.

11. The style of midcentury taste is well described by John Steegman in *Consort of Taste: 1830–1870,* London, 1950. See also Peter Conrad, *The Victorian Treasure-House,* London, 1973.

12. Quoted in *William Morris and the Middle Ages,* exh. cat., Whitworth Art Gallery, University of Manchester, 1984, nos. 64–95, p. 125.

13. For an exposition of this insight into Victorian culture, see Walter Houghton, *The Victorian Frame of Mind,* New Haven, 1957, passim.

14. L. Nochlin, *Realism,* Harmondsworth, 1971, passim.

15. See T. J. Clark, *Painting in Modern Paris,* New York, 1985.

16. See Nochlin, 1971, 37–38, for some general discussions of the humor involved in these French works.

17. See Brown, 1865, no. 42; Appendix 3, where *Manfred on the Jungfrau* (1840; Fig. 3) is touted as an early depiction of natural light, even though the work, Brown admitted, had been almost entirely repainted.

18. Brown visited Hunt and Millais at Ewell in November 1851, where the two Pre-Raphaelite Brothers were using their wet white ground technique out-of-doors. Brown thereafter tried it in *Jesus Washes Peter's Feet,* but was less than satisfied with the result. See Hunt, 1905, 1:277–78, and Brown, *Diary,* 16 August 1854, Surtees, 1981, 76. Brown was aware of the brightening effects of a dry white ground by May 1851, but this method too was indebted to Hunt and Millais. Brown wrote to Lowes Dickinson in May 1851 (Hueffer, 1896, 77): "As to the pure white ground, you had better adopt that at once, as I can assure you you will be forced to do so ultimately, for Hunt and Millais, whose works already kill everything in the exhibition for brilliancy, will in a few years force everyone who will not drop behind them to use their methods."

19. *The Times* (7 May 1851).

20. *Saturday Review* (4 July 1857). Patmore's authorship of this review and his close links to the Pre-Raphaelites are noted in Merle M. Bennington, *The Saturday Review, 1855–1868,* New York, 1966, and Newman and Watkinson, 1991, 107–8.

21. Brown's copy is in the Princeton University Library.

22. This idea was presented in Emile Zola's defense of Manet in 1866; see *Collection des Oeuvres complètes: Emile Zola,* Paris, n.d., 23:176, and was frequently voiced in the Impressionist circle in later years. See John House, *Monet: Nature into Art,* New Haven, 1986, chap. 14.

23. See, for example, Ruskin, 1903–12, 5:114.

24. Ford Madox Brown, *The Slade Professorship: Address to the Very Rev. the Vice-Chancellor of the University of Cambridge,* pamphlet, 20 December 1872. A copy of this address is in the Soskice papers, Parliament Record Office, London.

25. F. G. Stephens, one of the Pre-Raphaelite Brotherhood, stated in *Dante Gabriel Rossetti,* London, 1894, that "naturally enough, Brown was solicited to become a brother, but he, chiefly because of a crude principle which for a time was adopted by the other painters, declined to join the body. This principle was to the effect that when a member found a model whose aspect answered his idea of the subject required, that model should be painted exactly, so to say, hair for hair."

26. Brown, "On the Mechanism of a Historical Picture," *The Germ,* no. 2 (February 1850): 70–73.

27. Letter of 25 January 1857 to William Bell Scott, Princeton University Library. Brown had seen a photograph of Scott's mural painting at Wallington Hall, Northumberland, *Saint Cuthbert on Farne Island,* and was giving his opinion. On Scott's Wallington paintings, see Robin Ironside, "Pre-Raphaelite Paintings at Wallington," *Architectural Record* 93 (1942): 147; and R. Trevelyan, *A Pre-Raphaelite Circle,* London, 1978, 123 and 151.

28. See Nochlin, 1971, 33ff.

29. See L. Errington, "Social and Religious Themes in English Art, 1840–1860," diss., Courtauld Institute of Art, London, 1973. See also Alastair Grieve, "The Pre-Raphaelite Brotherhood and the Anglican High Church," *Burlington Magazine* (May 1969): 294–95.

30. See Brown, 1865, no. 3. See Appendix 3.

31. Hunt, *The Awakening Conscience* (1854; Tate Gallery, London); Rossetti, *Found* (1854; Bancroft Collection, Delaware Art Museum); Millais, *Accepted* (1853; Yale Center for British Art, New Haven), *The Dying Man* (1853–54; Yale Center for British Art, New Haven), *The Blind Man* (1853; Yale Center for British Art, New Haven).

32. Brown, 1865, no. 14; see Appendix 3.

33. See pages 98–99. The detailed history of this work is given in Bennett, 1988, no. 10533.

34. See page 99.

35. This point is elaborated in Bendiner, 1991.

36. See Brown's 1865 comments on the painting, in which the slave-like garments of Christ are mentioned; Brown, 1865, no. 12. See Appendix 3 and pages 104–5.

37. On Wilkie, see *Sir David Wilkie.* On British paintings of the poor in the last three decades of the century, see Julian Treuherz, *Hard Times; Social Realism in Victorian Art,* London, 1987.

38. See Brown's commentary on his Manchester mural *Chetham's Life Dream,* Appendix 4, where the establishment of institutions to help the underprivileged is described as peculiarly representative of nineteenth-century society. Many of the movements and institutions of the period are discussed in Gertrude Himmelfarb, *Poverty and Compassion: The Moral Imagination of the Late Victorians,* New York, 1991, and the same author's *The Idea of Poverty,* New York, 1984.

39. Diary, 13 July 1855, Surtees, 1981, 144.

40. Gombrich, 1961, 395. *The Story of Art* had been published in 1950.

41. The painting reproduced here as Figure 29 was begun in 1848, but cut down and altered in 1854 and 1855. It contains no grand cloudscape. In October 1848 Brown began a duplicate oil, which he put aside and took up again in 1849. In 1854, while at work on both versions, he also made a lithograph ("drawn from the original study"). The duplicate oil was destroyed during World War II. There exists, however, a later oil (formerly William Morris Gallery, Walthamstow), which dates from 1859–61. This later oil painting and the lithograph of 1854 both include a wonderful spread of clouds in the sky. One cloud-filled version was exhibited at Brown's one-man show as *Winandermere* (no. 25), and this was presumably the one formerly in the William Morris Gallery. It is Brown's reverie on this image in the 1865 catalogue that is given here. The complicated and confusing history of the Windermere-Winandermere images is given in Bennett, 1988, no. LL3638. There is a watercolor version, Bennett notes, also in the Carlisle Art Gallery. This and the William Morris Gallery oil, she suggests, may have been painted over copies of the 1854 lithograph, but there is also a problem of how many copies of this lithograph were actually produced. All this complexity is worthy of Brown's comedy. On the psychology involved in reading images in clouds and discussions of early examples of such readings, see Gombrich, 1961, chap. 4.

Chapter 4. Aestheticism

1. Walter Hamilton, *The Aesthetic Movement,* London, 1882, preface to 3d ed., and chap. 1.

2. Ibid., 23–24. Hamilton noted that the Grosvenor Gallery, established in London in 1877 by Sir Coutts Lindsay, gave "strength and stability" to Aestheticism.

3. See Stansky, 1985, passim.

4. *Athenaeum* (21 October 1865): 545–46.

5. Hamilton, 1882, 24.

6. Ibid., 31.

7. On Symbolism, see Philippe Julian, *The Symbolists,* Oxford, 1973; Robert Goldwater, *Symbolism,* London, 1981; Edward Lucie-Smith, *Symbolist Art,* London, 1972; Sven Lovgren, *The Genesis of Modernism: Seurat, Gauguin, Van Gogh and French Symbolism in the 1880s,* Bloomington, Ind., 1971; *Post-Impressionism: Cross-Currents in European Painting,* exh. cat., Royal Academy of Arts, London, 1979; *From Realism to Symbolism: Whistler and His World,* exh. cat., Wildenstein, New York, 1971; Robert Delevoy, *Symbolists and Symbolism,* New York, 1978.

8. Vernon Lee, *Miss Brown,* Edinburgh, 1884, 2:71.

9. Hamilton, 1882, 43–45.

10. See page 82.

11. Letter to F. Shields, 10 April 1882, in Hueffer, 1896, 355.

12. *Punch* 70 (5 February 1876).

13. *Punch* 80 (19 February 1881).

14. *Punch* 80 (19 February 1881). Walter Pater's

exquisite essays on Greek and Renaissance art, beginning in the mid-1860s, were published together as *Studies in the History of the Renaissance,* London, 1873, and constitute a monument of Aesthetic art appreciation. In one of his essays, "The School of Giorgione," Pater wrote that "all art constantly aspires to the condition of music." See Allen Staley, "The Condition of Music," *Art News Annual: The Academy* 33 (1967): 80–87.

15. *Punch* 49 (18 November 1865).

16. "A Legend of Camelot," five parts, *Punch* 50, (3 March–31 March 1866).

17. Leonee Ormond, *George Du Maurier,* London, 1869, 172–81.

18. Ibid., 243–51.

19. On the importance of *Autumn Leaves,* see Malcolm Warner, "John Everett Millais's 'Autumn Leaves': 'A picture full of beauty and without subject,'" in Leslie Parris, ed., *Pre-Raphaelite Papers,* London, 1984, 126–41.

20. Letters to George Rae of 23 October 1863, 26 April 1864, and 31 August 1864, in Rae Papers, Walker Art Gallery, Liverpool.

21. The model for Rossetti's *Girl at a Lattice* was a servant maid in Brown's household; see Surtees, 1971, no. 152, and Tate, 1984, no. 119. The Tate Gallery's painting called *The Writing Lesson* is undoubtedly to be identified with the work discussed by Hueffer, 1896, 184, and there called *Mauvais Sujet.* According to Hueffer, Brown presented *Mauvais Sujet* to the Mansion House Relief Fund. It was to be sold to raise funds for the starving Lancashire weavers. The weavers had been thrown out of work by the American Civil War, which cut off shipments of cotton to England.

22. See Rossetti's poem on the painting, in Surtees, 1971, no. 240.

23. Brown, 1865, no. 34; see Appendix 3.

24. See *Victorian High Renaissance,* 1978, no. 74, for a reproduction of Moore's *Shuttlecock* and discussions of his imagery. On Moore, see also Alfred Lys Baldry, *Albert Moore: His Life and Works,* London, 1894, and *Albert Moore and His Contemporaries,* exh. cat., by Richard Green, Laing Art Gallery, Newcastle upon Tyne, 1972.

25. Umbrellas seem to have been Brown's personal insignia. Perhaps because of the prominent umbrella in *The Last of England,* or perhaps because the umbrella was a sign of Brown's down-to-earth sensibility, Rossetti wrote to him in 1864 about a luncheon with the lawyer James Anderson Rose at the latter's club: "I fear the lawyers deserve their reputation in some respects—as I lost my umbrella (that monument of *your* pure taste), while it hung in the hall!" in O. Doughty and J. R. Wahl, eds., *Letters of Dante Gabriel Rossetti,* Oxford, 1965, 2:no. 536.

26. See Bennett, 1988, no. LL3639. The William

Henry Hunt watercolor in question was titled *Devotion,* and almost certainly is the work of that name now in the Manchester City Art Gallery. Its size, 18¼ × 11¾ in., almost exactly accords with the watercolor owned by Craven. On this work, see John Witt, *William Henry Hunt (1790–1864),* London, 1982, no. 435. The Hunt depicts a boy kneeling with hat and rosary at his side. Hunt had died in 1864, before he could produce a pendant for *Devotion* as Craven desired.

27. See, for example, Vernon Lee, 1884, passim.

28. Hunt letter to Thomas Combe, 12 February 1860, quoted in Surtees, 1971, no. 114.

29. Rossetti saw himself as the inventor of the wall motif, and accused Millais of stealing it. See O. Doughty, *Dante Gabriel Rossetti, A Victorian Romantic,* New Haven, 1949, 165–66.

30. Brown was fluent in French and would have been familiar with the common slang term "chat" for vagina, although "pussy," with the same vulgar meaning but not quite so widespread in use, had already been employed in English for centuries. See Eric Partridge, *A Dictionary of Slang and Unconventional English,* 18th ed., New York, 1984. It is even conceivable that the obviously sexual cat in Edouard Manet's *Olympia* (1863; Musée d'Orsay, Paris), which was widely condemned and mocked in the Paris press of 1865, led Brown to introduce the animal into his *Nosegay* of the same year. Rossetti had visited Manet's Paris studio in 1864, where he very likely saw *Olympia,* and would have communicated his impressions to Brown on his return to London in November 1864. Rossetti, who was disgusted by French art, wrote to his mother from Paris that Manet's pictures were "mere scrawls." See Doughty and Wahl, 1965, 2:no. 563. In addition, William Michael Rossetti definitely saw *Olympia* in 1865. He wrote in his diary on 23 May 1865, while in Paris, that Manet's *Olympia* was "a most extreme absurdity." See Doughty and Wahl, 1965, 2:no. 563 n.

31. On Byron's decline in reputation after 1840, see Samuel C. Chew, *Byron in England; His Fame and After-Fame,* New York, 1965; and Oscar J. Santucho, *George Gordon, Lord Byron: A Comprehensive Bibliography,* Metuchen, N.J., 1977, 24–29.

32. According to Mary Bennett's notes on the Brown family papers in a private collection, on 10 July 1871, Brown wrote to his patron, Frederick Craven, suggesting "The Dream of Sardanapalus" as a fit subject to match the *Don Juan* watercolor already owned by Craven.

33. See William Michael Rossetti, *Rossetti Papers, 1862–1870,* London, 1903, 402.

34. The neo-Gothic Town Hall had been completed in 1876. Its architect, Alfred Waterhouse, had considerable input in determining the mural

scheme, although a government committee composed of town councilors had the most control. After several inquiries into the matter, in January 1878, the Corporation of Manchester commissioned Brown and his friend, Frederic Shields, to paint twelve murals in the Great Hall of the Town Hall, a place devoted to ceremonies and banquets. Shields never even began any of the paintings, and eventually all twelve murals were produced by Brown. Brown began work in Manchester in 1879, using a medium of copal varnish, wax, and gum elemi developed by Thomas Gambier-Parry. After 1885, beginning with *Chetham's Life Dream* (Fig. 78), Brown painted in oil on canvas, and the image was then glued onto the Town Hall wall. This latter method, called marouflage, permitted Brown to leave his residence in Manchester in 1887, and return to London. Brown gave a paper on the Gambier-Parry process at a session of the Royal Institute of British Architects on 12 May 1881. See F. M. Brown, "The Gambier-Parry Process," *Royal Institute of British Architects: Sessional Papers* 21 (1880–81): 273–76. See also W. M. Rossetti, "Mr. Madox Brown's Frescoes in Manchester," *Art Journal* 43 (September 1881): 262–63.

35. Stephen Tschudi Madsen's *Sources of Art Nouveau,* New York, 1956, is still the most intensive study of the origins of Art Nouveau, but Madsen sees Rossetti's and England's formative contributions to the movement as "proto–Art Nouveau." I feel, however, that British developments in the style and subject matter of Art Nouveau go beyond the embryonic. On Art Nouveau, see also *Art Nouveau: Art and Design at the Turn of the Century,* exh. cat., Museum of Modern Art, New York, 1959; Robert Schmutzler, *Art Nouveau,* New York, 1978; and Debora Silverman, *Art Nouveau in Fin-de-siècle France,* Berkeley and Los Angeles, c. 1989.

36. On Mackmurdo and the Century Guild, see Stansky, 1985; Stuart Evans, "The Century Guild Connection," in J. G. Archer, ed., *Art and Architecture in Victorian Manchester,* Manchester, 1985, 250–68; John Doubleday, *The Eccentric A. H. Mackmurdo,* Colchester, 1979; Nikolaus Pevsner, "Arthur Heygate Mackmurdo," in *Studies in Art, Architecture and Design,* vol. 2, *Victorian and After,* London, 1968; Edward Pond, "Mackmurdo Gleanings," in J. M. Richards and N. Pevsner, eds., *The Anti-Rationalists,* London, 1973; A. Vallance, "Mr. Arthur H. Mackmurdo and the Century Guild," *Studio* 16 (1899): 183–92.

37. Examples of Mackmurdo's furnishings are in the Victoria and Albert Museum, London, and the William Morris Gallery, Walthamstow. See also the illustrations in the literature listed in the previous note.

38. See, for example (1887), 2:91–102: Herbert

Horne, "Thoughts toward a Criticism of the Works of Dante Gabriel Rossetti"; and (1889), 4:41, 82–97: in which Rossetti's *Bonifazio's Mistress* is reproduced and Rossetti's letters to Frederic Shields are published.

39. Insistent curvilinear rhythms wedded to moderately strong patternization can be discerned in Rossetti's watercolors as early as 1859; for example, *Writing in the Sand,* Surtees, no. 111, British Museum, London. On stained-glass painting by Morris's firm and its immediate predecessors, see Sewter, 1974. Brown's earliest stained-glass design, *The Transfiguration,* was made for Powell and Co. in 1857, before the foundation of Morris, Marshall and Faulkner. Brown's colored cartoon of the *Transfiguration* remains unlocated, but a reproduction of it appears in the unnumbered endpages of Hueffer, 1896.

40. See Brown's defense of simple designs for stained glass in his 1865 catalogue, no. 76; see Appendix 3.

41. Newman and Watkinson, 1991, 188.

42. Quoted in Roger W. Peattie, ed., *Selected Letters of William Michael Rossetti,* University Park, Pa., 1990, Letter 401, n. 5.

43. Rossetti, 1886, 48–54.

44. Selwyn Image, "St. Michael and St. Uriel, Designs by Mr. Ford Madox Brown for Painted Glass," *Century Guild Hobby Horse* 5 (1890): 112–18; "A Note Upon the Drawing of 'King René's Honeymoon' by Ford Madox Brown," *Century Guild Hobby Horse* 3 (1888): 121, 158–60.

45. Newman and Watkinson, 1991, 188.

46. On the visit to Pownall Hall in Cheshire, the home of Boddington, see ibid., 188. On the decoration of Pownall Hall, see Evans, 1985, passim. Mackmurdo also appears in Brown's address book, undated, in the Soskice Papers, Parliament Record Office, London.

47. F. M. Brown, "Of Mural Painting," in Arts and Crafts Exhibition Society, *Arts and Crafts Essays,* New York, 1893, 152.

48. Ibid., 156–57.

49. See Richard Dorment, "The Loved One: Alfred Gilbert's *Mors Janua Vitae*" in *Victorian High Renaissance,* 1978, 43–52.

50. *King René's Honeymoon* was first designed as one of a series of illustrated panels to decorate a cabinet designed and owned by John Pollard Seddon. The cabinet is today in the Victoria and Albert Museum, and was made to hold Seddon's architectural drawings. Brown's panel is devoted to the art of architecture. Panels showing King René engaged in the arts of sculpture and painting were designed and painted by Burne-Jones. And the fourth of the large panels, by Rossetti, shows King René making music. Six smaller panels on the cabinet include a

scene of the art of gardening by Rossetti, and the art of embroidery by Val Prinsep. According to the *Century Guild Hobby Horse* 3 (1888): 58, Brown was responsible for selecting the subject of King René's Honeymoon. John Pollard Seddon's book, *King René's Honeymoon Cabinet,* London, 1898, further noted that the idea was to counter the presentation of René in Sir Walter Scott's novel *Anna von Geierstein,* where the historical figure King René of Anjou appears as a ridiculous fop. See *William Morris and the Middle Ages,* exh. cat., Whitworth Art Gallery, Manchester, 1984, no. 65. There is no story of René's honeymoon in Scott's novel, and presumably Brown merely imagined that aspect of the cabinet subject. King René (1409–80) was long known as a noble devotee of all the arts. Thomas Seddon, incidentally, had written from France to Brown in 1853 that "I hope to become a *passé-maître en chevalerie.* I have got the Roi René's book on *Tournois* to read. He is such a courteous old gentleman, a perfect connoisseur of the olden time, who, if he lived now, would buy Hunt's pictures, and write the book of ball-room etiquette." See Watkinson, 1970, 138–39.

51. "Art and the People: A Socialist's Protest Against Capitalist Brutality; Addressed to the Working Classes," in May Morris, ed., *William Morris,* New York, 1910–15, 2:386–87.

52. On the distancing of Renaissance and later artists from "manual" craftsmen, see A. Blunt, *Artistic Theory in Italy, 1450–1600,* London, 1962; P. O. Kristeller, "The Modern System of the Arts," in *Renaissance Thought,* vol. 2, New York, 1965; D. Posner, "Concerning the 'Mechanical' Parts of Painting and the Artistic Culture of Seventeenth-Century France," *Art Bulletin* 75.4 (December 1993): 583–98; D. Summers, *The Judgment of Sense,* Cambridge, 1987, 235–65.

53. The anti-industrial sentiments of Ruskin and Morris have been treated extensively by scholars. Good summations of the ideas are in Nikolaus Pevsner, *Pioneers of Modern Design from William Morris to Walter Gropius,* London, 1949; Alf Bøe, *From Gothic Revival to Functional Form,* Oslo, 1957; and Paul Thompson, *The Work of William Morris,* London, 1967.

54. C. R. Ashbee founded the Guild of Handicraft in the East End of London in 1888; Walter Crane helped found in the same year the Arts and Crafts Exhibition Society, and invited Brown to join, which he did.

55. Letter to W. Kineton Parkes, 22 June 1887, in Peattie, 1990, no. 401, n. 5.

56. Letter to Burnand, 28 July 1880, in Ormond, 1969, 278–80.

57. See page 84.

58. Pp. 44–51.

59. Vol. 3, no. 13, pp. 61–63.

60. The minutes are today owned by S. Berger and H. Berger, Carmel, Calif. Typescripts of the minutes are in the archives of the Borough of Hammersmith Public Library.

61. See Watkinson, 1970, 150, pl. 27.

62. Diana Holman-Hunt, "The Holman Hunt Collection, A Personal Recollection," in L. Parris, ed., *Pre-Raphaelite Papers,* London, 1984, 219–20.

63. Hueffer, 1896, 161.

64. Ibid., 183.

65. Elizabeth Aslin, in *Nineteenth-Century English Furniture,* New York, 1962, pl. 67, reproduces a photograph of Brown's ladder-back in the collection of Mr. and Mrs. William Hoggatt. I have not had the opportunity, however, to view any Brown ladder-back in the flesh. Newman and Watkinson, 1991, pl. 90, illustrate two Brown ladder-backs in the photograph of an unidentified interior. The rustic chairs that were the forebears of Brown's ladder-back can be seen, for example, in a painting of 1793 by W. R. Bigg, *Cottage Interior with Old Woman Preparing Tea* (Victoria and Albert Museum, London).

66. See Newman and Watkinson, 1991.

67. See Newman and Watkinson, 1991, 184; and an unpublished letter to Herbert Gilchrist of 1 December 1890 in Princeton University Library, discussed below, page 79.

68. John D. Sedding, "The Handicrafts in the Old Days," in *Art and Handicraft,* London, 1893, 80.

69. The drawings, in the Fitzwilliam Museum, Cambridge, are illustrated in Newman and Watkinson, 1991, 103. A watercolor version of one of the panel drawings, depicting a soldier of the Napoleonic Wars recounting his experiences to his grandchildren, is in the Leathart family collection, Newcastle. The bookcase was exhibited by Brown at his 1865 exhibition (no. 98), and its subjects described by him in the catalogue; see Appendix 3.

70. Hueffer, 1896, 282, noted this design, but added that this Wagnerian work, intended to be carried out with inlaid ebony and ivory, was too expensive to be produced. Brown's daughter Cathy married Franz Hueffer (1845–89) in 1872. Mary Bennett has suggested, with good reason, that this piano was probably intended for Hueffer, who was music critic for *The Times,* and one of the earliest promoters of Wagner's music in England. This drawing was first owned by Catherine Hueffer. See Bennett, 1988, no. 10513.

71. Diary, 16 March 1857, Surtees, 1981, 194–95.

72. Ibid., 17 January 1858, Surtees, 1981, 200.

73. Ibid., 5 October 1849, Surtees, 1981, 67.

74. Newman and Watkinson, 1990, 52.

75. Surtees, 1981, 67 n. 31.

76. Princeton University Library.

77. Yeats, 1890, in Stansky, 1985, 270–73.

78. Brown, 1872, 7.

79. See, for example, Owen Jones, *The Grammar of Ornament*, London, 1856.

80. Ruskin in 1854 had interpreted the shiny ornate furnishings of Hunt's painting as indicative of moral depravity. See Ruskin, 1903–12, 12:334.

81. This point is made by Thompson, 1967, 78.

82. Ashbee's table is seen in a 1901 photograph, reproduced in Alan Crawford, *C. R. Ashbee; Architect, Designer and Craftsman*, New Haven, 1985, 305, pl. 150.

83. See Newman and Watkinson, 1991, 133.

84. Rossetti admired the enormous settle designed by Morris and Burne-Jones, and participated in the production of several pieces of furniture in 1856. Rossetti wrote to William Allingham on 18 December 1856, that Morris was "having some intensely mediaeval furniture made—tables and chairs like incubi and succubi. He and I have painted the back of a chair with figures and inscriptions in gules and vert and zure, and we are all three going to cover a cabinet with pictures." See Philip Henderson, *William Morris*, New York, 1967, 39–40. See also Aslin, 1962; and Thompson, 1967. The settle from Red Lion Square was originally ornamented with historiated panels and various ornamental paint, but in the 1950s, apparently, the entire piece of furniture was painted white. It remains in that state at the Red House, Bexley Heath.

85. Notes on the Brown Family Papers, kindly shown to me by Mary Bennett.

86. See page 105.

87. See above, note 80.

88. On the sources of the lectern in *Wycliffe* and *Chaucer*, see Strong, 1978, 65, and Surtees, 1981, 18 and 28. For Pugin's rich conceptions of Gothic furniture, see Pugin, 1835. The furniture that appears in Brown's medieval subjects after the foundation of Morris, Marshall and Faulkner tends to look like the rather un-medieval productions of the Morris firm (e.g., the bench with spindles that appears in the *Death of Sir Tristram* [Fig. 42]).

89. Some of Webb's painted cabinets designed for the Morris firm are in fact fairly grand, with turned legs, and sumptuous painted scenes. Brown, however, has never been associated with any of those colorful productions. Elizabeth Aslin claims, without documentation, that Brown was responsible, instead, for the plain and inexpensive "cottage" furniture mentioned in brochures of Morris and Co. at the turn of the century. See Aslin, 1962, 56.

90. Morris joined Street's Oxford office in January 1856, where he met Webb, who had been with Street for years. Morris settled in London around nine months later in Red Lion Square. Some writers (e.g., Peter Stansky, *William Morris*, Oxford, 1983, 14) have claimed that Street believed that an architect should design all the objects in his build-

ings, and saw Street's tutelage as vital to Morris's decision to become a decorative artist. Before Street, however, Pugin had set about designing numerous objects in wood, metal, tile, and cloth for his architecture. Indeed, Pugin had set up workshops with John Hardman for the production of his decorative art designs. See Stanton, 1971. On Cuddesdon Theological College, see Henry Russell Hitchcock, "G.E. Street in the 1850's," *Journal of the Society of Architectural Historians* 19.4 (December 1960): 145–72, where Street's influence on Webb and Morris is discussed. The influence of Street's Cuddesdon furniture on that of Webb and the Morris firm has been noted recently in Charlotte Gere and Michael Whiteway, *Nineteenth-Century Design from Pugin to Mackintosh*, New York, 1994, 78.

91. On the productions of Heal and Gimson and others in the Arts and Crafts Movement, see Aslin, 1962, and Elizabeth Aslin, *The Aesthetic Movement: Prelude to Art Nouveau*, New York, [1969]. The vernacular, non-medieval sources of Arts and Crafts design is emphasized by Alan Crawford, "Sources of Inspiration in the Arts & Crafts Movement," in S. Macready and F. H. Thompson, eds., *Influences in Victorian Art and Architecture*, London, 1985, 155–60.

92. Precedents for the Red House certainly exist among the works of English Gothic Revivalists. William Butterfield's *Vicarage at Coalpitheath* (1844–45) is a prime example, and Hitchcock, 1960, 170, notes the likely influence of Street's *Rectory of Saint Ebbe's, Paradise Square, Oxford* (1854–55) on Webb's *Red House*. What came to be (mis-)called the Queen Anne style was evidently a tendency long present in Gothic Revivalism, which Webb extracted and strengthened and perfected.

93. See Christopher Gilbert, *English Vernacular Furniture*, New Haven, 1991, 5, 103–5. See also Ivan Sparkes, *An Illustrated History of English Domestic Furniture*, Bourne End, Eng., 1980, 133.

94. See Gilbert, 1991, 104, 119–21, 158, 166.

95. See the hospital and workhouse furniture in the illustrations of T. Rowlandson and A. C. Pugin, *Microcosm of London*, London, 1808.

96. Prospectus of Morris, Marshall and Faulkner and Co., circulated 1861, repr., Philip Henderson, *The Letters of William Morris to His Family and Friends*, London, 1950, 386.

97. See William Rothenstein, *Men and Memories, 1900–1922*, New York, 1932, 2:133–34, 273–78.

Chapter 5. A Social Conscience

1. Brown, 1865, unnumbered entry for *Work*. See Appendix 3.

2. Peattie, 1990. Letter 203, p. 275, to Kenningale Robert Cook, 9 July 1871.

3. Sonnet to Ireland, dated 26 April 1847, Princeton University Library:

Sad Isle where fortune's wheel but leaves its rut,
Green Erin! Land of dark eyes and warm heart,
 Neath thine own frenzied clutch thy bosom smarts,
While pestilence shrieks in thy peasant's hut.
Priest-ridden, faction-torn, pale storm-bleached butt,
 For tyranny and error's ire-winged darts,
Will plenty, gushing, never flood thy marts.
But must thy babes still famine's lean jaws glut.
 And thou, proud eldest of her sister's twain
Through whose neglect lorn Cinderella weeps.
Doest thou *now feel* the woe thy folly reaps,
 Or doest thou retribution grudge in vain,
Peace!! Shut thy mouth, and open wide thy
 glittering heaps!

4. One of Brown's relatives, Richard Bromley, helped organize official relief programs for the Irish famine in 1847, and Brown was in contact with Bromley in the year of his sonnet; see Newman and Watkinson, 1991, 31–32; and Brown, *Diary,* 28 October 1847, Surtees, 1981, 11.

5. Brown, *Diary,* 5 October 1854, Surtees, 1981, 98.

6. Ibid., 7 August 1855, Surtees, 1981, 148.

7. Letter to Shields, 16 April 1886, in Hueffer, 1896, 376. On the Manchester labor bureau, see ibid., 376.

8. Letter to Lucy Rossetti, n.d. [March 1886], cited in Newman and Watkinson, 1991, 184. Information on *Commonweal* and Morris's gatherings is from the same source.

9. Brown, 1888, 52.

10. See Rowley, [1911 or 1912], and Newman and Watkinson, 1991, 184. See also Boime, 1981, 116–25. *The Workman's Chest of Drawers,* exhibited in 1887, 1888, and 1890, is noted as having been made by "Samuel Waddington" in *The Artist* (May 1898).

11. See Soskice, 1921, 1–4, and Newman and Watkinson, 1991, 190.

12. W. R. Lethaby, *Philip Webb and His Work* (1935), London, 1979, 248.

13. In Hueffer, 1896, 427.

14. On Maurice, the Working Men's College, and Maurice's movement, Christian Socialism, see F. D. Maurice, *The Life of Frederick Denison Maurice, Chiefly Told from His Own Letters,* 2 vols., London, 1884; Edward Norman, *The Victorian Christian Socialists,* Cambridge, 1987; Torben Christensen, *Origin and History of Christian Socialism, 1848–54,*

Aarhus, 1962; Himmelfarb, 1991. Although there were some unsuccessful attempts to form cooperative buying societies for workers, the early movement, under Maurice's guidance, was far more Christian than socialist.

15. Hueffer, 1896, 401. See also Ford Madox Hueffer, *Ancient Lights and Some New Reflections,* London, 1911, and see Boime, 1981, 116–25.

16. Newman and Watkinson, 1991, 184.

17. See Stansky, 1985, passim.

18. Brown, *Diary,* 9 May 1855, Surtees, 1981, 136.

19. On Emma Hill's family, and the dates of Brown's wedding and the birth of Catherine Brown, see Paden, 1967–68, 131–33.

20. Letter to William Davis, n.d., but from internal evidence can be dated 1857; Princeton University Library.

21. On Brown's parentage and background, see Paden, 1967–68, 124–35.

22. Brown, *Diary,* 26 August 1854, Surtees, 1981, 86–87.

23. Boime, 1981, 116–25.

24. Brown, *Diary,* 26 August 1854, Surtees, 1981, 86–87.

25. Brown's early teachers, Albert Gregorius of the Bruges Academy and Pieter van Hanselaer of the Ghent Academy, had both been students of Jacques-Louis David.

26. These untraced works are listed in Hueffer, 1896, 432.

27. This is Brown's description of his cartoon for *The Spirit of Justice,* published in the catalogue of the Westminster fresco exhibition, 1845, and reprinted in Hueffer, 1896, 33 n. 1.

28. See Himmelfarb, 1984, passim.

29. Wilkie's *Distraining for Rent* (1815; National Gallery of Scotland, Edinburgh) is a prime example. On Turner, see Eric Shanes, *Turner's Human Landscape,* London, 1990.

30. See Nochlin, 1971, 45–50, and Treuherz, 1987, 9.

31. Brown, 1865, no. 4; see Appendix 3.

32. The same embarrassment felt by Saint Peter appears in the contemporaneous *Last of England* (Fig. 29). The emigrating couple in the foreground of that painting, Brown noted, are "from the middle classes, high enough, through education and refinement, to appreciate all they are now giving up with the discomforts and humiliations incident to a vessel 'all one class.'" See Brown, 1865, no. 14; see Appendix 3.

33. See Brown, 1865, unnumbered entry for *Work;* see Appendix 3.

34. See Himmelfarb, 1984, 160–161, 183, and passim.

35. H. Mayhew, *London Labour and the London*

Poor, ed. John D. Rosenberg, New York, 1968, 1:370–71ff., and 2:242–43.

36. *Morning Chronicle* (19 October 1849), in Himmelfarb, 1984, 316.

37. Brown, 1865, unnumbered entry for *Work;* see Appendix 3. Boime notes this connection, and further sees some illustrations to Mayhew's book as influential on *Work.* But the visual links in my view are not convincing; see Boime, 1981, 116–25.

38. Brown, 1865, unnumbered entry for *Work;* see Appendix 3. The sonnet also appears on the back page of Brown's 1865 catalogue.

39. *Chartism,* London, 1839, and *Past and Present,* London, 1843, are particularly rich in the expression of this idea.

40. *Chartism,* in *English and Other Critical Essays,* Everyman ed., London, n.d., 177.

41. Brown, *Diary,* 15 December 1855, Surtees, 1981, 158: "Read the 3 vol of Carlyles Misscellany. The glorious kind hearted old chap. Boswel, Diderot, Cagliostro & the necklace are the best in the book, & among what he has ever done best. The Johnson, Goethe, Edward Irving, among, to me, the unsatisfactory ones, overdone, too many immensities, eternities, or such like superfluities, sometimes whole pages of mere gilded wind bladders looking something like real nuggets but not so. Seek to grasp them & they bob off in most tantallizing fashion. (This is Carlylian I hope.) On the other hand we must allow the great man his occasional weaknesses & caprices & flatulencies. Real gold and solid weight & closed packed wisdom is not wanting in the general run of it, more indeed than is attainable in any other writing now published, I opine." Brown, 1890, 134.

42. Brown, 1865, unnumbered entry for *Work;* see Appendix 3.

43. Carlyle's reactionary ideas on slavery in *Latter-Day Pamphlets* were attacked widely in the British press, and certainly seem far from Brown's social outlook. In 1875 Brown began, but never completed designing, a picture of John Brown Rescuing Slaves, according to Hueffer, 1896, 314. See also Hueffer, 184, where the intended picture is titled *John Brown Assisting the Escape of Runaway Slaves.*

44. Brown's view of Maurice is not known, but in his diary (17 March 1857, Surtees, 1981, 196), Brown refers to the minister as "spouting" during a meeting at the college, and Brown's tone is hardly laudatory. Even Brown's praising reference to Maurice in the 1865 catalogue description of *Work* (see Appendix 3) is not without ambiguity, for Brown noted that this English minister was "not above practical efforts, if even for a small resulting good." It is significant that Maurice was probably added to *Work* at the request of T. E. Plint, a Christian

Socialist businessman from Leeds, who commissioned Brown to complete the painting in 1856. In a letter to Brown (Hueffer, 1896, 112), Plint wrote: "Could you introduce *both* Carlyle and *Kingsley,* and change one of the four *fashionable* young ladies into a *quiet, earnest, holy-looking one,* with a book or two and *tracts?* I want *this* put in, for I am much interested in *this* work myself, and know those who are." Brown apparently received permission to put in Maurice in place of the similarly minded Charles Kingsley. And Brown did insert the tract lady requested by Plint. But look at what he did to her. She hands her tract on the evils of drink to one of the navvies, but he laughingly dismisses her efforts, and Brown remarked in his description of *Work:* "This well-intentioned lady has, perhaps, never reflected that excavators may have notions to the effect that ladies might be benefited by receiving tracts containing navvies' ideas! nor yet that excavators are skilled workmen, shrewd thinkers chiefly, and, in general, men of great experience in life, as life presents itself to them."

45. Brown, 1865, unnumbered entry for *Work;* see Appendix 3.

46. Treuherz, 1985, 167, views this Brown mural as partly dependent on William Bell Scott's mural at Wallington Hall, Northumberland, of a similar subject, *The Building of the Roman Wall* (1856–61), and sees Scott's Wallington project generally as influential. This is highly likely.

47. See Brown's description of the mural, *Particulars,* no. 1, in Appendix 4.

48. See Brown's description of the mural in *Particulars,* no. 6, Appendix 4.

49. See *Particulars,* no. 10, in Appendix 4. Although Brown presented the workers as destructive rioters, he also remarked in his description of the mural that "however disastrous to him [Kay] this inroad of the men might be, the combination of the masters to resist in the law courts his just claims to royalties proved even more so, and Kay retired to France a ruined man."

50. On bicycles and tricycles of the 1880s, see Arthur J. Palmer, *Riding High: The Story of the Bicycle,* New York, 1956, and Philip Lawton Sumner, *Early Bicycles,* London, 1966.

51. See John Lawrence Hammond, *C. P. Scott of the Manchester Guardian,* New York, n.d. [1934]. Scott and Brown were friendly in the 1880s, and Brown advised Scott on the decoration of the new Manchester City Art Galleries.

52. See F. M. Brown, "Self-Painted Pictures," *Magazine of Art* (1889): 184–89.

53. The Jubilee murals, in a decayed state, are in the Manchester City Art Galleries. Brown's drawings for the murals (Figs. 70 and 71) are in the Whitworth Art Gallery, University of Manchester.

Brown's work on the Jubilee murals is described in Brown, 1888, 52–55.

54. Brown proposed Peterloo as a subject in August 1878. By late 1878, the committee on the decoration of the Town Hall decided instead to have the Opening of the Bridgewater Canal (Fig. 82) represented. See Treuherz, 1985, 174–75. In 1886, the committee decided to drop the previously proposed mural subject of *Prince Charles Edward Reviewing the Manchester Regiment* (which concerned the Jacobite uprising) in favor of *John Dalton* (Fig. 80). The committee's decisions in both cases seem to reflect a desire to avoid any tendentious or divisive subject matter in the murals.

55. The Fawcett double portrait was commissioned by Sir Charles Dilke, another politician, in 1872. Both Fawcett and Dilke represented politics of a generally leftist tinge, and this commission again suggests Brown's left-wing political sympathies.

56. See J. H. Plumb, "The Victorians Unbuttoned," *Horizon* (Autumn 1969); Arthur S. Marks, "Brown's 'Take Your Son, Sir!'" *Arts Magazine* (January 1980): 135–41; and Jan Marsh, *The Pre-Raphaelite Sisterhood,* New York, 1985, 40–41. There is nothing in the painting in fact to suggest that it is anything more than a mother presenting her child to its proud father. Some observers have apparently understood the mother's remark in the title as a bitter statement. But the imperative tone is not necessarily condemnatory, and the grimacing face of the mother is Brown's habitual depiction of a laughing expression. Brown's first mention of *Take Your Son, Sir!* in his diary states: "During the winter I painted the study from Emma with the head back laughing at night in Newman St." (16 August 1854, Surtees, 1981, 78). Mary Bennett also notes (Tate, 1984, no. 82) that it is unlikely that Brown would have represented himself, his wife, and his child in a scene of improper sexual conduct.

57. Brown, *Diary,* 28 June 1856, Surtees, 1981, 181: "W.B. Scott called talked about the heat making one feel like in Paradise then about the changes that had come over him in twenty years, since the time when he believed in the power and efficacy of reason, the perfectibility of women and Mary Woolstonecraft."

58. On Emma's alcoholism, see Surtees, 1981, 129, 162n, 207, 209, 214; and Newman and Watkinson, 1991, 90, 95–96, 149–50, 177, 178–79.

59. Brown's amorous feelings toward Marie Spartali were first noted and discussed by Newman and Watkinson, 1991, 148–54, 155, 162, 175, 179. Spartali, from a prominent Greek family in London, became Brown's pupil in 1864 on the recommendation of Rossetti. In Brown's sonnet "Her Name!" (Soskice Papers, Parliament, London), written in 1869–71, Brown likens his beloved to other women,

real and literary, who are named Mary or Marie, and Mary Chaworth, "Byron's frenzied first-love," is mentioned. "Her Name!" is given above, Chap. 2, n. 53.

60. See the history of the painting given in Tate, 1964, no. 80.

61. Arthur Hughes was a Pre-Raphaelite follower. Brown wrote in his diary 9 September 1855, Surtees, 1981, 153: "Last night I had the mulligrubs & went for the first time to Munros & saw Hughes picture of the Lovers quarrel [*April Love*]—it is very beautiful indeed. The girl is lovely, draperies & all, but the greens of his foliage were so acid that made my mulligrubs worse I do think." Much later, on 26 December 1863, Brown wrote to George Rae (Rae Papers, Walker Art Gallery, Liverpool), "Morris writes me word that he takes your offer of April Love; but that he had been advised not to part with it under £150—I fancy it is a cheap picture."

62. A study of the dog-beating little girl, dated 1857, is in the Birmingham City Art Gallery. On the genesis of the picture, see Tate, 1984, no. 80.

63. See Philippe Aries, *Centuries of Childhood,* London, 1962; John Cleverley and D. C. Phillips, *Visions of Childhood: Influential Models from Locke to Spock,* New York, 1986, Peter Coveney, *Images of Childhood,* Harmondsworth, Middlesex, 1967.

64. On Rossetti's femmes fatales, see David Sonstroem, *Rossetti and the Fair Lady,* Middleton, Conn., 1970.

65. Brown, *Diary,* 4 September 1847, Surtees, 1981, 1–2, noted that he at first thought of calling the painting, "the Origin of our native tongue," or "the 'seeds of the English language.'"

66. Brown, 1865, no. 3; see Appendix 3.

67. See Hueffer, 1896, 166–67.

68. See Shanes, 1990, 113.

69. On sea-bathing as a particularly English phenomenon, see John K. Walton, *The English Seaside Resort: A Social History, 1750–1914,* New York, 1983.

70. Brown, *Diary,* 5 October 1854, Surtees, 1981, 98–99.

71. Brown, 1865, no. 13; see Appendix 3.

72. Hueffer, 1896, 83.

73. Hueffer, 1896, 401.

74. *Diary,* 5 October 1854, Surtees, 99. Surtees notes that the verse is a metrical version of Psalm 17 vv. 13 and 14, as used by the Church of Scotland, published in 1850.

75. Brown, for example, 6 July 1856, Surtees, 1981, 181.

76. Soskice, 1921, chap. 1.

77. Newman and Watkinson, 1991, 197. Hueffer, 1896, 398, described the funeral as "following the custom of French unsectarian burials," and notes that a "farewell oration" was delivered by Mr.

Moncure Conway, who had performed the same task at Oliver Madox Brown's funeral in 1874.

78. On William Cave Thomas, see Vaughan, 1979; *Art Journal* (1869): 217–19; *Portfolio* (1871): 149–153; W. C. Thomas, *Pre-Raphaelitism tested by the Principles of Christianity* (for private circulation), London, 1860; idem., *The Holiness of Beauty; or, The Conformation of the Material by the Spiritual,* London, 1863; idem., *Mural or Monumental Decoration,* London, 1869.

79. See A. Grieve, "The Pre-Raphaelite Brotherhood and the Anglican High Church," *Burlington Magazine* 111 (1969): 294–95. See also Edward Morris, "The Subject of Millais' *Christ in the House of His Parents,*" *Journal of the Warburg and Courtauld Institutes* 33 (1970): 343–45. Lindsay Errington, in her dissertation, "Social and Religious Themes in English Art, 1840–1860," University of London, 1973, also deals with Pre-Raphaelitism and the Oxford Movement.

80. See Bendiner, 1985, chap. 4.

81. Doughty, 1949, passim.

82. The complete catalogue description, given in Rabin, 1975, 25, reads: "Arrivée sur l'échafaud, elle demanda son aumonier, ci qui lui refuse. On lui arriva un ministre protestant qui, sous prétexte de zèle, n'eut pas honte d'insulter a ses sentiment: il lui déclara que, hors la communioin de l'église anglicane, elle serait damnée. Marie le pria de ne plus la tourmenter; mais il persista. Le Comte de Kent, al la fin, le fit taire. Ses deux suivants, voyant approcher le moment fatal, éclaterent en sanglots; Marie mit alors son doigt sur les lèvres pour imposer silence."

83. The *Art-Union* (February 1845): 54, noted: "The competition for painting an altar-piece for the Church of St. James, Bermondsey—for which our readers will recollect a sum of £500 was bequeathed by the late J. Harcourt, Esq—has resulted in the selection of Mr. John Wood. Of the integrity of the selection there can be no doubt. The judges appointed were Mr. Eastlake and Mr. Haydon—with a proviso, that if they differed, the final decision between them would rest with Mr. Cooke. They both agreed, however, in regard to Mr. Wood; and in that opinion they were eventually upheld by Mr. Cooke. . . . The seventy-one unsuccessful candidates will therefore, no doubt, be satisfied, although disappointed." In the *Art-Union* (March 1845): 74 and 77, the review of the British Institution exhibition included remarks on sketches of the Ascension for the Bermondsey altarpiece by Robinson Elliot (no. 37) and Frank Howard (no. 245).

84. For the *Builder* article, see Appendix 2. On Fuseli, his paintings and engravings, see Gert Schiff, *Johann Heinrich Fussli, 1741–1825,* 2 vols.,

Zurich, 1973. Fuseli's influence on Brown is discussed by Rabin, 1975, 28. It was also remarked by Sidney Colvin in 1870, who attributed Brown's "dramatic improvisation" to Fuseli's influence; see S. Colvin, "English painters of the Present Day, Mr. Ford Madox Brown," *Portfolio* 1 (June 1870): 81. In fact, Fuseli's effect on Brown was long-lasting, and *Cordelia's Portion* of 1865 (Fig. 52), while generally based on Brown's 1844 Lear drawings, seems derived from Fuseli's painting of the subject, Schiff, 1973, no. 739 (Fig. 123). This Fuseli painting of Lear Disinheriting Cordelia was engraved and published in John Boydell, *A Collection of Prints from Pictures Painted for the Purpose of Illustrating the Dramatic Works of Shakespeare, by the Artists of Great Britain,* London 1803, 2:no. 38. The Boydell publication is just the sort of work that Brown would have sought out when developing his own Shakespearean subjects. Colvin also mentioned William Blake as a source of inspiration, but Blake's work was hardly known on the Continent in the early 1840s, when Brown was in Paris. Brown is unlikely to have even heard of Blake's art before meeting D. G. Rossetti in 1848. Rossetti had purchased a Blake notebook in 1847. It is significant that in Brown's *Seeds and Fruits of English Poetry* (Fig. 13), designed in 1845, among the many English poets depicted and named in the canvas, Blake does not appear.

85. Brown, 1865, no. 3; see Appendix 3.

86. See Chapter 1.

87. Brown, *Diary,* 28 February 1848, Surtees, 1981, 32.

88. See Errington, 1973.

89. Hueffer, 1896, 290–92. Excerpts from Robertson's description are included in Hueffer's discussion of the painting.

90. Mary Bennett has pointed out (Tate, 1984, no. 180) that Cromwell's horse is, like that of William the Conqueror in *The Body of Harold* (Fig. 11), based on Delacroix's *Capture of Constantinople by the Crusaders* (Musée du Louvre, Paris). The choice by Brown of this source might stem from a conception of Cromwell as Christian conqueror, a latter-day Crusader.

91. In his 1865 catalogue description of this subject (Brown, 1865, no. 20; see Appendix 3), Brown remarked that "the farmer is intended to foreshadow the king, and everything is significant or emblematic." This suggestion of typology and symbolism, however, seems to be Brown's attempt to equal the success of Holman Hunt's *Finding of the Saviour in the Temple* (Birmingham Art Gallery), which was exhibited in 1860 with a descriptive pamphlet in which all sorts of hidden emblems and foretelling types were noted (see Bendiner, 1985, chap. 4). Brown's entire one-man show of 1865, centered upon

Work, was partly an attempt to follow Hunt's example. Furthermore, the suggestion in Brown's words of 1865 that Cromwell would become "king" nullifies any sense that the eventual Lord Protector was somehow different from monarchical rulers. Furthermore, Brown roundly condemned Puritan antagonism toward the arts in two articles: Brown, 1888, 42, and Brown, 1890, 134.

92. See Hueffer, 1896, 311–14.

93. The screen also appears in Brown's self-portrait of 1877 (Fig. 65), an Aesthetic vision of himself.

94. Except for a drawing of *Lord Jesus* in 1849, commissioned by the Dickinson Brothers, to be lithographed and used in schoolrooms. On the *Lord Jesus,* see *Diary,* 3 November 1849, Surtees, 1981, 69; and Newman and Watkinson, 1991, 54. Drawings for the work are in the Birmingham City Art Galleries.

95. See Bendiner, 1985, chap. 4.

96. Brown, 1865, no. 12; see Appendix 3.

97. This is from the entry for *Ehud and Eglon* (1863), an illustration for the Dalziel Bible: Brown, 1865, no. 67; see Appendix 3.

98. See K. Bendiner, "The Portrayal of the Middle East in British Painting, 1830–1860," diss., Columbia University, 1979.

99. Brown, 1865, no. 33, points out the dough-kneading, and notes that a poor woman would have had to carry out her household chores even when stricken with tragedy.

100. Ibid., no. 33; see Appendix 3.

101. Ibid.

102. Note for Charles Rowley, post-1883, Horsfall Papers, Manchester City Art Galleries, quoted in Tate, 1984, no. 137.

103. Letter to Rae, 25 September 1869, Rae Papers, Walker Art Gallery, Liverpool.

104. Notes on the Brown Family Papers, kindly shown to me by Mary Bennett.

105. Brown did of course devise religious stained-glass designs for Morris until 1875, and he did produce the watercolor *The Supper at Emmaus* in 1876 for Charles J. Pooley. The watercolor replicates exactly the stained-glass design for the Church of Jesus, Troutbeck, Westmorland. The location of the watercolor is unknown. It was sold at Christie's, 2 May 1924 (Crowther sale), and a photograph is in the Witt Library, London.

106. The connection to Dyce's mural has been pointed out by Treuherz, 1985, 187. The linkage is telling, because in many ways the Manchester Town Hall murals were for Brown the fulfillment of the goal of his youth, the decoration of the Houses of Parliament, the competitions for which he entered. In his lecture, "Style in Art," delivered not long before he began the Manchester murals, Brown specifically praised Dyce's *Baptism of Ethelbert,* "that most refined and beautiful of all the frescoes [in the House of Lords]." See Hueffer, 1896, 36.

107. Brown, *Particulars,* no. 2; see Appendix 4.

108. Brown, *Particulars,* no. 5; see Appendix 4.

Bibliography

Manuscripts

Notes by Mary Bennett on the Brown Family Papers, Kendal, Cumbria (The Brown Family Papers, formerly in a private collection, were sold in December 1995, and acquired by the Victoria and Albert Museum, London.)

F. M. Brown letters, poems and notes, Princeton University Library, Princeton, N.J.

Rae Papers, Walker Art Gallery, Liverpool.

Soskice Papers, Parliament Record Office, London.

Albert Moore and His Contemporaries, exh. cat. By Richard Green. Laing Art Gallery, Newcastle upon Tyne, 1972.

Andrews, Keith. *The Nazarenes: A Brotherhood of German Painters.* Oxford, 1964.

Aristotle. *Aristotle. Poetics I with the Tractatus Coislinianus.* Trans. Richard Janko. Indianapolis, Ind., 1987.

————. *Aristotle. The Poetics. Longinus on the Sublime. Demetrius on Style.* Loeb Classical Library. Cambridge, Mass., 1932.

Art Nouveau. Art and Design at the Turn of the Century, exh. cat. Museum of Modern Art, New York, 1959.

Aslin, Elizabeth. *The Aesthetic Movement: Prelude to Art Nouveau.* New York, 1969.

————. *Nineteenth-Century English Furniture.* New York, 1962.

Baldry, Alfred Lys. *Albert Moore: His Life and Works.* London, 1894.

Barrell, John. *The Dark Side of the Landscape.* Cambridge, 1980.

Bartsch, Adam. *Le peintre graveur.* 21 vols. Vienna, 1803–21.

Baudelaire, Charles. *De l'essence du rire et généralement du comique dans les arts plastiques.* Paris, 1855.

Bell, Quentin. *A New and Noble School: The Pre-Raphaelites.* London, 1982.

————. "The Pre-Raphaelites and Their Critics." In Leslie Parris, ed., *Pre-Raphaelite Papers.* London, 1984, 11–22.

Bendiner, Kenneth. "Brown and Wilkie." *Gazette des Beaux-Arts* (May–June 1993): 227–30.

————. *Ford Madox Brown: Il lavoro.* Turin, 1991.

————. *An Introduction to Victorian Painting.* New Haven, 1985.

————. "The Portrayal of the Middle East in British Painting, 1830–1860." Diss., Columbia University, New York, 1979.

Bennett, Mary. *Artists of the Pre-Raphaelite Circle; The First Generation. Catalogue of Works in the Walker Art Gallery, Lady Lever Art Gallery and Sudley Gallery.* London, 1988.

————. "Ford Madox Brown at Southend." *Burlington Magazine* (February 1973): 74–78.

————. "The Price of 'Work.'" In Leslie Parris, ed., *Pre-Raphaelite Papers.* London, 1984, 143–52.

————. "Waiting: An English Fireside of 1854–5. F.M. Brown's First Modern Subject Picture." *Burlington Magazine* (December 1986): 903–4.

Bennington, Merle M. *The Saturday Review, 1855–1868.* New York, 1966.

Blunt, Anthony. *Artistic Theory in Italy, 1450–1600.* London, 1962.

Boase, T. S. R. "The Decoration of the New Palace of Westminster, 1841–1863." *Journal of the Warburg and Courtauld Institutes* 17 (1954): 319–58.

Bøe, Alf. *From Gothic Revival to Functional Form.* Oslo, 1957.

Boime, Albert. "Ford Madox Brown, Thomas Carlyle and Karl Marx: Meaning and Mystification of Work in the Nineteenth Century." *Arts Magazine* (September 1981): 116–25.

Borowitz, Helen O. "'King Lear' in the Art of Ford Madox Brown." *Victorian Studies* (Spring 1978): 323–27.

Boydell, John. *A Collection of Prints from Pictures Painted for the Purpose of Illustrating the Dramatic Works of Shakespeare, by Artists of Great Britain.* London, 1803.

Briggs, Asa. *Saxons, Normans and Victorians.* Bexhill-on-Sea, 1966.

[Brown, Ford Madox]. *The Exhibition of WORK, and other Paintings by Ford Madox Brown,* exh. cat. 191 Piccadilly, London, 1865.

Brown, Ford Madox. "The Gambier Parry Process." *Royal Institute of British Architects: Sessional Papers* 21 (1880–81): 273–76. Paper read 12 May 1881.

———. "Historic Art." *Universal Review* (September 1888): 38–52.

———. "Modern vs. Ancient Art." *The Builder* (4 November 1848): 530–31.

———. "Of Mural Painting." In Arts and Crafts Exhibition Society, *Arts and Crafts Essays.* New York, 1893, 151–59.

———. "On the Influence of Antiquity on Italian Art." *The Builder* (2 December 1848): 580–81.

———. "On the Mechanism of a Historical Picture." *The Germ,* no. 2 (February 1850): 70–73.

———. "Our National Gallery." *Magazine of Art* (1890): 133–36.

[Brown, Ford Madox]. *Particulars Relating to the Manchester Town Hall and Description of the Mural Paintings in the Great Hall by Ford Madox Brown.* Pamphlet, n.d. [c. 1893].

Brown, Ford Madox. "The Progress of English Art Not Shown at the Manchester Exhibition." *Magazine of Art* (1889): 120–22.

———. "Self-painted Pictures." *Magazine of Art* (1889): 184–89.

———. *The Slade Professorship: Address to the Very Rev. the Vice-Chancellor of the University of Cambridge.* Pamphlet, 20 December 1872.

Bryant, Hallman B. "Two Unfinished Pre-Raphaelite Paintings: Rossetti's 'Found' and F.M. Brown's 'Take Your Son, Sir.' " *Journal of Pre-Raphaelite Studies* (November 1982): 56–67.

Bryson, John, and J. C. Troxell, eds. *Dante Gabriel Rossetti and Jane Morris Correspondence.* Oxford, 1976.

Buttafoco, Maria. "F.M. Brown o 'del meccanismo di una pittura di storia.' " *Annua dell istituto di storia dell arte* 1 (1981–82): 53–62.

Camille, Michael. *Image on the Edge: The Margins of Medieval Art.* London, 1992.

Carlyle, Thomas. *Chartism.* London, 1839.

———. *English and Other Critical Essays.* Everyman ed. London, n.d.

———. *Latter-Day Pamphlets.* London, 1850.

———. *Past and Present.* London, 1843.

Casteras, Susan P. *English Pre-Raphaelitism and Its Reception in America in the Nineteenth Century.* Rutherford, N.J., 1990.

Champfleury [Jules Husson]. *Histoire de la caricature.* Paris, 1865.

———. *Histoire de la caricature du moyen âge et sous la renaissance.* Paris, 1870.

Cherry, Deborah. "The Hogarth Club." *Burlington Magazine* (April 1980): 237–38.

Chew, Samuel C. *Byron in England; His Fame and After-fame.* New York, 1965.

Christensen, Torben. *Origin and History of Christian Socialism, 1848–54.* Aarhus, 1962.

Christian, John. "Early German Sources for Pre-Raphaelite Designs." *Art Quarterly* 36.1–2 (1973): 68ff.

Clark, T. J. *Painting in Modern Paris.* New York, 1985.

Cleverley, John, and D. C. Phillips. *Visions of Childhood: Influential Models from Locke to Spock.* New York, 1986.

Colvin, Sidney. "English Painters of the Present Day. Mr. Ford Madox Brown." *Portfolio* 1 (June 1870): 81–86.

"Comic Art and Caricature." *Encyclopedia of World Art,* vol. 3. New York, 1960.

Conrad, Peter. *The Victorian Treasure-House.* London, 1973.

Cooper, Anthony Ashley, Earl of Shaftesbury. *Characteristics of Men, Manners, Opinions, Times.* Ed. J. M. Robertson. Indianapolis, Ind., 1964.

Coveney, Peter. *Images of Childhood.* Harmondsworth, Middlesex, 1967.

Crawford, Alan. *C. R. Ashbee; Architect, Designer and Craftsman.* New Haven, 1985.

———. "Sources of Inspiration in the Arts and Crafts Movement." In S. Macready and F. H. Thompson, eds., *Influences in Victorian Art and Architecture.* London, 1985, 155–60.

Curtis, Gerard. "Ford Madox Brown's 'Work': An Iconographic Analysis." *Art Bulletin* 74 (December 1992): 623–36.

Davenport, S. K. "Illustration Direct and Oblique in the Margins of an Alexander Romance at Oxford." *Journal of the Warburg and Courtauld Institutes* 34 (1971): 83–95.

Delevoy, Robert. *Symbolists and Symbolism.* New York, 1978.

Dickens, Charles. *The Life and Adventures of Nicholas Nickleby.* London, 1839.

Dio Chrysostomus. *Dio Chrisostomus.* Trans. J. W. Cohoon. Loeb Classical Library. Cambridge, Mass., 1932.

Dorment, Richard. "The Loved One: Alfred Gilbert's *Mors Janua Vitae.*" In *Victorian High Renaissance,* exh. cat., by Allen Staley, et al. Manchester City Art Gallery, Minneapolis Institute of Art, and Brooklyn Museum, New York, 1978, 43–52.

Doubleday, John. *The Eccentric A. H. Mackmurdo.* Colchester, 1979.

Doughty, Oswald. *Dante Gabriel Rossetti: A Victorian Romantic.* New Haven, 1949.

Doughty, Oswald, and J. R. Wahl, eds. *Letters of Dante Gabriel Rossetti.* 3 vols. Oxford, 1965.

Drawings of John Everett Millais, exh. cat. By Malcolm Warner. Arts Council Touring Exhibition, Bolton, Brighton, Sheffield, Cambridge, Cardiff, 1979.

Du Maurier, George, "A Legend of Camelot." 5 parts. *Punch* 50 (3 March–31 March 1866).

Edelstein, T. J. "They Sang 'The Song of the Shirt': The Visual Iconology of the Seamstress." *Victorian Studies* 23.2 (Winter 1980): 183–210.

Emerson, Ralph Waldo. "Comic Theory." In Paul Lauter, ed., *Theories of Comedy.* Garden City, N.Y., 1964, 378–87.

English Caricature, 1620 to the Present, exh. cat. Victoria and Albert Museum, London, 1984.

Errington, Lindsey. "Social and Religious Themes in English Art, 1840–1860." Diss., Courtauld Institute of Art, London, 1973.

Evans, Stuart. "The Century Guild Connection." In J. G. Archer, ed., *Art and Architecture in Victorian Manchester.* Manchester, 1985, 250–68.

Fleming, G. H. *That Ne'er Shall Meet Again.* London, 1971.

Ford Madox Brown, 1821–1893, exh. cat. By Mary Bennett. Walker Art Gallery, Liverpool, 1964.

Freud, Sigmund. *Jokes and their Relation to the Unconscious.* 1905. *Standard Edition of the Complete Psychological Works of Sigmund Freud,* vol. 3. Trans. James Strachey. London, 1960.

From Realism to Symbolism: Whistler and His World, exh. cat. By Allen Staley et al. Wildenstein, New York, 1971.

Ganz, Margaret. *Humor, Irony, and the Realm of Madness; Psychological Studies in Dickens, Butler and Others.* New York, 1990.

Gere, Charlotte, and Michael Whiteway. *Nineteenth-Century Design from Pugin to Mackintosh.* New York, 1994.

Gilbert, Christopher. *English Vernacular Furniture.* New Haven, 1991.

Goldsmith, Oliver. *The Vicar of Wakefield.* In *The Works of Oliver Goldsmith,* vol. 1. Ed. P. Cunningham. New York, 1900.

Goldwater, Robert. *Symbolism.* London, 1981.

Gombrich, E. H. *Art and Illusion.* 2d ed., rev. New York, 1961.

Grean, Stanley. *Shaftesbury's Philosophy of Religion and Ethics.* Athens, Ohio, 1967.

Grieve, Alastair. "The Pre-Raphaelite Brotherhood and the Anglican High Church." *Burlington Magazine* (May 1969): 294–95.

———. "Style and Content in Pre-Raphaelite Drawings." In Leslie Parris, ed., *Pre-Raphaelite Papers.* London, 1984, 23–43.

Gurlitt, Cornelius. *Sir Edward Burne-Jones.* Munich, 1895.

Hamburger, Michael. Review of M. Camille, *Image on the Edge. Art Bulletin* 75 (June 1993): 319–27.

Hamilton, Walter. *The Aesthetic Movement.* 3d ed. London, 1882.

Hammond, John L. *C. P. Scott of the Manchester Guardian.* New York, n.d. [1934].

Heleniak, Katherine M. *William Mulready.* New Haven, 1980.

Henderson, Philip. *The Letters of William Morris to His Family and Friends.* London, 1950.

———. *William Morris.* New York, 1967.

Hilton, Timothy. *The Pre-Raphaelites.* London, 1970.

Himmelfarb, Gertrude. *The Idea of Poverty.* New York, 1984.

———. *Poverty and Compassion: The Moral Imagination of the Late Victorians.* New York, 1991.

Hobbes, Thomas. *The English Works of Thomas Hobbes.* Ed. William Molesworth. London, 1839–41.

Hofmann, Werner. *Caricature from Leonardo to Picasso.* New York, 1957.

Holman-Hunt, Diana. "The Holman Hunt Collection, A Personal Recollection." In Leslie Parris, ed., *Pre-Raphaelite Papers.* London, 1984, 206–25.

Horne, Herbert. "Thoughts Toward a Criticism of the Works of Dante Gabriel Rossetti." *Century Guild Hobby Horse* 2 (1887): 91–102.

Houghton, Walter. *The Victorian Frame of Mind.* New Haven, 1957.

House, John. *Monet: Nature into Art.* New Haven, 1986.

Hueffer, Ford Madox. *Ancient Lights and Some New Reflections.* London, 1911.

_____. *Ford Madox Brown: A Record of His Life and Work.* London, 1986.

Hunt, F. K. *The Book of Art.* London, 1846.

Hunt, William Holman. *Pre-Raphaelitism and the Pre-Raphaelite Brotherhood.* 2 vols. London, 1905.

Image, Selwyn. "St. Michael and St. Uriel, Designs by Mr. Ford Madox Brown for Painted Glass." *Century Guild Hobby Horse* 3 (1888): 121, 158–60.

Ironside, Robin. "Pre-Raphaelite Paintings at Wallington." *Architectural Record* 93 (1942): 147ff.

Jameson, Anna. *Memoirs of the Early Italian Painters, and of the Progress of Painting in Italy: From Cimabue to Bassano.* London, 1845.

Janko, Richard. *Aristotle on Comedy.* London, 1984.

Johnson, E. D. H. 'The Making of Ford Madox Brown's 'Work.'" In I. B. Nagel and F. S. Schwarzbach, eds., *Victorian Artists and the City.* New York, 1980, 142–52.

_____. *Paintings of the British Social Scene From Hogarth to Sickert.* New York, 1986.

Jones, Owen. *The Grammar of Ornament.* London, 1856.

Julian, Philippe. *The Symbolists.* Oxford, 1973.

Klenze, Camillo von. "The Growth of Interest in the Early Italian Masters, from Tischbein to Ruskin." *Modern Philology* 4 (October 1906): 207–68.

Klingender, F. D. *Hogarth and English Caricature.* London, 1945.

Kristeller, P. O. "The Modern System of the Arts." In *Renaissance Thought,* vol 2. New York, 1965.

Kugler, Franz. *Handbook of the History of Painting.* London, 1842.

_____. *Kugler's Handbook of Painting: The German, Flemish, Dutch, Spanish and French Schools.* 1st English ed., 1846. London, 1854.

Landow, George P., et al., eds. *A Pre-Raphaelite Friendship: The Correspondence of William Holman Hunt and John Lucas Tupper.* Ann Arbor, Mich., 1980.

Landow, George P. *William Holman Hunt and Typological Symbolism.* New Haven, 1979.

Lee, Vernon. *Miss Brown.* 2 vols. Edinburgh, 1884.

Lethaby, W. R. *Philip Webb and His Work.* 1935. London, 1979.

Lindsay, Lord. *Sketches of the History of Christian Art.* London, 1847.

Linnel, J. J. and W. Linnel. *The Prize Cartoons.* London, 1843.

Lovgren, Sven. *The Genesis of Modernism: Seurat, Gauguin, Van Gogh and French Symbolism in the 1880s.* Bloomington, Ind., 1971.

Lucie-Smith, Edward. *Symbolist Art.* London, 1972.

"Madox Brown's Designs for Furniture." *The Artist* (May 1898): 44–51.

Madsen, Stephen Tschudi. *Sources of Art Nouveau.* New York, 1956.

Marks, Arthur Sanders. "Brown's 'Take Your Son, Sir!'" *Arts Magazine* (January 1980): 135–41.

Marsh, Jan. *The Pre-Raphaelite Sisterhood.* New York, 1985.

Maurice, F. D. *The Life of Frederick Denison Maurice, Chiefly Told from His Own Letters.* 2 vols. London, 1884.

Mayhew, Henry. *London Labour and the London Poor.* Ed. J. D. Rosenberg. New York, 1968.

Millais, J. G. *The Life and Letters of Sir John Everett Millais.* 2 vols. London, 1899.

Mills, Ernestine. *The Life and Letters of Frederic Shields.* London, 1912.

Morris, Edward. "The Subject of Millais's *Christ in the House of His Parents.*" *Journal of the Warburg and Courtauld Institutes* 33 (1970): 343–45.

Morris, May, ed. *William Morris.* New York, 1910–15.

Newman, Teresa, and Ray Watkinson. *Ford Madox Brown and the Pre-Raphaelite Circle.* London, 1991.

Nicoll, John. *The Pre-Raphaelites.* London, 1970.

Nochlin, Linda. *Realism.* Harmondsworth, Middlesex, 1971.

Norman, Edward. *The Victorian Christian Socialists.* Cambridge, 1987.

"A Note Upon the Drawing of 'King René's Honeymoon' by Ford Madox Brown." *Century Guild Hobby Horse* 3 (1888): 121, 158–60.

Oppenheimer, Paul, ed. *Till Eulenspiegel: His Adventures.* New York, 1991.

Ormond, Leonee. *George Du Maurier.* London, 1969.

Paden, W. D. "The Ancestry and Families of Ford

Madox Brown." *Bulletin of the John Rylands Library, Manchester* 50 (1967–68): 124–35.

Palmer, Arthur J. *Riding High: The Story of the Bicycle.* New York, 1956.

Partridge, Eric. *A Dictionary of Slang and Unconventional English.* 18th ed. New York, 1984.

Pater, Walter. *Studies in the History of the Renaissance.* London, 1873.

Paulson, Ronald. *Hogarth.* 2 vols. New Brunswick, N.J., 1991.

Peattie, Roger W., ed. *Selected Letters of William Michael Rossetti.* Vol. 1. 1986.

Pevsner, Nikolaus. "Arthur Heygate Mackmurdo." In *Studies in Art, Architecture and Design,* vol. 2, *Victorian and After.* London, 1968.

———. *Pioneers of Modern Design from William Morris to Walter Gropius.* London, 1949.

Pierpont Morgan Library. *Medieval and Renaissance Manuscripts: Major Acquisitions, 1924–1974.* New York, 1974.

Plato. *Plato. Laws. Vol. 2.* Trans. R. G. Bury. Loeb Classical Library. Cambridge, Mass., 1925.

———. *Plato's Republic.* Trans. P. Shorey. Loeb Classical Library. Cambridge, Mass., 1946.

———. *Plato. The Statesmen. Philebus. Ion.* Loeb Classical Library. Cambridge, Mass., 1925.

Plumb, J. H. "The Victorians Unbuttoned." *Horizon* (Autumn 1969).

Pond, Edward. "Mackmurdo Gleanings." In J. M. Richards and N. Pevsner, eds., *The Anti-Rationalists.* London, 1973.

Posner, Donald. "Concerning the 'Mechanical' Parts of Painting and the Artistic Culture of Seventeenth-century France." *Art Bulletin* 75.4 (December 1993): 583–98.

Post-Impressionism: Cross Currents in European Painting, exh. cat. Royal Academy of Arts, London, 1979.

The Pre-Raphaelites, exh. cat. Tate Gallery, London, 1984.

Pugin, A. W. N. *Contrasts.* 2d ed. London, 1841.

———. *Gothic Furniture in the Style of the Fifteenth Century.* London, 1835.

Rabin, Lucy R. *Ford Madox Brown and the Pre-Raphaelite History-Picture.* New York, 1978.

Randall, Lilian. "Exempla as a Source of Gothic Marginal Illustration." *Art Bulletin* 39 (1957): 97–107.

———. *Images in the Margins of Gothic Manuscripts.* Berkeley and Los Angeles, 1966.

Rathbone, Harold. *The Cartoons of Ford Madox Brown.* London, privately printed, 1895.

Reynolds, exh. cat. By Nicholas Penny et al. Royal Academy of Arts, London, 1986.

Rio, Alexis F. *De la poésie chrétienne.* Paris, 1836.

Robertson, David. *Sir Charles Eastlake and the Victorian Art World.* Princeton, N.J., 1978.

Rosenblum, Robert. *Transformations in Late Eighteenth-Century Art.* Princeton, N.J., 1969.

Rossetti, William Michael. "Ford Madox Brown: Characteristics." *Century Guild Hobby Horse* 1 (1886): 48–54.

———. "Mr. Madox Brown's Frescoes in Manchester." *Art Journal* 43 (September 1881): 262–63.

———. *Rossetti Papers, 1862–1870.* London, 1903.

Rothenstein, William. *Men and Memories, 1900–1922.* 2 vols. New York, 1932.

Rowlandson, T., and A. C. Pugin. *Microcosm of London.* London, 1808.

Rowley, Charles. *Fifty Years of Work Without Wages.* London, n.d. [1911 or 1912].

Ruskin, John. *The Works of John Ruskin.* Library Edition. Ed. E. T. Cooke and A. D. O. Wedderburn. 39 vols. London, 1903–12.

Santucho, Oscar J. *George Gordon, Lord Byron: A Comprehensive Bibliography.* Metuchen, N.J., 1977.

Schapiro, Meyer. *Late Antique, Early Christian and Medieval Art.* New York, 1978.

———. *Romanesque Art.* New York, 1977.

Schiff, Gert. *Johannes Heinrich Fussli, 1741–1825.* 2 vols. Zurich, 1973.

Schmutzler, Robert. *Art Nouveau.* New York, 1978.

Scott, Sir Walter. *Anne of Geierstein.* Vols. 41 and 42 of *The Works of Sir Walter Scott.* Boston, 1913.

Sedding, John. "The Handicrafts in the Old Days." In *Art and Handicraft.* London, 1893, 50–81.

Seddon, John Pollard. *King René's Honeymoon Cabinet.* London, 1898.

———. "Mr. Ford Madox Brown and the Slade Professorship at Cambridge." *Architect* 7 (11 January 1873): 19–20.

Sewter, A. C. *The Stained Glass of William Morris and His Circle.* 2 vols. New Haven, 1974, 1975.

Shanes, Eric. *Turner's Human Landscape.* London, 1990.

Shaw, J. Byam. *Paintings by Old Masters at Christ Church College.* London, 1967.

Shaw, Henry. *Dresses and Decorations of the Middle Ages*. London, 1843.

———. *Handbook of Mediaeval Alphabets and Devices*. London, 1845.

———. *Specimens of Ancient Furniture*. London, 1836.

Silverman, Debora. *Art Nouveau in Fin-de-siècle France*. Berkeley and Los Angeles, n.d. [c. 1989].

Sir Edwin Landseer, exh. cat. By Derek Hill. Royal Academy of Arts, London, 1961.

Sir Edwin Landseer, exh. cat. By Richard Ormond. Philadelphia Museum of Art and Tate Gallery, London, 1982.

Sir David Wilkie of Scotland, exh. cat. By W. J. Chiego et al. North Carolina Museum of Art, Raleigh, 1987.

Smetham, S., and W. Davies, eds. *Letters of James Smetham*. London, 1892.

Sonstroem, David. *Rossetti and the Fair Lady*. Middleton, Conn., 1970.

Soskice, Juliet. *Chapters from Childhood: Reminiscences of an Artist's Granddaughter*. London, 1921.

Sparkes, Ivan. *An Illustrated History of English Domestic Furniture*. Bourne End, Eng., 1980.

Spencer, Herbert. "The Philosophy of Laughter." *Macmillan's Magazine* (March 1860). In *Essays*, vol. 2. London, 1901.

Staley, Allen. "The Condition of Music." *Art News Annual: The Academy* 33 (1967): 80–87.

———. *The Pre-Raphaelite Landscape*. Oxford, 1973.

———. "Post-Pre-Raphaelitism." In *Victorian High Renaissance*, exh. cat. Manchester City Art Gallery, Minneapolis Institute of Art, Brooklyn Museum, New York, 1978, 21–31.

Stansky, Peter. *Redesigning the World; William Morris, the 1880s, and the Arts and Crafts Movement*. Princeton, N.J., 1985.

———. *William Morris*. Oxford, 1983.

Stanton, Phoebe. *Pugin*. London, 1971.

Steegman, John. *Consort of Taste: 1830–1870*. London, 1950.

Stephens, F. G. *Dante Gabriel Rossetti*. London, 1894.

———. "The Purpose and Tendency of Early Italian Art." *The Germ* 1.2 (February 1850): 58–64.

Strong, Roy. *And When Did You Last See Your Father*. London, 1978.

Strutt. John. *A Complete View of the Dress and Habits of the People of England*. London, 1842.

———. *Sports and Pastimes of the People of England*. London, 1833.

Summers, David. *The Judgment of Sense*. Cambridge, 1987.

Sumner, Philip Lawton. *Early Bicycles*. London, 1966.

Surtees, Virginia. *The Diary of Ford Madox Brown*. New Haven, 1981.

———. *The Paintings and Drawings of Dante Gabriel Rossetti (1828–1882): A Catalogue Raisonné*. 2 vols. Oxford, 1971.

Tait, E. M. "The Pioneer of Art Furniture. Madox Brown's Furniture Designs." *The Furnisher: A Journal of Eight Trades* (October 1900): 61–63.

Thierry, Auguste. *History of the Conquest of England by the Normans*. London, n.d.

Thomas, William Cave. *The Holiness of Beauty; or, the Conformation of the Material by the Spiritual*. London, 1863.

———. "On the Influences which tend to Retard the Progress of the Fine Arts." *The Builder* (9, 16, and 23 September 1848).

———. *Mural and Monumental Decoration*. London, 1869.

———. "Pre-Raphaelitism Tested by the Principles of Christianity." (For private circulation.) London, 1860.

Thompson, E. Maunde. *The Grotesque and Humorous in the Illumination of the Middle Ages*. London, 1896.

Treuherz, Julian. "Ford Madox Brown and the Manchester Murals." In J. H. G. Archer, *Art and Architecture in Victorian Manchester*. Manchester, 1985, 162–207.

———. *Hard Times: Social Realism in Victorian Art*. London, 1987.

———. *Pre-Raphaelite Paintings from Manchester City Art Galleries*. Manchester, 1993.

———. "The Pre-Raphaelites and Medieval Illuminated Manuscripts." In Leslie Parris, ed., *Pre-Raphaelite Papers*. London, 1984, 153–61.

Trevelyan, R. *A Pre-Raphaelite Circle*. London, 1978.

Valliance, A. "Mr. Arthur H. Mackmurdo and the Century Guild." *Studio* 16 (1899): 183–92.

Vaughan, William. *German Romanticism and English Art*. New Haven, 1979.

Walton, John K. *The English Seaside Resort: A Social History, 1750–1914*. New York, 1983.

Warner, Malcolm. "John Everett Millais's 'Autumn Leaves': 'A picture full of beauty and without subject.'" In Leslie Parris, ed., *Pre-Raphaelite Papers*. London, 1984, 126–41.

Watkinson, Raymond. *Pre-Raphaelite Art and Design*. Greenwich, Conn., 1970.

Weinberg, Gail S. "First of All First Beginnings: Ruskin's Studies of Early Italian Paintings at Christ Church." *Burlington Magazine* (February 1992): 111–20.

William Morris and the Middle Ages, exh. cat. Whitworth Art Gallery, University of Manchester, 1984.

William Holman Hunt. exh. cat. By Mary Bennett. Walker Art Gallery, Liverpool, 1969.

Witt, John. *William Henry Hunt (1790–1864).* London, 1982.

Wolff, Michael, and Celina Fox. "Pictures from the Magazines." In E. J. Dyos and Michael Wolff, eds., *The Victorian City.* London, 1973, 2:559–82.

Wood, Christopher. *The Pre-Raphaelites.* New York, 1981.

Wright, T. H. *A History of Domestic Manners and Sentiments in England.* London, 1862.

———. *A History of English Culture.* London, 1874.

Yeats, W. G. "The Arts and Crafts. An Exhibition at William Morris's." *Providence (R.I.) Sunday Journal,* 26 October 1890.

Zola, Emile. *Collections des oeuvres complètes.* Paris, n.d.

Index

Illustrations

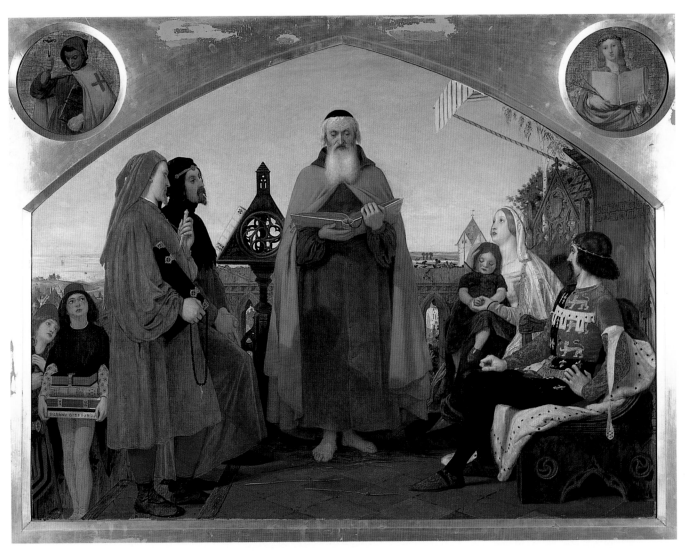

Color Plate I. *Wycliffe Reading His Translation of the New Testament to His Protector, John of Gaunt, Duke of Lancaster, in the Presence of Chaucer and Gower, 1847–48.* Retouched 1859–61. Oil on canvas, 47 x 60 1/2 inches (119.5 x 153.5 cm). Bradford Art Galleries and Museums.

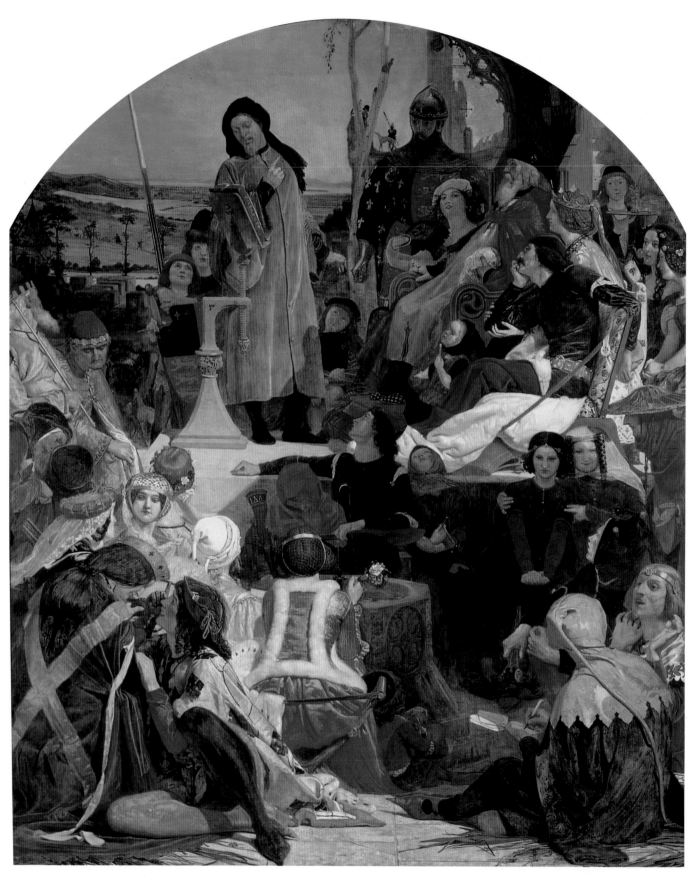

Color Plate II. *Geoffrey Chaucer Reading the "Legend of Custance" to Edward III and His Court, at the Palace of Sheen, on the Anniversary of the Black Prince's Forty-fifth Birthday,* 1845–51. Oil on canvas, arched top, 146 1/2 x 116 1/2 inches (372 x 296 cm). The Art Gallery of New South Wales, Sydney.

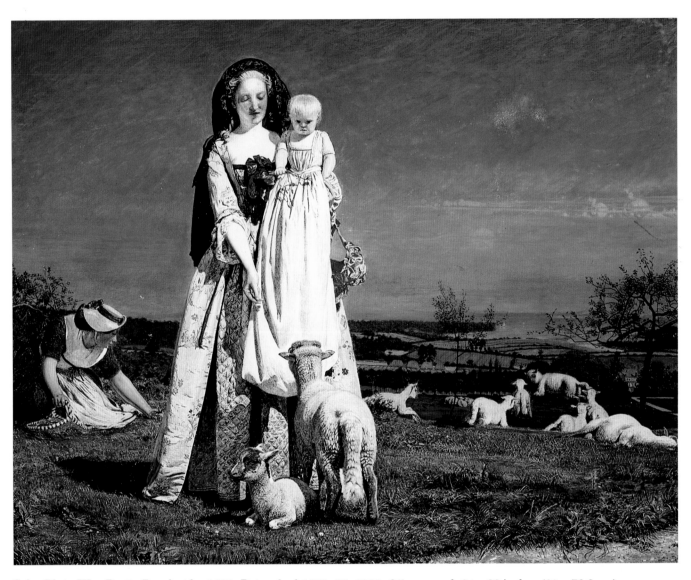

Color Plate III. *Pretty Baa-lambs,* 1851. Retouched 1851–53, 1859. Oil on panel, 24 x 30 inches (61 x 76.2 cm). Birmingham Museums and Art Gallery.

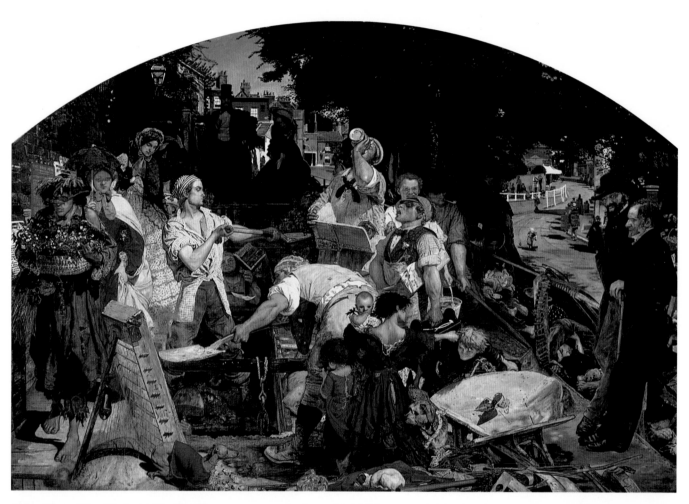

Color Plate IV. *Work,* 1852–65. Oil on canvas, arched top, 53 15/16 x 77 11/16 inches (137 x 197.3 cm). Manchester City Art Galleries.

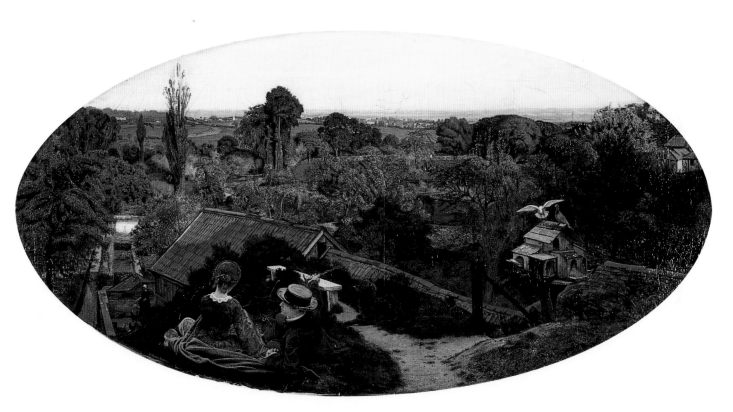

Color Plate V. *An English Autumn Afternoon,* 1852–53. Retouched 1855. Oil on canvas, oval, 28 1/4 x 53 inches (71.7 x 134.6 cm). Birmingham Museums and Art Gallery.

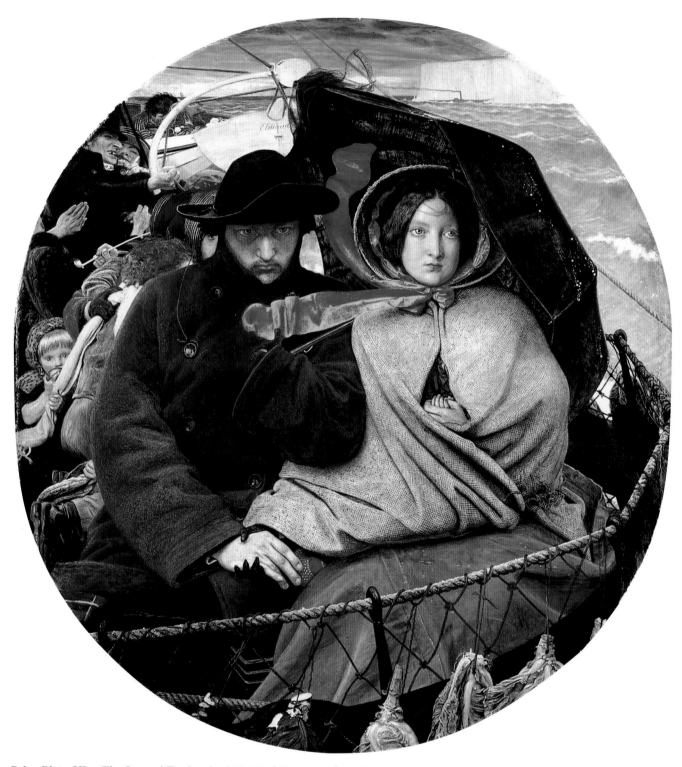

Color Plate VI. *The Last of England,* 1852–55. Oil on panel, oval, 32 1/2 x 29 1/2 inches (82.5 x 75 cm). Birmingham Museums and Art Gallery.

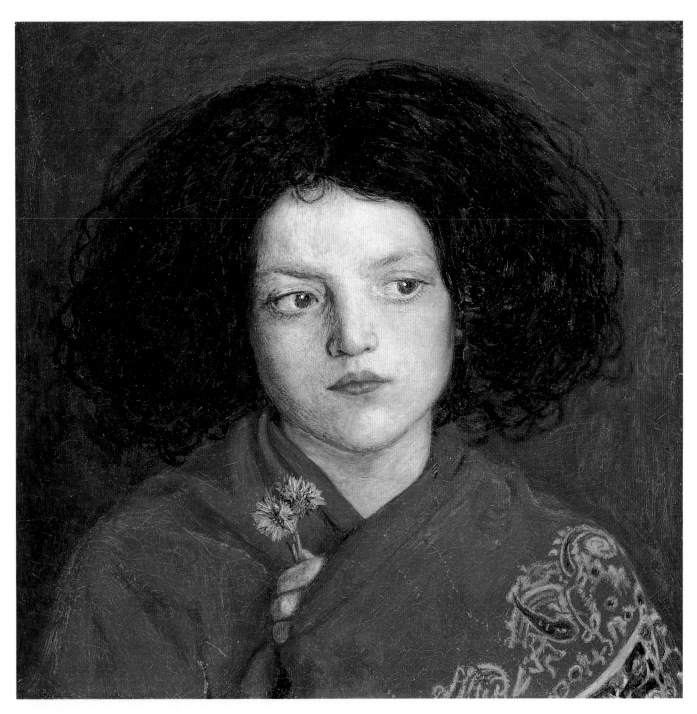

Color Plate VII. *The Irish Girl,* 1860. Oil on canvas, 10 1/4 x 10 inches (26 x 25.4 cm). Yale Center for British Art, New Haven, Paul Mellon Fund.

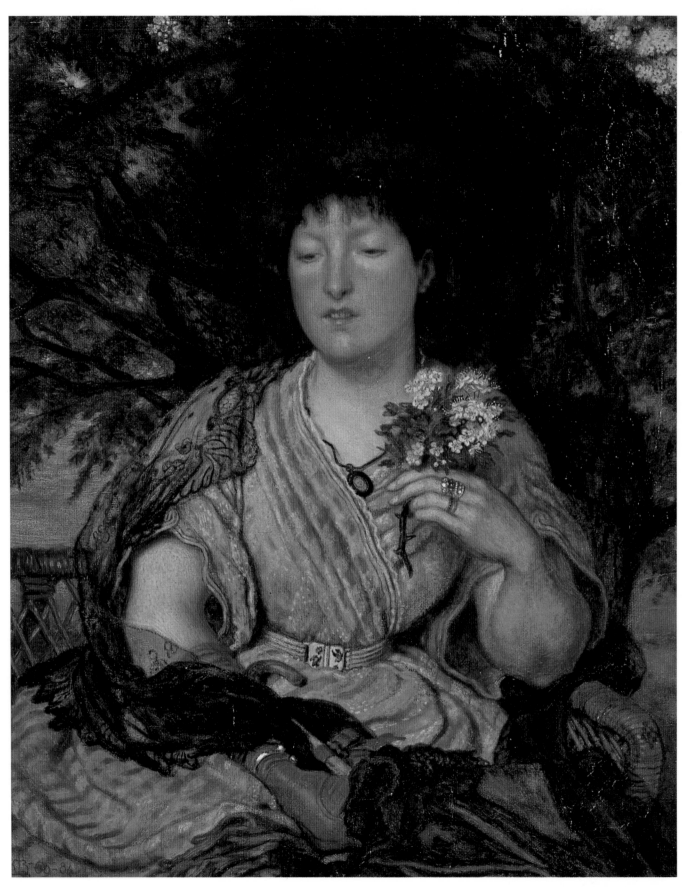

Color Plate VIII. *May Memories,* 1869–84. Oil on canvas, 16 x 12 1/2 inches (40.6 x 33.7 cm). Sold Christie's, London, 24 October 1980.

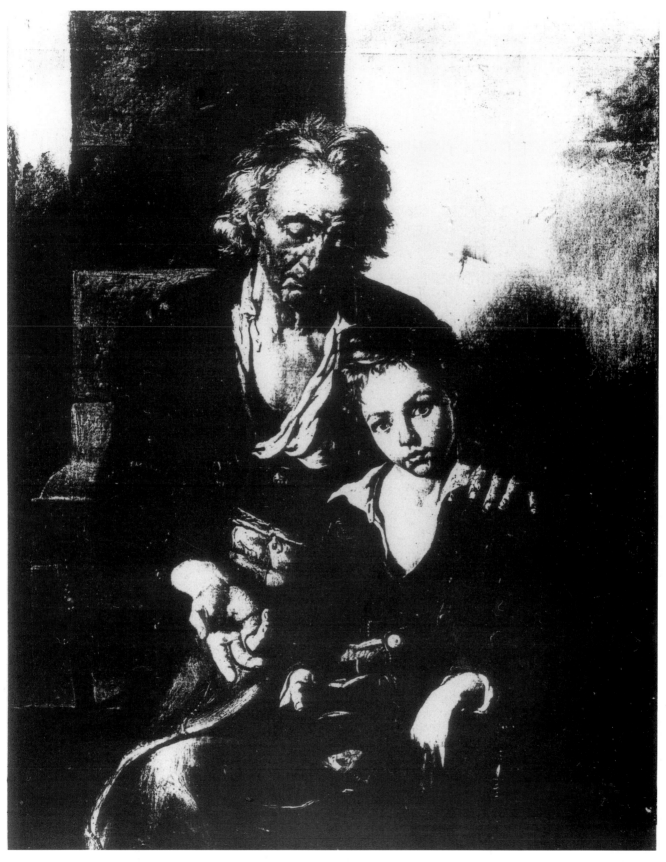

Fig. 1. F. M. Brown, *Blind Beggar and Child*, 1837. Oil on canvas, 49 1/2 x 38 1/2 inches (125.8 x 97.8 cm). Location unknown. Photo courtesy of Fine Art Society, London. This early painting remains untraced. The Fine Art Society in London owned it in the 1950s and has a photograph of the picture in its files. The date 1837 is inscribed on the canvas. Hueffer, 1896, p. 432, misdated the painting 1836.

Fig. 2. F. M. Brown, *The Execution of Mary Queen of Scots*, 1840–42. Oil on canvas, 30 3/4 x 27 3/8 inches (78.2 x 69.5 cm). Whitworth Art Gallery, University of Manchester. This is a small version of the large painting (now lost), which was exhibited at the Paris Salon in 1842. The large painting is reproduced in Hueffer, 1896, opposite p. 26, and is very close to this small version. The small oil almost certainly was a sketch for the large painting, and was developed into a finished painting at the same time.

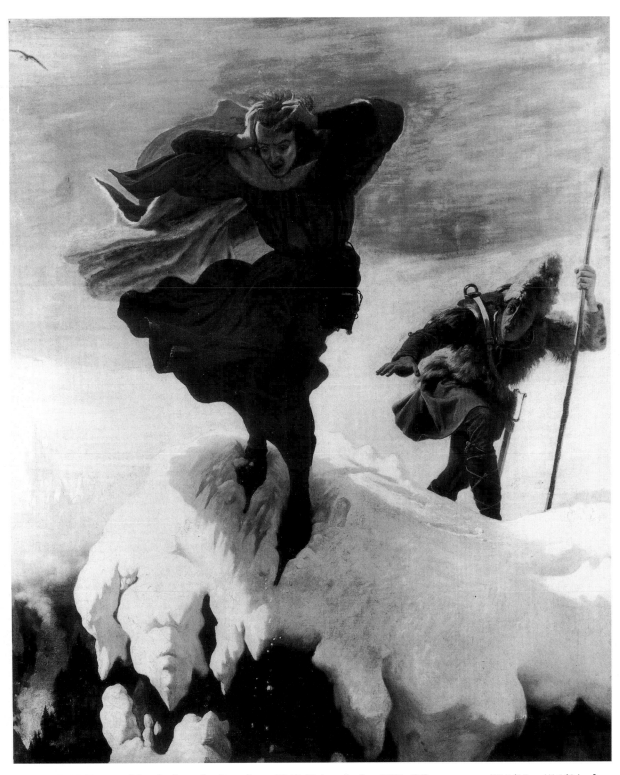

Fig. 3. F. M. Brown, *Manfred on the Jungfrau*, 1840. Retouched c. 1861. Oil on canvas, 55 1/16 x 45 1/4 inches (140.2 x 115 cm). Manchester City Art Galleries. The subject is taken from Byron's play *Manfred*. The original coloring of the painting was completely altered by Brown, c. 1861.

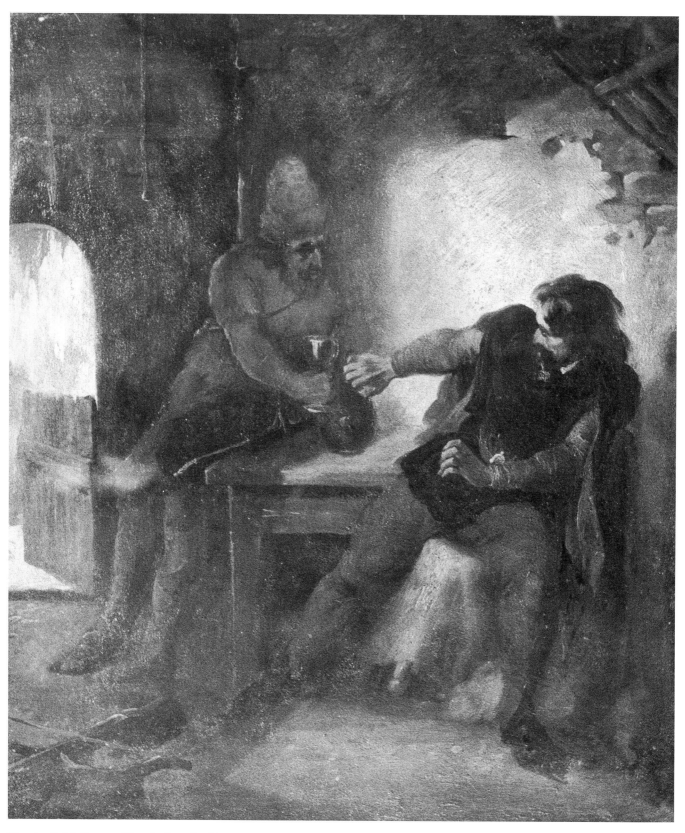

Fig. 4. F. M. Brown, *Manfred in the Chamois Hunter's Hut*, 1840. Oil on canvas, 22 3/8 x 18 3/4 inches (56.8 x 47.6 cm). City of Nottingham Museums; Castle Museum and Art Gallery. The subject is from Byron's play *Manfred*. This is a sketch for a painting in a private collection in Ireland. The larger, finished painting is rather different in composition from this sketch.

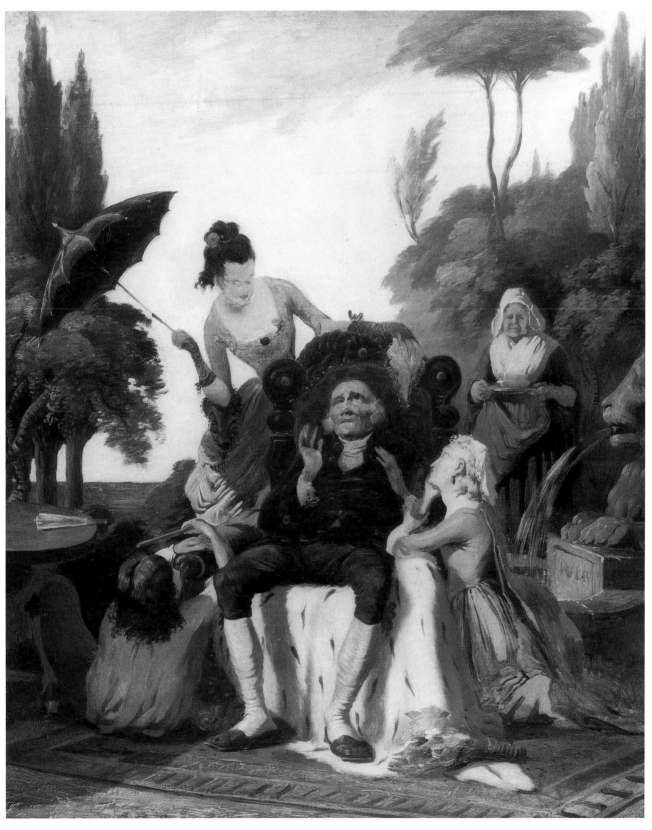

Fig. 5. F. M. Brown, *Dr. Primrose and His Daughters (Scene from "The Vicar of Wakefield")*, c. 1840–41. Oil on canvas, 28 9/16 x 23 1/8 inches (72.6 x 58.7 cm). Manchester City Art Galleries.

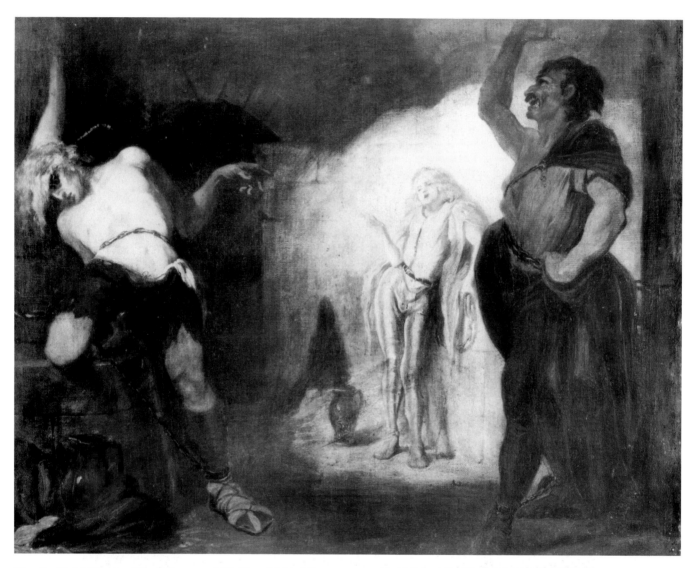

Fig. 6. F. M. Brown, *The Prisoner of Chillon*, 1843. Oil on canvas, 20 15/16 x 25 9/16 inches (53.2 x 64.9 cm). Manchester City Art Galleries. The subject is from Byron's poem of the same title. Brown would treat the same subject in an entirely different composition in 1856 to illustrate R. A. Wilmott, *Poets of the Nineteenth Century* (London, 1857).

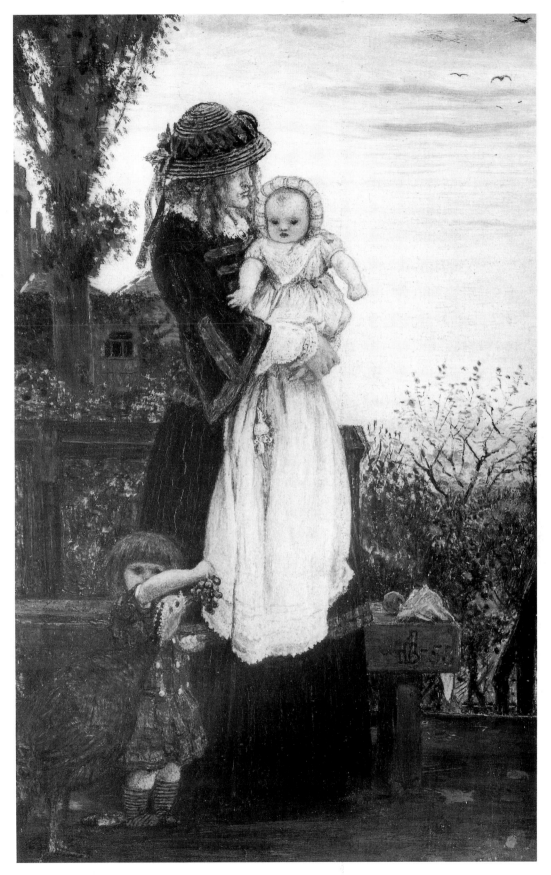

Fig. 7. F. M. Brown, *Out of Town*, 1843–58. Oil on canvas, 9 1/8 x 5 11/16 inches (23.2 x 14.4 cm). Manchester City Art Galleries. Begun in France as a study of Brown's first wife, it was taken up and finished in very different circumstances in England in 1858.

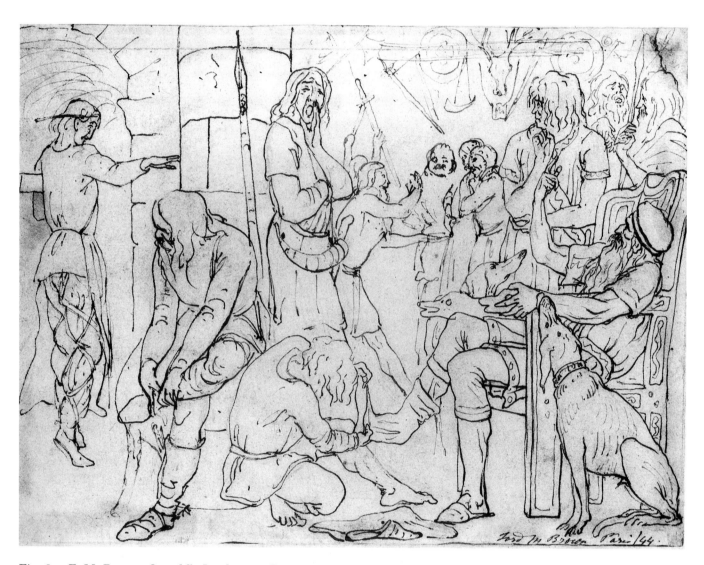

Fig. 8. F. M. Brown, *Oswald's Insolence to Lear*, 1844. Pen and ink on paper, 8 1/8 x 10 3/4 inches (20.7 x 27.6 cm). Whitworth Art Gallery, University of Manchester. This is one of sixteen drawings illustrating *King Lear* executed by Brown in Paris. The others are also in the Whitworth Art Gallery. In the catalogue of his 1865 one-man show, Brown dated these drawings to 1843. But he evidently later thought 1844 was their year of origin and inscribed the drawings with that date.

Fig. 9. F. M. Brown, *The Ascension*, 1844. Oil on canvas, 36 x 17 1/2 inches (91.4 x 44.5 cm). Forbes Magazine Collection New York. This sketch was submitted to a competition for an altarpiece for the church of St. James, Bermondsey. The contest was won by John Wood, whose *Ascension* still hangs in the church.

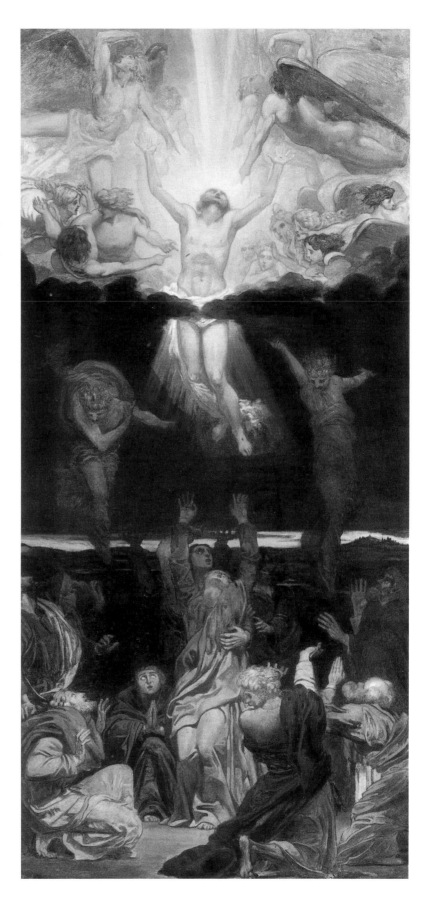

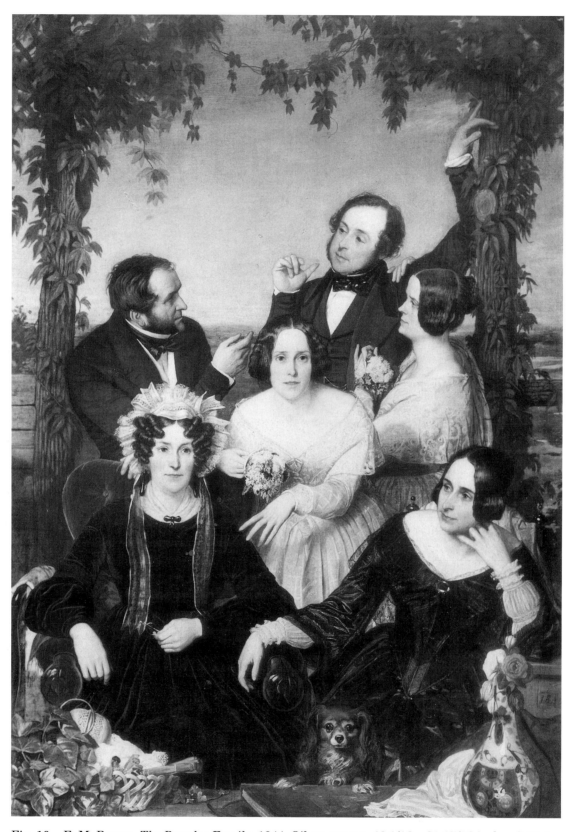

Fig. 10. F. M. Brown, *The Bromley Family*, 1844. Oil on canvas, 46 1/16 x 31 15/16 inches (117.4 x 81.1 cm). Manchester City Art Galleries. The sitters are members of the family of Elisabeth Bromley, Brown's first wife. Brown was himself related to the Bromleys through his mother. Brown's first wife was his cousin. Teresa Newman and Ray Watkinson (1991, p. 20) have identified the sitters as Richard Bromley (upper left), his wife, Clara (in the center), Augustus and Helen Bromley (upper right), Mary Bromley, Elisabeth's mother (lower left), and Elisabeth, Mrs. Ford Madox Brown (lower right).

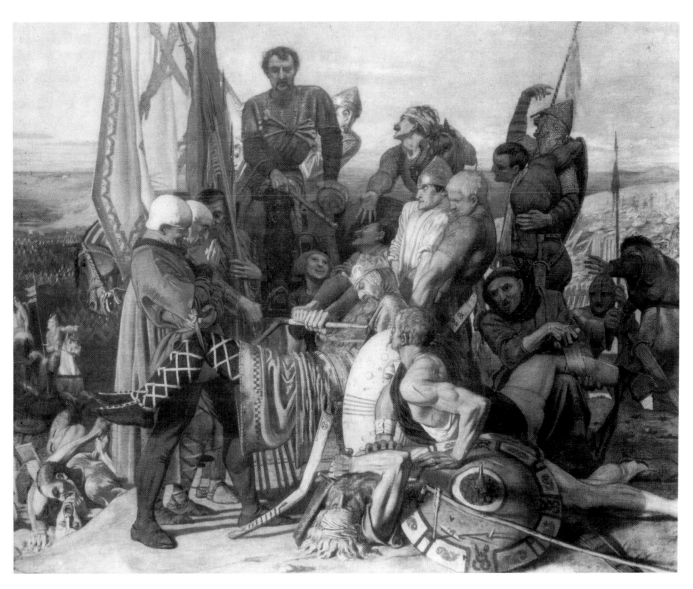

Fig. 11. F. M. Brown, *The Body of Harold Brought Before William the Conqueror* (*Willelmus Conquistator*), 1844–61. Oil on canvas, 41 1/2 x 48 1/4 inches (105 x 123.1 cm). Manchester City Art Galleries. This oil painting is a replica (on a smaller scale) of Brown's large cartoon for the Parliament fresco competition of 1844. The painting, in at least sketch form, was exhibited alongside the black-and-white cartoon at Westminster Hall in 1844 to indicate color. This oil version was thoroughly repainted in 1861 and titled *Willelmus Conquistator* by Brown in 1865. It is very close in almost every detail (save color) to the original cartoon (which is now in the Camberwell School of Art, London).

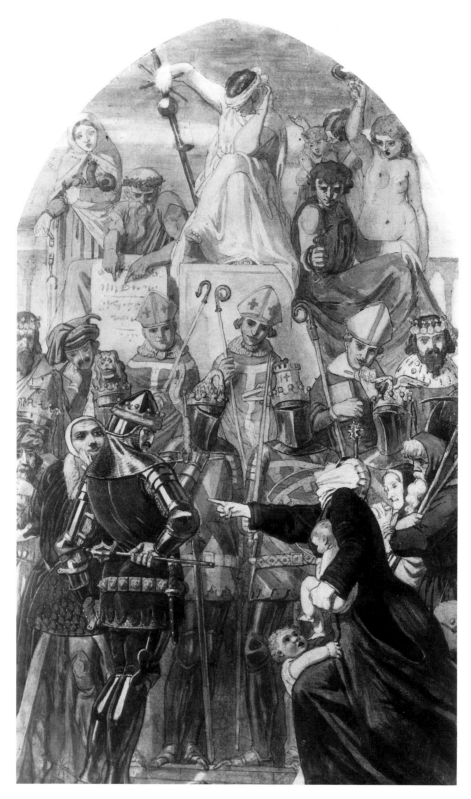

Fig. 12. F. M. Brown, *Study for "The Spirit of Justice,"* 1845. Pencil, watercolor, and bodycolor on paper, arched top, 29 13/16 x 20 3/8 inches (75.7 x 51.7 cm). Manchester City Art Galleries. This is a small study for Brown's large cartoon, which was submitted to the 1845 Parliament fresco competition. The original cartoon, in black and white, exists only in a few fragments, one of which is also at the Manchester City Art Galleries. A watercolor study for *The Spirit of Justice*, slightly larger than the Manchester watercolor, diverging in details and misdated 1843, was on the London art market (Stone Gallery) in 1971. The Parliament mural of the *Spirit of Justice* was eventually carried out by Daniel Maclise.

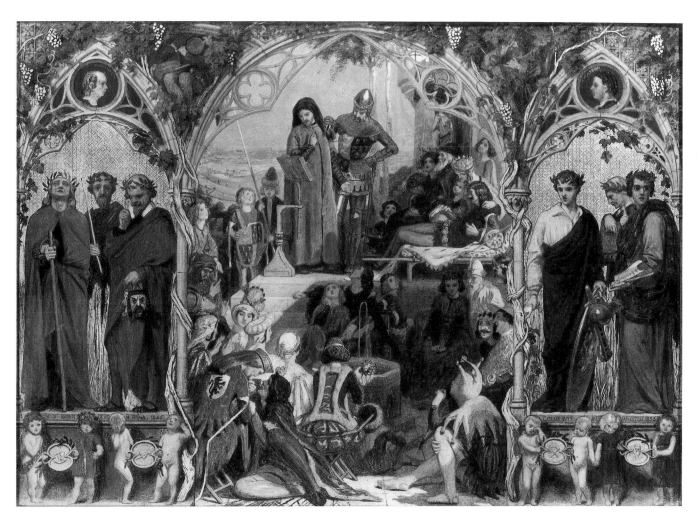

Fig. 13. F. M. Brown, *The Seeds and Fruits of English Poetry*. 1845–51. Retouched 1853. Oil on canvas, 13 3/8 x 18 1/8 inches (34 x 46 cm). Ashmolean Museum, Oxford. Original sketch for a subject that was later reduced to *Chaucer* (Fig. 14). It was begun in Rome in 1845 and color was added in 1853 in Hampstead. This celebration of the English language includes portraits of, or references to, Chaucer, Milton, Spenser, Shakespeare, Goldsmith, Byron, Pope, Burns, Thomson, Campbell, Moore, Shelley, Keats, Chatterton, Kirke White, Coleridge, and Wordsworth.

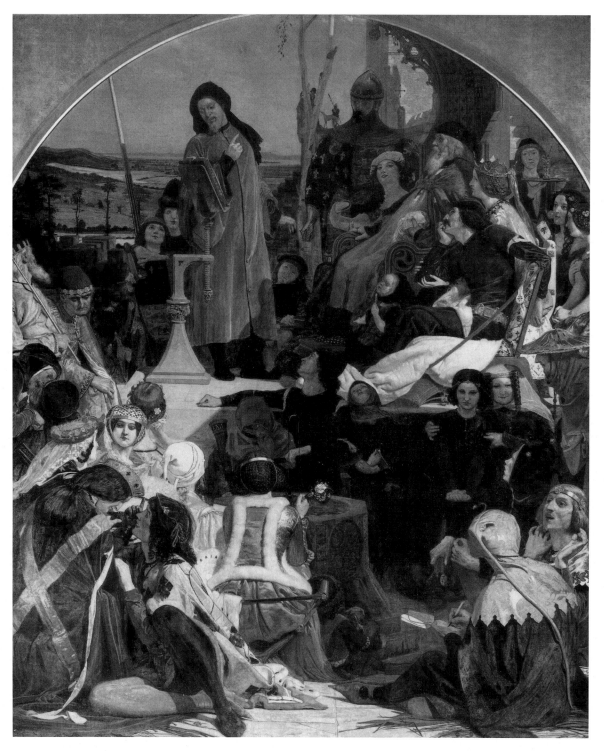

Fig. 14. F. M. Brown, *Geoffrey Chaucer Reading the "Legend of Custance" to Edward III and His Court, at the Palace of Sheen, on the Anniversary of the Black Prince's Forty-Fifth Birthday*, 1845–51. Oil on canvas, 146 1/2 x 116 1/2 inches (372 x 296 cm). Art Gallery of New South Wales, Sydney. A smaller replica (1851, 1867–68) is in the Tate Gallery, London. The Chaucer image began as part of a larger representation of great English writers, *The Seeds and Fruits of English Poetry* (Fig. 13). Among the figures identified by Brown in the Royal Academy exhibition catalogue of 1851 are: John of Gaunt (upper right, wearing helmet); Edward III (enthroned at right); Alice Perrers (Edward's mistress, to the king's right); the Black Prince with his wife and child (to Edward's left); John Froissart talking to the poet John Gower (lower right); Thomas of Woodstock whispering to Lady Bohun (lower left); Chaucer's wife, Philippa, talking to her sister (above Woodstock and Bohun); a Provençal troubadour and his minstrels (center, below Chaucer); a cardinal, the papal nuncio, talking to the Countess of Warwick, and pointing to the seated jester (lower right, above Gower).

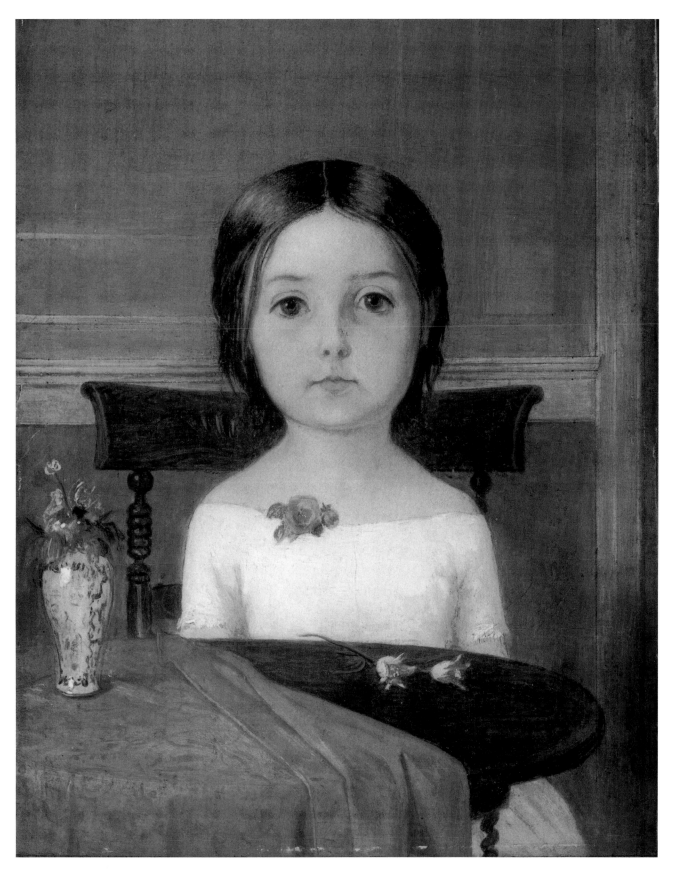

Fig. 15. F. M. Brown, *Millie Smith*, 1846. Oil on paper laid down on panel, 9 x 6 7/8 inches (22.8 x 17.5 cm). Board of Trustees of the National Museums and Galleries on Merseyside (Walker Art Gallery, Liverpool). A portrait of the daughter of Brown's landlord in Southend, where Brown and his daughter Lucy stayed briefly in 1846. An oil study of Millie Smith's head from two viewpoints is in the Manchester City Art Galleries and dates from the same period.

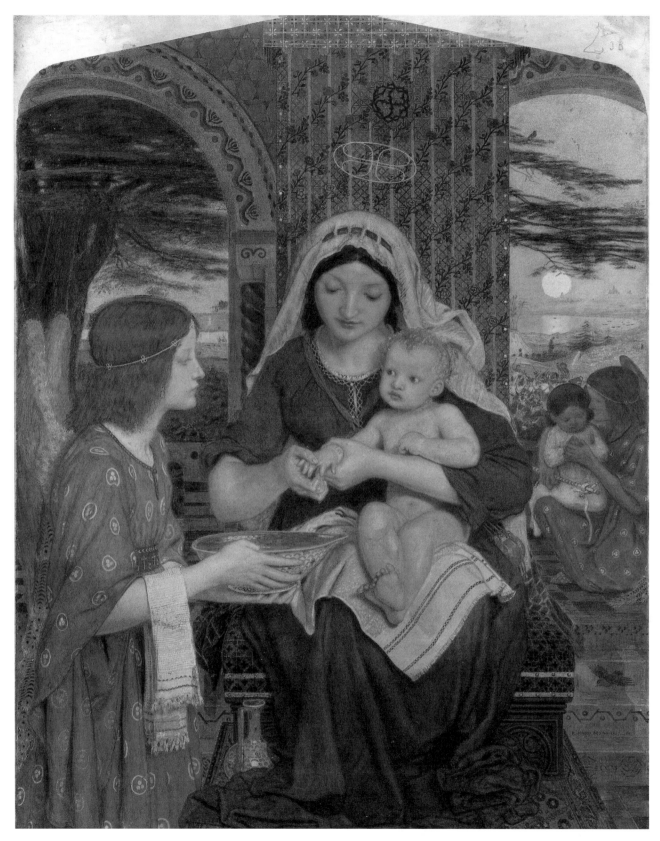

Fig. 16. F. M. Brown, *Oure Ladye of Saturday Night (Oure Ladye of Good Children)*, 1847. Retouched 1854, 1861, 1864. Pastel and watercolor, with gold paint, arched top, 30 5/8 x 23 1/4 inches (77.8 x 59 cm). Tate Gallery, London. Originally a cartoon in black chalk, titled *Oure Ladye of Saturday Night* (an amusing reference to the theme of bathing). It was retitled *Oure Ladye of Good Children* in an American exhibition of 1857–58, during which it was damaged. It was considerably reworked in 1861, when color was added. A replica of 1866 is in the collection of Mr. and Mrs. Allen Staley, New York.

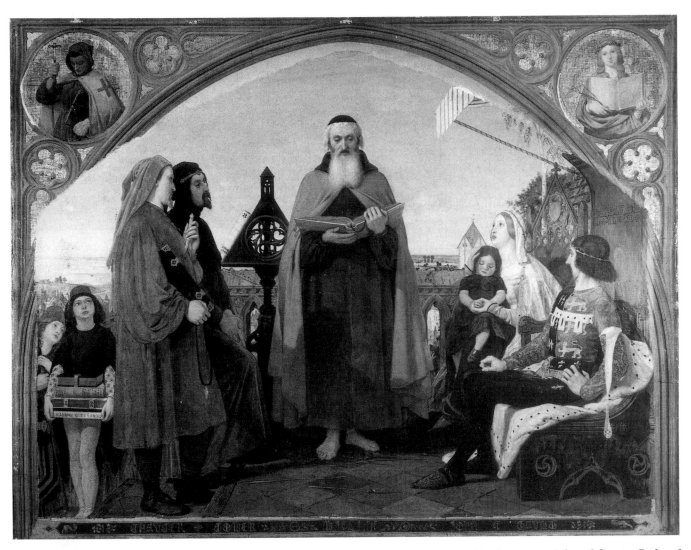

Fig. 17. F. M. Brown, *Wycliffe Reading His Translation of the New Testament to His Protector, John of Gaunt, Duke of Lancaster, in the Presence of Chaucer and Gower*, 1847–48. Retouched 1859–61. Oil on canvas, 47 x 60 1/2 inches (119.5 x 153.5 cm). Bradford Art Galleries and Museums.

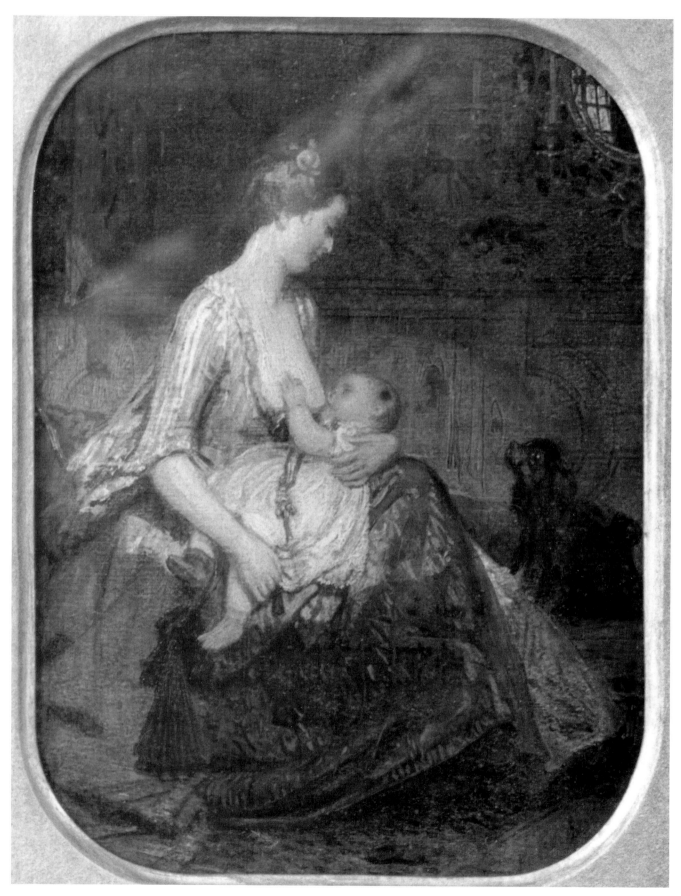

Fig. 18. F. M. Brown, *The Infant's Repast (The Young Mother)*, 1848. Oil on board, 8 x 5 7/8 inches (29.3 x 14.9 cm). The National Trust, Wightwick Manor, Wolverhampton. This is a replica of an untraced painting of 1848.

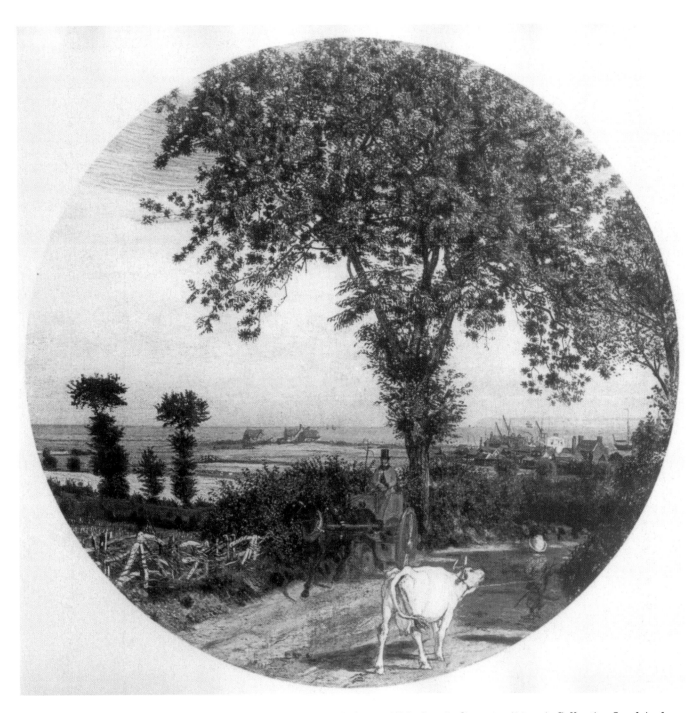

Fig. 19. *Southend*, 1848. Retouched 1858. Oil on canvas, circle, 11 1/2 inches in diameter (29 cm). Collection Lord Andrew Lloyd Webber.

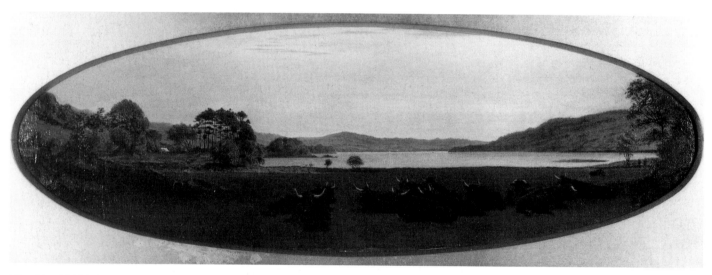

Fig. 20. F. M. Brown, *Windermere*, 1848. Cut down and retouched in 1854–55. Oil on canvas 6 7/8 x 19 3/8 inches (17.5 x 49.2 cm). Board of Trustees of the National Museums and Galleries on Merseyside (Lady Lever Art Gallery, Port Sunlight). Brown made a duplicate of this oil in 1848–49 (now destroyed). Both oils were retouched in 1854–55, when Brown also made a lithograph of the subject, in which the sky is filled with clouds. The cattle were added in 1854. Another oil painting of the subject (formerly William Morris Gallery, Walthamstow) was produced in 1859–61 and also showed a rich cloudscape. This last oil was apparently the work that Brown exhibited in his one-man show of 1865 (no. 25) with the title *Winandermere*.

Fig. 21. *Lear and Cordelia*, 1848–49. Retouched 1853–54, 1863. Oil on canvas, arched top, 28 x 39 inches (71 x 99 cm). Tate Gallery, London. This major early work illustrates Act IV, Scene VII in Shakespeare's tragedy. In Paris in 1844 Brown had made sixteen drawings illustrating *King Lear* (for example, Fig. 8).

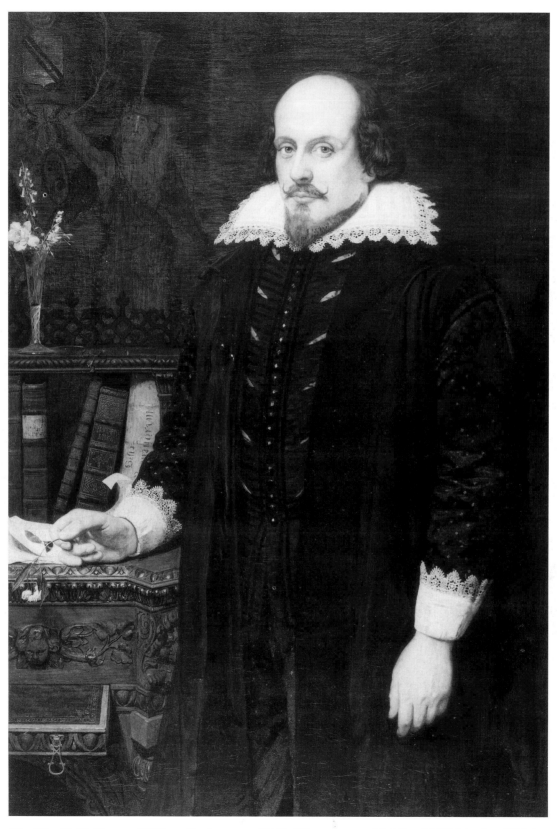

Fig. 22. F. M. Brown, *William Shakespeare*, 1849. Oil on canvas, 53 3/8 x 34 7/16 inches (135.6 x 87.5). Manchester City Art Galleries. A work commissioned by the Dickinson Bros., London printsellers.

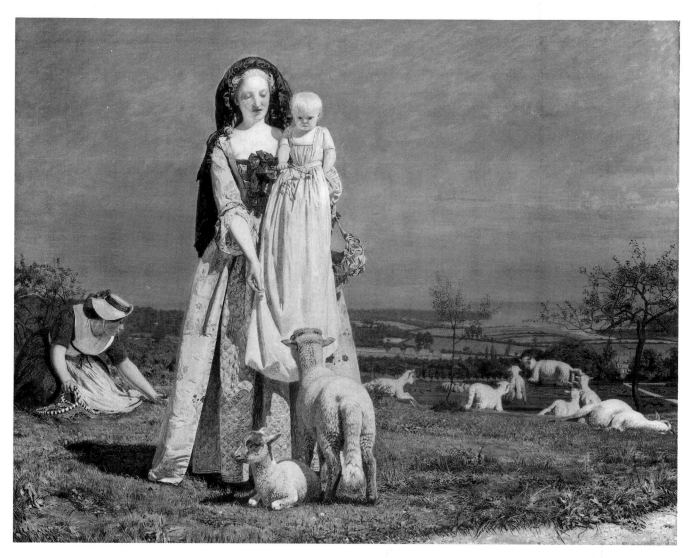

Fig. 23. F. M. Brown, *Pretty Baa-lambs*, 1851. Retouched 1852–53, 1859. Oil on panel, 24 x 30 inches (61 x 76.2 cm). Birmingham Museums and Art Gallery. A small oil version of 1852 (Ashmolean Museum, Oxford), more loosely painted, shows a lower horizon and less complex background. That was apparently what the original, Birmingham painting looked like before Brown added the present landscape distance around 1859.

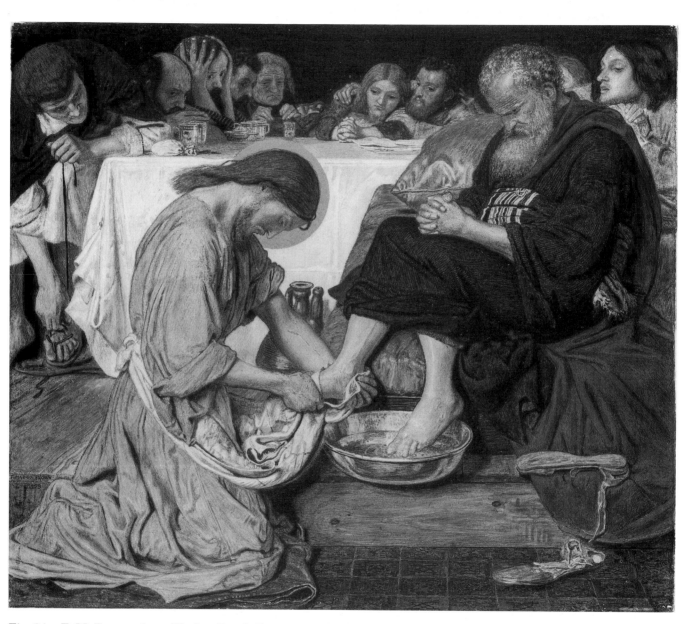

Fig. 24. F. M. Brown, *Jesus Washes Peter's Feet*. 1851–56. Retouched 1857, 1858, 1876, 1892. Oil on canvas, 46 x 52 1/4 inches (117 x 133.5 cm). Tate Gallery, London. In 1856 Brown drastically reworked the canvas, clothing the previously nude Jesus, retouching his legs, and retouching Peter's garments. A small watercolor variant of 1858 is in the Tate Gallery, London. Another watercolor, showing the original, naked figure of Jesus, was produced in 1876 and is now in the Manchester City Art Galleries.

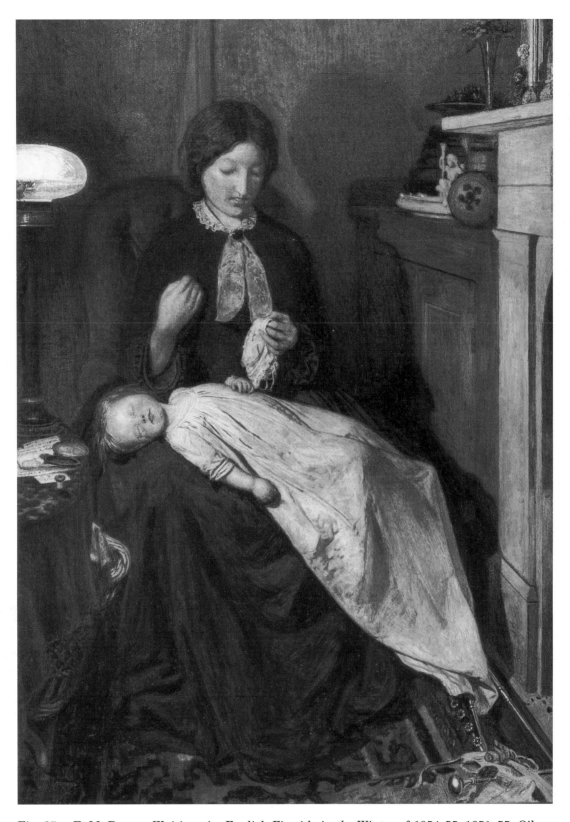

Fig. 25. F. M. Brown, *Waiting: An English Fireside in the Winter of 1854–55*, 1851–55. Oil on panel, 12 x 8 inches (30.5 x 20 cm). Board of Trustees of the National Museums and Galleries on Merseyside (Walker Art Gallery, Liverpool). This is the finished sketch for a larger painting (private collection), which was exhibited by Brown in 1853 at the Royal Academy as *Waiting*, This larger work is reproduced in Hunt, 1905, vol. 1, p. 279. The letter and portrait miniature on the table (and the title reference to 1854–55) were added in 1855, in order to allude to the Crimean War.

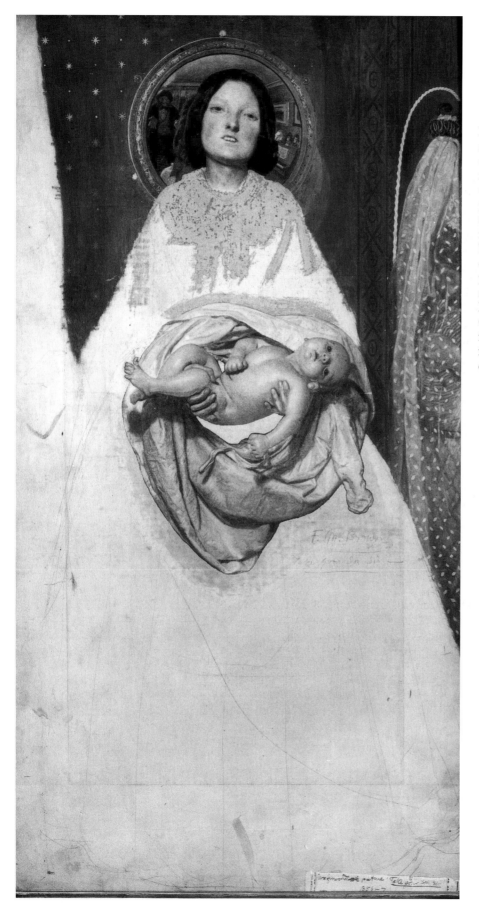

Fig. 26. F. M. Brown, *Take Your Son, Sir!*, 1851, 1856–57, 1860, 1892. Oil on paper, mounted on canvas, 27 1/4 x 15 inches (70.4 x 38.1 cm). Tate Gallery, London. An unfinished painting, commenced in 1851 as a study of Brown's wife, Emma. The round convex mirror in the background is related to other such objects in several Pre-Raphaelite paintings and drawings, all of which stem from the mirror in Jan Van Eyck's *Arnolfini Wedding* (National Gallery, London). Such mirrors later, in the 1870s and 1880s, became a frequent feature of Aesthetic interior decoration.

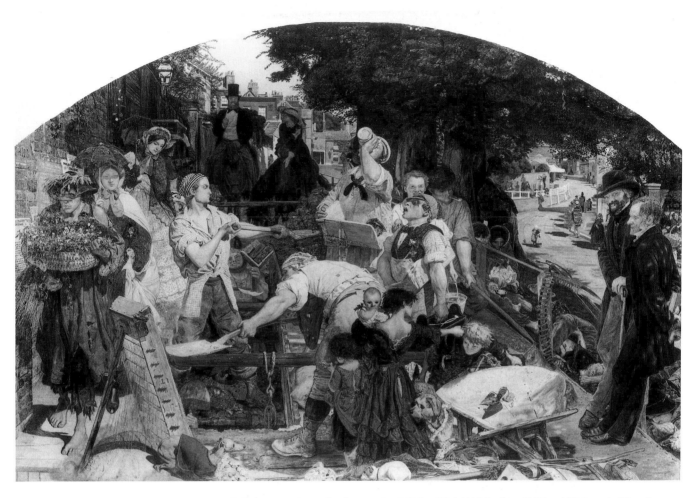

Fig. 27. F. M. Brown, *Work*, 1852–65. Oil on canvas, arched top, 53 15/16 x 77 11/16 inches (137 x 197.3 cm). Manchester City Art Galleries. Inscriptions on frame: "Neither did we eat any man 's bread for naught, but wrought with labour and travail night and day." "I must work while it is day for night cometh when no man can work." "Seest thou a man diligent in his business? He shall stand before Kings." This major canvas was discussed by Brown at length in the catalogue of his one-man show in 1865 (see appendix, pages 151–56). Designed first in 1852, the painting was taken up in earnest in 1856, when Brown received a commission from T. E. Plint to complete the painting. It was essentially finished by 1863. A smaller oil replica (Birmingham Museums and Art Gallery), was commissioned by James Leathart in 1859 and completed in 1863. The Birmingham version gives the tract-distributing lady (at left) the features of Mrs. Leathart. Among the many other characters represented in *Work* are the road laborers (or navvies) in the center of the composition, with a beer-seller in their midst. At left are a poor flower-seller, a lady with a greyhound, and a pastry-cook's assistant. At right are Thomas Carlyle, Rev. F. D. Maurice, an orange-seller harassed by a policeman, sandwich-board carriers advertising the candidacy of Bobus for a seat in Parliament (Bobus was an unsavory character in Carlyle's *Past and Present*), and various unemployed people. At the top of the figural composition is a mounted gentleman with his daughter. In the foreground is a group of ragged children. The setting is the main thoroughfare of Hampstead. The navvies are laying water pipes.

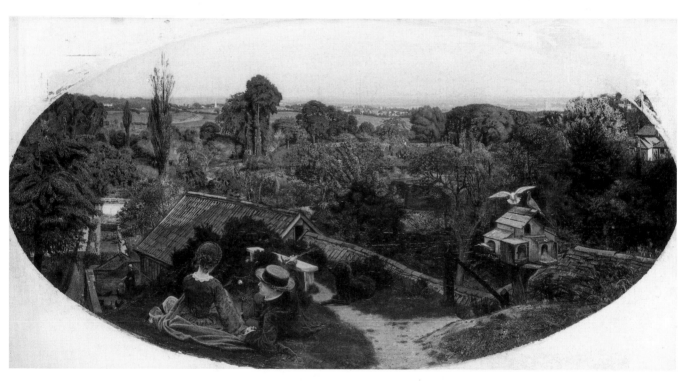

Fig. 28. F. M. Brown, *An English Autumn Afternoon*, 1852–53. Retouched 1855. Oil on canvas, oval, 28 1/4 x 53 inches (71.7 x 134.6 cm). Birmingham Museums and Art Gallery. The landscape represents the surroundings of Hampstead as seen from the back window of the building where Brown had his studio.

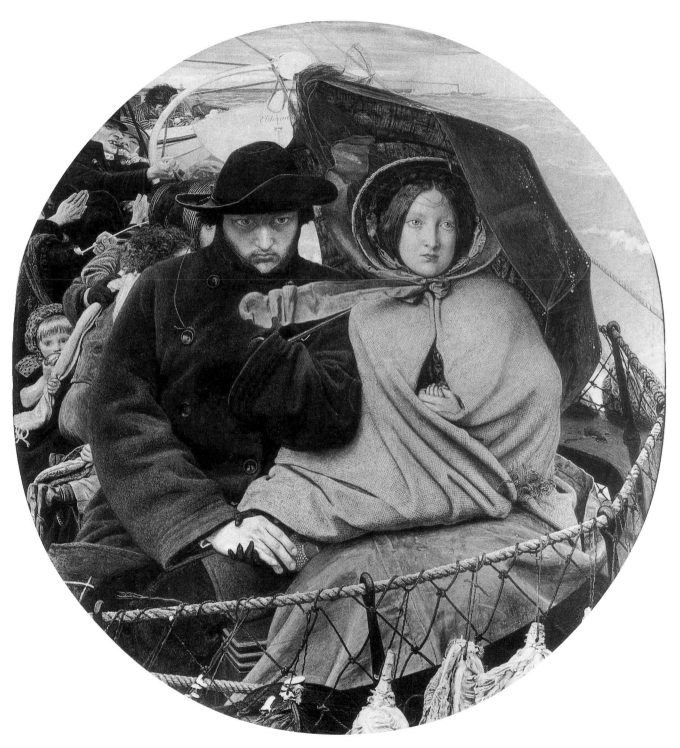

Fig. 29. F. M. Brown, *The Last of England*, 1852–55. Oil on panel, oval 32 1/2 x 29 1/2 inches (82.5 x 75 cm). Birmingham Museums and Art Gallery. A small oil replica (1860), with many changes in detail, is in the Fitzwilliam Museum, Cambridge. A small watercolor replica (1864–66) is in the Tate Gallery, London. The original oil sketch for the picture, which was finished in 1855, was sold at Sotheby's, London, November 6, 1995. A highly finished pencil drawing, which Brown seems to have referred to as a "cartoon" and dated 1852, is in the Birmingham Museums and Art Gallery. The drawing, approximately half the scale of the Birmingham oil, was also completed in 1855.

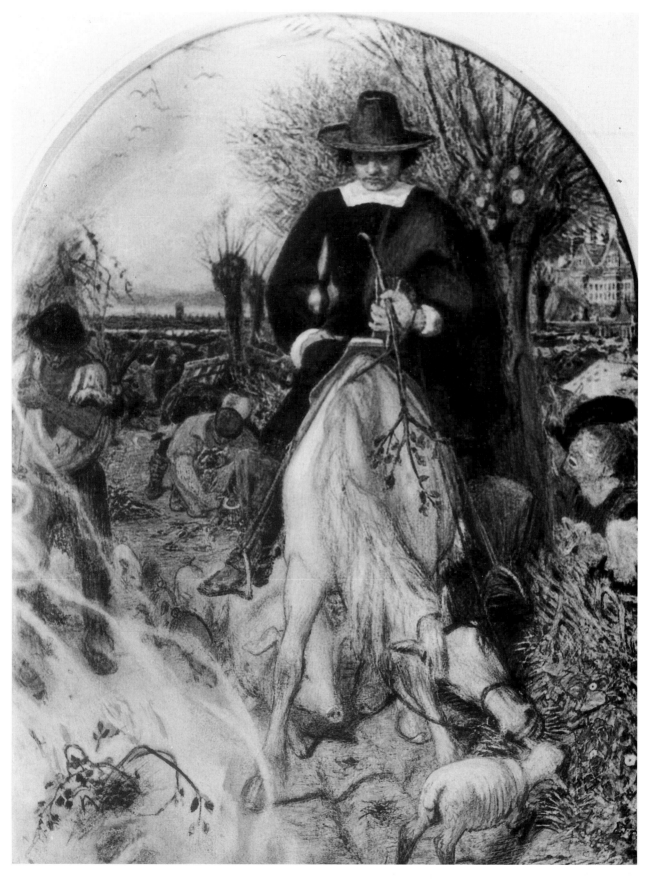

Fig. 30. F. M. Brown, *St. Ives, An.Dom. 1635 (St. Ives, An.Dom. 1636)*, 1853–56. Retouched 1874. Gouache, pen and ink, pastel, 13 1/2 x 9 3/4 inches (34.3 x 24.7 cm). Whitworth Art Gallery, University of Manchester. This is the first version of *Cromwell on His Farm* (Fig. 31).

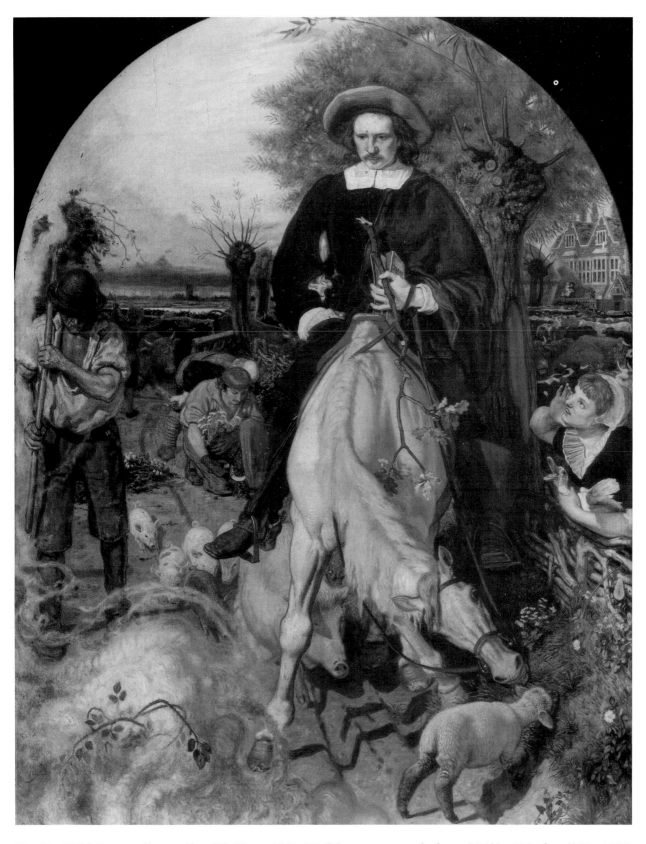

Fig. 31. F. M. Brown, *Cromwell on His Farm*, 1853–74. Oil on canvas, arched top, 56 1/4 x 41 inches (143 x 104.3 cm). Board of Trustees of the National Museums and Galleries on Merseyside (Lady Lever Art Gallery, Port Sunlight). Inscriptions on frame: "Lord, how long wilt Thou hide Thyself—for ever? And shall Thy wrath burn like fire?" (Psalm 89) "Living neither in any considerable height nor yet in obscurity, I did endeavour to discharge the duty of an honest man" (Cromwell's speech of September 12, 1654). This is the final, large oil version of *St. Ives, An. Dom. 1635*, which was first sketched out in 1853 (Fig. 30).

Fig. 32. F. M. Brown, *Carrying Corn*, 1854–55. Oil on panel, 7 3/4 x 10 7/8 inches (19.7 x 27.6 cm). Tate Gallery, London. The field of turnips and wheat depicted here was in Finchley, near Brown's residence.

Fig. 33. F. M. Brown, *The Brent at Hendon*, 1854–55. Oil on millboard, oval 8 1/4 x 10 1/2 inches (21 x 26.7 cm). Tate Gallery, London.

Fig. 34. F. M. Brown, *The Hayfield*, 1855–56. Oil on panel, 9 7/16 x 13 1/16 inches (24 x 33.2 cm). Tate Gallery, London. The hayfield depicted here was on the Tenterden estate at Hendon, Middlesex, near Brown's residence in Finchley.

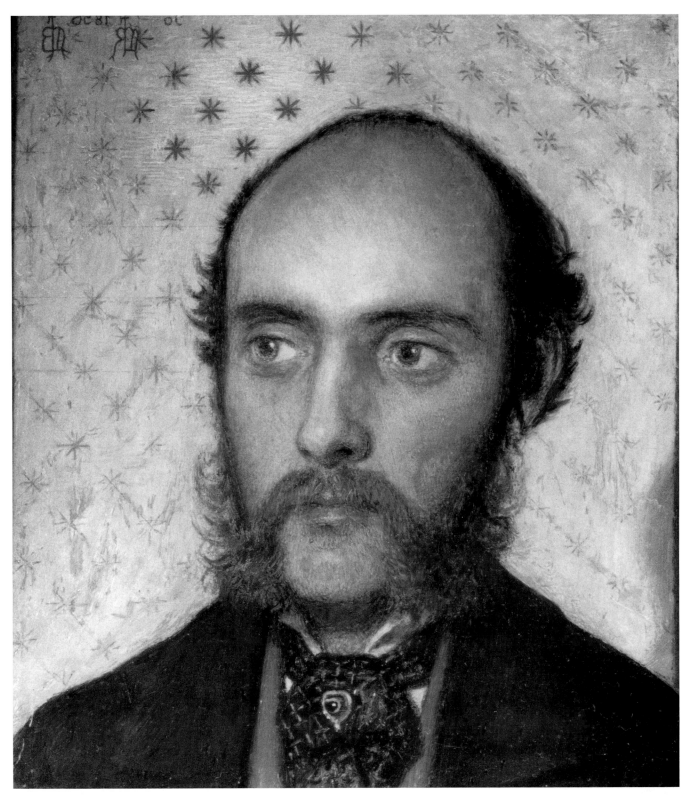

Fig. 35. F. M. Brown, *William Michael Rossetti by Lamplight*, 1856. Oil on panel, 6 3/4 x 6 1/2 inches (17.2 x 16.5 cm). The National Trust, Wightwick Manor, Wolverhampton. William Michael Rossetti, one of the original Pre-Raphaelite Brotherhood, married Brown's daughter Lucy in 1874. This painting was given in 1856 to Rossetti's mother, who undertook the education of Lucy.

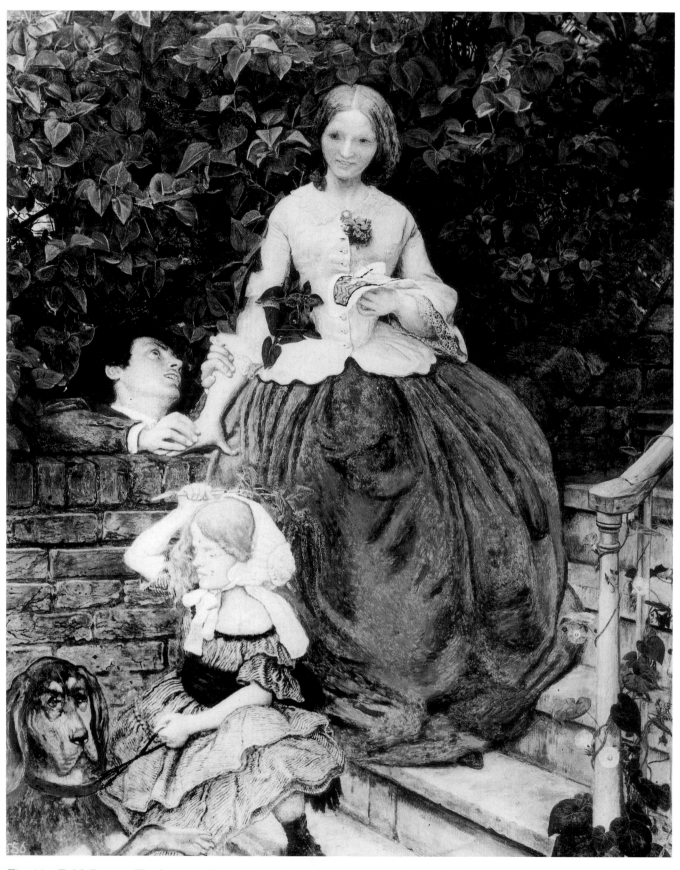

Fig. 36. F. M. Brown, *The Stages of Cruelty*, 1856–90. Oil on canvas, 27 7/8 x 23 9/16 inches (73.3 x 59.9 cm). Manchester City Art Galleries. Originally titled *Stolen Pleasures Are Sweet*, the present title, imitating that of William Hogarth's famous series of prints, was given by Brown to this work around 1860. A watercolor sketch for the painting is in the Warrington Museum. A fine watercolor replica dated 1890 is in the Ashmolean Museum, Oxford.

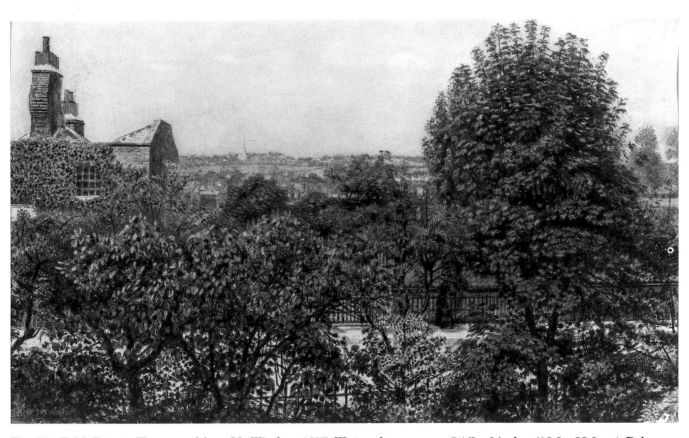

Fig. 37. F. M. Brown, *Hampstead from My Window*, 1857. Watercolor on paper, 5 1/2 x 9 inches (13.9 x 22.8 cm). Delaware Art Museum, Wilmington.

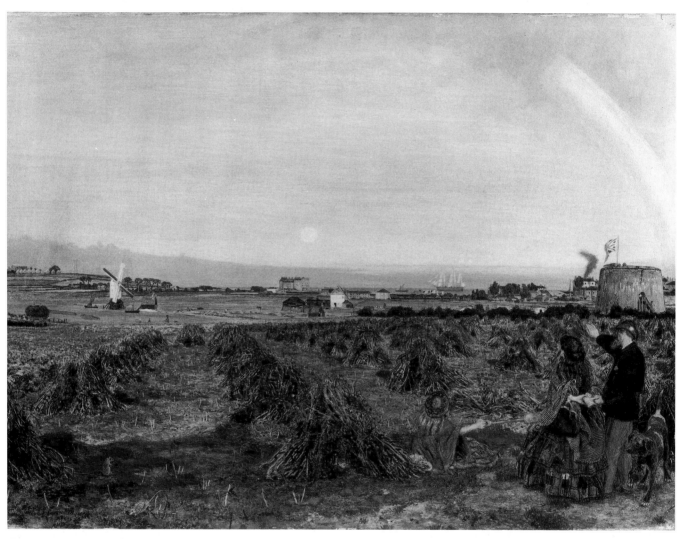

Fig. 38. F. M. Brown, *Walton-on-the-Naze*, 1859–60. Oil on canvas, 12 1/2 x 16 1/2 inches (31.7 x 42 cm). Birmingham Museums and Art Gallery.

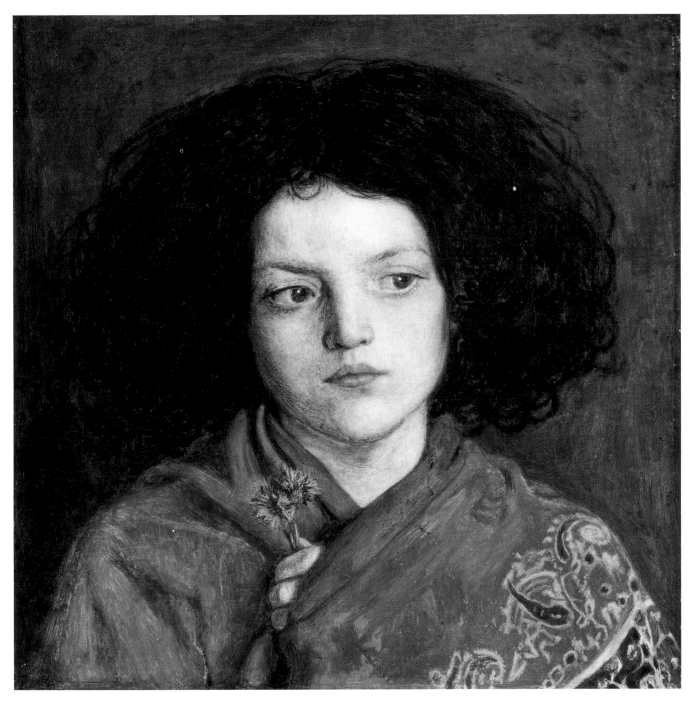

Fig. 39. F. M. Brown, *The Irish Girl*, 1860. Oil on canvas, 10 1/4 x 10 inches (26 x 25.4 cm). Yale Center for British Art, New Haven, Paul Mellon Fund. Painted as a pendant to *The English Boy* (Fig. 40).

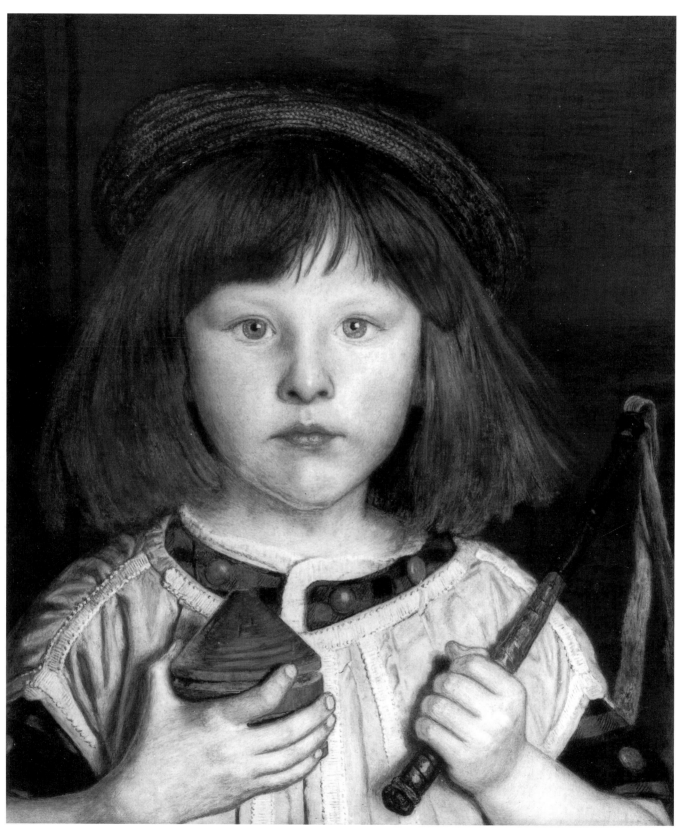

Fig. 40. F. M. Brown, *The English Boy*, 1860. Oil on canvas, 15 9/16 x 13 1/8 inches (39.6 x 33.3 cm). Manchester City Art Galleries. Painted as a pendant to the *Irish Girl* (Fig. 39).

Fig. 41. F. M. Brown, *King René's Honeymoon*, 1864. Watercolor on paper, 10 1/4 x 6 3/4 inches (26 x 17.1 cm). Tate Gallery, London. There are many versions of this image, which was first designed as an ornamental panel on John Pollard Seddon's drawing cabinet (Victoria & Albert Museum, London) in 1861. Rossetti and Burne-Jones provided the other main panels, which as a whole describe an imagined honeymoon of the famous fifteenth-century patron of the arts and amateur artist, King René of Anjou. The panels describe music, sculpture, painting, and architecture, the last being Brown's contribution. The idea for the decoration apparently came from Brown (see *Century Guild Hobby Horse*, vol. III, 1888, p. 158). The literature on the cabinet often states that Brown was inspired by Sir Walter Scott's novel *Anna von Geierstein*, where King René is a character. But there is no story of René's honeymoon in that novel, and Scott largely mocks the prissy dilettantism of René. The cabinet decorations in fact counter Scott's view and celebrate René's devotion to all the arts. This point is noted in J. P. Seddon's little book on this chest, published in 1898. Brown's pen and wash design for the cabinet panel itself (1861) is in the Birmingham Museums and Art Gallery. Cartoons the same size as the Birmingham drawing are in the British Museum, London, and the Ashmolean Museum, Oxford. The Tate owns a tracing of the subject. A watercolor dated 1864 (10 1/2 x 7 inches) was sold at Christie's, London, 25 October 1991. An oil version of 1864 is also noted by Hueffer, 1896, p. 440. Stained-glass versions of the cabinet panel images, including Brown's, are in the Victoria & Albert Museum, London.

Fig. 42. F. M. Brown, *The Death of Sir Tristram*, 1864. Oil on canvas, 25 1/2 x 23 inches (64.8 x 58.4 cm). Birmingham Museums and Art Gallery. Inscription on frame: "Sir Trystram. How he was traytoursly slayne with a trenchaunt glayve, by Kinge Marke, and how the Lady La Beale Isoud threw herself fauning on his bodye and soe died." The subject was first designed in 1862 as part of a series of stained-glass windows. The windows were produced by Morris, Marshall & Faulkner for the home of Walter Dunlop of Bradford and today are in the Bradford Art Galleries. The other artists who worked on the Dunlop windows were Edward Burne-Jones, D. G. Rossetti, Arthur Hughes, Val Prinsep, and William Morris. Brown's cartoon for the Tristram window is in the Fitzwilliam Museum, Cambridge. A watercolor version of the subject (1864) is in the Cecil Higgins Art Gallery, Bedford.

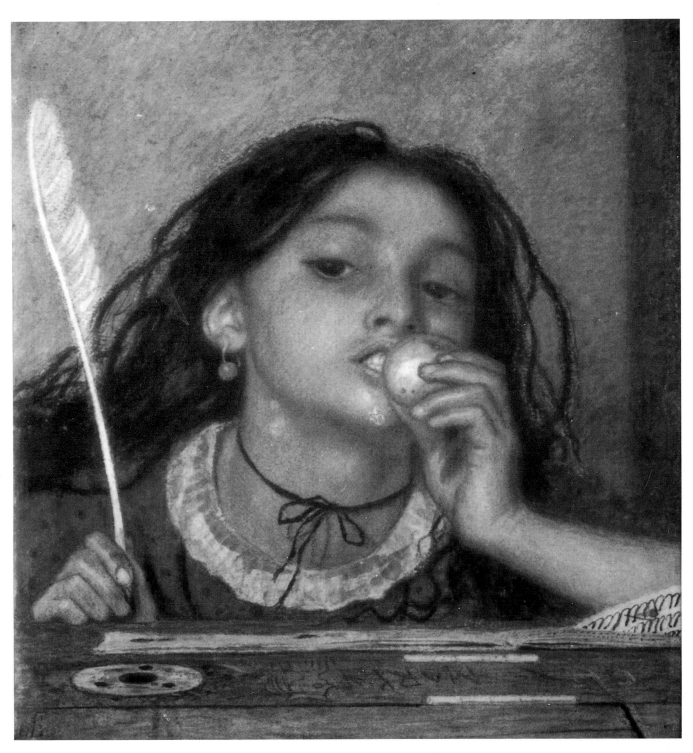

Fig. 43. F. M. Brown, *The Writing Lesson (Mauvais sujet)*, 1863. Watercolor on paper, 9 x 8 inches (22.9 x 20.3 cm). Tate Gallery, London. Brown presented this small picture to the Mansion House Relief Fund. It was to be sold to obtain money for the starving Lancashire weavers, who were unemployed because the American Civil War had stopped shipments of cotton to England. See Hueffer, 1896, p. 184.

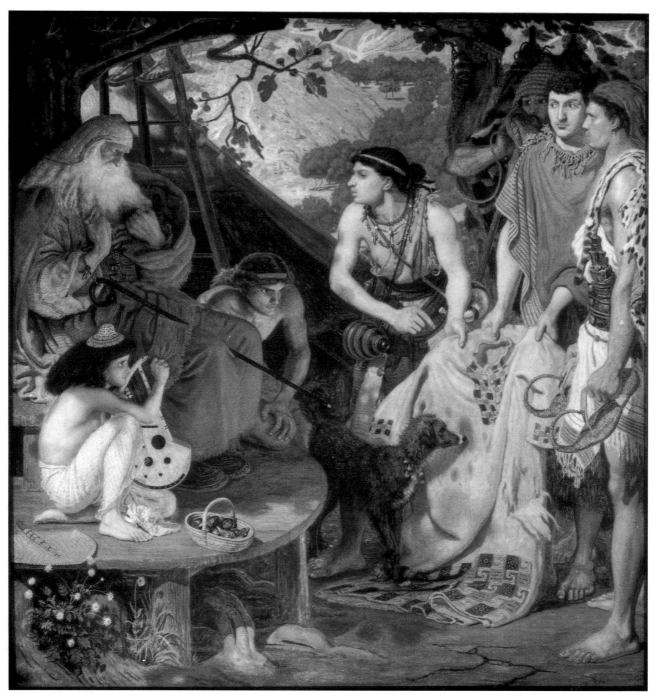

Fig. 44. F. M. Brown, *Jacob and Joseph's Coat* (*The Coat of Many Colors*), 1864–66. Retouched 1869. Oil on canvas, 42 1/2 x 40 5/8 inches (108 x 103.2 cm). Board of Trustees of the National Museums and Galleries on Merseyside (Walker Art Gallery, Liverpool). This painting is based on a drawing of 1863–64 (British Museum), to be engraved for *Dalziel's Bible Gallery* (London, 1881). The landscape background is based on a topographical painting by Thomas Seddon, *The Well of Enrogel* (Harris Museum and Art Gallery, Preston). A small watercolor version (1867) is in the Tate Gallery, London. A small oil version (1868–71) is in the Museo de Arte, Ponce, Puerto Rico.

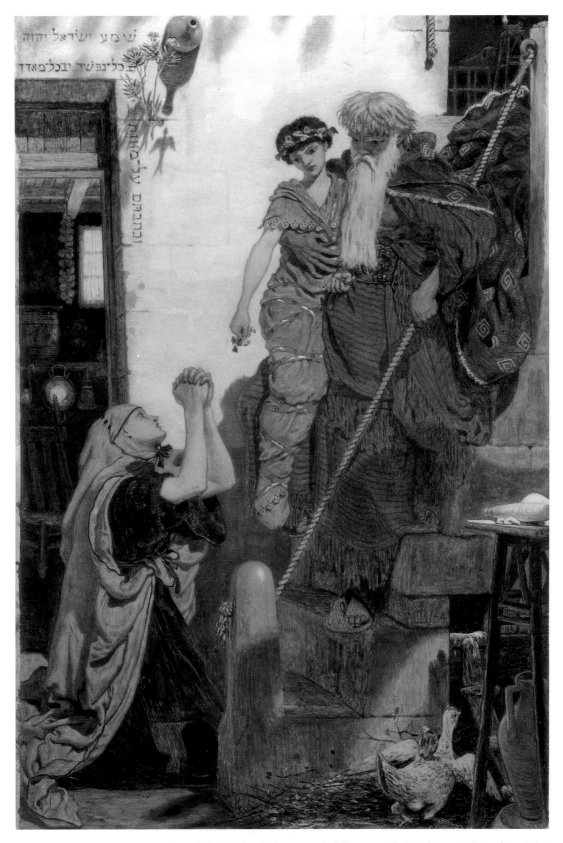

Fig. 45. F. M. Brown, *Elijah and the Widow's Son*, 1864. Oil on panel, 20 3/4 x 13 1/2 inches (52.5 x 34.3 cm). Birmingham Museums and Art Gallery. The subject was designed as an illustration for the *Dalziel's Bible Gallery* (London, 1881). The original drawing for the engraved illustration is in the Victoria & Albert Museum, London, which also owns a large watercolor version of the image, dated 1868. A smaller watercolor version, dated 1864, was sold at Sotheby's, London, 10 November 1981.

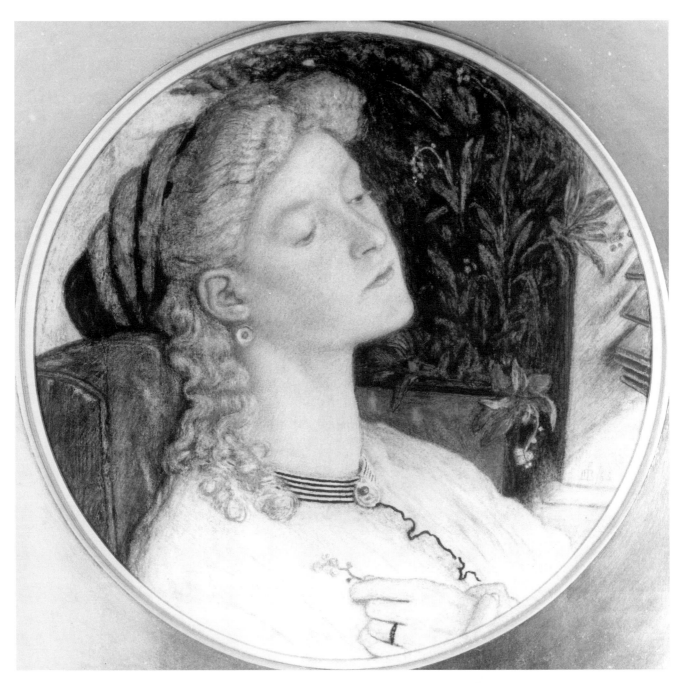

Fig. 46. F. M. Brown, *Myosotis*, 1864. Watercolor on paper, circle, 11 1/2 inches in diameter (29.2 cm). Collection of Albert Gallichan and Peter Rose, Brighton.

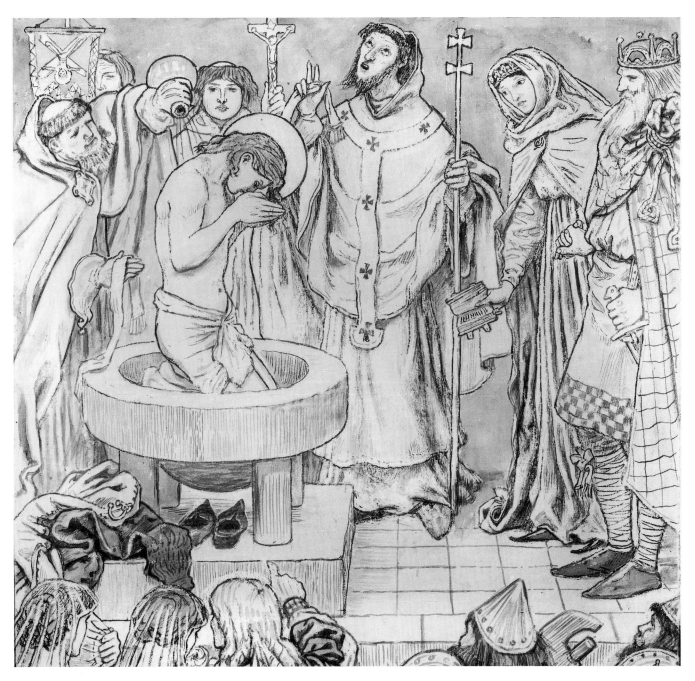

Fig. 47. F. M. Brown, *The Baptism of Saint Oswald*, 1864. Black chalk and ink on paper, 18 5/8 x 18 7/8 inches (47.3 x 48 cm). Victoria & Albert Museum, London. Working for Morris, Marshall & Faulkner, Brown designed stained-glass windows for St. Oswald's, Durham. This is one of the series of window cartoons illustrating the life of Saint Oswald.

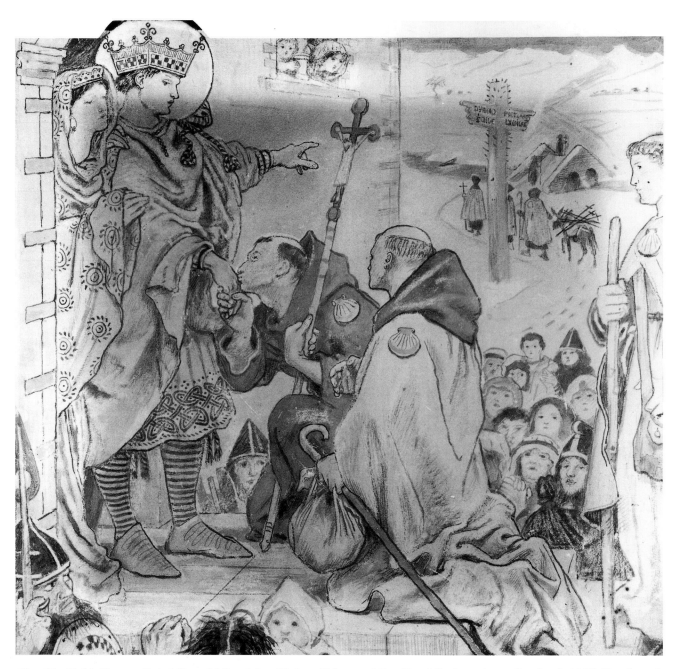

Fig. 48. F. M. Brown, *Saint Oswald Receiving Bishop Aidan and Sending Missionaries to Scotland*, 1865. Brush and black ink on paper, 19 5/8 x 19 1/4 inches (49 x 48.9 cm). Victoria & Albert Museum, London. Another of Brown's stained-glass window cartoons for St. Oswald's, Durham, illustrating the life of this early British saint.

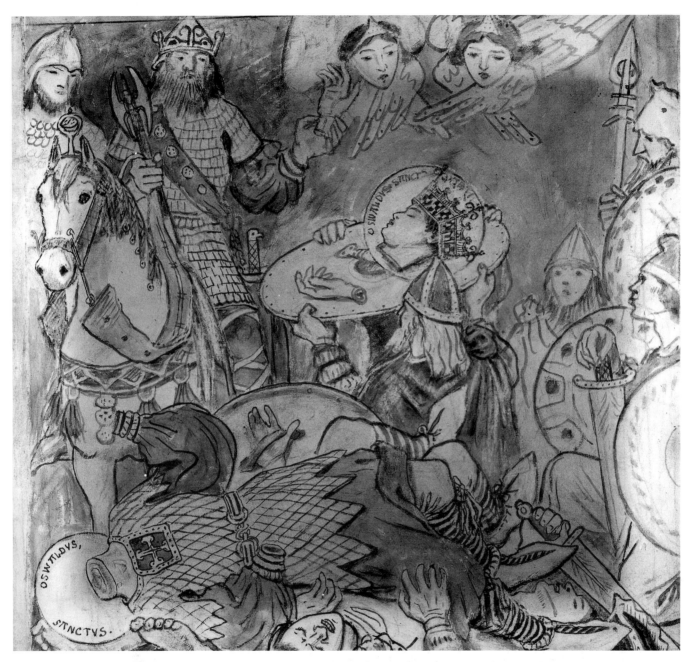

Fig. 49. F. M. Brown, *The Death of Saint Oswald,* 1865. Black chalk and ink on paper, 19 1/8 x 20 inches (48.6 x 50.8 cm).
Victoria & Albert Museum, London

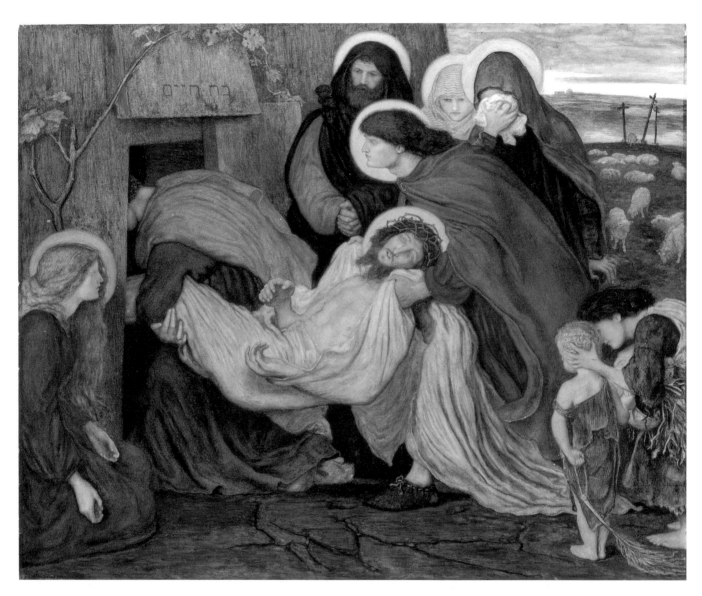

Fig. 50. F. M. Brown, *The Entombment*, 1870–71. 37 x 44 inches (94 x 112 cm). Watercolor on paper. National Gallery of Victoria, Melbourne. As a member of Morris, Marshall & Faulkner, Brown first designed this subject for a stained-glass window in St. Olave's, Gatcombe, Isle of Wight in 1865. In 1866 he made a drawing of the image, which in 1867 was engraved and published in *Lyra Germanica*, a collection of hymns, and at the same time he began an oil, which was completed in 1868 (Faringdon Collection, Buscot Park, Gloucestershire). A watercolor (Leathart Family collection, Newcastle) was also begun around 1866 and finished in 1869. The Melbourne watercolor, begun last, has additions of sheep and children at the right. Brown wrote to T. H. McConnel on 4 March 1867 regarding the children looking at the event, and noted, "but I nevertheless do not feel certain that it would not interfere with the solemnity of the scene." He offered to carry out the oil either with or without the children. (Notes on the Brown Family Papers, kindly shown to me by Mary Bennett.)

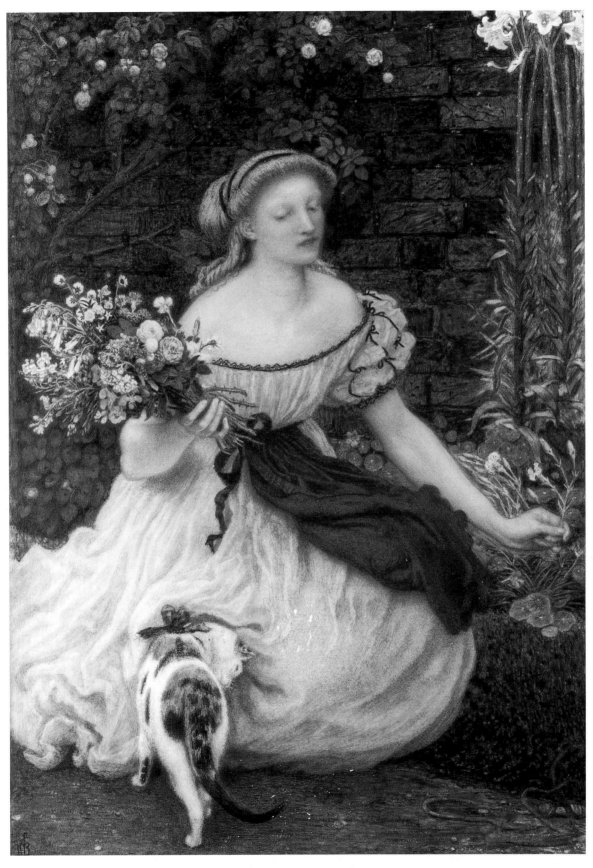

Fig. 51. F. M. Brown, *The Nosegay*, 1865. Watercolor on paper, 18 3/4 x 12 3/4 inches (47.6 x 32.4 cm). Ashmolean Museum, Oxford. Commissioned by Frederick Craven of Manchester to be paired with a William Henry Hunt watercolor of a boy praying. A smaller watercolor version from 1867 is in the Lady Lever Art Gallery, Port Sunlight.

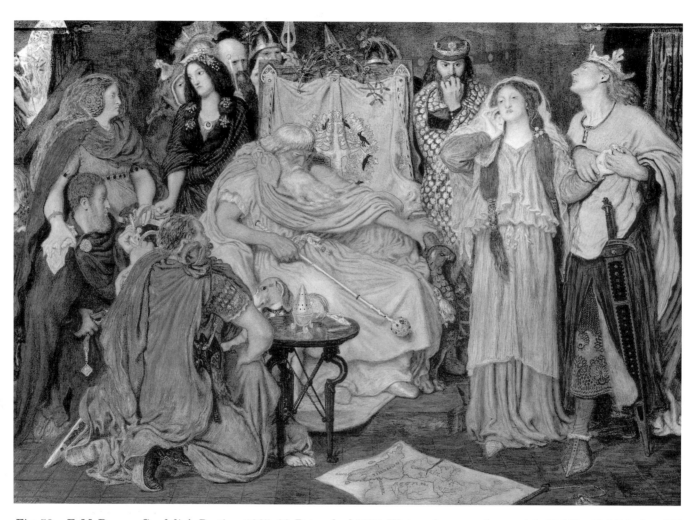

Fig. 52. F. M. Brown, *Cordelia's Portion*, 1865–66. Retouched 1872. Watercolor, gouache, pastel, 29 1/2 x 42 1/4 inches (75 x 107.3 cm). Board of Trustees of the National Museums and Galleries on Merseyside (Lady Lever Art Gallery, Port Sunlight). This work stemmed from several of Brown's King Lear drawings made in Paris in 1844 (Whitworth Art Gallery, Manchester). The cartoon for this image was worked up in black and white in 1869 for autotype engraving and is now in the Manchester City Art Galleries. An oil version, from 1875, is in the Southampton Art Gallery.

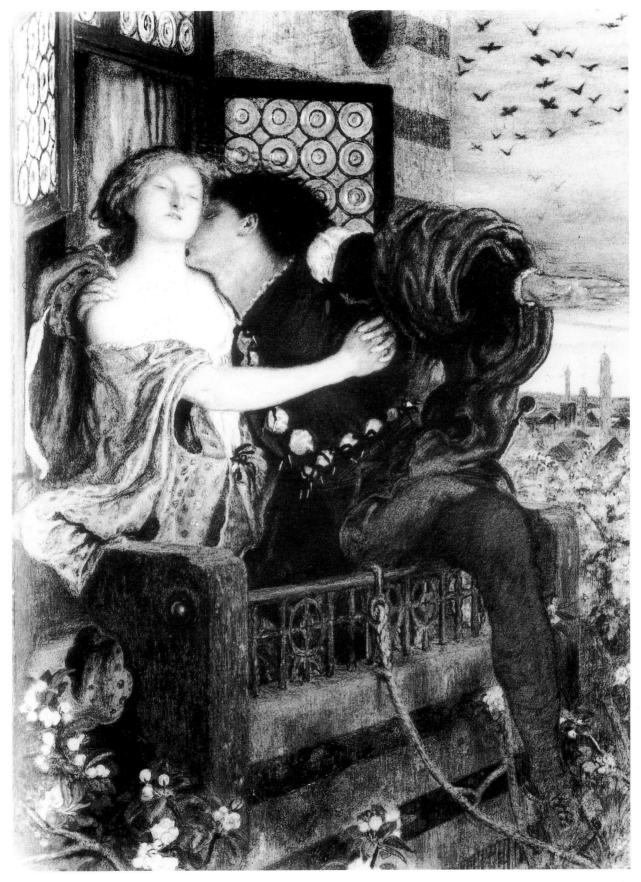

Fig. 53. F. M. Brown, *Romeo and Juliet*, 1867. Watercolor with bodycolor, 18 7/8 x 13 inches (48 x 33 cm). Whitworth Art Gallery, University of Manchester. A large oil version of this Shakespearean subject, dated 1870, is in the Delaware Art Museum. A drawing, dated 1876, is in the Bradford Art Galleries.

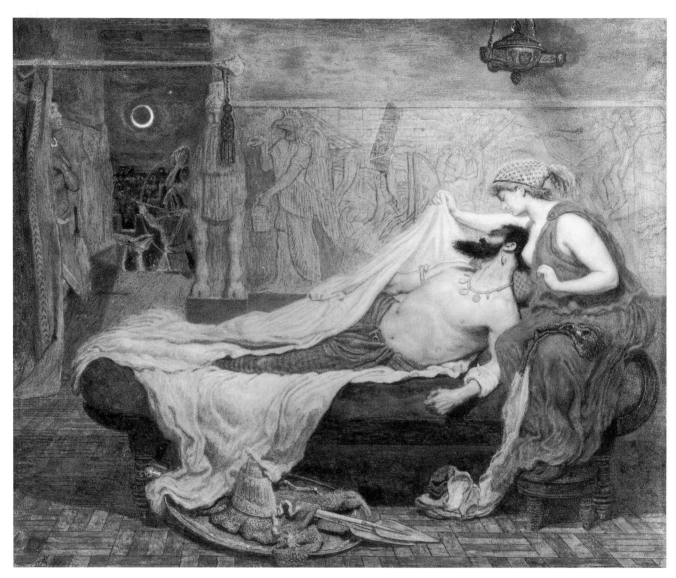

Fig. 54. F. M. Brown, *The Dream of Sardanapalus*, 1871–72. Watercolor on paper, 18 7/8 x 22 7/8 inches (48.2 x 58 cm). Delaware Art Museum, Samuel and Mary R. Bancroft Collection, Wilmington. First designed in 1869 as an illustration for *The Poetical Works of Lord Byron* (London: Moxon, 1870), ed. W. M. Rossetti. Another watercolor, smaller but very similar, and dated 1875, was formerly in the James Coats Gallery, New York (reproduced in *Connaissance des Arts*, April 1963, p. 89). A large oil version, begun in 1873 and not completed until 1891, remains untraced.

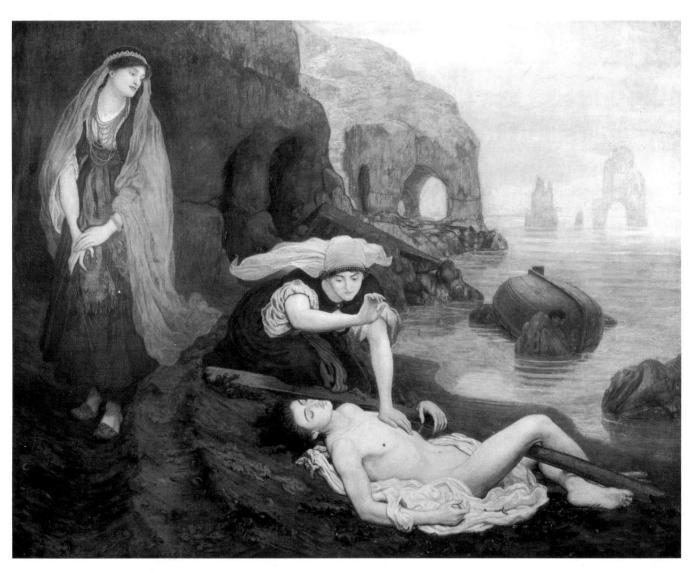

Fig. 55. F. M. Brown, *Don Juan Found by Haidée*. 1870–73. Retouched until 1876. Oil on canvas, 66 3/4 x 83 1/2 inches (166.8 x 214.6 cm). Birmingham Museums and Art Gallery. This work illustrates Canto 11, verses 110–112 of Byron's *Don Juan*. It was first designed in 1869 as an illustration for *The Poetical Works of Lord Byron* (London: Moxon, 1870), ed. W. M. Rossetti. Another oil version is in the Musée d'Orsay, Paris (given by Brown's friend Mathilde Blind). A watercolor version in the National Gallery of Victoria, Melbourne, dates from 1869–70. That watercolor was made for Frederick Craven of Manchester, to be paired with D. G. Rossetti's watercolor of *Tibullus*.

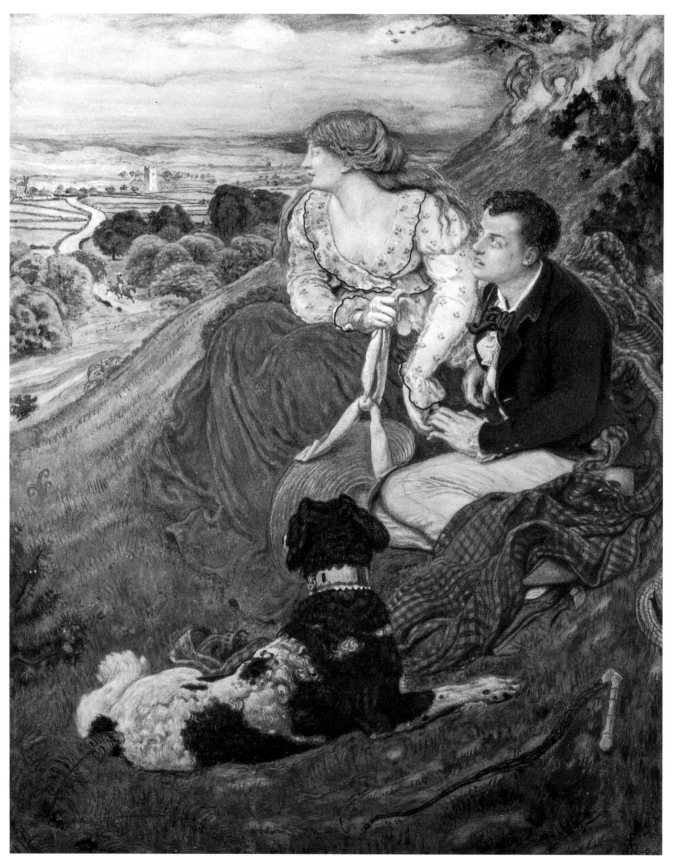

Fig. 56. F. M. Brown, *Byron's Dream*, 1889. Watercolor on paper, 27 3/4 x 21 1/4 inches (70.5 x 54 cm). Whitworth Art Gallery, University of Manchester. The image was designed originally in 1869 for the frontispiece of *The Poetical Works of Lord Byron* (London: Moxon, 1870), ed. W. M. Rossetti. An oil version from 1874 is in the Manchester City Art Galleries. Byron's poem deals with the poet's first love, Mary Chaworth.

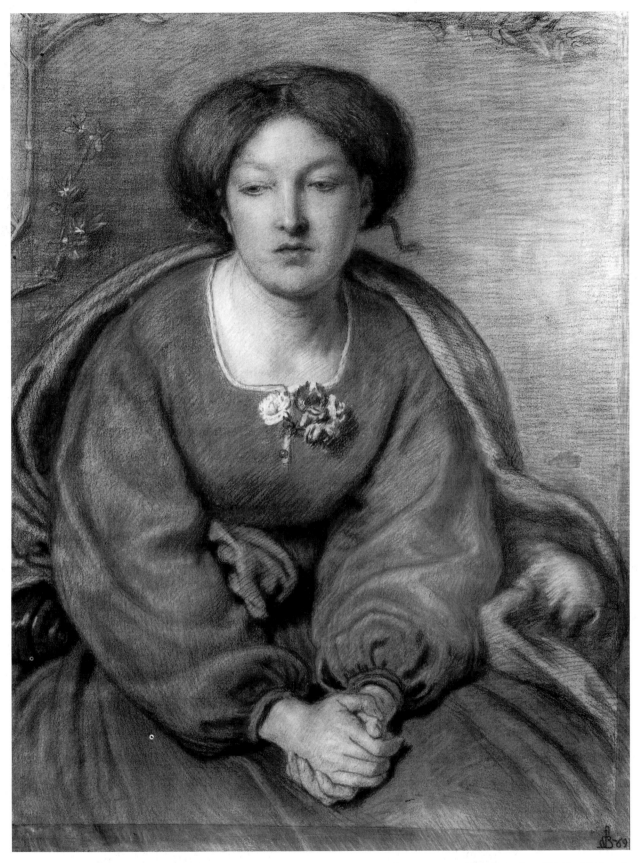

Fig. 57. F. M. Brown, *Mrs. Ford Madox Brown*, 1869. Pastel on tinted paper, 31 x 22 1/2 inches (78.7 x 57.2 cm).
Maidstone Museum and Art Gallery.

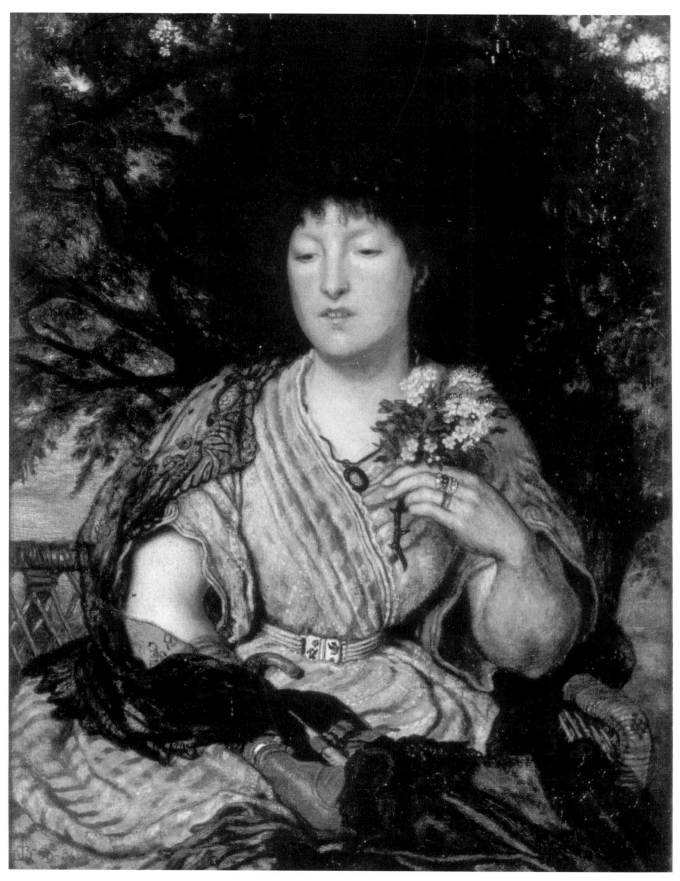

Fig. 58. F. M. Brown, *May Memories*, 1869–84. Oil on canvas 16 x 12 1/2 inches (40.6 x 33.7 cm). Sold Christie's, London, 24 October 1980. Photo courtesy of Christie's.

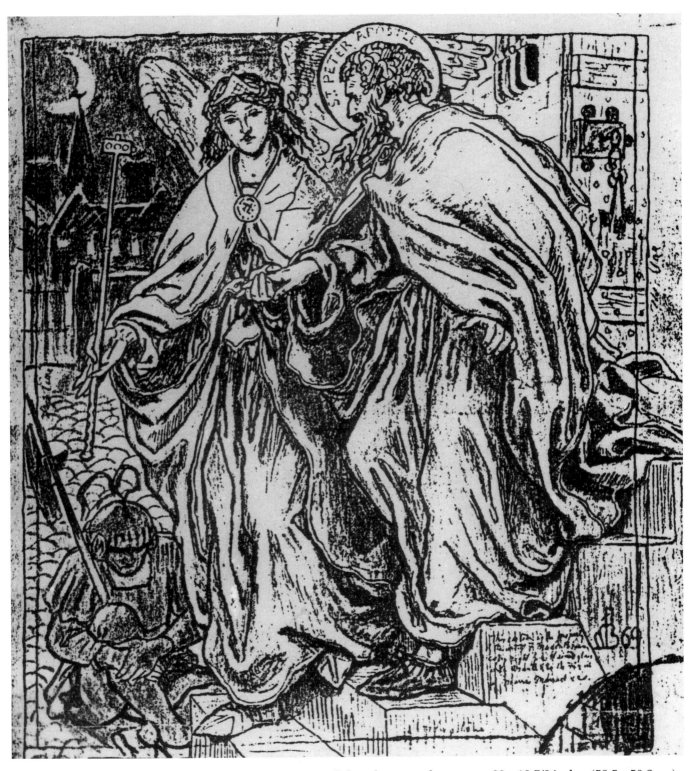

Fig. 59. F. M. Brown, *The Liberation of Saint Peter*, 1869. Ink and gray wash on paper, 23 x 19 7/8 inches (58.5 x 50.2 cm). Sold Christie's, London, 22 February 1977. Cartoon for a stained-glass window in St. Peter's, Stepney. The window was destroyed during World War II. The design was also utilized for windows in other churches decorated by Morris, Marshall & Faulkner, including the parish church of Llanllwchalarn, Montgomery.

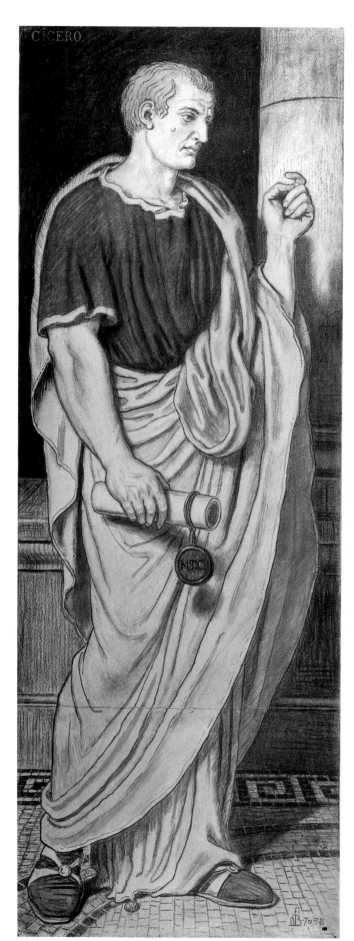

Fig. 60. F. M. Brown, *Cicero*, 1870–78. Ink and black chalk on paper, 42 x 18 inches (106.6 x 45.7 cm). University of Manchester. This is one of a series of cartoons of great men. Most were originally designed for windows at Peterhouse College, Cambridge. The cartoons were retouched c. 1878 and bought by Charles Rowley, who presented them to Owens College, Manchester.

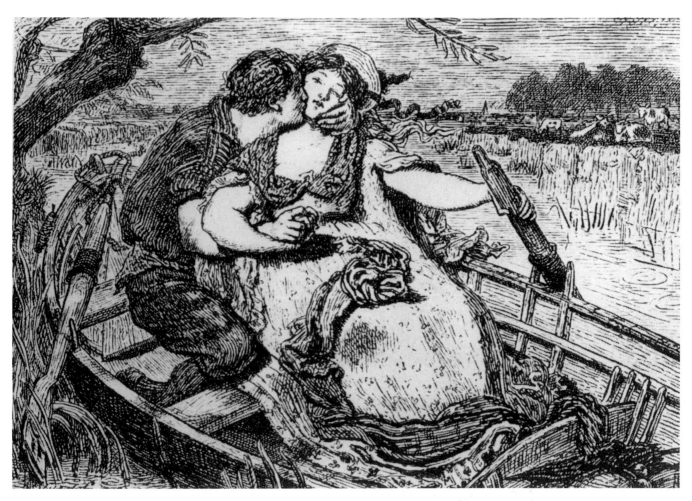

Fig. 61. F. M. Brown, *Down Stream*, 1871. Wood engraving. *Dark Blue* (October 1871). An illustration to Rossetti's poem "Down Stream," published in a short-lived magazine called *Dark Blue*. A pencil drawing for the illustration was sold at Sotheby's, London, 29 October 1985.

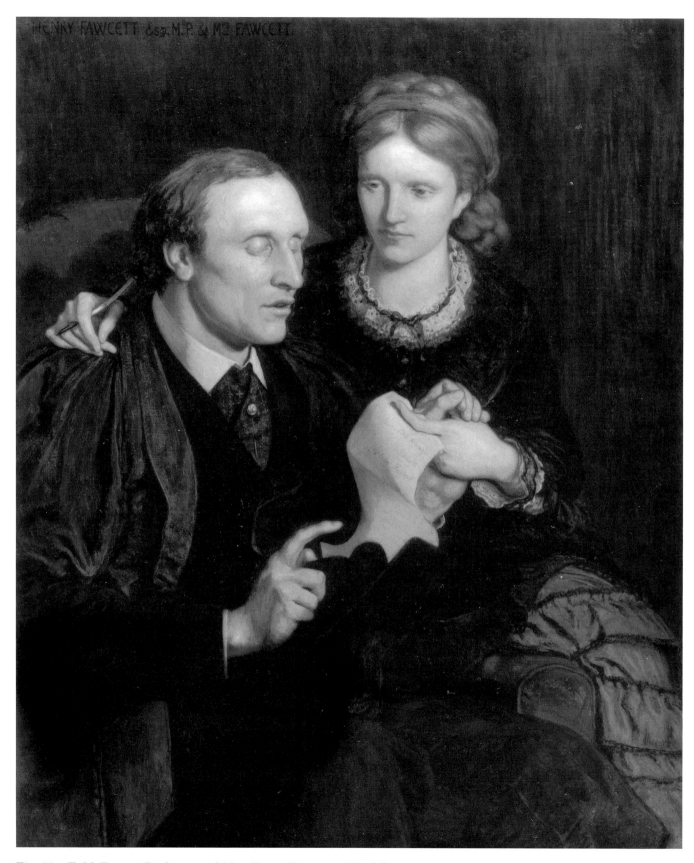

Fig. 62. F. M. Brown, *Professor and Mrs. Henry Fawcett*, 1872. Oil on canvas, 43 x 33 inches (109.2 x 83.8 cm). National Portrait Gallery, London. Fawcett (1833–84), who had been blinded in a shooting accident, was a professor of political economy at Cambridge and an M.P. He became postmaster general under Gladstone. His wife, Dame Millicent Garrett Fawcett (1847–1929), became leader of the nonmilitant Suffragists. The double portrait was commissioned by the radical Liberal Sir Charles Dilke.

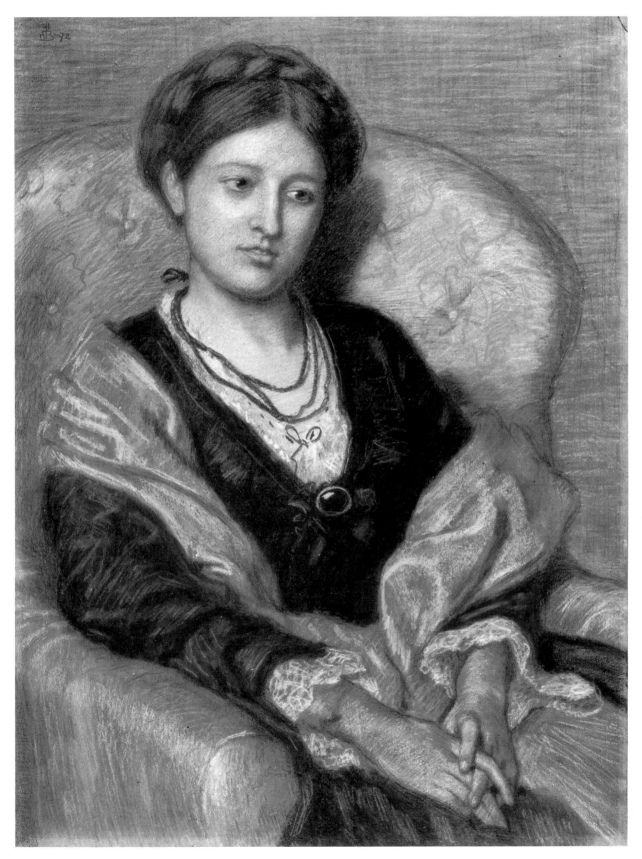

Fig. 63. F .M. Brown, *Iza Hardy*, 1872. Pastel on paper, 29 x 21 inches (73.7 x 53.2 cm). Birmingham Museums and Art Gallery. The sitter was a novelist.

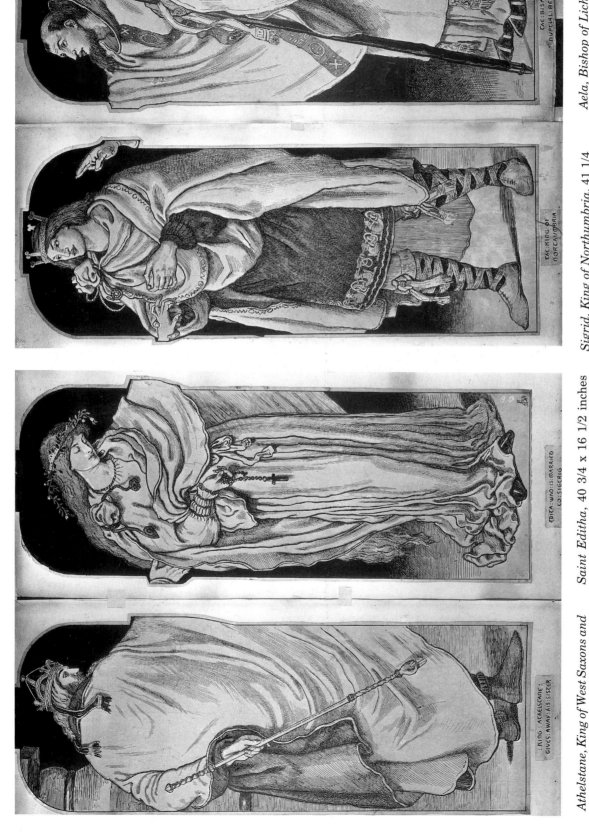

Athelstane, King of West Saxons and Mercians, Giving Away His Sister, Saint Editha, 41 1/4 x 15 3/4 inches (104.8 x 40.1 cm).

Saint Editha, 40 3/4 x 16 1/2 inches (103.5 x 41.9 cm).

Sigrid, King of Northumbria, 41 1/4 x 16 1/4 inches (104.6 x 41.3 cm).

Aela, Bishop of Lichfield, Giving His Nuptial Benediction, 41 1/4 x 16 inches (104.5 x 40.6 cm).

Fig. 64. F. M. Brown, four cartoons for the stained-glass windows of St. Editha, Tamworth, Staffordshire, 1873. Ink with bodycolor on tracing paper laid down on card. Whitworth Art Gallery, University of Manchester.

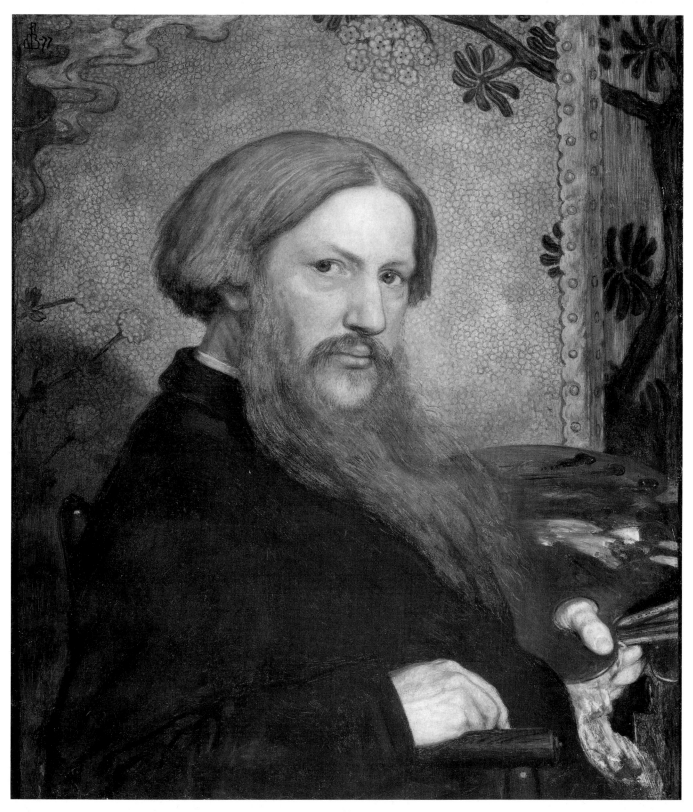

Fig. 65. F. M. Brown, *Self-Portrait*, 1877. Oil on canvas, 29 3/8 x 24 inches (74.6 x 61 cm). Courtesy of Fogg Art Museum, Harvard University Art Museums, Gift of Grenville L. Winthrop. The artist sits in a Sussex chair, manufactured by Morris, Marshall & Faulkner. The decorative leather screen also appears in *Cromwell, Protector of the Vaudois* (Fig. 67).

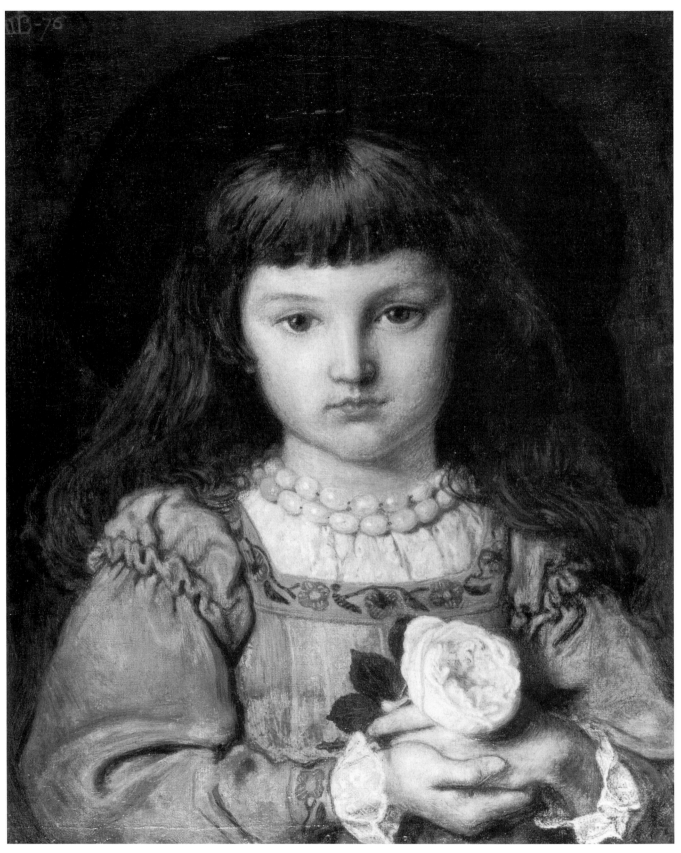

Fig. 66. F. M. Brown, *La Rose de l'infante* (*Child with Rose*), 1876. Oil on canvas, 18 x 14 inches (45.7 x 35.6 cm). Courtesy of Fogg Art Museum, Harvard University Art Museums, Gift of Grenville L. Winthrop. This *infanta*, or Spanish princess, is a portrait of Effie, the daughter of Marie Spartali Stillman.

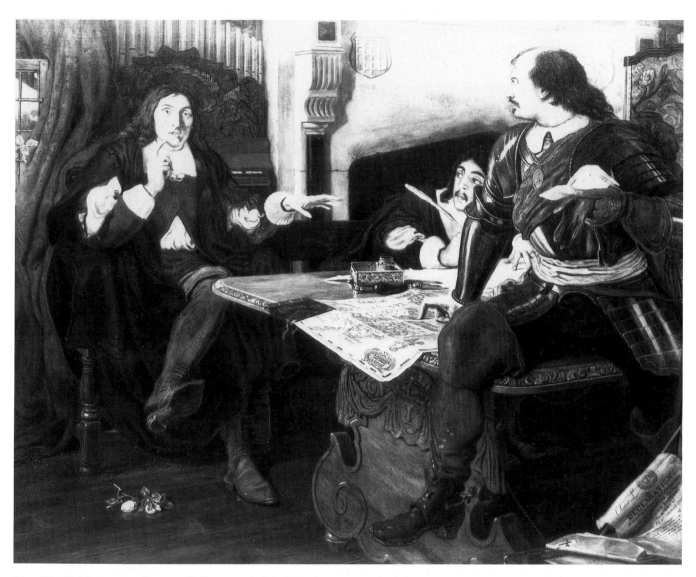

Fig. 67. F. M. Brown, *Cromwell, Protector of the Vaudois*, 1877–78. Oil on canvas, 31 x 38 inches (78.7 x 96.5 cm). City of Nottingham Museums, Castle Museum and Art Gallery. This is a replica of the slightly larger oil of 1877 in the Manchester City Art Galleries. The decorative leather screen in this historical scene appears in Brown's *Self-Portrait* of 1877 (Fig. 65).

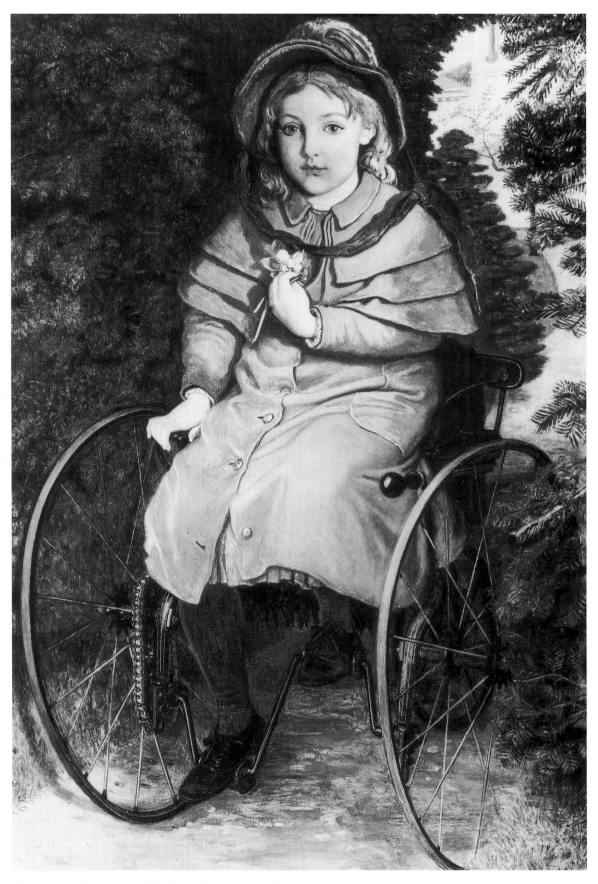

Fig. 68. F. M. Brown, *Madeline Scott*, 1883. Oil on canvas, 48 1/16 x 30 7/8 inches (122.1 x 78.5 cm). Manchester City Art Galleries. The sitter, the daughter of the *Manchester Guardian* editor C. P. Scott, is shown on a tricycle. Her father was an enthusiastic bicyclist and supporter of F. M. Brown.

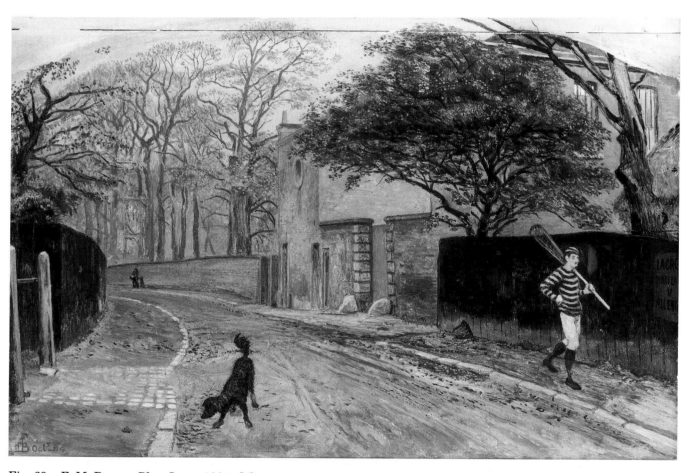

Fig. 69. F. M. Brown, *Platt Lane*, 1884. Oil on canvas, 15 1/2 x 10 1/4 inches (39.4 x 26 cm). Tate Gallery, London. Platt Lane was in a suburban neighborhood in Manchester.

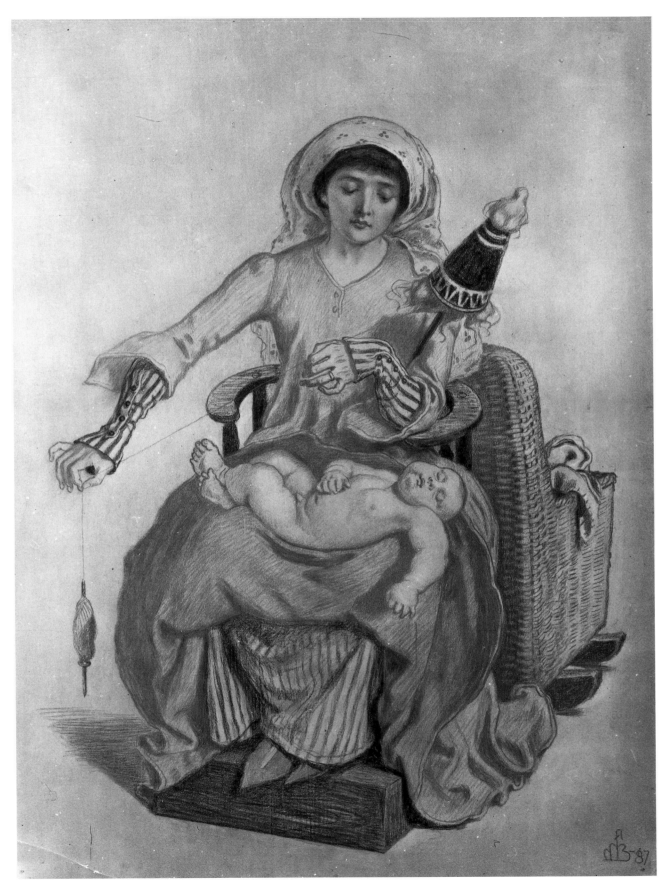

Fig. 70. F. M. Brown, *Spinner*, 1887. Red, black, brown, and white chalk on paper, 29 5/8 x 21 1/2 inches (75.1 x 54.6 cm). Whitworth Art Gallery, University of Manchester. Design for one of a series of huge decorative panels at the Manchester Jubilee Exhibition of 1887, which represented the commercial activities of the city.

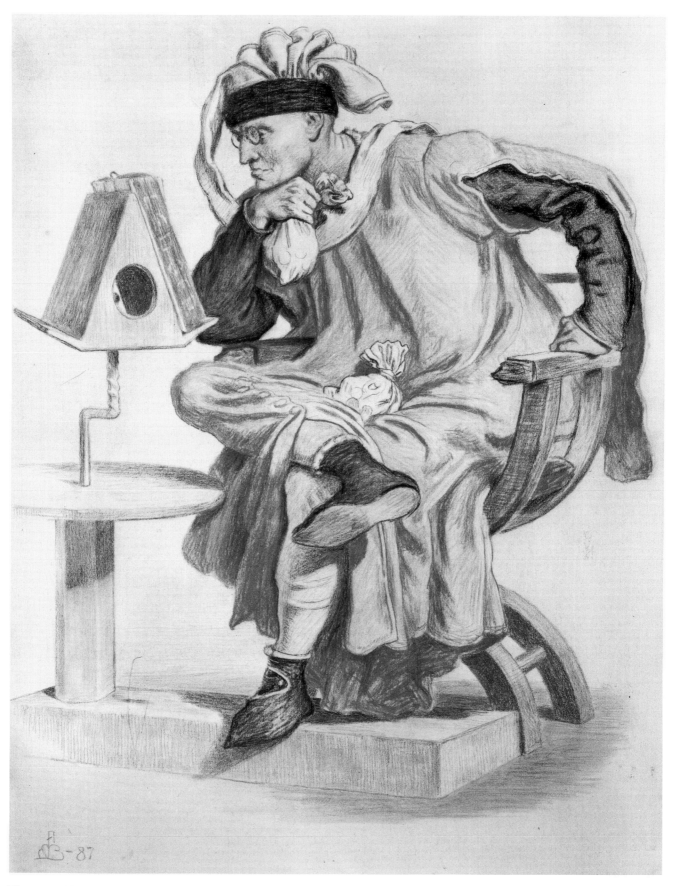

Fig. 71. F. M. Brown, *Merchant*, 1887. Red, black, and brown chalk on paper, 30 x 21 3/4 inches (76.2 x 55.1 cm). Whitworth Art Gallery, University of Manchester. This is another of the designs for the decorative panels at the Manchester Jubilee Exhibition of 1887.

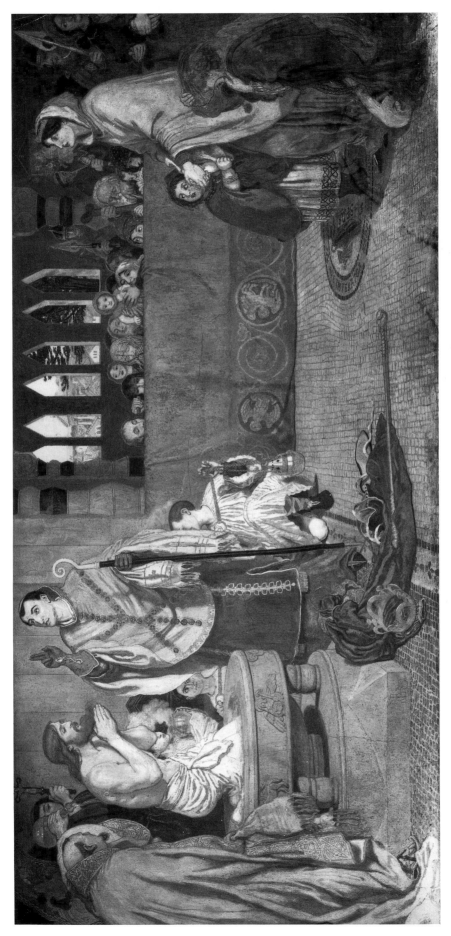

Fig. 72. F. M. Brown, *The Baptism of Edwin A.D. 627*, 1879–80. Gambier-Parry wax and spirit medium on plaster wall, 58 x 125 inches (143.3 x 317.5 cm). Great Hall, Town Hall, Manchester. The first of Brown's Manchester murals to be completed. The design was begun in 1878. A full-scale replica in colored chalk, developed from the cartoon and dated 1879–91, is in the National Gallery of Victoria, Melbourne. A small oil version of 1879 is in the City Art Gallery, Carlisle.

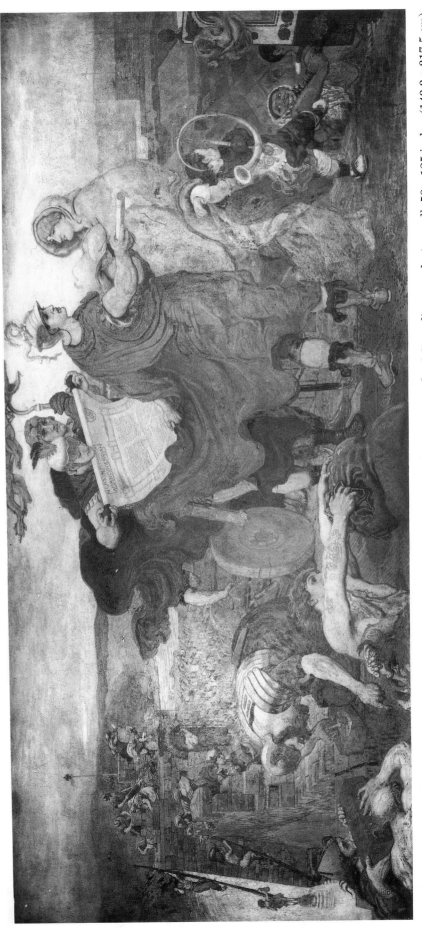

Fig. 73. F. M. Brown, *The Romans Building a Fort at Mancenion*, 1880. Gambier–Parry wax and spirit medium on plaster wall, 58 x 125 inches (143.3 x 317.5 cm). Great Hall, Town Hall, Manchester. This Manchester mural was designed in 1879, and begun on the wall in the following year. A reduced version in oil, dated 1879–90, is in the Aberdeen City Art Gallery.

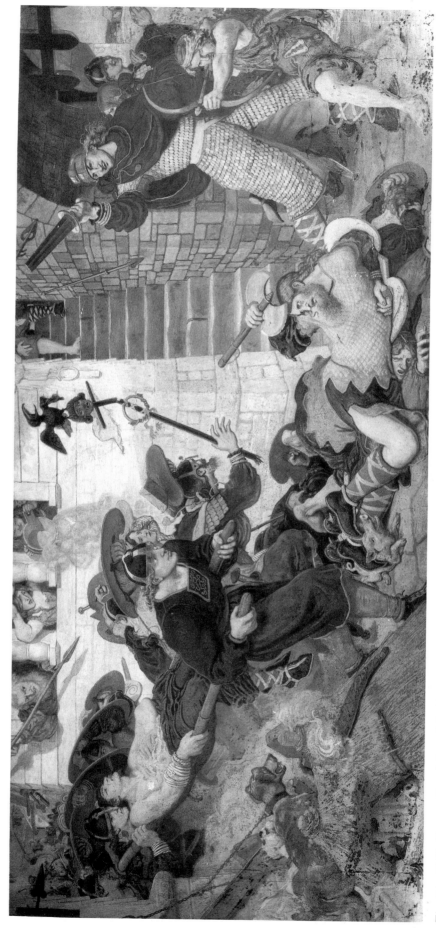

Fig. 74. F. M. Brown, *Expulsion of the Danes from Manchester*, 1881. Gambier-Parry wax and spirit medium on plaster wall, 58 x 125 inches (143.3 x 317.5 cm). Great Hall, Town Hall, Manchester. This mural was begun in 1880.

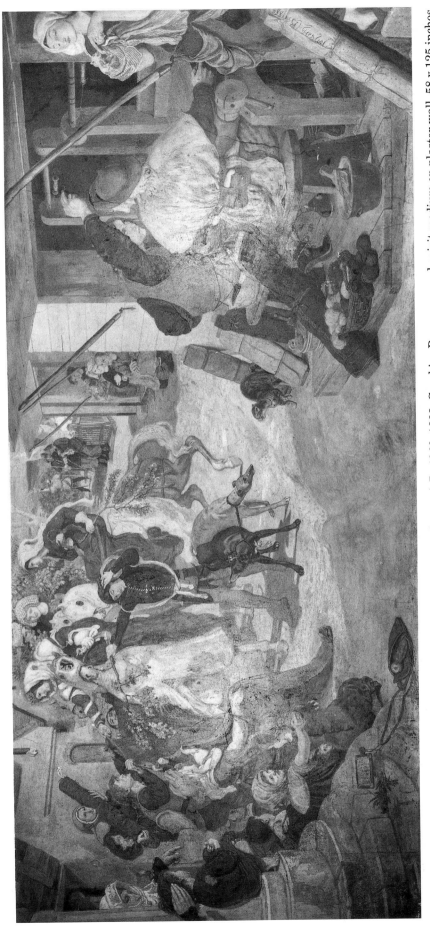

Fig. 75. F. M. Brown, *The Establishment of Flemish Weavers in Manchester A.D. 1363*, 1882. Gambier-Parry wax and spirit medium on plaster wall, 58 x 125 inches (143.3 x 317.5 cm). Great Hall, Town Hall, Manchester. This mural was designed in 1881. A small replica in tempera on panel is in the Manchester City Art Galleries.

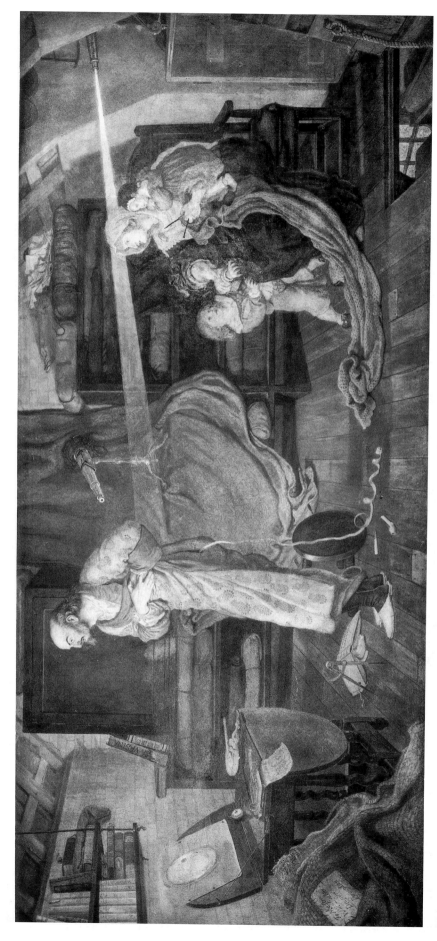

Fig. 76. F. M. Brown, *Crabtree Watching the Transit of Venus, A.D. 1639*, 1883. Gambier-Parry wax and spirit medium on plaster wall, 58 x 125 inches (143.3 x 317.5 cm). Great Hall, Town Hall, Manchester. This mural was designed in 1881 but was not begun to be painted on the wall until 1882, and ba

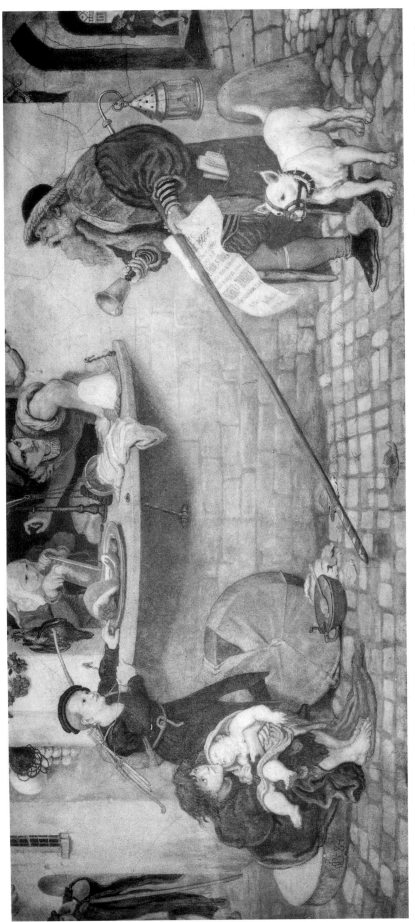

Fig. 77. F. M. Brown, *The Proclamation Regarding Weights and Measures A.D. 1556*, 1884. Gambier-Parry wax and spirit medium on plaster wall, 58 x 125 inches (143.3 x 317.5 cm). Great Hall, Town Hall, Manchester. This Manchester mural was designed in 1881 but was not begun to be painted on the wall until 1883.

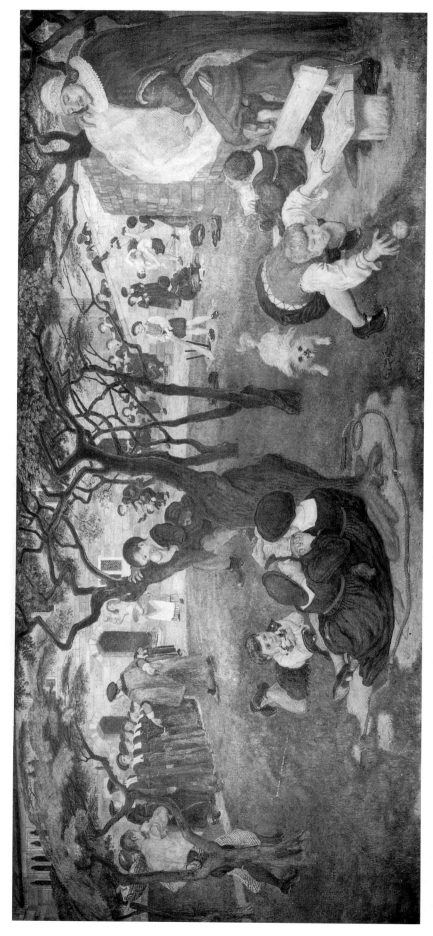

Fig. 78. F. M. Brown, *Chetham's Life Dream, circa A.D. 1640*, 1886. Oil on canvas glued to plaster wall, 58 x 125 inches (143.3 x 317.5 cm). Great Hall, Town Hall, Manchester. This was the first of the Manchester murals to be painted on canvas. It was begun in 1885.

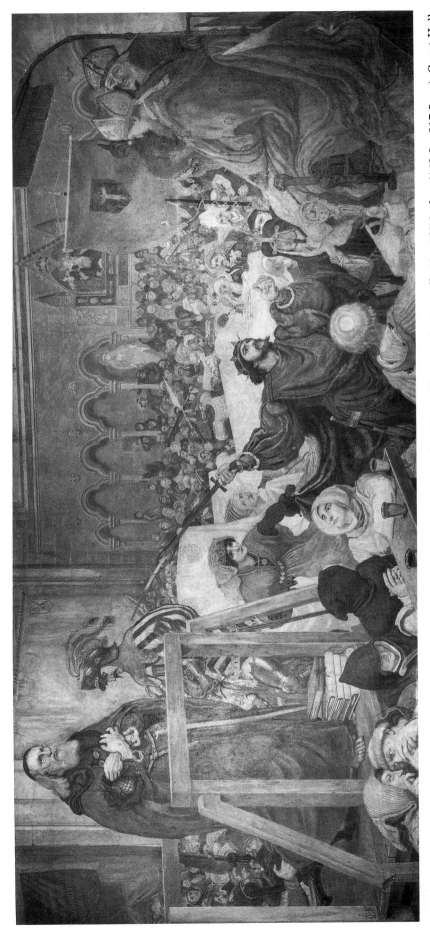

Fig. 79. F. M. Brown, *The Trial of Wycliffe A.D. 1377*, 1886. Gambier-Parry wax and spirit medium on plaster wall, 58 x 125 inches (143.3 x 317.5 cm). Great Hall, Town Hall, Manchester. This mural was begun in 1885. A small oil replica, dated 1885, is in the Glasgow Art Gallery.

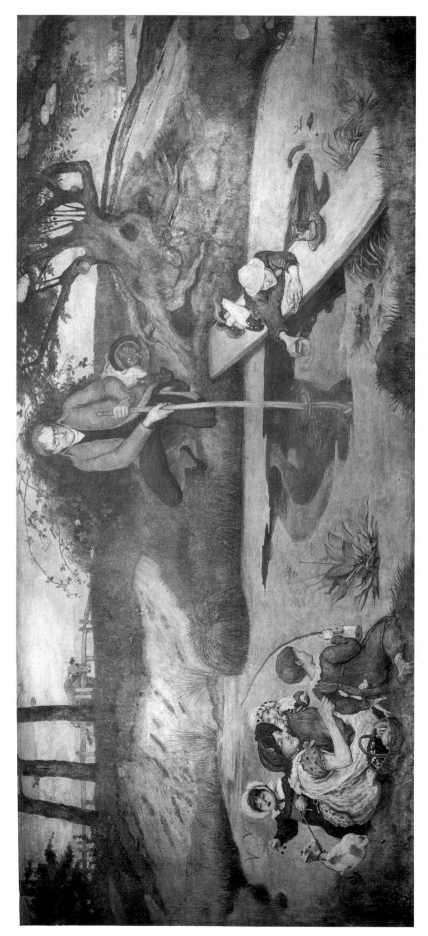

Fig. 80. F. M. Brown, *Dalton Collecting Marsh-Fire Gas*. 1887. Oil on canvas glued to plaster wall, 58 x 125" (143.3 x 317.5 cm). Great Hall, Town Hall, Manchester. Studies for this mural were first made in 1886.

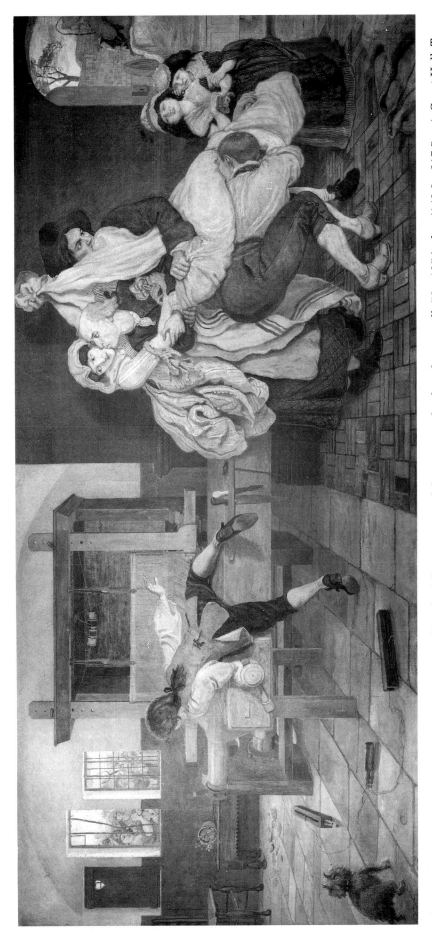

Fig. 81. F. M. Brown, *John Kay, Inventor of the Fly Shuttle, A.D. 1753*, 1890. Oil on canvas glued to plaster wall, 58 x 125 inches (143.3 x 317.5 cm). Great Hall, Town Hall, Manchester. This mural was begun in 1888. A small, unfinished replica is in the Manchester City Art Galleries.

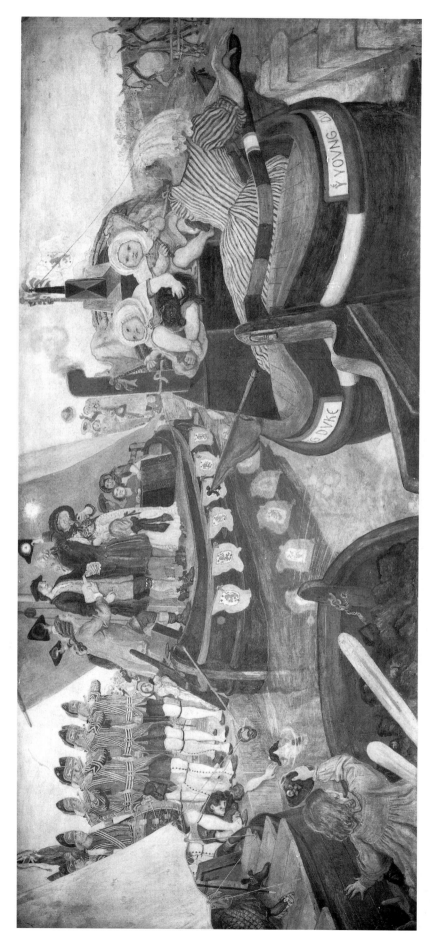

Fig. 82. F. M. Brown, *Opening of the Bridgewater Canal, A.D. 1761*, 1892. Oil on canvas glued to plaster wall, 58 x 125 inches (143.3 x 317.5 cm). Great Hall, Town Hall, Manchester. The cartoon for this mural was begun in 1890.

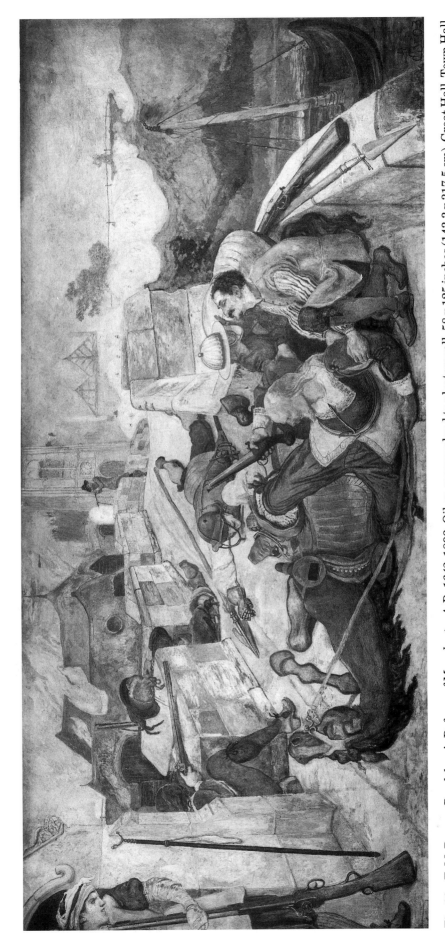

Fig. 83. F. M. Brown, *Bradshaw's Defence of Manchester A.D. 1642*, 1893. Oil on canvas glued to plaster wall, 58 x 125 inches (143.3 x 317.5 cm). Great Hall, Town Hall, Manchester. This was the last of the Manchester murals to be completed. It was finished after Brown had suffered a stroke.

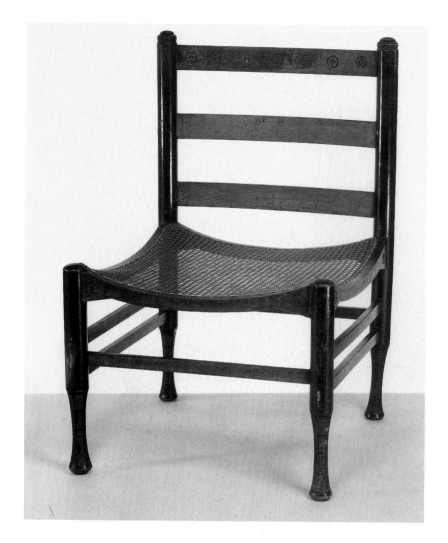

Fig. 84. F. M. Brown, "Egyptian Chair," manufactured by Morris, Marshall & Faulkner. Victoria & Albert Museum, London.

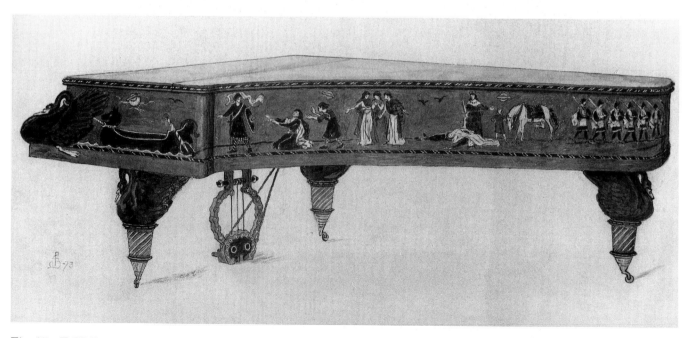

Fig. 85. F. M. Brown, Design for "Lohengrin Piano," 1873. Black and sepia wash on paper, 11 1/4 x 19 1/4 inches (28.5 x 49 cm). Board of Trustees of the National Museums and Galleries on Merseyside (Walker Art Gallery, Liverpool).

Fig. 86. F. M. Brown, "A Workman's Chest of Drawers," exhibited 1887, 1888, and 1890. Illustration from *The Artist*, May 1898.

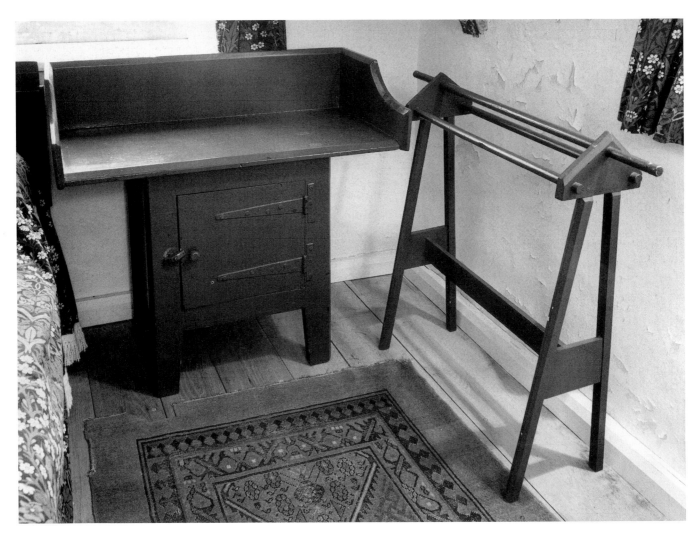

Fig. 87. F. M. Brown, Furniture at Kelmscott Manor: washstand and towel horse. Kelmscott Manor, Lechlade, Gloucestershire.

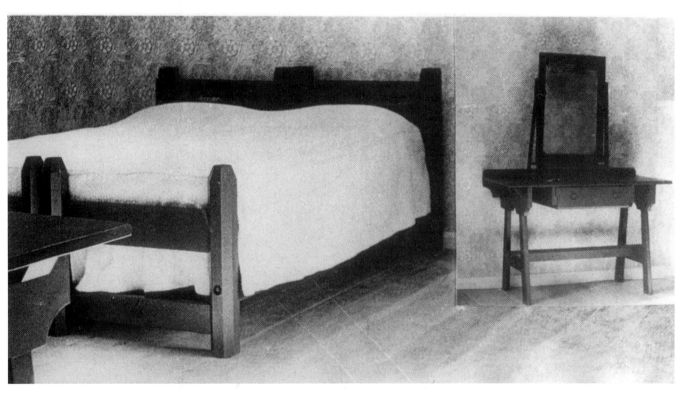

Fig. 88. F. M. Brown, Furniture at Kelmscott Manor: beds and dressing table. Kelmscott Manor, Lechlade, Gloucestershire.

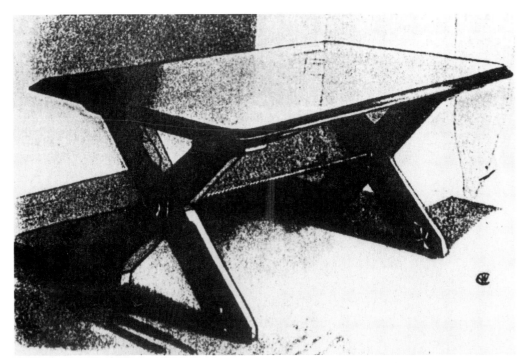

Fig. 89. F. M. Brown, X-leg table. Illustration from *The Artist*, May 1898.

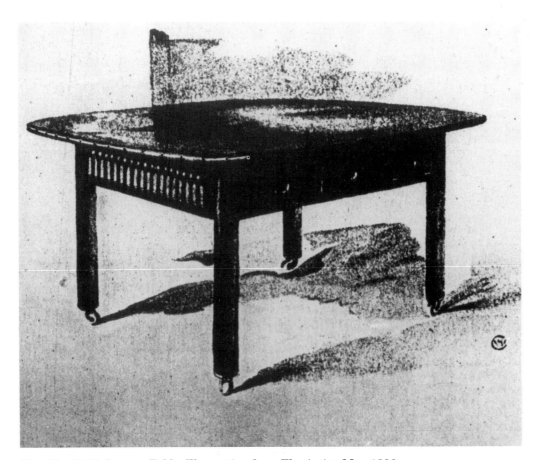

Fig. 90. F. M. Brown, Table. Illustration from *The Artist*, May 1898.

Fig 91. F. M. Brown, Cabinet for paints and books. Illustration from *The Artist*, May 1898.

Fig. 92. F. M. Brown, Ladder-back chair. Photo from Elizabeth Aslin, *Nineteenth-Century English Furniture*. New York: T. Yoseloff, c. 1962.

Fig. 93. Morris & Co., London. Sussex chairs and related furniture. Advertisement from Morris & Co. catalogue, c. 1910.

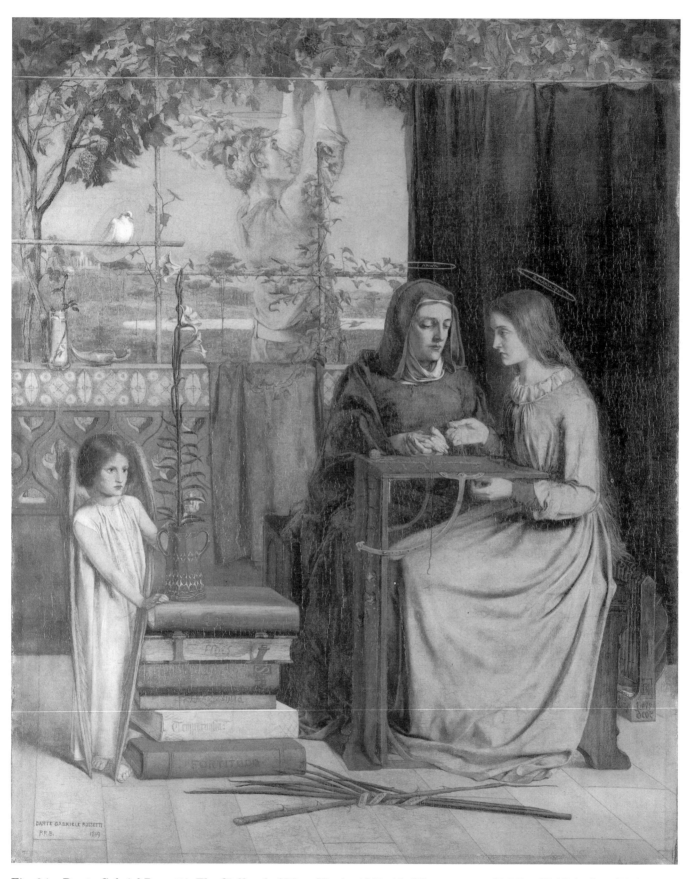

Fig. 94. Dante Gabriel Rossetti, *The Girlhood of Mary Virgin*, 1848–49. Oil on canvas, 32 3/4 x 25 3/4 inches (83.2 x 65.4 cm). Tate Gallery, London.

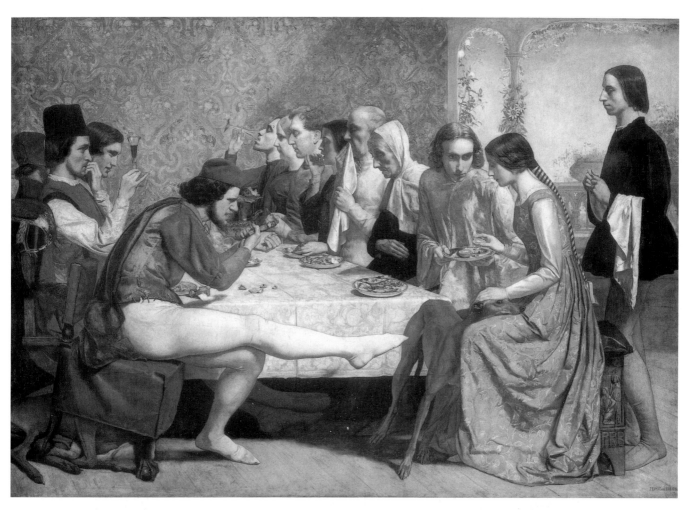

Fig. 95. John Everett Millais, *Lorenzo and Isabella*, 1848–49. Oil on canvas, 40 1/2 x 56 1/4 inches (102.9 x 142.9 cm). Board of Trustees of the National Museums and Galleries on Merseyside (Walker Art Gallery, Liverpool).

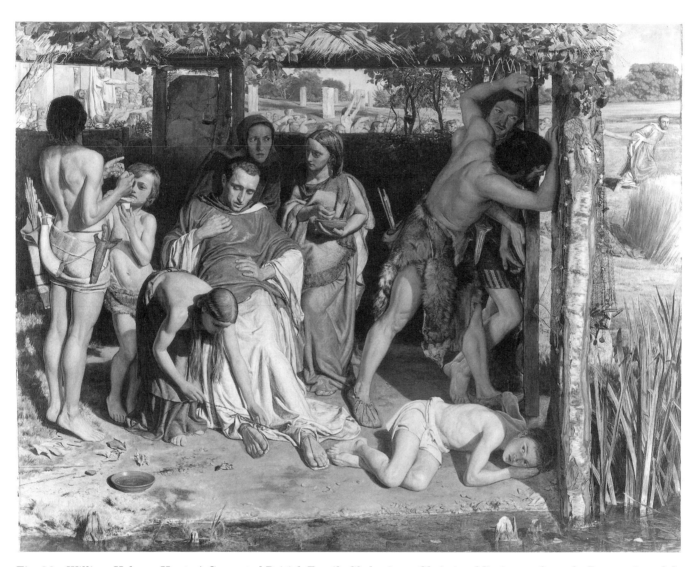

Fig. 96. William Holman Hunt, *A Converted British Family Sheltering a Christian Missionary from the Persecution of the Druids*, 1849–50. Oil on canvas, 43 3/4 x 52 1/2 inches (111 x 133.3 cm). Ashmolean Museum, Oxford.

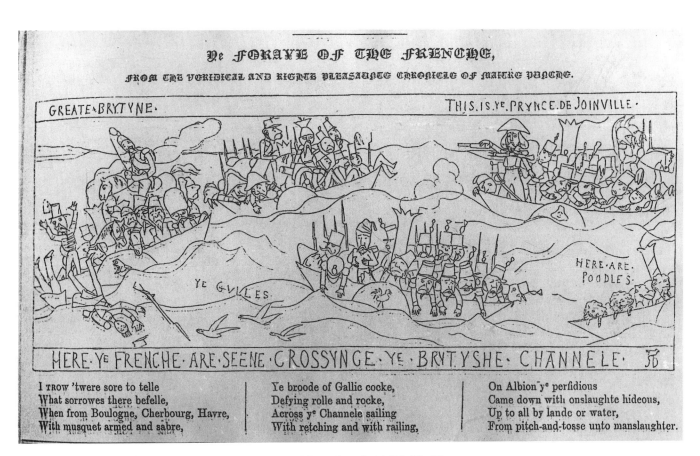

Fig. 97. Richard Doyle, "Our Barry-eux Tapestry," *Punch*, vol. 14 (1848), 33.

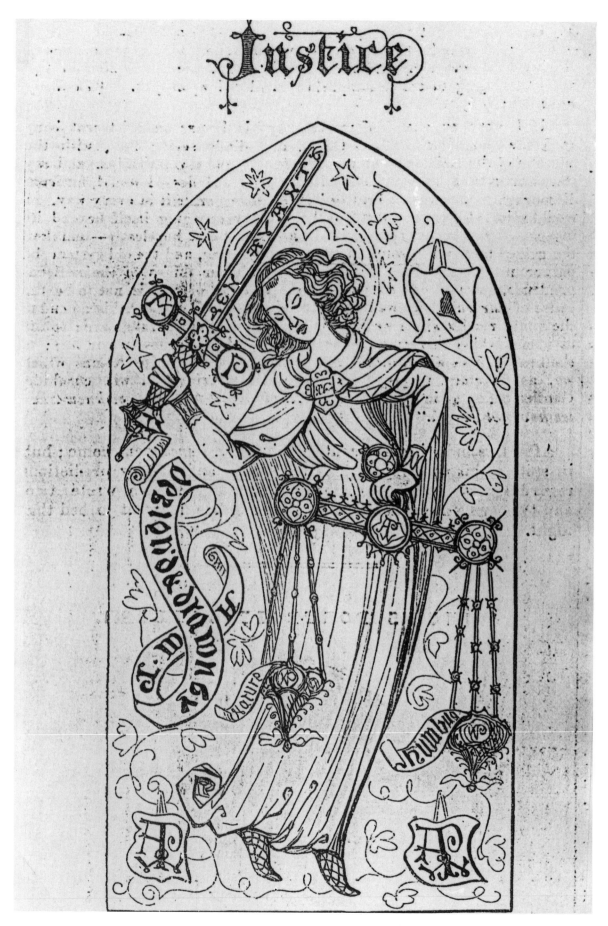

Fig. 98. "Justice for Parliament (A Cartoon)," *Punch*, vol. 9 (1845), 150.

ADVICE TO ASPIRING ARTISTS.

T the Palace of Westminster a clever artist has now a chance of a good job or two; and we especially address those who are desirous of that sort of employment. Painting being an imitative art, it behoves every painter to cultivate his faculty of imitation. He can do nothing without a model, and the best models that he can choose are the Germans. Accordingly, let him allow his hair to grow long, and let him also wear mustaches and a great beard. He will likewise do well to dress in the style of the middle ages; or if his clothes are not middle-aged, they should at least be old, and the dirtier and shabbier they are, consistently with common decency, the better. This is that judicious kind of imitation which, if not tantamount to originality, is the next thing to it, and is sure to gain credit for it at any rate.

As to copying RAPHAEL and MICHAEL ANGELO, he need take pattern from them in no respect except in his personal costume. It is now admitted that those individuals were very poor daubers, their style being a great deal too free and easy, and not at all cramped, stiff, and wooden enough for high art. They had, in particular, a certain bad knack of foreshortening, a

A YOUNG MAN ABOUT TOWN.
(*Gothic.*)

Fig. 99. "Advice to Aspiring Artists," *Punch*, vol. 9 (1845), 103: Initial A and "A Young Man About Town (Gothic)."

A SCENE FROM GOTHIC LIFE.

Fig. 100. "Advice to Aspiring Artists," *Punch*. vol. 9 (1845), 103: "A Scene from Gothic Life."

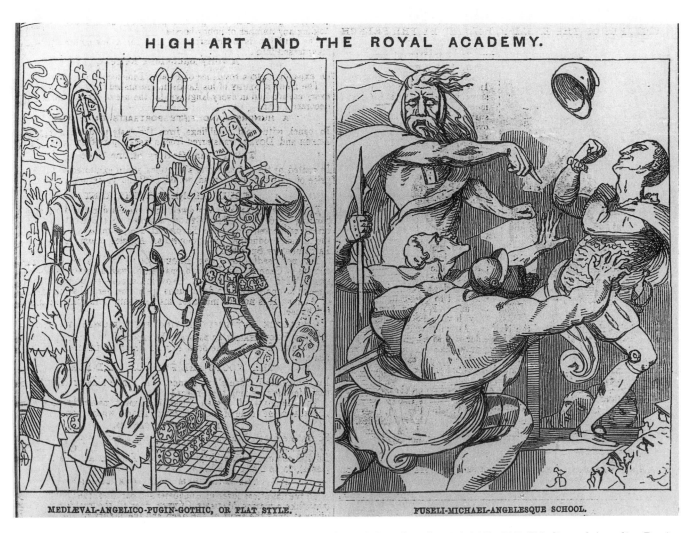

Fig. 101. Richard Doyle, "High Art and the Royal Academy," *Punch*, vol. 14 (1848), 197: "Mediaeval-Angelico-Pugin-Gothic, or Flat Style" and "Fuseli-Michael-Angelesque School."

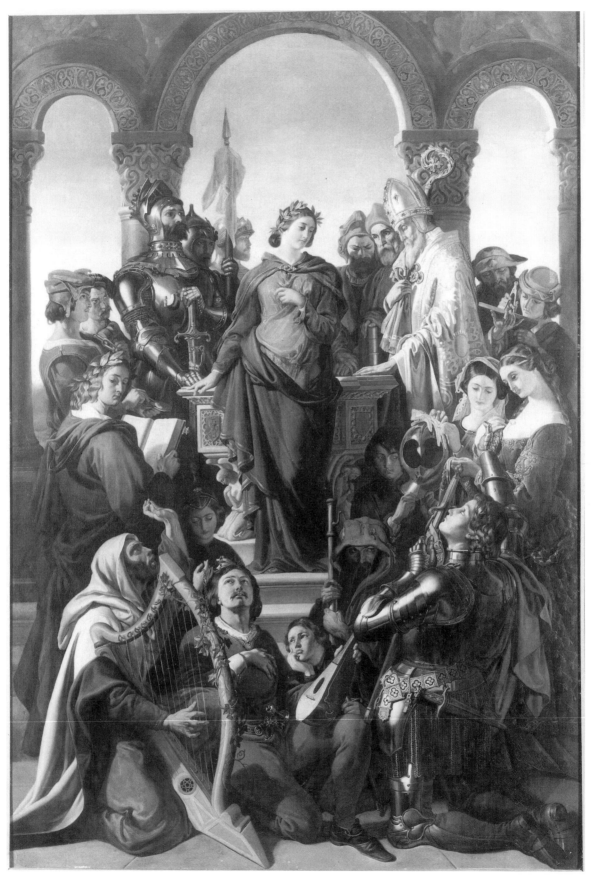

Fig. 102. Daniel Maclise, *The Spirit of Chivalry*, c. 1845. Oil on canvas, 49 1/2 x 35 1/4 inches (125.8 x 89.5 cm). Reproduced by Permission of Sheffield Arts and Museums Department. An oil version of Maclise's 1845–47 fresco in the House of Lords.

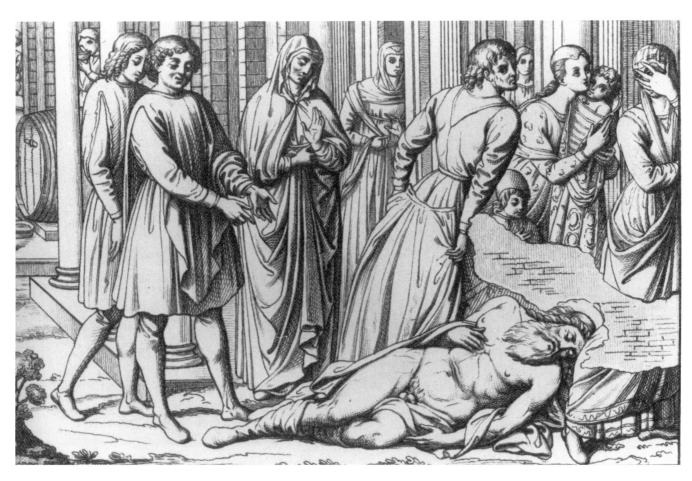

Fig. 103. Detail of a line engraving after Benozzo Gozzoli, *The Drunkenness of Noah*, Campo Santo, Pisa, from Paolo Lasinio figlio, *Pittura a fresco del camposanto di Pisa* (Florence, 1832), pl. XXI.

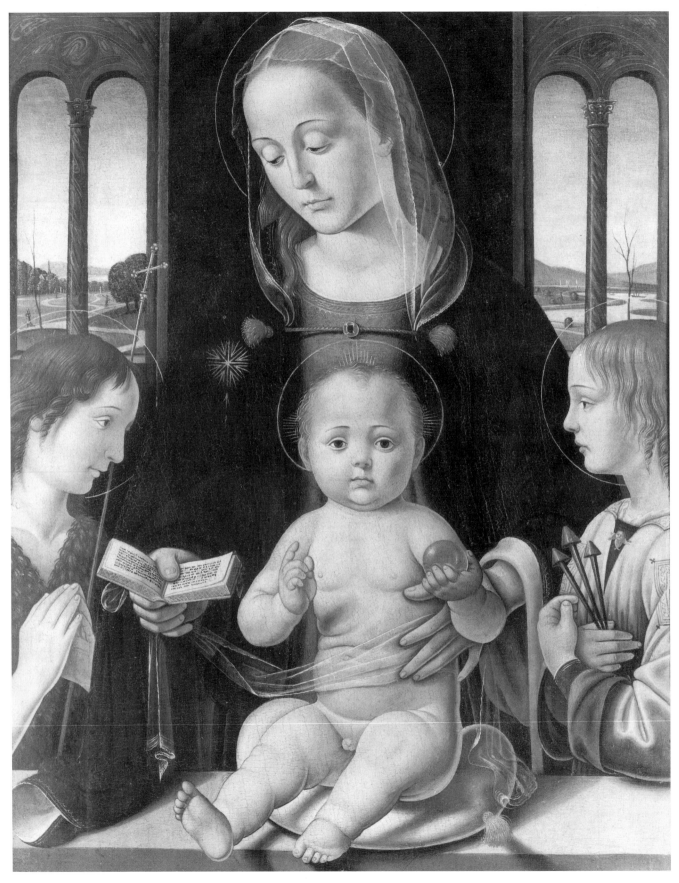

Fig. 104. Attributed to Giovanni Battista Utili or Biaggio d'Antonio da Firenze (formerly attributed to Filippo Lippi),
Virgin and Child with Saint John and Angel. Oil on panel, 25 1/2 x 19 3/4 inches (64.8 x 50.2 cm). The Governing Body,
Christ Church, Oxford.

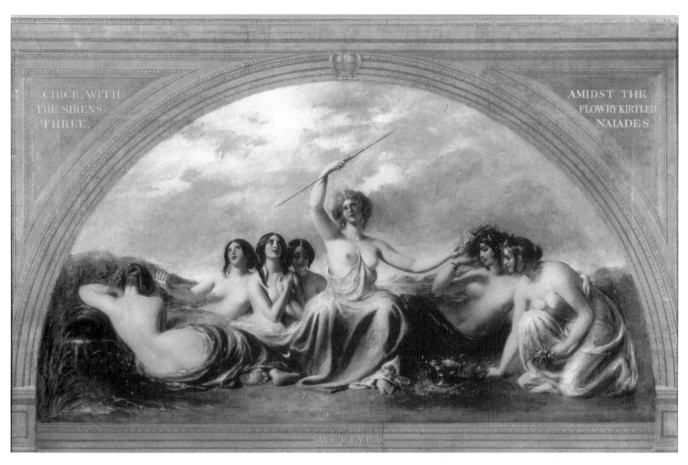

Fig. 105. William Etty, *Scene from Milton's Comus, "Circe with the Sirens three amidst the flowery kirtled Naiades,"* 1846. Oil on canvas, 46 1/2 x 71 1/2 inches (118 x 181.6 cm). Art Gallery of Western Australia, Perth.

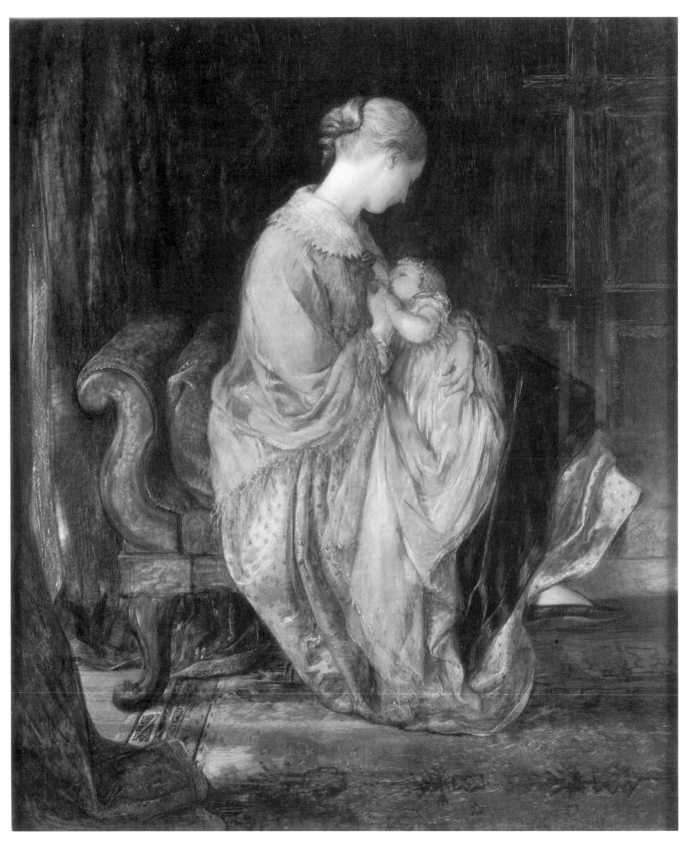

Fig. 106. Charles West Cope, *The Young Mother*, 1845. Oil on canvas, 12 x 10 inches (30.5 x 20.4 cm). Victoria & Albert Museum, London.

Fig. 107. Edwin Landseer, *The Sanctuary*, 1842. Oil on canvas, 24 x 60 inches (61 x 152.5 cm). The Royal Collection © Her Majesty Queen Elizabeth II.

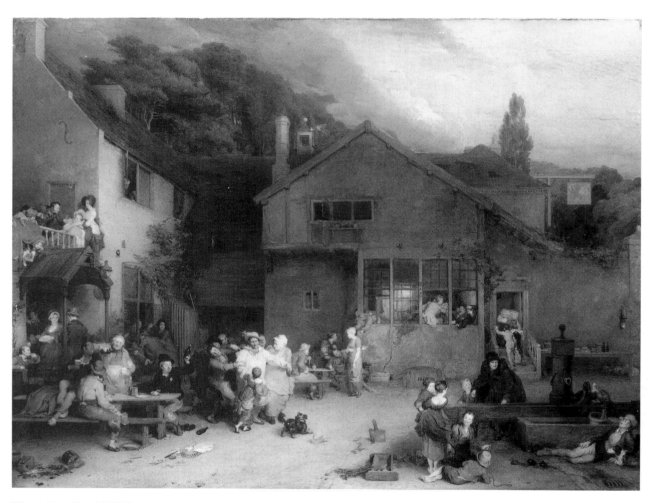

Fig. 108. David Wilkie, *The Village Festival (The Village Holiday)*, 1811. Oil on canvas, 37 x 50 3/8 inches (94 x 127.6 cm). Tate Gallery, London.

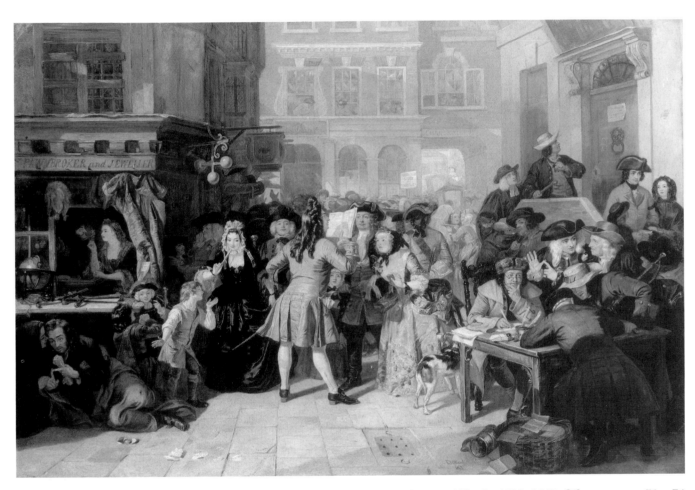

Fig. 109. Edward Matthew Ward, *The South Sea Bubble, A Scene in Change Alley in 1720*, 1847. Oil on canvas, 51 x 74 inches (129.5 x 188 cm). Tate Gallery, London.

Fig. 110. "The Real Street Obstructions," *Punch*, vol. 19 (1850), 30.

Fig. 111. Dante Gabriel Rossetti, *Fra Pace*, 1856. Watercolor on paper, 13 3/4 x 12 3/4 inches (34.9 x 32.4 cm). Private Collection.

Fig. 112. Photograph: The Sitting Room, Panshanger, Herefordshire, c. 1858. The Home of Lord Cowper. Photo from Susan Lasdun, *Victorians at Home*. London: Weidenfeld & Nicolson, c. 1981.

Fig. 113. Henry Eyles, easy chair, 1851. Shown at the Great Exhibition of 1851. Victoria & Albert Museum, London.

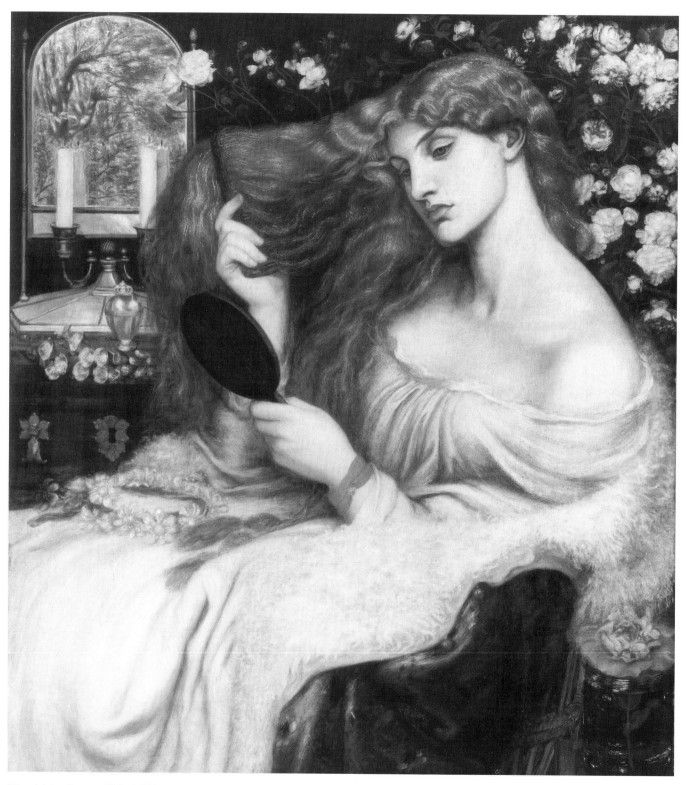

Fig. 114. Dante Gabriel Rossetti, *Lady Lilith*, 1868. Oil on canvas, 37 1/2 x 32 inches (95.2 x 81.3 cm). Delaware Art Museum, Samuel and Mary R. Bancroft Collection, Wilmington.

INTELLECTUAL EPICURES.

STEEPED IN ÆSTHETIC CULTURE, AND SURROUNDED BY ARTISTIC WALL-PAPERS, BLUE CHINA, JAPANESE FANS, MEDIÆVAL SNUFF-BOXES, AND HIS FAVOURITE PERIODICALS OF THE EIGHTEENTH CENTURY, THE DILETTANTE DE TOMKYNS COMPLACENTLY BOASTS THAT HE NEVER READS A NEWSPAPER, AND THAT THE EVENTS OF THE OUTER WORLD POSSESS NO INTEREST FOR HIM WHATEVER.

Betsy Waring (who goes out a-charing) and is a Martyr to Rheumatics (what comes o' damp attics), expresses similar views. In her own words:—
"I'VE OFTEN HEARD RUMOURS
OF WARS AND CONTUMOURS,
SEA-SARPINTS, AND COMICS AS LIGHTS UP THE SKY;
STEAM-HINGINS A-BUSTIN',
AND BANKS AS FOLKS TRUST IN,
BUT THEY DON'T NEVER FRET A OLD 'OOMAN LIKE I!"

Fig. 115. George Du Maurier, "Intellectual Epicures," *Punch*, vol. 60 (1876), 33.

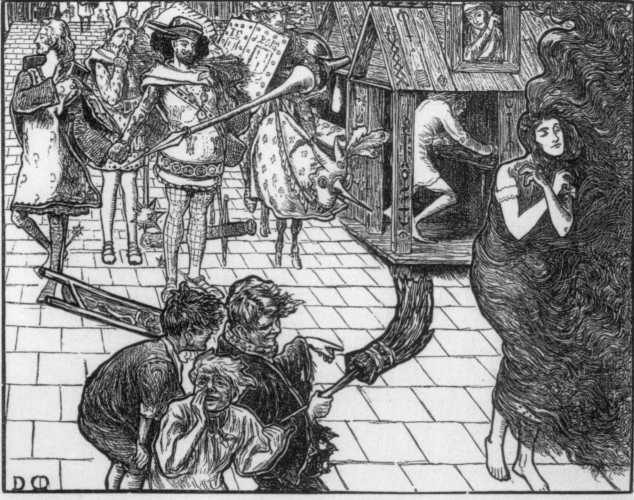

A Legend of Camelot.—Part 1.

TALL Braunighrindas left her bed
At cock-crow, with an aching head.
⊕ miſerie !
" I yearn to suffer and to do,"
She cried, " ere sunset, something new !
⊕ miſerie !
" To do and suffer, ere I die,
I care not what. I know not why.
⊕ miſerie !
" Some quest I crave to undertake,
Or burden bear, or trouble make."
⊕ miſerie !
She shook her hair about her form
In waves of colour bright and warm.
⊕ miſerie !
It rolled and writhed, and reached the floor :
A silver wedding-ring she wore.
⊕ miſerie !
She left her tower, and wandered down
Into the High Street of the town.
⊕ miſerie !
Her pale feet glimmered, in and out,
Like tombstones as she went about.
⊕ miſerie !
From right to left, and left to right ;
And blue veins streakt her insteps white ;
⊕ miſerie !
And folks did ask her in the street
" How fared it with her long pale feet ?"
⊕ miſerie !
And blinkt, as though 'twere hard to bear
The red-heat of her blazing hair !
⊕ miſerie !

Sir Galahad and Sir Launcelot
Came hand-in-hand down Camelot ;
⊕ miſerie !
Sir Gauwaine followèd close behind ;
A weight hung heavy on his mind.
⊕ miſerie !
" Who knows this damsel, burning bright,"
Quoth Launcelot, " like a northern light ?"
⊕ miſerie !
Quoth Sir Gauwaine : " I know her not !"
" Who quoth you did ?" quoth Launcelot.
⊕ miſerie !
" 'Tis Braunighrindas !" quoth Sir Bors.
(Just then returning from the wars).
⊕ miſerie !
Then quoth the pure Sir Galahad :
" She seems, methinks, but lightly clad !
⊕ miſerie !
" The winds blow somewhat chill to-day ;
Moreover, what would Arthur say !"
⊕ miſerie !
She thrust her chin towards Galahad
Full many an inch beyond her head . . .
⊕ miſerie !
But when she noted Sir Gauwaine
She wept, and drew it in again !
⊕ miſerie !
She wept : " How beautiful am I !"
He shook the poplars with a sigh.
⊕ miſerie !
Sir Launcelot was standing near ;
Him kist he thrice behind the ear.
⊕ miſerie !

" Ah me !" sighed Launcelot where he stood,
" I cannot fathom it !" . . . (who could ?)
⊕ miſerie !
Hard by his wares a weaver wove,
And weaving with a will, he throve ;
⊕ miſerie !
Him beckoned Galahad, and said,—
" Gaunt Braunighrindas wants your aid . .
⊕ miſerie !
" Behold the wild growth from her nape !
Good weaver, weave it into shape !"
⊕ miſerie !
The weaver straightway to his loom
Did lead her, whilst the knights made room ;
⊕ miſerie !
And wove her locks, both web and woof,
And made them wind and waterproof ;
⊕ miſerie !
Then with his shears he opened wide
An arm-hole neat on either side,
⊕ miſerie !
And bound her with his handkerchief
Right round the middle like a sheaf.
⊕ miſerie !
" Are you content, knight ?" quoth Sir Bors
To Galahad ; quoth he, " Of course !"
⊕ miſerie !
" Ah, me ! those locks," quoth Sir Gauwaine,
" Will never know the comb again !"
⊕ miſerie !
The bold Sir Launcelot quoth he nought ;
So (haply) all the more he thought.
⊕ miſerie !

Fig. 116. George Du Maurier, "A Legend of Camelot.—Part I," *Punch*, vol. 50 (1866), 94.

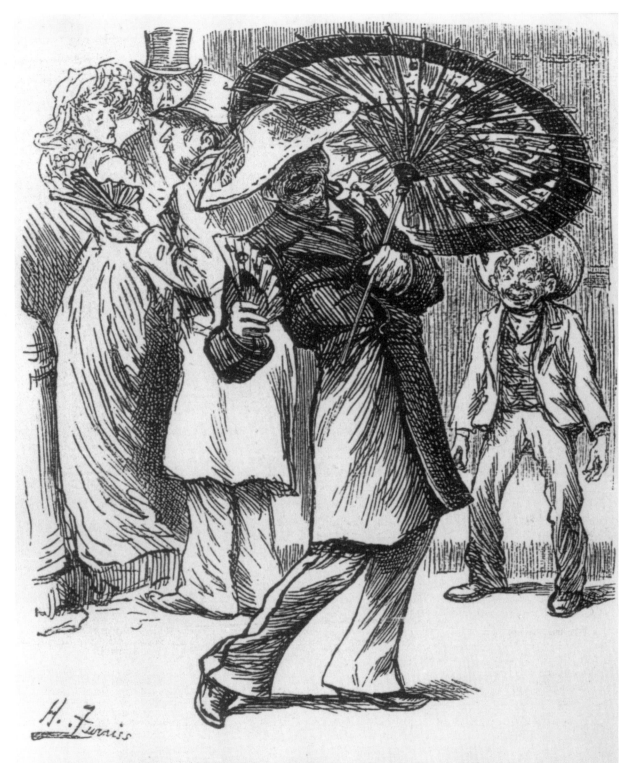

THE CHEAP ÆSTHETIC SWELL.

(Showing 'ow 'Arry goes in for the Intense—'Eat. Therm. 97° in the Shade.

TWOPENCE I GAVE FOR MY SUNSHADE,
 A PENNY I GAVE FOR MY FAN,
THREEPENCE I PAID FOR MY STRAW,—FORRIN MADE—
 I'M A JAPAN-ÆSTHETIC YOUNG MAN!

Fig. 117. Harry Furniss, "The Cheap Aesthetic Swell," *Punch*, vol. 81 (1881), 41.

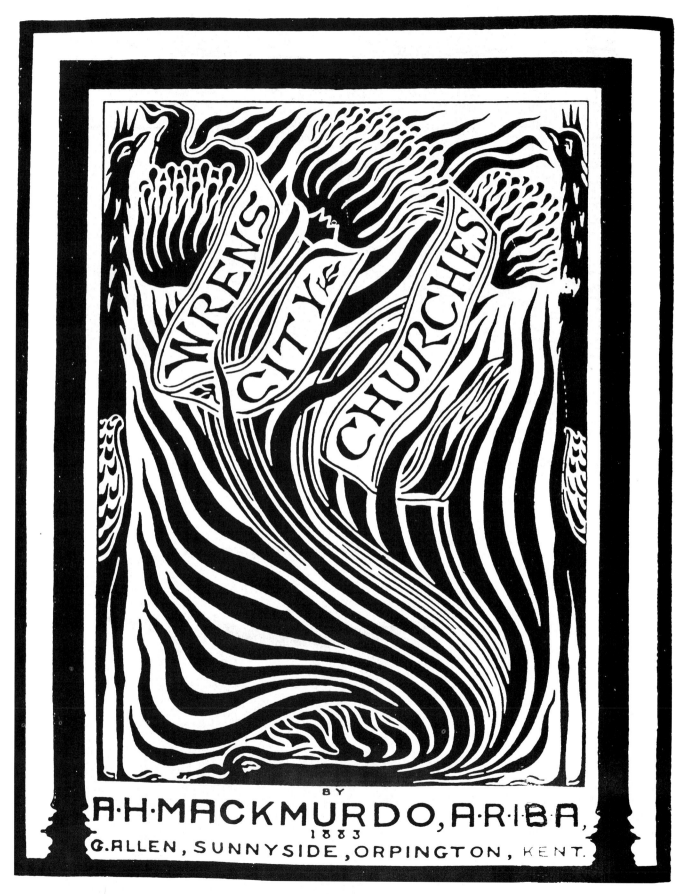

Fig. 118. A. H. Mackmurdo, title page of *Wren's City Churches*. London, 1883.

ÆSTHETIC LOVE IN A COTTAGE.

Miss Bilderbogie. "YES, DEAREST JOCONDA! I AM GOING TO MARRY YOUNG PETER PILCOX! WE SHALL BE VERY, *VERY* POOR! INDEED HOW WE ARE GOING TO *LIVE*, I CANNOT TELL!"

Mrs. Cimabue Brown. "OH, MY BEAUTIFUL MARIANA, HOW *NOBLE* OF YOU BOTH! NEVER MIND *HOW*, BUT *WHERE* ARE YOU GOING TO LIVE?"

Miss Bilderbogie. "OH, IN DEAR OLD KENSINGTON, I SUPPOSE—EVERYTHING IS SO CHEAP THERE, YOU KNOW!—PEACOCK FEATHERS ONLY A *PENNY A-PIECE!*"

Fig. 119. George Du Maurier, "Aesthetic Love in a Cottage," *Punch*, vol. 80 (1881), 78.

Fig. 120. G. E. Street, table for Cuddesdon Theological College, c. 1854–56. Victoria & Albert Museum, London.

THE HOME OF THE RICK-BURNER.

Fig. 121. John Leech, "The Home of the Rick-Burner," *Punch*, vol. 7 (1844), 17.

Fig. 122. Arthur Hughes,
April Love, 1855–56. Oil on
canvas, 35 x 19 1/2 inches
(88.9 x 49.5 cm). Tate Gallery,
London.

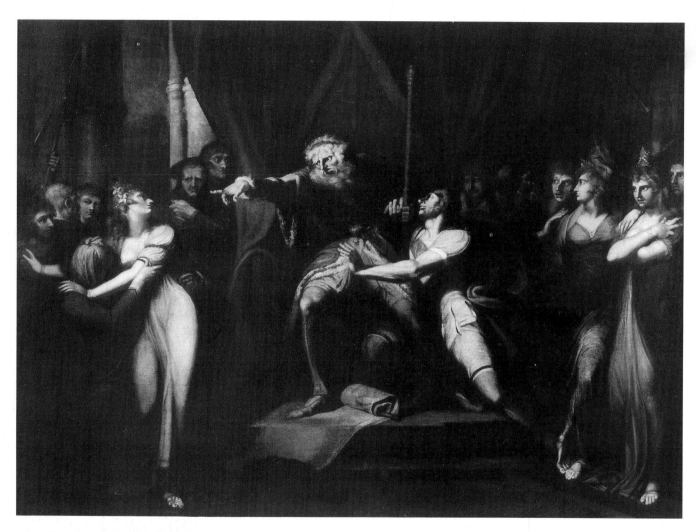

Fig. 123. Henry Fuseli, *Lear Disinheriting Cordelia (Lear Banishing Cordelia)*, 1785–90. Oil on canvas, 101 3/4 x 126 3/4 inches (259 x 363 cm). (Schiff #739). Art Gallery of Ontario, Toronto.